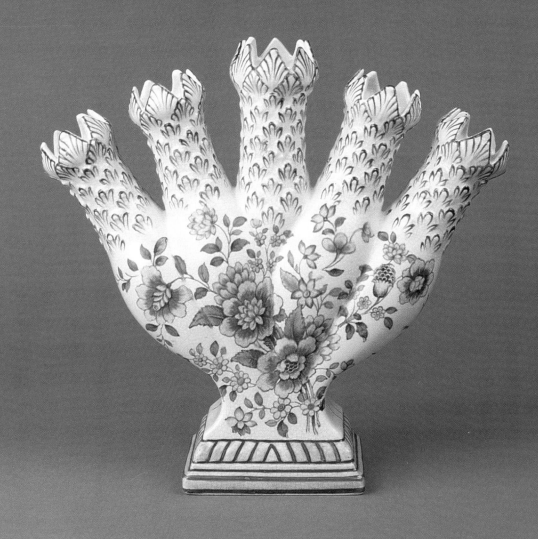

Quintal Flower Horn. *Minton. Impressed "MINTON". Height 7¾ ins: 20cm.*

The Dictionary
of
Blue and White
Printed Pottery 1780-1880

VOLUME II

(Additional Entries and Supplementary Information)

A.W.COYSH AND R.K.HENRYWOOD

Antique Collectors' Club

ISBN 1 84149 093 0

British Library Cataloguing-in-Publication Data
A catalogue record for this book is available from the British Library

The endpapers show the source print after a painting by J. Landseer for the pattern
on dinner wares by an unknown maker entitled "Game Keeper"

Printed in England
by the Antique Collectors' Club Ltd., Woodbridge, Suffolk
on Consort Royal Satin paper

The Antique Collectors' Club

The Antique Collectors' Club was formed in 1966 and quickly grew to a five figure membership spread throughout the world. It publishes the only independently run monthly antiques magazine, *Antique Collecting*, which caters for those collectors who are interested in widening their knowledge of antiques, both by greater awareness of quality and by discussion of the factors which influence the price that is likely to be asked. The Antique Collectors' Club pioneered the provision of information on prices for collectors and the magazine still leads in the provision of detailed articles on a variety of subjects.

It was in response to the enormous demand for information on 'what to pay' that the price guide series was introduced in 1968 with the first edition of *The Price Guide to Antique Furniture* (completely revised 1978 and 1989), a book which broke new ground by illustrating the more common types of antique furniture, the sort that collectors could buy in shops and at auctions rather than the rare museum pieces which had previously been used (and still to a large extent are used) to make up the limited amount of illustrations in books published by commercial publishers. Many other price guides have followed, all copiously illustrated, and greatly appreciated by collectors for the valuable information they contain, quite apart from prices. The Price Guide Series heralded the publication of many standard works of reference on art and antiques. *The Dictionary of British Art* (now in six volumes), *The Pictorial Dictionary of British 19th Century Furniture Design*, *Oak Furniture* and *Early English Clocks* were followed by many deeply researched reference works such as *The Directory of Gold and Silversmiths*, providing new information. Many of these books are now accepted as the standard work of reference on their subject.

The Antique Collectors' Club has widened its list to include books on gardens and architecture. All the Club's publications are available through bookshops world wide and a full catalogue of all these titles is available free of charge from the addresses below.

Club membership, open to all collectors, costs little. Members receive free of charge *Antique Collecting*, the Club's magazine (published ten times a year), which contains well-illustrated articles dealing with the practical aspects of collecting not normally dealt with by magazines. Prices, features of value, investment potential, fakes and forgeries are all given prominence in the magazine.

Among other facilities available to members are private buying and selling facilities and the opportunity to meet other collectors at their local antique collectors' clubs. There are over eighty in Britain and more than a dozen overseas. Members may also buy the Club's publications at special pre-publication prices.

As its motto implies, the Club is an organisation designed to help collectors get the most out of their hobby: it is informal and friendly and gives enormous enjoyment to all concerned.

For Collectors — By Collectors — About Collecting

ANTIQUE COLLECTORS' CLUB
5 Church Street, Woodbridge, Suffolk IP12 1DS, UK
Tel: 01394 385501 Fax: 01394 384434
Email: sales@antique-acc.com Website: www.antique-acc.com
——— *or* ———
Market Street Industrial Park, Wappingers' Falls, NY 12590, USA
Tel: 845 297 0003 Fax: 845 297 0068
Email: info@antiquecc.com Website: www.antiquecc.com

Contents

Colour Plates

Acknowledgements

The authors wish to express their appreciation to all friends, colleagues and correspondents who have contributed additional information, illustrations, corrections or encouragement. The help we have received has been extensive, and we would like to thank the following individuals and organisations:

Sarabeth Abir; Alan W.H. Aitchison; Frank G. Allen; Jeffrey Anderson; Fiona Aston, Dorset County Council (Bridport Library); Philip Barrett; Joan Bartholomew; Sylvia and Ramsey Bowes; Terry G. Brown; Judith Busby; Geoffrey Castle; Chelmsford Area Library; Richard Clements; Bill Coles; Rhoda Cope; Robert Copeland; Janet Coysh; Dreweatt-Neate (Auctioneers); Robert J. Dunn; Dr. Soli Engineer; Tony Fields; Una des Fontaines; G.B. Photographic Services; Cliff and Barbara Gazely; Ron Govier; Nancy Gunson; Dr. D.J. Harris; Anne von Heidiken; P. Heighton; A.R. Higgott; Dr. Maurice Hillis; F.E. Holloway; John Holmes; Janet M. Hope; Lt. Col. R.W.W. How; The Ironmongers' Company; Margaret Ironside; Pat Kenyon; Pat Latham; James Lewis; J.K. Linacre; Willow Little; Liverpool Museum (National Museums and Galleries on Merseyside); Terry Lockett; May & Son (Auctioneers) ; Maurice Milbourn; David Nairne; T.M. Neal; Newbury District Museum; Sue Norman; Doreen and Freddie Otto; Colin and Patricia Parkes; Bert and Liz Plimer; Judy Pollitt; John Potter; Martin and Rosalind Pulver; Mrs. J.E. Read; Bill Saks; Dr. Elizabeth Sherwood; Deborah Skinner; C.S.B. Smith; Liz Smith; Peggy D. Smythe; City Museum and Art Gallery, Stoke-on-Trent; John and Sally Storton; Hugh Stretton; J.R. Trotter; Joyce Waite; Joy Warren; E. Wilderspin; Audrey Wildish; Ruth Woollen; Sheila Wye; Denis Young.

The Friends of Blue

The Friends of Blue is a society which promotes mutual interest in, and further study of, underglaze blue transfer-printed earthenwares. Both the present authors were founder members of the society which includes many notable collectors, dealers and other authorities amongst its membership. It holds meetings twice a year and publishes a quarterly Bulletin which continues to be a useful source of news, information and illustrations of previously unrecorded patterns. With a following that is strong in Britain, North America, and elsewhere in the world, it is an invaluable organisation which we hope will go from strength to strength.

Introduction

Since the original publication of *The Dictionary of Blue and White Printed Pottery 1780-1880* in 1982, many previously unrecorded patterns have been reported by collectors both in this country and overseas. Other patterns have appeared in more recent publications, particularly later issues of the bulletin of the Friends of Blue. Many collectors have expressed interest in an addition to the *Dictionary*, and it seemed appropriate, therefore, to assemble the results of our own researches and the information kindly supplied by others into this volume. The subject appears to be inexhaustible, especially since the early pieces have become difficult to obtain and many collectors have been led to develop an interest in the later wares. The original dating of the *Dictionary* was intended to indicate the period during which these wares were commonly made, but it now seems appropriate to extend the scope occasionally where pieces of interest justify it. This is true particularly of special order wares and patterns which continued in production after 1880.

The most significant change for the makers of printed wares took place five years after Queen Victoria came to the throne. This was the Copyright Act of 1842, which precluded the potters from using the book illustrations which had provided sources for most patterns for at least four decades. The engraved views of country houses and the daily life of villagers were now denied to them, and they not only had to look around for new subjects but also needed to find titles for them. The result was a veritable flood of what we usually describe as "romantic" patterns, reflecting in some degree the interests of the day. Titles were chosen for the new patterns to attract public interest and to help boost sales, and in very many cases the titles selected bear little or no relation to the patterns themselves.

In the years before the Napoleonic Wars, it was the custom for wealthy young men, particularly second sons, to tour Europe, often with a tutor and sometimes even with an artist. This became known as "The Grand Tour", and those who were not in a position to travel themselves could get some vicarious enjoyment from reading the letters and diaries of those who could. Even after the Napoleonic Wars, travellers published accounts of their journeys. William Wordsworth wrote *Memorials of a Tour on the Continent* (1822) and William Beckford his *Letters from Italy with Sketches of Spain and Portugal* (1835). However, when peace came, railways began to spread slowly across Europe and travel became easier.

In 1841 Thomas Cook organised the first "Grand Circular Tour of the Continent", and within five years was publishing a monthly magazine, *The Excursionist*. Small wonder, then, that the romantic names of far-away European villages, towns and cities began to make their appearance as titles on blue-printed wares. The scenes themselves, of course, could no longer be copied from the plates in books, but the potters were not too concerned with accuracy. The scope of the journeys undertaken can be shown by the titles to be found on printed wares; thus Paris, Geneva, Lausanne, Rhône, Viege, the Alps, Milan, Roselle, Terni, Rome, Marino, to Naples, and then through the mountains again to Berlin and Brussels. An extension of this tour into Greece and the eastern Mediterranean is revealed in many more pattern titles.

Some patterns appear to have been named after famous people of the day. These include Canova, the Italian sculptor who was received by the Prince Regent; Mario, the Italian operatic singer; and notable politicians such as George Clarendon and the Earl of Camden.

Fewer patterns were named after events in the news which would soon be forgotten by the public. Nevertheless, there are exceptions. Cleopatra's Needles attracted attention over a long period, even before one was erected on the London Embankment, and hence a pattern

called "Cleopatra". The battle at Alma in the Crimea, when the combined armies of Britain and France defeated the Russians in 1854, also merited use of the name as a pattern title. The opening of London's Zoological Gardens in 1828 attracted a great deal of attention, since members of the public could see elephants, giraffes, zebras and other strange creatures for the first time, and many zoological patterns resulted. Even the Victorian interest in needlework is reflected. The tapestry craze, producing what came to be known as "Berlin Wool Work", swept through Britain. In 1847 over 14,000 paper patterns, many of them floral, were imported from that city together with the necessary wools, hence many blue-printed floral patterns such as "Berlin Roses" and "Berlin Wreath". Titles like "Cashmere" and "Chintz" also reflect the interests of the Victorian ladies.

It can be seen that printed ceramic patterns have a special interest for the social historian, reflecting as they do the life and interests of the period in which they were made. Indeed, the collector of these printed wares is provided with an opportunity to delve into a veritable cornucopia of subjects. We very much hope that our own fascination is both reflected in the entries in this volume, and shared by fellow collectors, wherever they may be.

Abbreviations and Conventions

This volume contains additional information from many sources. Entries which are entirely new are labelled as such, but other entries supplement information already in the *Dictionary*, and the relevant page number is indicated after the title, e.g. (D253).

Abbreviations

*	Indicates a cross reference to an illustration under the appropriate entry in this volume.
c.	circa. An approximate date.
(D123)	A cross-reference indicating page 123 of the main *Dictionary*.
fl.	floruit — flourished; used here to indicate the period when a firm or craftsman was in business.
Ill:	Illustrated in. This is followed by a book reference and the number of the illustration in the book, or the page number, e.g. p.204.
(qv)	*quod vide* — which see; used here as a cross-reference to another entry in this volume.
(sic)	Thus or so. Indicates an exact quotation though its incorrectness suggests that it is not. It is used particularly when a printed title on wares has been spelt wrongly or in a manner that is not generally accepted today.

Book references

References to *The Dictionary of Blue and White Printed Pottery 1780-1880* are shortened simply to *Dictionary*. Other book references which occur frequently are given by stating only the name of the author, which is followed, where relevant, by the number of the illustration or page. Books referred to in this way are as follows:

Copeland	R. Copeland, *Spode's Willow Pattern & Other Designs after the Chinese.*
Copeland 2 †	R. Copeland, *Blue and White Transfer-Printed Pottery.*
Cox †	A. Cox and A. Cox, *Rockingham Pottery & Porcelain 1745-1842.*
Coysh 1	A.W. Coysh, *Blue and White Transfer Ware, 1780-1840.*
Coysh 2	A.W. Coysh, *Blue-Printed Earthenware, 1800-1850.*
Drakard & Holdway †	D. Drakard and P. Holdway, *Spode Printed Ware.* (Note that in this case the references given, such as P345, refer to the pattern number allocated by the authors and not the page number in the book.)
FOB	Friends of Blue Bulletin, numbers 1 to 59 (bulletin no. given).
Godden BP	G.A. Godden, *British Pottery: An Illustrated Guide.*
Godden I	G.A. Godden, *An Illustrated Enclyopaedia of British Pottery and Porcelain.*
Godden M	G.A. Godden, *Encyclopaedia of British Pottery and Porcelain Marks.*
Jewitt	L. Jewitt, *The Ceramic Art of Great Britain.*
Lawrence	H. Lawrence, *Yorkshire Pots and Potteries.*
Little	W.L. Little, *Staffordshire Blue.*
Lockett	T.A. Lockett, *Davenport Pottery and Porcelain.*
May	J. May and J. May, *Commemorative Pottery, 1780-1900.*
Milbourn †	M. and E. Milbourn, *Understanding Miniature British Pottery and Porcelain 1730-Present Day.*
NCS	The Northern Ceramic Society Newsletter, numbers 1 to 69 (newsletter no. given).

Walker	J. Walker, *The Universal Gazetteer*.
Whiter	L. Whiter, *Spode: A History of the Family, Factory and Wares from 1733-1833*.
P. Williams	P. Williams, *Staffordshire Romantic Transfer Patterns*.
S.B. Williams	S.B. Williams, *Antique Blue and White Spode*. (Illustration numbers refer to the third edition.)
Williams & Weber †	P. Williams and M.R. Weber, *Staffordshire II, Romantic Transfer Patterns*.

References to other books and publications are given by stating the name of the author and title, followed by the illustration or page number. Full details of all new book references above (indicated by †) and additional books and source books are listed in the Bibliography and Appendix III at the end of this volume. Others are as given in the *Dictionary*.

Pattern Names

When pattern names are marked on the wares they are given within quotes, e.g. "Celeste". Where any other title is given it is either an authentic factory name which was not marked on the wares or a name which is in general use. In a few cases it has been necessary to adopt a title which draws attention to the pattern's most prominent features. This is true particularly in Appendix I, but it is emphasised that these titles have been adopted for convenience only and are by no means intended to be taken as definitive. Series titles which are marked on the wares are also given in quotes, e.g. "Classical Antiquities". In other cases series titles are either consistent with those already used in the *Dictionary* or have been selected to be as unique and self-explanatory as possible.

As discussed in the Introduction, the titles adopted by the potters often reflected the names of people or places in the news at the time, but it is important to recognise that in some cases they bear little or no relation to the subject matter of the pattern itself. Wherever possible, all new entries explain the significance of the titles used, and the opportunity has been taken to add similar information which has come to light since publication of the *Dictionary*.

Place Names

Once again, any information about the architecture or history of a building or place is included in the last entry where multiple entries have proved necessary.

Sizes

Dimensions are given to the nearest quarter inch and to the nearest centimetre. Unless otherwise stated any dimension is the maximum measurement, such as the diameter of plates, length of dishes, height of jugs, but an appropriate note is added where this would otherwise not be clear.

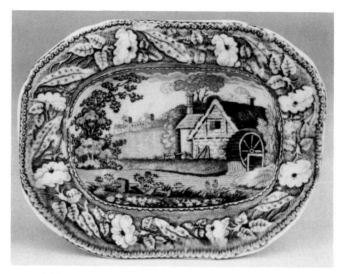

"**Abbey Mill**". *Minton Miniature Series. Printed title mark. Miniature deep dish 4 ¼ ins:11cm.*

"Abbey" (D15)
This pattern is not standard but all variations appear to show a ruined abbey in a woodland setting. An additional maker was Thomas Edwards, and examples produced by George Jones & Sons in the 20th century have also been noted.

"Abbey Mill" (D15)
A dish from the Minton Miniature Series is illustrated here.

Absalom's Pillar (D15)
The Concise Dictionary of the Bible (1865) states that the title Absalom's Tomb, which is sometimes used for this building, is undoubtedly incorrect. Quoting Joshua 7:26, "And they raised over him a great heap of stones unto this day", it points out that "the Ionic pillars which surround its base show that it belongs to a much later period, even if it be a tomb at all".

Adams, Harvey, & Co. (New) fl.1870-1885
Sutherland Road Works, Longton, Staffordshire. In a long and glowing account, Jewitt noted that this firm was "to a large extent catering for the American markets". The initials H.A. & Co. appear on printed wares.

Adderley, W.A. (& Co.) (New) fl.1874-1905
Daisy Bank Pottery, Longton, Staffordshire. William Alsager Adderley continued to produce the blue printed wares introduced by his predecessors Hulse, Nixon & Adderley (qv). The style became W.A. Adderley & Co. in 1886. The initials W.A.A. appear in cartouche marks on patterns such as "Berlin" and the typical romantic-style design titled "Mycene".

"Aesop's Fables" Series (D16-17)
Spode/Copeland & Garrett. Additional scenes are:
 "The Fox and the Grapes" *
 "The Leopard and the Fox"
 "The Lion, the Bear & the Fox" *
 "The Lioness and the Fox"
 "The Peacock and the Crane" *
 "The Stag Looking into the Water"
Eight scenes from the series are catalogued by Drakard & Holdway as P907-1 to P907-8, and 24 of the scenes are

illustrated on pulls from the original copper plates by Lynne Sussman in *Spode/Copeland Transfer-Printed Patterns Found at 20 Hudson's Bay Company Sites*, pp.21-34.

"Albion" (D18)
Three other potters used this title:
 (vii) Wood & Brownfield. Ill: Copeland 2 p.23.
 (viii) Lewis Woolf of Ferrybridge.
 (ix) Maker unknown with initials W.G.

Allason, John (New) fl.1838-1841
Seaham Harbour Pottery, Sunderland, Durham. This pottery was built in 1836 and was taken over by workers from Dawson's Low Ford Pottery in 1838, but their operation survived only until 1841. It was later reopened, but wares with an impressed mark "JOHN ALLASON / SEAHAM POTTERY" are believed to date from the 1838-1841 period. The only recorded blue-printed patterns are a design titled "Forest" and the standard Willow Pattern.

"Alma" (New)
Maker unknown. A romantic scene with a floral border. The title "ALMA" is printed within a simple panel mark.
 The Alma is a small river in the Crimea. It was on the banks of this river that the combined armies of Britain, France and Turkey defeated the Russians in the autumn of 1854.

"Alton Abbey, Staffordshire" (New)
John & Richard Riley. Large Scroll Border Series. Hexagonal sauce tureen stand.
 Alton Abbey, now popularly known as Alton Towers, was built between 1810 and 1852 for the 15th and 16th Earls of Shrewsbury. Much of the building is unused and in ruins, but the grounds are open to the public as "a world of fun, fantasy and excitement".

"Alva" (D21)
This pattern may have been named after either of two towns called Alva, one a burgh in Clackmannanshire (Fife), the other on the salt plains of Oklahoma in the U.S.A.

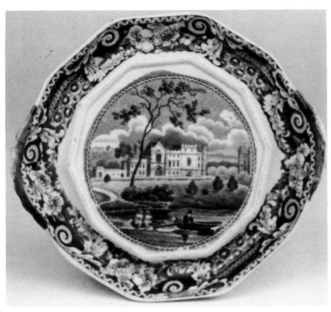

"Alton Abbey, Staffordshire". *John & Richard Riley. Large Scroll Border Series. Printed title mark with makers' name. Sauce tureen stand 6¾ins:17cm.*

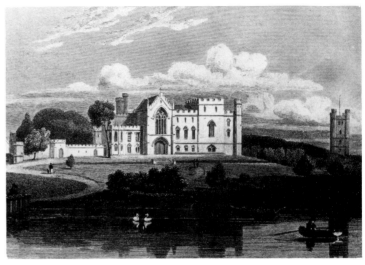

"Alton Abbey, Staffordshire". *Source print from John Preston Neale's "Views of the Seats of Noblemen and Gentlemen in England and Wales, Scotland and Ireland".*

"Amaranthine Flowers" (New)

Maker unknown with initial W. An open floral pattern noted on dinner wares with moulded edges. A printed floral cartouche incorporates the title "Amaranthine Flowers" in script together with the body name "Stone China" and the maker's initial W, which may relate to Edward Walley who was making printed wares between 1845 and 1856.

The name "Amaranthine" is taken from the word for an imaginary unfading flower and a genus which includes prince's feather and love-lies-bleeding, hence the phrase "everlasting flowers".

American Subjects (New)

As noted in the *Dictionary* (D7), the majority of American subjects were excluded since they have been extensively documented elsewhere. One major reference which was omitted from the original bibliography is E.B. Larsen's *American Historical Views on Staffordshire China* (see Bibliography)

"Amport House, Hampshire" (D21)

The view by an unknown maker in the Crown Acorn and Oak Leaf Border Series is illustrated here on a pierced dessert plate.

The house shown is the second house on the site, built in 1806, with a tetrastyle portico on the recessed centre between two five-bay extensions. It was replaced by a third house in 1857, built in the Elizabethan style by William Burn for the 14th Marquess of Winchester.

Ancient Granary at Cacamo (D22)

This Caramanian Series pattern originated in the Spode period but a version with the border from the well-known Italian pattern was reintroduced by Copeland at the end of the 19th century.

The pattern illustrated on a dessert plate in the *Dictionary* which combines this view with a rare floral border is catalogued separately by Drakard & Holdway under an adopted title of The Turk (qv).

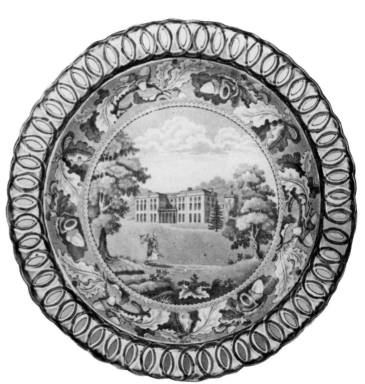

"Amport House, Hampshire". *Maker unknown. Crown Acorn and Oak Leaf Border Series. Printed title mark. Pierced dessert plate 8¼ins:21cm.*

An Ancient Hindoo Temple in the Fort of Rotas, Bahar (New)

An aquatint published in January 1796 in Thomas Daniell's *Oriental Scenery* (Part I, 11). It was used by an unknown maker as the basis for a pattern printed on dinner and dessert wares.

Rotas Ghur, or Rohtasgarh, is a considerable hill fort which lies close to the River Son, about 90 miles upstream from its confluence with the Ganges near Patna. The fort itself stands on an eminence above the river and this temple is on the slopes below. Daniell was attracted by its granite construction, and wrote "The Hindoos, who formerly preferred elevated places for their temples, could not, it would seem, resist the temptation of building in this place, the situation being delightful, and water and wood, with every other convenience, abundant".

"Ancient Rome" (D22)

A dish decorated with this pattern and bearing an impressed mark "CAREY & SONS" is illustrated here. It does not have the usual printed title mark, so although Careys is a possible maker for all pieces with this pattern, unmarked examples can still not be attributed with certainty.

"Ancient Ruins" (D22)

A pattern marked with a cartouche in the form of a vignette of ruins with the title on a fallen gravestone has been reported with an impressed mark for William Ridgway. It is not yet clear whether it is the same as the pattern by an unknown maker already recorded in the *Dictionary*.

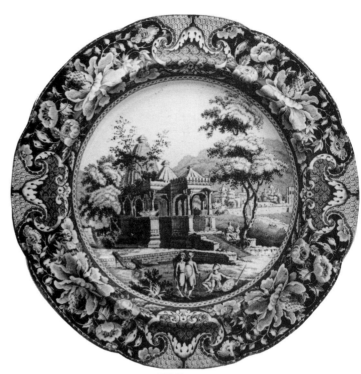

An Ancient Hindoo Temple in the Fort of Rotas, Bahar. *Maker unknown. Unmarked. Soup plate 9ins:23cm.*

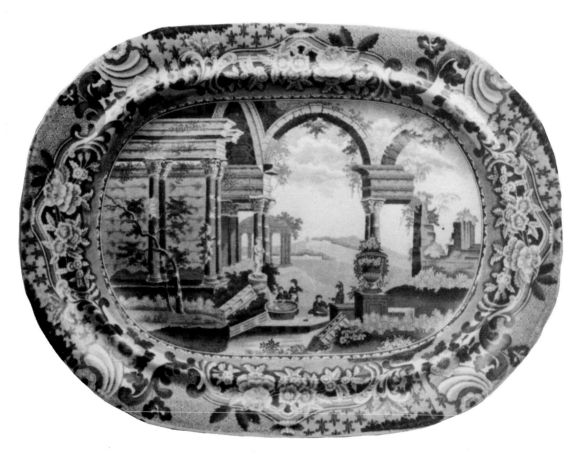

"Ancient Rome". *Carey & Sons. Impressed "CAREY & SONS". No title mark. Dish 16½ ins:42cm.*

"Ancona" (New)
Edward Challinor.

"A considerable seaport in the Pope's territories on the Adriatic Sea, having Umbria on the south and Urbino on the west. Commerce has increased rapidly through the patronage of Clement XII who made it a free port and built a mole to make the harbour safe" (Walker, 1810).

Angus Seats Series (D22-24)
John & William Ridgway. The soup plate with an unidentified view from this series is illustrated here.

A drainer with an impressed name Sharp or Sharpe has been reported, but the size and form of the mark is unknown and no Staffordshire maker of this name can be traced at the appropriate period. There was a potter called Thomas Sharpe, subsequently Sharpe Brothers & Co., at Swadlincote in Derbyshire from 1821 onwards, but there appears to be no record of blue-printed wares being produced there in the 1820s, and the mark reported may possibly relate to a retailer.

Angus Seats Series. *John & William Ridgway. Unidentified view. Unmarked. Soup plate 9½ins:24cm.*

"Animum Rege" (New)
Rule thy mind. A motto illustrated here on a plate by Copeland & Garrett. The arms appear in an early badge book which survives at the Spode factory, where they are listed as belonging to Shuter of Lewisham. There is also an added note that they were matched in December 1845, which suggests that a service was first made at an earlier date and that some extra or replacement wares were required.

See: Armorial Wares.

"Antelope" (D24)
The antelope also appears on a soup tureen in a series titled "Zoological" by Robinson, Wood & Brownfield.

"Antiquarian" (New)
Thomas Fell & Co. A romantic scene within a floral border marked with the title "ANTIQUARIAN" in an octagonal frame with the maker's initials T.F. & Co. beneath. Some examples are also impressed "FELL & CO." in a curve above an anchor.

"Antique Scenery" Series (D24)
Maker unknown. One previously recorded view is illustrated in this volume:
"Stratford upon Avon, Warwickshire" *
Additional views are:
"Fonthill Abbey, Wiltshire"
"Melrose Abbey, Roxburghshire" *

"Antique Vases" (D24)
The Greek vases sold to the British Museum by Sir William Hamilton (D169) attracted considerable attention over the years and were probably the inspiration for these patterns. His collection included the famous Warwick and Portland vases.

"Antiquities" (New)
Maker unknown. A romantic scene with classical columns and figures in the foreground. The printed mark gives the title in script on a fluted horizontal column.

"Antwerp" (New)
Thomas Dimmock & Co. "Select Sketches" Series. Sauce tureen.

Antwerp was described by Walker in 1810 as "a large, handsome city of Brabant, with a strong citadel, seated on the Scheldt. . . The streets are large and regular, in number 212, beside which are 22 public squares; the harbour is very

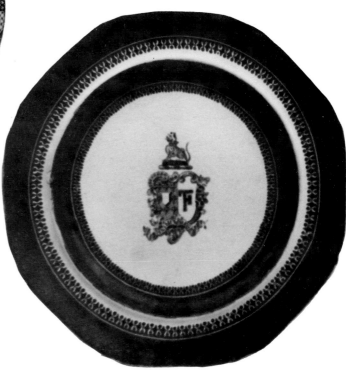

"Animum Rege". *Copeland & Garrett. Unidentified coat-of-arms. Printed crown and wreath makers' mark. Plate 8¼ins:21cm.*

commodious, the river being 400 yards wide, and at the time of high water 12ft deep so that large vessels may come up to the quay''.

''April'' (New)
See: ''Thomson's Seasons''.

''Arabian'' (New)
Ridgway, Morley, Wear & Co. A pattern of interlacing Moorish tracery with a matching border. A scroll cartouche bears the title ''ARABIAN'' with the makers' initials R.M.W. & Co. beneath.

''Arabian Sketches'' (New)
Maker unknown with initials T.H.W. A scenic pattern recorded on a ewer featuring a group of figures and horses in the foreground. The title ''Arabian Sketches'' is printed in script within a flowery cartouche mark, beneath which are the unidentified initials T.H.W.

''Arcadia'' (D24)
Arcadia was described by Walker in 1810 as ''a seaport of the Morea, near the gulf of the same name''. It is 64 miles south west of Corinth and 22 miles north of Navarin. It may well be that the potters had the important American market in mind when selecting this title since there are four towns of the same name in the U.S.A.

''Archery'' (D25)
The pattern recorded by the Herculaneum Pottery was also produced in sepia.

''Archipelago'' (D25)
This title was also used by John Ridgway & Co. for a series of designs showing sailing boats within a border of idealised flowers on a geometric ground. The wares are marked with the makers' initials within an oval strap with the title on a ribbon beneath, and were also printed in pink. Ill: Williams & Weber p.547.

''Arctic Scenery'' (D25-27)
Maker unknown. Further research reported by Bert Plimer has led to the identification of another source book for these arctic views: John Franklin's *Narrative of a Journey to the Shores of the Polar Sea, in the years 1819 to 1822*, published in 1823. The full list of views recorded to date, with their sources where known and the wares on which they were printed, is:

(i) A sledge bearing eskimos being drawn by huskies, with two ships, *Griper* and *Hecla*, in the background. Copied from ''H.M. Ships Hecla & Griper in Winter Harbour'' (Parry 1821) and ''Sledges of the Eskimaux'' (Parry 1824). Soup plate 10½ins:27cm. Ill: Coysh 2 148; D26 (bottom).

(ii) Two men by a sledge with covered longboats in the left background. Plate. Ill: P. Williams p.192.

(iii) A scene with dogs and a sledge, a group of huntsmen by a makeshift tent on the right. Drainer, and dish 17ins:43cm. Ill: FOB 26.

(iv) Eskimos building igloos while men with rifles stand by. Birds in the sky. Plate 9½ins:24cm. Ill: D26 (top, right).

(v) A man with gun, two eskimos and two dogs in the foreground, a partly built igloo in the background. Copied partly from ''Eskimaux Building a Snow Hut'' (Parry 1824). Plate 10¾ins:27cm. Ill: D26 (top, left).

(vi) An eskimo family seated with their dog in the foreground, with the ships *Hecla* and *Griper* amongst ice floes behind. Copied from ''Situation of H.M. Ships Hecla &

Griper, from the 17th to the 23rd of August 1820'' (Parry 1821) and ''Esquimaux of the Inlet called the River Clyde, West Coast of Baffin's Bay'' (Parry 1821). Soup tureen.

(vii) A large naval cutter and several smaller boats on a lake. Copied from ''Expedition Crossing Lake Prosperous, May 30, 1820'' (Franklin). Tureen stand 8½ins:22cm.

(viii) Two men, one aiming his rifle, and two dogs in the right foreground, covered longboats in the left background (similar to scene (ii) already listed). Dish 11ins:28cm.

(ix) An eskimo family group in front of igloos on the right, with two small sailing boats to the left. Dish 10ins:25cm, and shaped dish 6¾ins:17cm..

The scenes numbered (iii), (viii) and (ix) are not in either Franklin or the two Parry books.

The printed cartouche mark from the series is illustrated here. Examples have also been reported with the mark of the Dublin retailer Warren (qv).

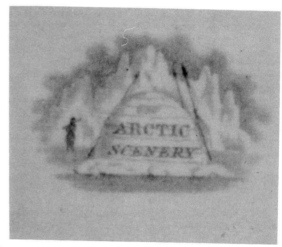

''Arctic Scenery'' Series. *Maker unknown. Printed series mark.*

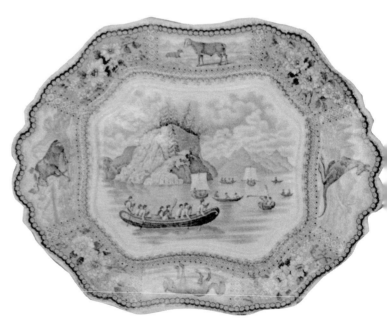

''Arctic Scenery'' Series. *Maker unknown. Scene (vii). Printed series title mark. Tureen stand 8½ins:22cm.*

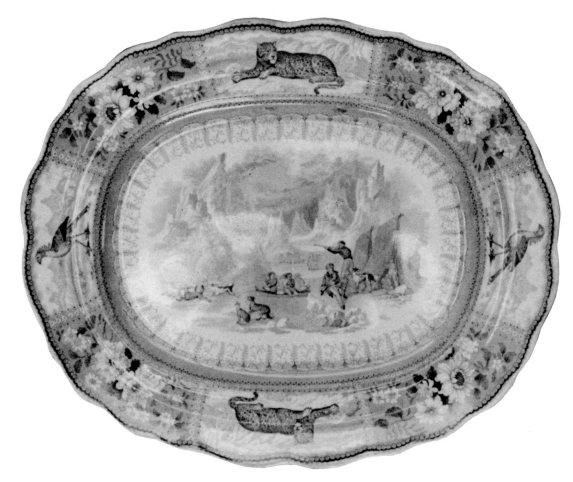

"Arctic Scenery" Series. *Maker unknown. Scene (iii). Printed series title mark. Dish 17ins:43cm.*

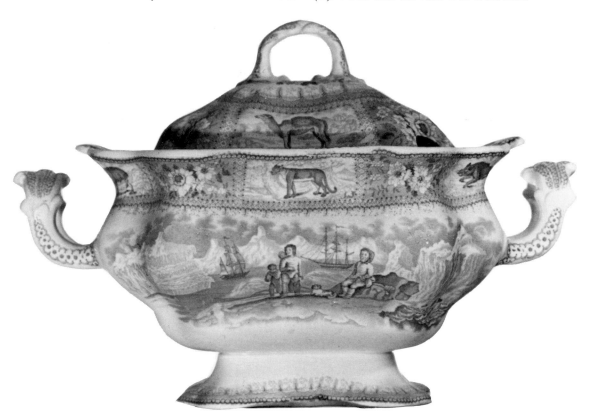

"Arctic Scenery" Series. *Maker unknown. Scene (vi). Unmarked. Soup tureen, overall length 15ins:38cm.* *continued*

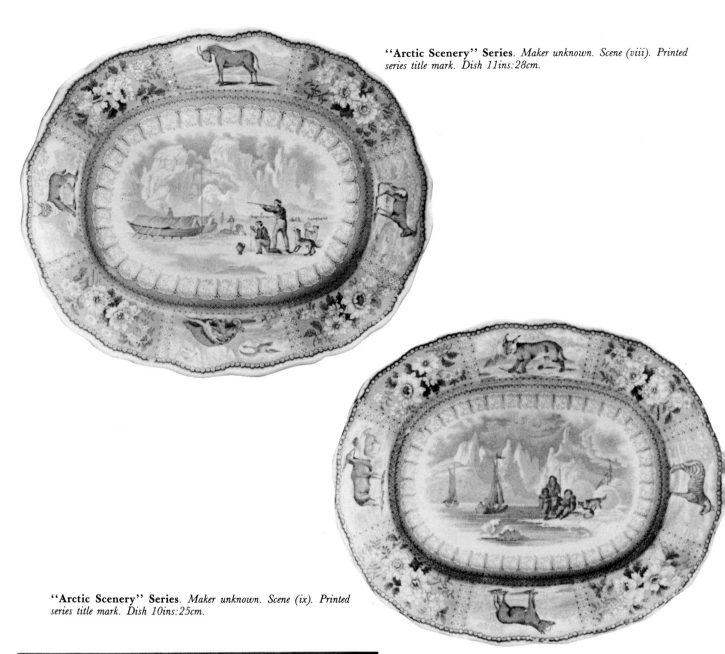

"**Arctic Scenery**" **Series**. *Maker unknown. Scene (viii). Printed series title mark. Dish 11ins:28cm.*

"**Arctic Scenery**" **Series**. *Maker unknown. Scene (ix). Printed series title mark. Dish 10ins:25cm.*

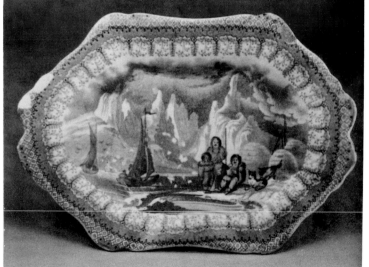

"**Arctic Scenery**" **Series**. *Maker unknown. Scene (ix). Unmarked. Shaped dish 6¾ins:17cm.*

18

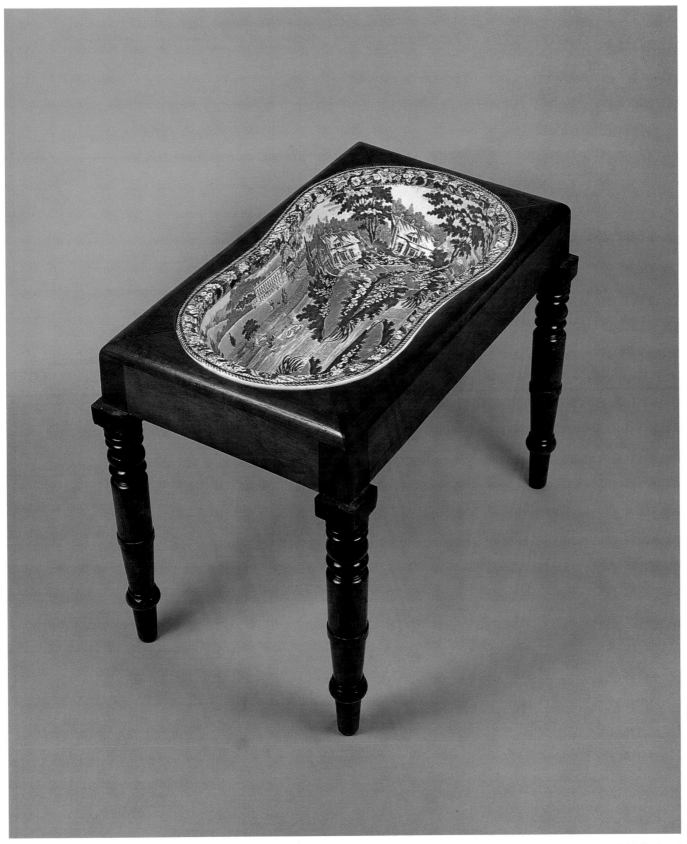

Colour Plate I. Bidet. *Enoch Wood & Sons. Grapevine Border Series. View identified as "Orielton, Pembrokeshire". Impressed "WOOD". Length, excluding wooden stand, 19ins:48cm.*

"Ardennes" (New)
Edward Challinor & Co.

The Ardennes are a range of wooded hills lying on either side of the River Meuse, in France, Belgium and Luxemburg. The hills were mined for coal, iron, lead and slate, but the area near Dinant in Belgium was a popular holiday resort. Part of the French area is a department of the same name, comprising the northern part of Champagne.

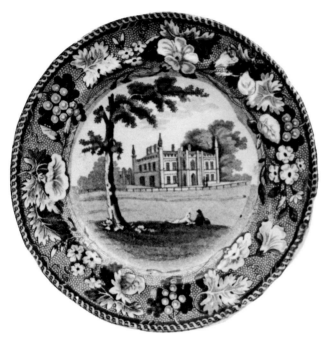

"Armitage Park, Staffordshire". *Enoch Wood & Sons. Grapevine Border Series. Printed title mark. Cup plate 5½ins:14cm.*

"Armitage Park, Staffordshire" (D27)
A cup plate from the Grapevine Border Series by Enoch Wood & Sons is illustrated here.

"Armorial" (New)
William Smith & Co. An impressive pattern of buildings and figures, rather reminiscent of some contemporary views of Cuba, illustrated here on a ewer. The title is printed on a shield backed by flags, with the makers' initials W.S. & Co. beneath. The number "76" is printed amongst the flags in the mark, the significance of which is not yet known.

Armorial Wares (D27)
Additional civic or livery company services are:
 City of Liverpool: "Deus Nobis Haec Otia Fecit"
 Ironmongers' Company: "Assher Dure"
Additional family services are:
 Fagan: "Deo Patrieque Fidelis"
 Ferrers: "Malgré L'Envie"
 Gordon: "Fortuna Sequatur Ne Nimium"
 Shuter: "Animum Rege"
 Thompson: "Spectemur Agendo"
 Several other mottoes are also known on blue-printed wares, including:
 Earl of Dumfries: "Avito Viret Honore"
 Trinity College, Oxford: "Virtus Vera Nobilitas"

 Unidentified: "Ex Fumo Dare Lucem"
 Unidentified: "Give Thanks to God"
 Unidentified: "Pro Deo, Rege et Patria"
Examples without mottoes which depict just a coat-of-arms or an armorial crest are often difficult to identify. Two examples with unidentified crests are illustrated here and another under the entry for the retailer John Du Croz (qv). Wares with the coat-of-arms of Christ's Hospital (qv) are also known.

The Artist (New)
Maker unknown. A title adopted for a scene noted on a bowl, which shows a seated lady painting or sketching a large building.

"As You Like It, Act 4, Scene 3" (New)
John Rogers & Son. "The Drama" Series. Diamond-shaped dish 10ins:25cm.
 See: "As You Like It, Act 4, Scene 2" (D27).

Asgill House, Richmond (New)
Minton. Minton Miniature Series. Square bowl. Ill: Milbourn 121-122.

The bowl, which is printed with the titled view of "St. Mary's, Dover", also bears an untitled view on the outside which has been identified as Asgill House at Richmond in Surrey.

The house is situated in the south-east corner of Old Palace Lane, facing the river, and was built between 1760 and 1765 by Sir Robert Taylor (1714-1788) for Sir Charles Asgill, Bart., Lord Mayor of London. In 1787 some small architectural changes were made by Theodosius Keene, and it was referred to early in the 19th century as "Mr. Keene's, Richmond".

"Asiatic Palaces" (D28)
The later wares, produced when the style of the firm was Ridgways, show various romantic scenes on gadrooned circular or hexagonal plates. Four examples are illustrated by Williams & Weber, pp.72-73.

"Asiatic Pheasants" (D28-29)
Other potters who used this design were:
 William Adams & Co., Tunstall, Staffordshire
 Barker & Kent, Fenton, Staffordshire
 Bodley & Harrold, Burslem, Staffordshire
 Cartwright & Edwards, Fenton, Staffordshire
 Cochran & Fleming, Glasgow, Scotland
 Thomas Fell & Co., Newcastle-upon-Tyne, Northumberland
 Hawley Bros., Rotherham, Yorkshire
 Holdcroft, Hill & Mellor, Burslem, Staffordshire
 John Thomas Hudden, Longton, Staffordshire
 Poulson Brothers, Ferrybridge, Yorkshire
 Worthington & Harrop, Hanley, Staffordshire
 Unidentified initial marks such as B. & G. and R.K. & Co. have also been noted, usually associated with the common cartouche mark found on this pattern.

"Asiatic Plants" (New)
Maker unknown. A floral pattern with a romantic-style border noted on an ornately moulded jug in the rococo style. The printed mark is in the form of a leafy spray bearing the title "ASIATIC PLANTS". Similar patterns with different floral sprays have also been recorded on teawares printed in green and mulberry.

"**Armorial**". *William Smith & Co. Printed title on a shield backed by flags amongst which is the number "76", with makers' initials beneath. Ewer, height 7½ ins:19cm.*

"**As You Like It, Act 4, Scene 3**". *John Rogers & Son. "The Drama" Series. Diamond-shaped dish 10ins:25cm.*

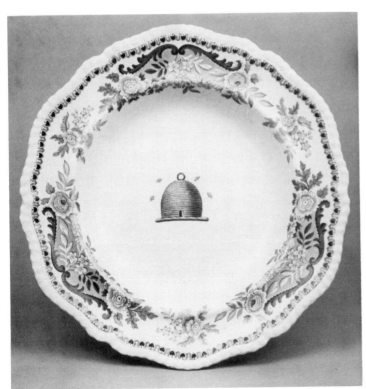

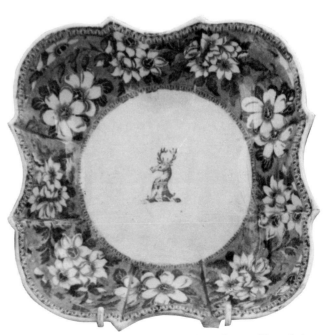

Armorial Wares. *Unidentified crest of a beehive. Spode. Printed and impressed "SPODE". Soup plate 10¼ ins:26cm.*

Armorial Wares. *Unidentified crest. Maker unknown. Unmarked. Cruciform dessert dish 8½ ins:22cm.*

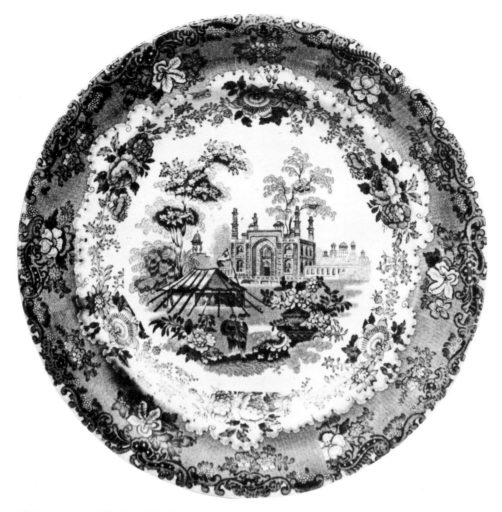

"Asiatic Scenery". *Joseph Harding. Printed title cartouche with maker's name "J. HARDING". Plate 10¼ ins:26cm.*

"Asiatic Scenery". *Source print taken from Thomas Daniell's "Oriental Scenery".*

"Asiatic Scenery" (D29)

A plate by Joseph Harding is illustrated here together with the original source print titled "Gate of the Tomb of the Emperor Akbar at Secundra, near Agra", taken from Thomas Daniell's *Oriental Scenery* (Part I, 9). Thomas and William Daniell had attached themselves to a party bound for Agra, and their tents appear in the foreground. The mausoleum was built by Akbar's son, Jahangir, in 1613.

"Asiatic Scenic Beauties" (New)

Jones. A pattern reported on a dessert plate with a moulded rim. A cartouche mark with the title has the name "JONES" beneath together with the number 44, possibly some form of pattern number. The maker may have been Elijah Jones, but there were several potters of this name in Staffordshire in the second quarter of the 19th century when these wares were probably produced (see D199).

"Asiatic Temples" (New)

John & William Ridgway. A design showing temples and pagodas within a wide floral border, illustrated on a teapot in Williams & Weber p.74.

"Asiatic Views" (D29)

The pattern listed by Francis Dillon is one of a series which was also produced by Podmore, Walker & Co. Both firms used the same scroll cartouche mark, but with the appropriate initials, either F.D. or P.W. & Co.

"Assher Dure" (New)

An old Norman French motto which in modern language would be "Assez Dure", meaning sufficiently hard. It is associated with the coat-of-arms of the Worshipful Company of Ironmongers of the City of London.

This motto has been noted on Minton dinner wares, one plate being known with a printed name mark "GARDINER", a Master of the company in 1905. Other blue-printed dinner wares were made by Minton for the company with their previous motto "God is Our Strength" (qv), some of which also bear the name of the Master in office when the wares were ordered.

Audley End, Essex (D29-30)

The figures and cows in the foreground of this view by an unknown maker, illustrated in the *Dictionary*, are taken from an engraving of Wanstead House in Grey's *The Excursions Through Essex* (1818).

See: "British Scenery" Series.

"August" (New)

See: Seasons Series; "Thomson's Seasons".

"Aurora" (New)

Maker unknown. A flow blue pattern of flowers and scrolls known with a retailer's mark for J. & A. Bradley of 47 Pall Mall, London.

The same title has been recorded on a floral pattern made by Francis Morley and a romantic scene made by Beech & Hancock, but the colours of these are not known.

Aurora was the Roman goddess of the dawn, but the word is more frequently used to describe a coloured sky at sunrise or in connection with the impressive atmospheric phenomena known as the *aurora borealis* and *aurora australis*.

"Australian" (New)

Dixon, Phillips & Co. A series of typical romantic scenes with a border featuring baskets of fruit and exotic birds, found on dinner wares. The printed scroll cartouche mark contains the title "AUSTRALIAN" and has the full makers' name "DIXON PHILLIPS & CO." above. Some examples also bear an impressed makers' mark. A blue-printed plate is illustrated by J.T. Shaw (ed) in *Sunderland Ware: The Potteries of Wearside* (1973), figure 27, and a brown-printed dish by John C. Baker in *Sunderland Pottery* (1984), Colour Plate XII.

"Autumn" (New)

See: "Seasons"; Seasons Series; "Thomson's Seasons".

"Avito Viret Honore" (New)

He flourishes by ancestral honours. The motto of John Crichton-Stuart, Earl of Dumfries, which appears printed below his coat-of-arms on a mug produced by an unknown maker to commemorate his birth on 20th June 1881. He was later to become the 4th Marquess and 9th Baronet of Bute, and the hereditary keeper of Rothesay Castle. His father, the 3rd Marquess of Bute, was M.P. for Cardiff from 1857 to 1880, and the mug bears a retailers' mark for the local Cardiff firm of F. Primavesi & Son(s) (qv).

See: Armorial Wares.

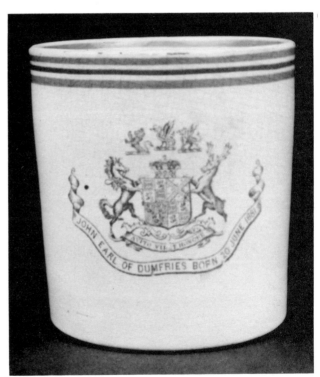

"Avito Viret Honore". Maker unknown. Printed retailer's mark for "F. PRIMAVESI / & SONS / CARDIFF". Mug 3½ ins:9cm.

Baby Feeder. *Maker unknown. Unmarked. Height 5¾ ins: 15cm.*

Baby Feeder (New)

A vessel shaped rather like a small coffee pot with a curved long narrow spout, perforated to form a nipple at the tip. They were earlier referred to as bubby pots. Blue-printed baby feeders are rare but one by an unknown maker is illustrated here. An example by Wedgwood, decorated with the Hibiscus pattern, is illustrated by R. Reilly and G. Savage in *The Dictionary of Wedgwood*, p.28.

"Bacharach" (New)

Wood & Challinor. A romantic scene noted on a sauce tureen stand with handles moulded in the form of a rose. The printed cartouche mark includes the title "BACHARACH" and a framed monogram of the initials W. & C. It is thought to be one of a series of Continental views, two others being titled "Lake of Como" (qv) and "Viege" (qv).

Bacharach is a town on the Rhine halfway between Mainz and Coblenz. It has always been noted for its wines.

Badger (New)

The animal previously listed as a badger in the "Zoological Sketches" Series by Job Meigh & Son was incorrectly identified. The pattern actually depicts a skunk.

Bagster, John Denton (D31)

Research by Hugh Stretton has located the following list of copper plates which were offered for sale from Bagster's works in the *Staffordshire and Pottery Mercury* dated 6th September 1828:

Table Sets:	Vignette, Empress, Metropolitan Scenery, Flower Basket, Birds Nest, Willow, Wine Press, Japan — for filling up Toy Plate.
Tea Sets:	Bee, Jar, Flower Basket, Hay Maker, Rustic, Bridge, Vignette, Grape and Bird, Nun, New Fruit, Broseley.
Ewer and Basin:	Lucano, Gothic, Filigree, Broseley, Metropolitan Scenery.

It should be emphasised that these patterns were not necessarily printed in blue, and the titles may not have been printed on the wares. Nevertheless, the inclusion of Metropolitan Scenery is interesting. It may be that the series commonly attributed to Goodwins & Harris on the basis of one marked piece, was originally produced by Bagster, and the copper plates were later re-used by the Goodwin firm.

"The Baker" (New)

See: "The Progress of a Quartern Loaf".

Baker, William, & Co. (New) fl.1839-1932

Fenton Potteries, Fenton, Staffordshire. Jewitt described the output of this firm as "the commoner class of printed, sponged, and pearl-white granite wares suitable for British North American, United States, West Indian, African, and Indian markets". He stated that nothing was produced for the home trade. However, their mark has been reported on a "Woodland" pattern.

"Bamboo" (D33)

One other potter used this title:

(ii) John Meir & Son. A pattern of frames against a background of bamboos, noted on a plate and on toilet wares. The title appears as part of a cartouche in the form of a circular strap encircling a Staffordshire knot, surmounted by a crown, and with the word "IRONSTONE" beneath.

"Barlborough Hall, Derbyshire" (D34)

There is a third view with this title:

(iii) Maker unknown. Crown Acorn and Oak Leaf Border Series. Plate. Ill: FOB 38.

"Baronial Halls" (D34)

The designs under this title by Knight, Elkin & Co. form a series, although only three views are known:

"Chip Chase"
"Cobham Hall"
"Stow Hall"

They were printed in either blue or grey, and some examples have a blue border with a black centre. The view of "Stow Hall" was favourably reviewed by the *Art-Union* during 1844 in its report on the Royal Hibernian Academy's eighteenth exhibition.

Bartlett, William Henry (New) 1809-1854

A topographical illustrator who was apprenticed to John Britton, co-author with Edward Brayley of *The Beauties of England and Wales*. Bartlett travelled widely in Europe, North America and the East, and illustrated and published many books. A number of his engravings were copied for patterns on printed wares, particularly views from his *Canadian Scenery*, which were used by William Ridgway, Son & Co. (Copeland 2 p.29), Francis Morley & Co., Podmore, Walker & Co., G.L. Ashworth & Bros., Thomas Godwin and Edge, Malkin & Co. His work also appeared in William Beattie's *Scotland* (1838), the second volume of which was used by John Meir & Son for their views in the "Northern Scenery" Series.

Basket (D34)

The pottery baskets which were made by weaving strips of clay together are usually referred to as twig baskets. Examples of this design are known marked Leeds Pottery, and were also made by other potteries. Thomas Wolfe's Stoke factory was noted for its basket work.

"Batavia" (New)

J. & M.P. Bell & Co. A circular central medallion featuring a Greek key band is surrounded by a design of tropical leaves which are repeated in the border. Ill: FOB 31.

Batavia was described as "a very large, handsome city, in the Isle of Java, the capital and storehouse of all the Dutch settlements, and the residence of their governor-general in the East Indies. . . It contains a prodigious number of inhabitants of different nations" (Walker, 1810).

"Bath & Bristol Cathedrals" (New)

Careys. Cathedral Series. Sauce tureen.

Bath Cathedral is better known as Bath Abbey. The present church was begun in 1499 by Bishop King, replacing a Norman building which was destroyed by fire. A great deal of restoration was carried out in the 19th century. It is closely linked with Wells Cathedral, and the Bishop is known as the Bishop of Bath and Wells.

Bristol Cathedral was originally an Augustinian abbey founded by Robert Fitzhardinge in 1142. Additions were made over the years and the building was not completed until the nave and west towers were added between 1868 and 1888 to the designs of G.E. Street.

"Battle Between a Buffalo and a Tiger" (D35)

An untitled version of this Indian Sporting scene is illustrated in this volume on a dish by Edward Challinor from his "Oriental Sports" Series (qv).

Beaded Frame Mark Series (D35-36)

One previously recorded view is illustrated in this volume:

"Tyburn Turnpike"* (Colour Plate XXVI)

An additional view is:

"Richmond, Yorkshire"

The view originally listed as "Near Caernarvon" is actually titled "Near Carnarvon" (sic). An attribution of this series to Mason, based particularly on dessert wares of very distinctive shapes, has gained strong support but no marked pieces have yet been recorded.

The Bear and the Bees (New)

This Aesop's fable, alternatively titled the Bear and the Beehives, was used by Minton, Hollins & Co. as part of a set printed on Tiles (qv).

A bear began to plunder hives and rob them of their honey until a whole swarm attacked him. Despite the fact that they could not pierce his rugged coat, the stings so annoyed his eyes and nostrils that he tore at the skin with his own claws.

Injuries and wrongs not only call for revenge but often carry their punishment along with them.

"Bear Forest, Ireland" (D36)

An untitled view of this house in Cork has been identified on a jug printed with the Royal coat-of-arms and the wording "Imperial Measure" (qv).

"Beatrice" (D36)

One other potter used this title:

(ii) Wedgwood & Co. A design registered in 1880.

"Beauties of England and Wales" (D36)

Maker unknown. The printed rock cartouche mark from this series is illustrated here together with an unidentified view on a soup plate overleaf. Examples are uncommon and the Monnow Bridge and Gatehouse at Monmouth remains the only identified view.

"Beauties of England and Wales". *Maker unknown. Printed series mark.*

"Beauties of England and Wales". *Maker unknown. Printed rock cartouche with series title. Soup plate 9¾ins:25cm.*

"Beckenham Place, Kent" (D36)

This view by William Adams is part of the Flowers and Leaves Border Series and not the Bluebell Border Series as noted in the *Dictionary*. It is illustrated here on a plate 6ins:15cm.

Beckenham Place was built by John Cator in 1787 using materials from Wricklemarsh at Blackheath, which was being demolished. Some of the chimney pieces were in turn removed to Woodbastick Hall in Norfolk when Beckenham Place was itself demolished.

"Beckenham Place, Kent". *William Adams. Flowers and Leaves Border Series. Printed title mark and impressed maker's eagle mark. Plate 6ins:15cm.*

"Bedfords, Essex" (D37)

The view in the Crown Acorn and Oak Leaf Border Series has also been noted on a plate 8½ins:21cm.

Beech & Hancock (New) fl.1857-1876

Tunstall, Staffordshire. A firm called Beech, Hancock & Co. worked the Swan Bank Pottery at Burslem between 1851 and 1855. They then transferred to the Church Bank Works at Tunstall where they traded as Beech & Hancock. A move took place to the confusingly-named Swan Bank Works in Tunstall in about 1862 and the partnership was succeeded by James Beech, potting alone, in 1876. Printed wares were produced marked with either the names in full or the initials B. & H.

Beehive and Vases (D37)

A dish with this pattern, illustrated as maker unknown in the *Dictionary*, has been noted with a printed cartouche mark bearing the inscription "R. STEVENSON & WILLIAMS / Cobridge / Staffordshire". Ill: FOB 42.

The Beemaster (D38)

See: Pickle Set.

Beggar Woman (New)

An alternative title for the pattern by an unknown maker listed in this volume as the Fortune Teller (qv).

"Bell Tavern, Lower Thames Street" (New)

A dinner plate printed with the flow blue "Hindoostan" pattern has been noted with the inscription "BELL TAVERN, LOWER THAMES STREET" printed in underglaze blue around the central pattern.

Lower Thames Street runs along the north bank of the Thames between London Bridge and the Tower of London. The Bell Tavern may well have served the porters at the adjacent Billingsgate Market.

Belle Vue Views Series (D39)

Belle Vue Pottery. An additional view is:

"Guy's Cliff, Warwickshire"

This view appears to have been copied from John Preston Neale's *Views of the Seats of Noblemen and Gentlemen in England and Wales, Scotland and Ireland*. Four of the other views listed, Blytheswood, Cambusnethan, Carstairs and Lee House, are now known to be copied from engravings in *Select Views on the River Clyde*, published by Joseph Swan in 1830. The book contains engravings by Joseph Swan after drawings by J. Fleming, and the accompanying text is by John M. Leighton.

The series was also produced in green.

"Belzoni" (D40)

Another dish printed with one of these hunting scenes by Enoch Wood & Sons is illustrated in Williams & Weber p.522.

Benevolent Cottagers (New)

The source of the pattern previously entered under the title Hospitality (D181-182) has now been identified as the painting "The Benevolent Cottagers" by Sir Augustus Wall Callcott R.A. (qv). An engraving of the painting is illustrated here together with a matching plate. The figures in the foreground have also been recorded on a small mug by an unknown maker with the title "THE BENEVOLENT COTTAGERS" printed around the rim. Ill: FOB 40.

Benevolent Cottagers. *Maker unknown. Unmarked. Plate 8¾ins:22cm.*

Benevolent Cottagers. *Engraving of the source painting by Sir Augustus Wall Callcott.*

"Berlin" (New)

W.A. Adderley. This title appears in a cartouche mark with initials W.A.A. beneath for William Alsager Adderley of Longton.

The title was probably inspired by the city itself, which was an essential stop on the Grand Tour. It was founded in the early 13th century and became the residence of the Hohenzollerns and then the capital of Brandenburg. From 1701 it was the capital of the Kingdom of Prussia and grew into an important industrial and commercial centre. It was occupied by the French under Napoleon, and in 1871 it was established as the capital of Germany.

"Berlin Chaplet" (New)

Maker unknown. A floral pattern noted on a toilet box. The printed mark includes both the title and the body name "Stone China".

A chaplet is a wreath of flowers for the neck or head.

Berlin Patterns (New)

Floral designs such as "Berlin Chaplet", "Berlin Roses" and "Berlin Wreath" were almost certainly derived from the patterns published in Berlin for woolwork embroidery. They were printed on squared paper and were imported into England between 1810 and 1860, together with coloured worsteds. A typical floral example is illustrated here.

Berlin Patterns. *Typical multi-colour printed floral pattern published in Berlin for woolwork embroidery.*

Bewick, Thomas (D42)

Several more patterns are now known to have been copied or derived from Bewick engravings, including the two illustrated here.

The dish is printed with a scene which shows a leopard stalking an antelope. It is almost an exact copy of a tailpiece printed within the section on "Animals of the Cat Kind" in *A General History of Quadrupeds* (1790). The same tailpiece was also used by an unknown maker for a section of the border on the pattern known as The Bewick Stag (D42).

The scene on the saucer showing an old woman feeding the geese, although not an exact copy, is probably based on the other tailpiece shown here. There are several differences, but the similarity is too close for coincidence.

An unmarked mug has been noted with two other Bewick vignettes printed within framed reserves with an overall vermicelli border similar to one used on teawares by the Don Pottery (see D111). The scene on one side of the mug shows four boys dressed as cavalrymen riding on gravestones, accurately copied from a Bewick engraving except for the addition of an extra gravestone inscribed "MEMENTO MORI" in the foreground. On the reverse is another scene which Bewick himself described: "Three idle lads, and a wicked ignorant fellow, a Tanner, have tied a tin kettle to the tail of the poor dog, it is in the utmost terror — this in a cathedral City". The dog is shown being chased through the town while the tanner looks on.

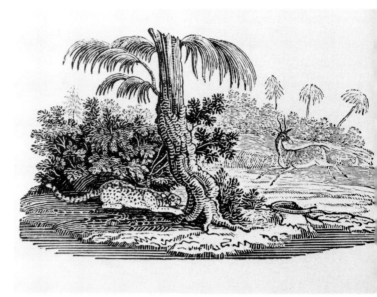

Bewick, Thomas. *Source engraving for the Leopard and Antelope pattern from a woodcut in Bewick's "A General History of Quadrupeds".*

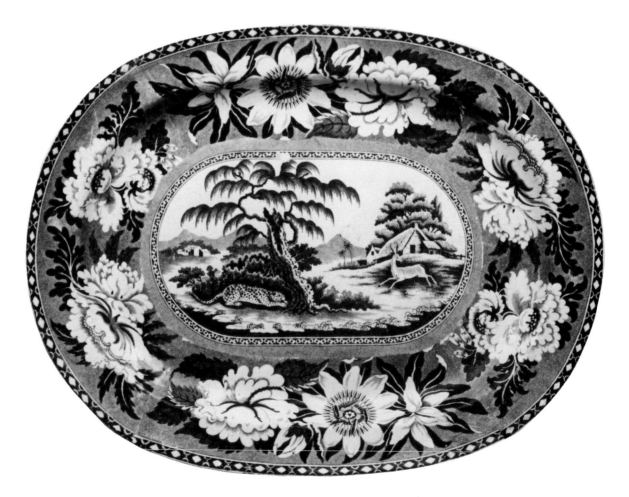

Bewick, Thomas. *Leopard and Antelope. Maker unknown. Unmarked. Dish 16¾ ins:43cm.*

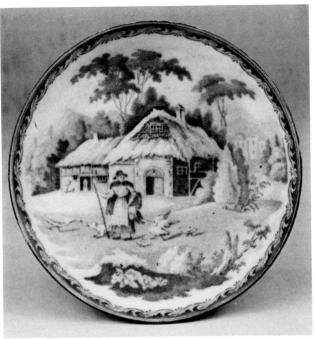

Bewick, Thomas. *Feeding the Geese. Maker unknown. Unmarked. Saucer 5¼ ins:13cm.*

Bewick, Thomas. *Bewick woodcut possibly used as the source engraving for the Feeding the Geese pattern.*

"Bickley, Kent" (D42)

The view by Enoch Wood & Sons in their Grapevine Border Series was also printed on a cup plate 4¾ ins:12cm, which is illustrated here together with the source print taken from John Preston Neale's *Views of the Seats of Noblemen and Gentlemen in England and Wales, Scotland and Ireland.*

Bickley, or Bickley Place as it was usually called, was built for John Wells by Robert Mylne in about 1780. It was demolished c.1968.

Bidet (D42)

Blue-printed bidets were made both with and without drain holes, and the outside surfaces were sometimes printed, sometimes left plain. All examples noted to date are from major factories such as Clews, Spode, Wedgwood, and Enoch Wood. Two different Spode examples in the Tower pattern are illustrated by Drakard & Holdway S177-178, and a Wedgwood example, printed both inside and out with Botanical flowers, has been noted. A bidet decorated with the view of "Orielton, Pembrokeshire" from Enoch Wood & Sons' Grapevine Border Series and fitted into its original stand is illustrated in Colour Plate I.

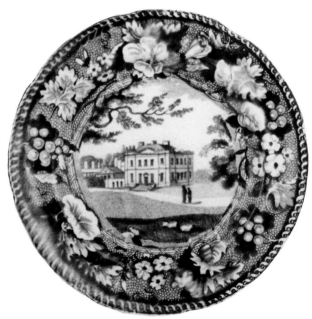

"Bickley, Kent". *Enoch Wood & Sons. Grapevine Border Series. Impressed makers' eagle mark. Cup plate 4¾ ins:12cm.*

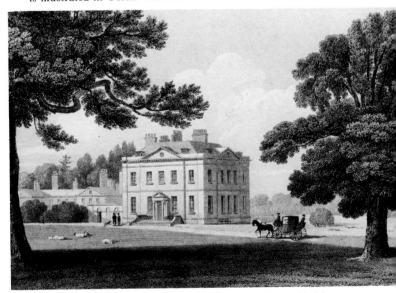

"Bickley, Kent". *Source print taken from John Preston Neale's "Views of the Seats of Noblemen and Gentlemen in England and Wales, Scotland and Ireland".*

"Bird Cage" (New)

Maker unknown. A pattern featuring a bird perched amongst some flowers next to an ornate bird cage, noted on teawares. The border is composed of floral sprays on a background of bars, and the title "BIRD CAGE" appears within a scroll cartouche. Ill: Williams & Weber pp.334-335.

"Birkett" (New)

See: "God is Our Strength".

Biscuit Box (New)

A cylindrical ceramic container for biscuits, usually fitted with a plated lid and handle, greatly favoured in late-Victorian times.

Bisham Abbey, Berkshire (D44)

Another untitled view is illustrated here on an unmarked mug.

"Black Rock Castle, Near Cork" (New)

Careys. "Irish Views" Series. Vegetable dish 12½ ins:32cm.

Black Rock Castle lies on the River Lee, three miles to the east of Cork. It was founded in 1604 and rebuilt in 1830, its tower later being utilised as a lighthouse.

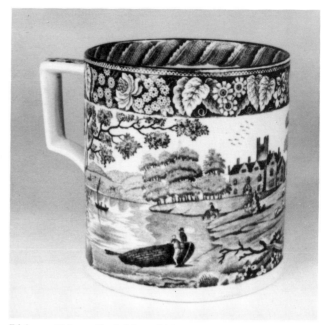

Bisham Abbey, Berkshire. *Maker unknown. Unmarked. Mug 5¼ ins:14cm.*

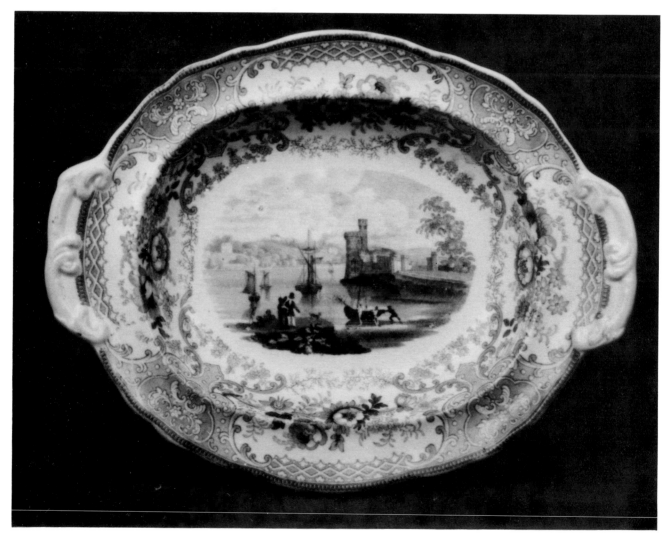

"Black Rock Castle, Near Cork". *Careys. "Irish Views" Series. Printed title mark with makers' name. Vegetable dish, length 12½ ins:32cm.*

Blue Rose Border. *Maker unknown. Indistinct impressed name with initials D.H. beneath. Soup plate 9½ins:24cm.*

Blue Rose Border. *Maker unknown. Unmarked. Cakestand, diameter 11ins:28cm, height 3ins:8cm.*

Blue Rose (D45)

This Spode floral pattern is catalogued by Drakard & Holdway as P822. It is also illustrated in Whiter 55; S.B. Williams 148.

Blue Rose Border (D45)

Two pieces printed with scenes within versions of the Blue Rose Border are illustrated here. The soup plate bears an impressed mark in the form of an indistinct name with the initials D.H. beneath. This may refer to one of the potters at Dale Hall, Burslem, Staffordshire, but an attribution must await a more clearly marked example. Although the cakestand is unmarked, it is of very good quality and could be from the Wedgwood Blue Rose Border Series (see next entry). The view on this piece is very similar to that of Cashiobury in Hertfordshire (see D73).

Blue Rose Border Series (D46)

Wedgwood. Additional views are:

(viii) A view identified as the Tower of London illustrated in this volume on a Foot Bath (qv) and also found on a soup tureen.

(ix) A view identified as Greenwich Hospital, noted on a toilet box and cover.

Bluebell Border Series (D46)

Previously recorded views by James & Ralph Clews illustrated in this volume are:

"Gloucester Cathedral" *

"Lumley Castle, Durham" *

The view of "Beckenham Place, Kent" listed as part of this series by William Adams is now known to belong to the Flowers and Leaves Border Series.

The name Bluebell Border Series was retained in the *Dictionary* since it had been widely accepted. However, the border flowers are almost certainly snakeshead fritillaries (*Fritillaria meleagris*), sometimes known as the ginny hen flower, which used to grow freely in the pasture lands of Wiltshire.

Bodley & Harrold (New) fl.1863-1865

Scotia Pottery, Burslem, Staffordshire. A short-lived partnership which appears to have overlapped with Edward F. Bodley & Co. who operated at these works until c.1881. Blue-printed wares typical of the period were made, marked with initials B. & H., although the same initials could apply to other potters such as Beech & Hancock, Blackhurst & Hulme, and Bednall & Heath.

Booth, T.G. & F. (New)

Church Bank Works, Tunstall, Staffordshire. This firm succeeded Thomas G. Booth in 1883 (see below) and the initials T.G. & F.B. appear as part of printed marks on blue and white wares.

Booth, Thomas, & Co. (New) fl.1868-1872

Knowles Works, Burslem, and Church Bank Works, Tunstall, Staffordshire. The firm of Evans & Booth became Thomas Booth & Co. in 1868 and took over the Church Bank Works in the same year. The firm became Thomas Booth & Son in 1872, Thomas G. Booth in 1876, and then T.G. & F. Booth in 1883 (see above). Blue-printed wares were marked with initials T.B. & Co. and a beehive mark was sometimes used.

"Boquet" (sic) (New)

William Ridgway. A simple borderless design of scattered floral sprays. The title "BOQUET" (sic) appears within a beehive and vase cartouche with the maker's initials W.R.

Botanical (New)

A rather general adopted title for a series of Spode patterns previously listed under Botanical Patterns (D49-50). Five typical centres are catalogued by Drakard & Holdway as P903-1 to P903-5. Other illustrations can be seen in Coysh 1 119-120; Whiter 54 and 96; S.B. Williams 149-152.

"Bouquet" (New)

Knight, Elkin & Co. A floral pattern incorporating small seated Chinese figures.

Bourdaloue (D52)

See: Coach Pot.

Bourne, Charles (New) 1817-1830

Grosvenor Works, Fenton, Staffordshire. Charles Bourne has previously only been recorded as a manufacturer of porcelain and no marked blue-printed earthenwares have yet been noted. However, research by Hugh Stretton has located the following list of earthenware copper plates which were offered for sale from Bourne's works in the *Staffordshire Advertiser* dated 9th July 1831:

Lucano pattern (23)

Willow pattern (20)

Old Willow pattern (20)

Zebra pattern (24)

British Views (27)

Most of these patterns are well-known in blue, but the inclusion of British Views is interesting. It is important not to jump to the conclusion that it is the well documented "British Views" Series (qv), but this must be one possibility.

"Bower" (New)

Maker unknown. A romantic scene featuring a man and woman in oriental costume standing below an archway of flowers. The border is panelled with floral motifs. Ill: Williams & Weber p.142.

Bowpot (D53)

This Spode floral pattern is catalogued by Drakard & Holdway as P813. It is also illustrated in Copeland pp.141-142; Whiter 42; S.B. Williams 167-168.

"Bracelet" (New)

Holland & Green. A geometric pattern with circles resembling bracelets. A printed mark incorporates the makers' initials H. & G.

"Bradford" (New)

See: "Clare College".

Bradley, James & Andrew (New) fl.c.1845-c.1848

A mark of J. & A. Bradley, who were retailers at 47 Pall Mall, London, has been noted on wares by an unknown maker printed with a flow blue pattern titled "Aurora".

The Bradley firm is listed in the London directories from 1812 through to 1872, and traded under various styles as follows:

1812-1844: John Bradley & Co., 54 Pall Mall (1812-1820) and 47 Pall Mall (1821-1844).

1845-1848: James & Andrew Bradley, 47 Pall Mall.

1852-1864: James Watson Bradley, 47 Pall Mall.

1866-1872: M.A. Bradley & Co., 47 Pall Mall.

The firm is continuously noted in the directories as "Colebrook-dale China-manufacturers", including "China and glass manufacturers to his Majesty, their Royal Highnesses the Duke of Cumberland, and Princess Augusta" (1828-1834), "China and glass manufacturers &c. to Her Majesty & Royal Family" (1853-1864), and "China and glass manufacturers &c. to Her Majesty & Royal Family & HRH the Prince of Wales" (1866-1869). It is possible that the firm was related in some way to the earlier Coalport-based pottery of Walter Bradley & Co., but despite being listed as manufacturers, they probably acted only as agents for the Coalport factory. They almost certainly also sold wares from other potters.

Brameld & Co. (D55)
Considerable new information about the Bramelds and their factory near Swinton has been published in Cox. Most blue-printed wares are illustrated together with recorded title marks where they were used. Included are a previously unrecorded child's plate printed with the Lord's Prayer, and also a particularly important marked circular dish with a view inscribed:

<div style="text-align:center">

North-west view
of the Earthenware Manufactory at
Swinton, near Rotherham, in Yorkshire.
Established in the year 1745

</div>

One early pattern, which was found on teaware shards during excavations of the Swinton site, is given the title Shepherd in Cox 32, and is shown here on an unmarked tea plate.

Brandenburg House (New)
Minton. Minton Miniature Series. Small tureen. Ill: Milbourn 119-120.

This untitled view has been identified from the source print in the 1811 edition of the Cooke's *Views on the Thames*.

There were many houses or villas along the stretches of the Thames near Richmond, and Brandenburg House was on the Middlesex bank.

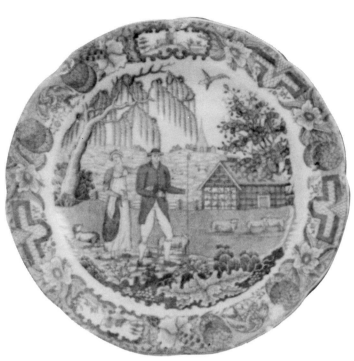

Brameld & Co. *Shepherd pattern. Unmarked. Plate 7ins:18cm.*

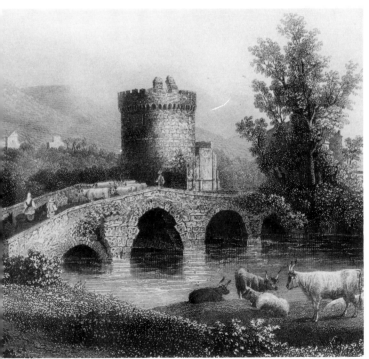

Bridge of Lucano. *Possible source print for the Spode pattern, also copied by other potters, after a painting by H. Bibby.*

"Bretton Hall, Yorkshire" (D55)
The view by John & Richard Riley in their Large Scroll Border Series can also be seen on the dish illustrated on D406 which is mismarked "Wistow Hall, Leicestershire".

Bridge (New)
An alternative name for a Spode chinoiserie pattern catalogued by Drakard & Holdway as Queen Charlotte (qv).

Bridge of Lucano (D55-56)
Two other potters used this design:
 (vi) William Reid.
 (vii) Don Pottery. Examples are known with a printed mark of a lion rampant within a belt inscribed "GREEN, DON POTTERY" (see Lawrence pp.248-249, mark 87).

The commonly accepted source for this view, a print from Merigot's *Views...in Rome and its Vicinity* (1796-98) is illustrated by Drakard & Holdway P712. However, as stated in the *Dictionary*, its resemblance to the actual Spode pattern is slight, and the engraving by A.H. Payne after a painting by H. Bibby, illustrated here, is much closer.
 See: Charles Bourne.

Brighton Pavilion (New)

A view identified as the Royal Pavilion at Brighton is illustrated in Colour Plate XXIV on an ornate covered jug by an unknown maker from the series titled "Royal Sketches" (qv). In view of its cover and the strainer behind the spout, this jug may have been intended for serving toast water to invalids.

The marine pavilion at Brighton was initially a classical Palladian building with a central rotunda and flanking wings, designed by Henry Holland and completed in 1787. It was extended by P.G. Robinson between 1801 and 1803 by the addition of two oval-shaped wings and canopies above every window. The interior was decorated in the Chinese style. Further changes were made by Nash, beginning in 1815, and new state apartments were added in 1817, featuring domes in an Indian style which can be seen on the jug illustrated. After the death of George IV, William IV and, later, Queen Victoria, thought little of the famous pavilion, and in 1850 it was acquired by the town of Brighton. It contains some of the most dazzling and magnificent interiors in the world, and is now open to the public.

Brindley, John, & Co. (New) fl.c.1828

Broad Street, Shelton, Hanley, Staffordshire. A previously unrecorded maker of blue-printed wares. The firm appears in a directory for 1828 but not in either 1822 or 1830. A rare impressed mark with the wording "BRINDLEY & CO. WARRANTED STAFFORDSHIRE" in a circle has been noted on a small dish decorated with the Wild Rose pattern.

"British Cathedrals" Series (New)

A series of views by Charles Meigh marked with a circular cartouche containing the series title, a title for each individual view, and the maker's initials C.M. Only one view is so far known:

"St. Pauls"

British Cobalt Blue (D58)

An interesting printed mark in the form of the wording "British Cobalt/Blue" is illustrated here on a presentation jug dated 1820 and decorated with the Italian pattern. This jug bears the impressed initial P twice, once on the base and once at the lower terminal of the handle. This mark has been attributed to Pountney & Allies of Bristol, who are known to have used this pattern, but it could be an individual potter's mark.

There was a warehouse at Bristol owned by the importers of Saxon smalt, a vitreous frit coloured with cobalt, which was also used to produce the famous Bristol blue glass. The blue printing pigment known as British Cobalt Blue was used by several potters, including John Mare, who was in business in 1820 and is known to have copied this Italian pattern.

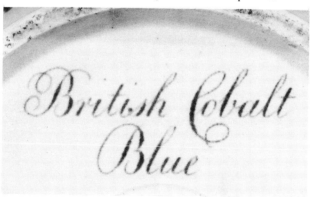

"The British Flora" (New)

John Meir & Son. A pattern printed on dinner wares marked with initials I.M. & S.

British Flowers (D58)

Five centres from this series of Spode floral patterns are catalogued by Drakard & Holdway as P902-1 to P902-5. An example is also illustrated in Whiter 52.

"British Lakes" (D58)

Another potter used this title:

(iii) Hopkin & Vernon. Believed to be the same as the patterns already recorded by Ralph Stevenson & Son. The printed mark of a tree is the same, but the initials H. & V. appear at the base in place of R.S. & S.

The patterns made by Ralph Stevenson & Son were also produced by them in sepia and in pink.

"British Marine" (D59)

Further examples of this pattern appear on a soup plate in FOB 32 and a dessert plate in FOB 39. The designs vary from piece to piece and it appears that it is a series rather than a single pattern. The maker remains unknown.

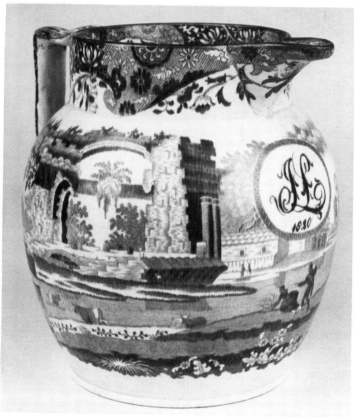

British Cobalt Blue. *Maker unknown. Presentation jug in the Italian pattern inscribed with monogram J.L. and date 1820. Printed "British Cobalt/Blue" in script. Impressed letter P on base and at lower terminal of handle. Height 7½ ins:19cm.*

British Cobalt Blue. *Maker unknown. Printed mark on presentation jug.*

"British Palaces" (D59)

A further example of a dish bearing this title with a view identifiable as Windsor Castle is illustrated in FOB 39.

"British Rivers" (D59)

These designs have now been recorded with initials C.P. Co. as part of a printed vignette mark in the form of a stone bridge. The initials relate to the Clyde Pottery Co. which succeeded Andrew Muir and Thomas Shirley & Co. at the Clyde Pottery, Greenock, from 1857. Two of the designs on plates are illustrated by Williams & Weber, pp.144-145.

"British Scenery" (New)

This title appears on a series of views already recorded as the "British Scenery" Series (D59 and below). However, another later series of rural views with the same title was produced by Davenport; one meat dish has been reported with a date mark for 1852. It is interesting to note that the copper plates were offered for sale or hire by A. Wenger of Hanley when the Davenport factory closed in 1887. The patterns may also have been produced in other colours, and a jug and saucer are shown by Williams & Weber pp.146-147.

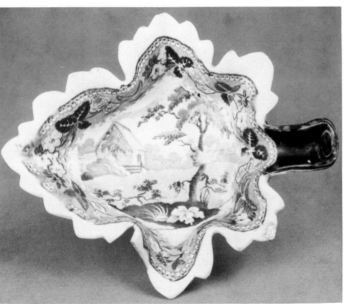

"British Scenery" Series. *Unidentified view. Attributed to Ridgway. Unmarked. Pickle dish 5 ¾ ins:14cm.*

"British Scenery" Series (D59-60)

Additional scenes are:

(ix) Cashiobury, Hertfordshire. A view of Cashiobury taken from a John Preston Neale print, similar to the view used by Enoch Wood & Sons in their Grapevine Border Series (D73).

(x) Leamington Baths. A view illustrated here similar to the scene titled "Leomington Baths" (sic) from the Passion Flower Border Series. Dish 18 ½ ins:47cm.

(xi) Family Group. A woman with a basket on her head, a small boy in the foreground, a wooden bridge, a mounted man with another horse, and a church and houses in the wooded background.

(xii) Lakeside Castle. A small castle by a lake with one man in a boat and two talking on the near bank. Pierced basket. Ill: FOB 51.

(xiii) Curved Path. A couple walk along a curved path from

a small arched bridge in the foreground towards a predominantly single-storey country house. Bourdaloue or Coach Pot (qv).

In addition, the view numbered (vi), described as Palladian Mansion, is now known to show Wanstead House in Essex and is illustrated overleaf on a dish together with the source print taken from Grey's *The Excursions Through Essex*. The house was demolished in 1823.

An example of the scene of Tintern Abbey on a drainer is illustrated in FOB 35 with the impressed mark "OLD OCTAGON", the significance of which remains unknown.

In view of extensive research by Doreen Otto and others, based particularly on the shapes of these wares, there is now overwhelming evidence to support an attribution to John & William Ridgway. The view listed as Lakeside Castle above has been found printed inside a distinctive pierced basket of known Ridgway shape, while a small pickle dish illustrated here, decorated with an unidentified view not listed above, is of the same unusual shape as one printed with a view from the Oxford and Cambridge College Series (D284). There are many other shapes which also compare with wares made by the Ridgways including a dessert dish with the pattern called Riverside Cottages illustrated by G.A. Godden in Plate 20 of *Ridgway Porcelains* (1985).

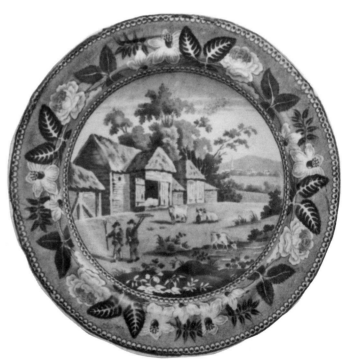

"British Scenery" Series. *Thatched Barns; view (vii). Attributed to Ridgway. Printed series title mark. Dished cereal plate 6 ½ ins:16cm.*

continued

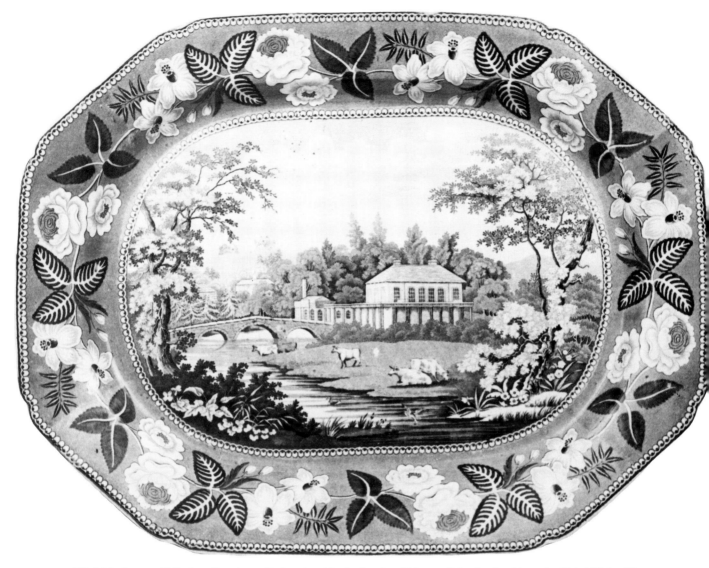

"British Scenery" Series. *Leamington Baths; view (x). Attributed to Ridgway. Printed series title mark. Dish 18½ ins:47cm.*

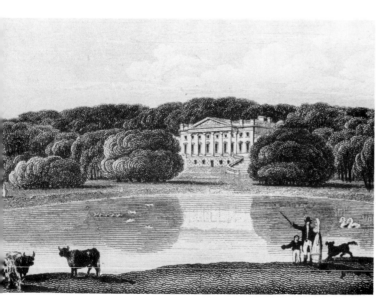

"British Scenery" Series. *Source print for the view of Wanstead House taken from Grey's "The Excursions Through Essex".*

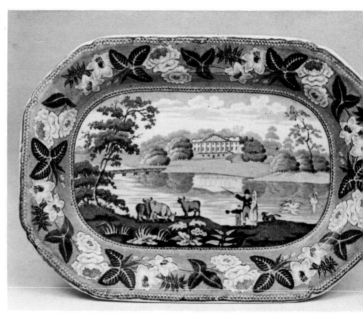

"British Scenery" Series. *Wanstead House; view (vi). Attributed to Ridgway. Printed series title mark. Dish 9½ ins:24cm.*

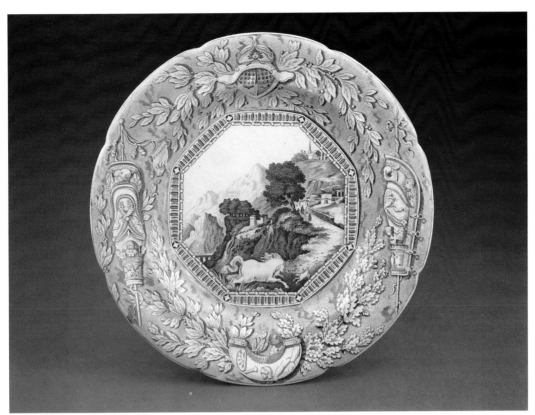

Colour Plate II. "EYAOPIA". *Don Pottery. Printed maker's mark and name "EYAOPIA" incorporated in border. Plate 10ins:25cm.*

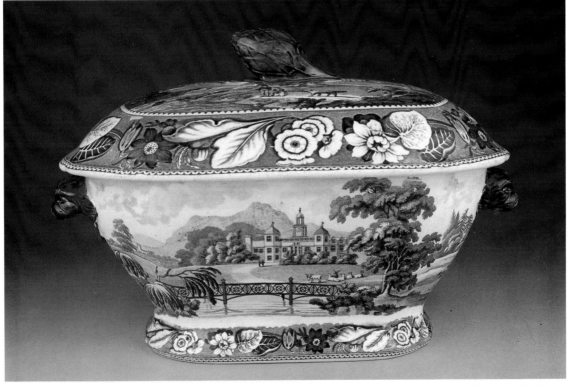

Colour Plate III. "British Views" Series. *Maker unknown. Views (xiii) and (xiv). Printed series title mark on both base and cover. Soup tureen and cover, overall length 13¼ ins:34cm.*

"British Views" (D60)

A third potter used this title:

(iii) Minton. A view of a country house which is illustrated here on a dish with a blue rose-type border. It has an ornate printed title mark in the form of a floral and scroll plaque with a lion passant above, and a cursive initial M and the body name "Stone China" beneath. The house shown has not yet been identified.

The dish marked "British Views" by Henshall & Co. illustrated in Colour Plate II of the *Dictionary* is now known to depict Compton Verney in Warwickshire. The same view can be seen on a plate by Enoch Wood & Sons in their Grapevine Border Series (D92).

"British Views". *Minton.*
Ornate printed title mark on dish.

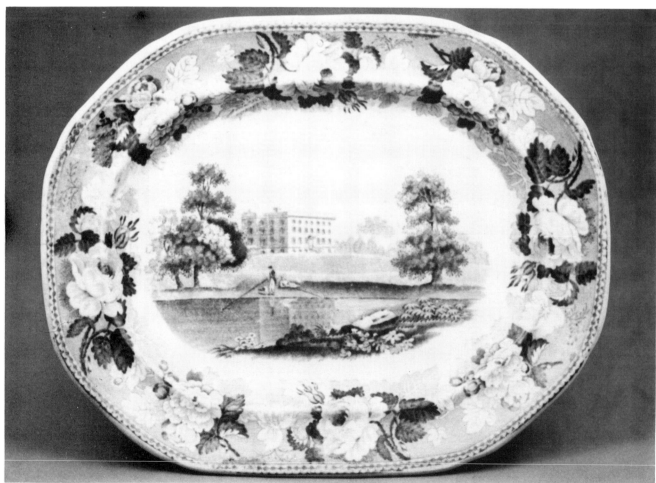

"British Views". *Minton. Ornate printed title mark with cursive maker's initial M. Dish 9¾ins:25cm.*

"British Views" Series (D60-62)

Maker unknown. Additional views are:

(x) A large house amongst hills in the background. A river in the foreground with two men sitting on the far bank and a sailing boat on the far right. Dish. Ill: FOB 46.

(xi) A large house in the middle distance right with a lake behind to the left. Another lower lake or river in the left foreground with a sailing boat. Dish 17¼ins:44cm. Ill: FOB 46.

(xii) Figures in the porch of a country mansion on the left are watching a carriage departing down the drive towards trees on the right. Dish 10½ins:27cm, and interior of soup tureen.

(xiii) A central country house with an ornate bridge in the foreground and a herd of deer just behind it to the right (Colour Plate III). Soup tureen.

(xiv) A country house in the background with two men and a dog near a waterfall in the foreground. One man is standing and fishing, the other is seated holding his hat (Colour Plate III). Cover of soup tureen.

The views numbered (viii), (xi), (xii), (xiii) and (xiv) are

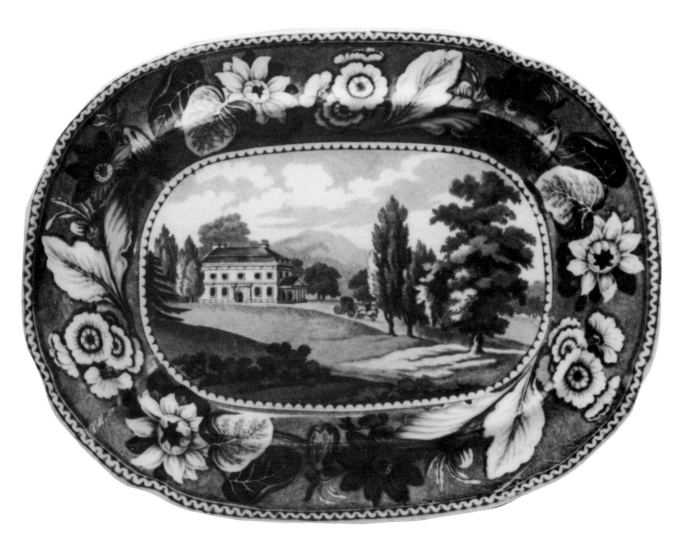

"British Views" Series. *Maker unknown. View (xii). Printed series title mark. Dish 10½ins:27cm.*

continued

Colour Plate IV. Chocolate Pot. *Pountney & Allies/Pountney & Goldney. View of "Oxford". "River Thames" Series. Printed titles mark. Height 7½ins:19cm.*

Colour Plate V. Coffee Pot. *Maker unknown. Unmarked. Height 9¾ins:25cm.*

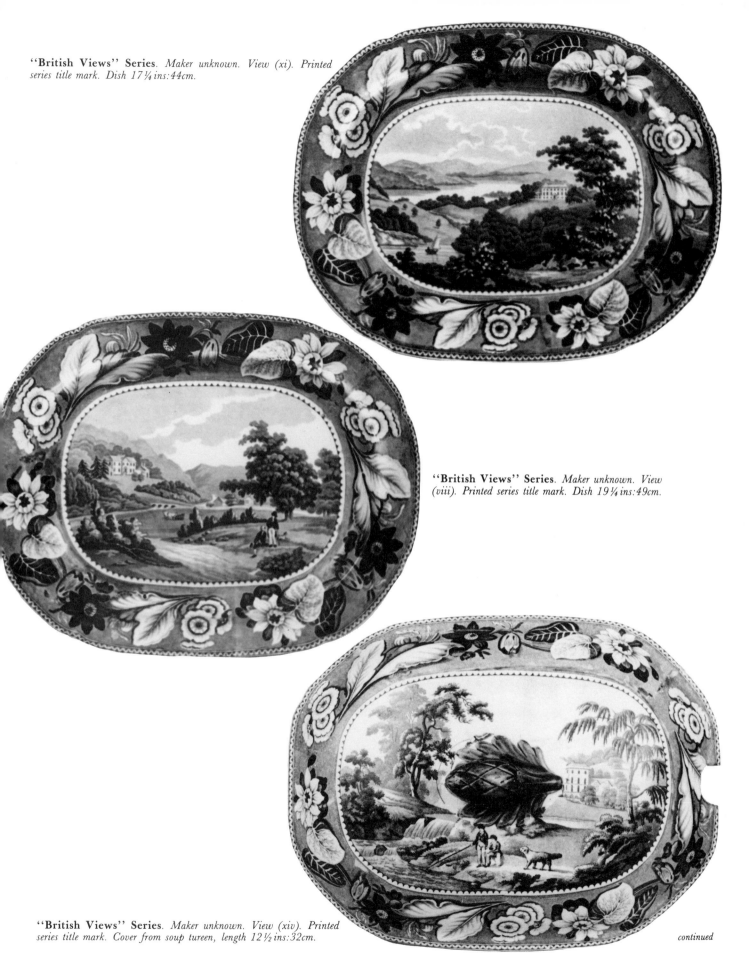

"British Views" Series. *Maker unknown. View (xi). Printed series title mark. Dish 17¼ ins:44cm.*

"British Views" Series. *Maker unknown. View (viii). Printed series title mark. Dish 19¼ ins:49cm.*

"British Views" Series. *Maker unknown. View (xiv). Printed series title mark. Cover from soup tureen, length 12½ ins:32cm.*

continued

"British Views" Series. *Possible source print for the idealised view of Comb Bank in Kent, taken from Angus' "The Seats of the Nobility and Gentry in Great Britain and Wales...".*

"British Views" Series. *Source print for the water dog taken from the "Sportsman's Cabinet".*

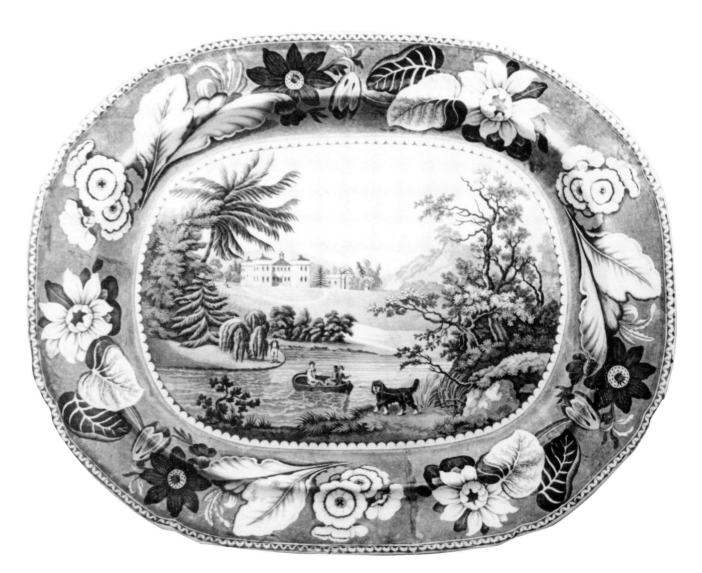

"British Views" Series. *Maker unknown. View (ix), an idealised view of Comb Bank in Kent with a water dog in the foreground. Printed series title mark. Dish 21¼ ins:54cm.*

illustrated, (xiii) in Colour Plate III, (xiv) in Colour Plate III and p.41. In addition, the view numbered (ix), illustrated on the dish in Colour Plate I of the *Dictionary,* appears to be an idealised view of Comb Bank in Kent, probably derived from a print by W. Angus in *The Seats of the Nobility and Gentry in Great Britain and Wales. . .* (1787), a source also used by the Ridgways for their Angus Seats Series. The foreground is taken from a Philip Reinagle painting of a water dog which was engraved by Scott for the *Sportsman's Cabinet* (1803). The dish is illustrated opposite together with the two source prints. The same dog also appears on another country house view, not listed above, noted on a very large unmarked ewer.

The distinctive border from the series can also be seen on a small Butter Boat (qv), an item which was not commonly included in transfer-printed dinner services at this period.

It is interesting to note that 27 earthenware copper plates listed as British Views were amongst a batch offered for sale in July 1831 from the works run by Charles Bourne (qv). It is important not to jump to the conclusion that Bourne produced this "British Views" Series, but it must be a possibility. No marked blue-printed earthenwares made by Bourne have yet been recorded.

Broseley (D62)
The Spode version of this widely used pattern is catalogued by Drakard & Holloway as P614. Copeland refers to it as Two Temples II, variation Broseley. Examples are also illustrated in Copeland pp.53-66; Drakard & Holloway S136 and S147; Whiter 18.

Brown-Westhead, Moore & Co. (New) fl.1862-1905
Cauldon Place, Hanley, Staffordshire. The works operated by John Ridgway passed to Bates, Brown-Westhead & Moore in 1859, but this short-lived partnership was succeeded by T.C. Brown-Westhead, Moore & Co. in 1862. They were to become one of the most important of the Victorian pottery firms, and traded under the same name until the formation of Cauldon Ltd. in 1905. The output was vast, including much expensive ornamental china, and while utilitarian blue-printed wares were produced, they appear to have been a relatively unimportant part of the business.
See: "Pro Deo, Rege et Patria".

"Brussels" (New)
John Wedg Wood. A romantic pattern with a building beside a river and figures on the opposite bank beneath a palm tree. The printed mark is in the form of an oval garter with the word "IRONSTONE", containing the title "Brussels", and tied with a ribbon inscribed "J. WEDGWOOD", clearly designed to be confused with the more famous Wedgwood factory. Ill: P. Williams p.208; Williams & Weber p.556.

Before 1530 Brussels was the residence of the Dukes of Brabant, but it then became the capital of The Netherlands under the Hapsburgs until the Belgian revolution in 1830. Famous for its lace, and a noted art centre, it has a picturesque old town, "narrow but crooked", dominated by the Palais de Justice, and has been described as "Paris in miniature". It was an important visit on the Grand Tour, and after the Battle of Waterloo in 1815, many hundreds of English visitors, including Byron, used it as a base to wander over the nearby battleground and to search for souvenirs.

Bubby Pot (New)
See: Baby Feeder.

Buddleia (New)
An alternative name for a Spode chinoiserie pattern catalogued by Drakard & Holloway as Temple Landscape (qv).

Bude (New)
An adopted titled for a Spode floral pattern printed in blue on stone china wares, but with brown rims and added gilding. Ill: Copeland p.142; S.B. Williams 169.

Buffalo (D62)
The Spode version of this pattern is catalogued by Drakard & Holloway as P616. It is also illustrated in Copeland pp.100-116; Whiter 20; S.B. Williams 96. A plate with an impressed mark of Thomas Wolfe is illustrated in FOB 34.

The Bull (New)
A painting under this title by the Dutch artist Paulus Potter (qv) is now known to be the source for part of a pattern on wares marked 'Semi-China Warranted'' (D328).

Bungalow (New)
An adopted title for a chinoiserie pattern featuring a single storey building with rustic corner posts, illustrated here on an unmarked cup. A version of the pattern was used by Spode but only on bone china. Ill: Copeland pp.80-81; Drakard & Holloway P617 and S143.

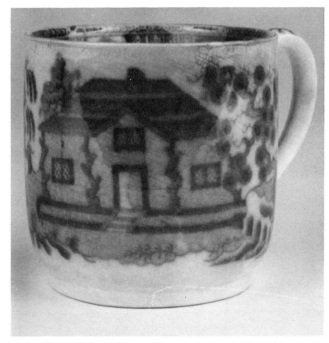

Bungalow. *Maker unknown. Unmarked. Cup, height 2¼ ins:6cm.*

Burgess & Leigh (New) fl.1862 et seq.
Burslem, Staffordshire. This firm operated at Burslem from 1862, took over the earthenware side of Samuel Alcock's Hill Pottery in 1867, and moved to the Middleport Pottery in c.1889. The partnership became a limited company in 1919 and still operates today. Blue printed floral patterns have been noted marked with initials B. & L.

Burnell, Thomas (New) fl.c.1823-1851

A printed retailer's mark in the form of an anchor with "T. BURNELL" above and "LONDON" beneath is illustrated here on an oval dish from a miniature dinner service by an unknown maker. The use of a retailer's mark on miniature wares, normally intended as children's playthings, must be considered unusual.

Thomas Burnell is first listed in a London directory for 1823 as proprietor of a Toy Warehouse at 131 Whitechapel. In 1826 one directory lists him as a China and Glass Dealer at 88 London Wall, whereas another gives him as a Potter & Glass Seller at 1 Coleman Street in the City. Entries for the latter address continue in the directories until 1845 when his address is given as 39 Moorgate Street. Subsequent entries give both addresses, with a final entry listing just Moorgate Street appearing in 1851.

Burnell, Thomas. *Printed retailer's mark.*

Burnell, Thomas. *Maker unknown. Printed retailer's mark of an anchor with "T. BURNELL" above and "LONDON" beneath. Miniature dish 4¼ ins:11cm.*

Butter Boat. *Maker unknown. Border from the "British Views" Series. Unmarked. Length 3¼ ins:8cm.*

"Burns' Cotter" (D63)

This rare Brameld pattern, decorated with a scene based on Robert Burns' poem *The Cottar's Saturday Night*, is illustrated on a miniature plate, together with the printed cartouche mark, in Cox 45 (Mark 68). Part of the poem runs:

His clean hearth-stone, his thrifty wifie's smile,
The lisping infant, prattling on his knee,
Does a' his weary carking cares beguile,
And makes him quite forget his labor and his toil.

Butter Boat (New)

A small boat-shaped vessel with a handle, used for pouring liquid butter served as a sauce with dishes such as asparagus. Butter boats are not common in earthenware, and transfer-printed examples are few and tend to be decorated with early chinoiserie-type patterns. An unusual example is illustrated here with the border from the "British Views" Series. A Spode example printed with the Geranium pattern is illustrated in Drakard & Holdway S125, where it is described as a pickle container.

"Byland Abbey, Yorkshire" (D63-64)

The view by an unknown maker in the "Antique Scenery" Series was also used on a square salad bowl.

Byron Views Series (D64)

Copeland & Garrett. One previously recorded view is illustrated in this volume:

"Interlachen" (sic) *

Note that one title listed was slightly incomplete; it has a prefix and should read "The Tomb of Cecilia Metella".

"Caerfilly Castle, Glamorganshire" (sic) (D66)
A plate from the Pineapple Border Series by an unknown
maker is illustrated here.

Callard & Callard (New) **fl.1872-1904**
A miniature plate by an unknown maker is illustrated here
with the standard Willow pattern but with a superimposed
scroll inscribed:

> CALLARD & CALLARD
> QUEENS TERRACE
> ST JOHNS WOOD

This was almost certainly intended for use as an advertising
give-away, possibly the equivalent of a Trade Card (qv), and
other small plates of similar design were made for use by
Richard Stanway (qv), dated 1879, and by John Mortlock
(D253).

Callard & Callard were a firm of bakers and confectioners,
one of several related companies formed by the Callard family
in Victorian times. Their London family empire appears to
have started in 1847 with Thomas Karr Callard, a baker at 4
Blenheim Terrace, St. John's Wood. He traded there
continuously until 1886, but in 1856, a separate business was
established under the name of Callard & Bowser at 1 Queen's
Terrace, also St. John's Wood. In 1859 both firms are listed
as "Bakers and Manufacturers of the Prepared Farinaceous
Food for Infants". In 1872, Callard & Bowser moved to
Finchley Road, where they were listed as Wholesale
Confectioners, and they were later to develop into the famous
makers of butterscotch, a product which was first mentioned
along with Rahat Lakuhm (locum is Turkish delight) in a
directory for 1877.

From 1872 the Queen's Terrace address was occupied by
Callard & Callard, and they continued to trade both there and
from other addresses as bread and biscuit bakers, cooks and
confectioners, until 1904. In 1899 their entry includes "the
manufacturers of Ivory Jelly for invalids". From 1905 the
premises were taken by Stewart & Co., also bakers,
presumably related to an earlier partnership listed as Callard,
Stewart & Watt Ltd.

Callcott, Sir Augustus Wall (New) **1779-1844**
Sir Augustus Wall Callcott first exhibited at the Royal
Academy in 1799 and was to become one of the most popular
artists of the 19th century. He was a friend of J.M.W. Turner,
was elected A.R.A. in 1806 and R.A. in 1810, was knighted
on the accession of Queen Victoria in 1837, and became
Conservator of the Royal Pictures. His earlier work consisted
mainly of English landscapes, but in later years he
concentrated on foreign landscapes and then figure painting.

Two patterns are known to have been derived from his
pictures. The pattern by J. & M.P. Bell & Co. listed as
"Going to Market" was based on a painting which was in the
collection of R. Vernon and was engraved for the *Art-Union*,
March 1841, and also for the *Art-Journal*, June 1850, under an
alternative title of "Crossing the Stream". The pattern
previously listed under the title Hospitality has now also been
identified as a Callcott painting — "The Benevolent
Cottagers", and the figures in the foreground were also used
on a small mug by an unknown maker with the picture's title
printed around the rim. Ill: FOB 40.

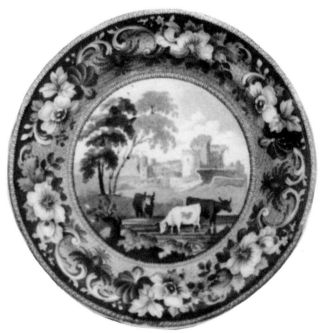

"Caerfilly Castle, Glamorganshire". *Maker unknown.*
Pineapple Border Series. Printed title mark. Plate 7¼ ins:19cm.

Callard & Callard. *Maker unknown. Unmarked. Miniature*
advertising plate 2¾ ins:7cm.

"Cambrian Bridges" (D67)
A printed mark noted on a jug with this pattern is in the form
of a floral cartouche with the maker's initials E.J. beneath,
possibly for Elijah Jones of Cobridge.

45

"Cambridge" (D68)
The view in the Cherub Medallion Border Series by Herculaneum was also used on a sauce tureen.

"Camden" (New)
Maker unknown. A simple geometric pattern recorded on teawares. The title "CAMDEN" appears printed beneath the pre-Victorian Royal arms, similar to a mark used by John Ridgway. Ill: Williams & Weber p.340.

John Ridgway titled several patterns after important persons of the day, others being Clarendon (qv) and Napier (qv), and this one is probably named after Sir Charles Pratt (1714-1794), 1st Earl Camden, a distinguished lawyer and statesman who let out his land in St. Pancras for building in 1791. Hence Camden Town and places with names such as Camden Passage. The name would have been popular abroad since there are two towns called Camden in Australia and 12 in America. The potter may well have had the export possibilities in mind.

Camel (D68)
The design commonly referred to as the Camel pattern by John Rogers & Son was also produced by Dixon, Austin & Co., but without the essential feature of the camel itself. It has been noted on a three-part soap box with the impressed mark "DIXON, AUSTIN & CO.", the pierced inner liner being printed with a simple floral spray, and both the liner and lid bearing a border of acorns. The lower box has a wide border with vignettes featuring alternately cupids at play and the missing camel.

The camel also appears on the lid of a soup tureen in a series by Robinson, Wood & Brownfield titled "Zoological" (qv).

Candleholder (New)
A term used to describe two different forms of candlestick. One looks rather like a flattened mug but has a holder for the candle potted as an integral part attached to the base inside. The other is similar to a chamber candlestick but is fitted with a hood to shelter the flame from draughts, and a carrying handle is attached to the back of the hood. An example of the latter printed with a scenic pattern titled "Pratt's Italian" (qv) is illustrated here, and another similar example can be seen in FOB 39. They appear to be of rather late date, certainly well into the second half of the 19th century. This latter form of candleholder was made in wood at the end of the 18th century, and is sometimes referred to as a candleshield.

Candlestick (D68)
A pair of unmarked candlesticks by an unknown maker printed with a floral design and the border from the "Verona" pattern (D377) is illustrated here. Two other forms of candlestick are usually referred to as Candleholders (qv).

"Canovian" (New)
Sewell (probably Sewell & Donkin). A scene of children playing amongst classical ruins within a border of flowers and feathers. A scroll and leaf cartouche contains the title "CANOVIAN" and an example with the impressed mark "SEWELL" has been recorded.

The title was possibly adopted following publicity accorded to Antonio Canova (1757-1822), an Italian neo-classical sculptor who worked in England for many years and exhibited at the Royal Academy from 1817 until his death. He was received by the Prince Regent who presented him with a diamond-studded snuffbox. Countess Albrizzi published *The Works of Canova* in 1824, describing the monuments he had executed for English patrons.

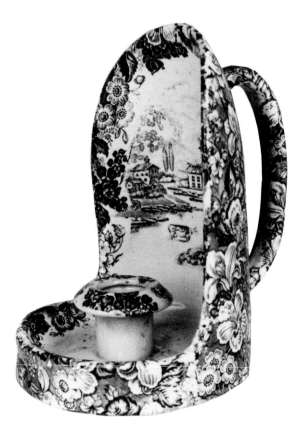

Candleholder. *Two views of a candleholder by Pratt. Printed cartouche inscribed "Pratt's Italian". Height 6¾ ins:17cm.*

Candlestick. Maker unknown. Pair of candlesticks printed with the border from the "Verona" pattern. Unmarked. Height 12¼ins:31cm.

not adapted from Mayer prints. The view Sepulchre with Annexe is illustrated in this supplement, but all other known views from the series are illustrated by Drakard & Holdway and catalogued by them as P905-1 to P905-21.

The pattern of the Ancient Granary at Cacamo within a rare floral border is catalogued separately by Drakard & Holdway under an adopted title of The Turk (qv). Some examples from the Caramanian Series were produced by Copeland with the border from the Italian pattern around the turn of the century.

See: Custard Cup.

"Caravansary at Kustchiuk Czenege" (New)
Maker unknown. Ottoman Empire Series.

There are various spellings for the word caravanserai, which is a large unfurnished inn with a central courtyard for night-time accommodation of caravans and other travellers in Eastern countries. It has not proved possible to locate Kustchiuk Czenege with any certainty, but it may be Kutchuk Kainarji where a peace treaty was signed between Russia and the Ottoman Empire in 1774. The town appears on a historical map of the Ottoman Empire just inland from the Black Sea, in the vicinity of the River Danube and close to the present border between Romania and Bulgaria.

"Carroll" (New)
Samuel Alcock & Co. A simple design of floral scrolls recorded on plates printed in dark blue. The title appears within a scroll cartouche with the makers' initials S.A. & Co. Ill: Williams & Weber p.341.

This pattern was almost certainly made primarily for the American market where the name Carroll was well known early in the 19th century. Charles Carroll (1737-1832) was one signatory of the Declaration of Independence and had been sent in 1776 to persuade the Canadians to war against England. John Carroll (1735-1815) was the Roman Catholic Bishop of Baltimore, Archbishop from 1811, and a staunch federalist. There is a town called Carroll in Iowa and at least five other towns called Carrollton elsewhere in the United States.

"Canterbury" (D69)
A plate from the Cherub Medallion Border Series by Herculaneum is illustrated here.

Cappellemans, J.B. (New)
Marks naming the Brussels firm of J.B. Cappellemans Aîné can be found on wares which are also marked W. Smith & Cie. One example can be seen in the *Dictionary* (D340). A partnership was formed by the two firms from 1847 to produce wares at Jenappes, and the venture finally closed in 1870.

See: William Smith & Co.

Caramanian Series (D70)
Spode. Previously recorded scenes illustrated in this volume are:

 The Castle of Boudron *
 Citadel near Corinth *

Additional scenes are:

 Caramanian Castle
 Caramanian Vase
 A Colossal Vase near Limisso in Cyprus
 Sepulchre with Annexe *

With the exception of the third, a Colossal Vase near Limisso in Cyprus, these are adopted titles since the scenes are

"Canterbury". Herculaneum. Cherub Medallion Border Series. Printed title mark and impressed "HERCULANEUM". Plate 8½ins:22cm.

"Cashmere" (D73)

Two other potters used this title:

(ii) Francis Morley & Co. A floral pattern with two goats, noted in pale blue and flow blue. This may be the same as the pattern recorded in the *Dictionary* by the firm's predecessors Ridgway & Morley. Ill: Williams & Weber p.78.

(iii) Edge, Malkin & Co. A flow blue pattern showing farm animals beneath some trees, marked with initials E.M. & Co.

The title is derived from the use of the hair of Tibetan and Bokhara goats which yields the famous cashmere wool.

Cassiobury, Hertfordshire (New)

This is the modern spelling for the Elizabethan mansion listed as "Cashiobury, Hertfordshire" in the *Dictionary* (D73). In addition to the views made by Ralph Hall and Enoch Wood & Sons, it has also been identified on one scene from the "British Scenery" Series.

Castle (D73)

This Spode pattern is catalogued by Drakard & Holdway as P711 and illustrated by them on several different shapes. It is also illustrated in Copeland p.156; Coysh 1 104; Little 60; Whiter 67; S.B. Williams 79-83. Another firm which used this pattern was Baker, Bevans & Irwin at the Glamorgan Pottery, Swansea, and a stone china plate illustrated here was made by James & Ralph Clews.

The Castle of Boudron (D73)

A dish from the Caramanian Series by Spode is illustrated here. This simple octagonal shape was previously unlisted, but was introduced as a replacement for the earlier oval shape for all dishes in the series.

Castle. *James & Ralph Clews. Printed seal mark with makers' name "CLEWS", and "Stone China" beneath. Plate 6¼ ins:16cm.*

The Castle of Boudron. *Spode. Caramanian Series. Impressed "Spode". Dish 18½ ins:47cm.*

"Castle Richard" (New)

Griffiths, Beardmore & Birks. Light Blue Rose Border Series. Sauce tureen.

The sauce tureen illustrated here is printed with two different views, neither of which bears much similarity to the engraving of Castle Richard (see below and "Craig Castle") which appeared in John Preston Neale's *Views of the Seats of Noblemen and Gentlemen in England and Wales, Scotland and Ireland*, the source for other views in this series. It may be mismarked, although the title could possibly refer to the view on the cover which is obscured by the knop.

Castle Richard, Waterford (New)

This house has been identified on one of the untitled views in the so-called "Irish Scenery" Series by Elkins & Co. A plate printed in mulberry is illustrated in Williams & Weber p.202.

Castle Richard, more recently known as Glencairn Abbey, lies two miles south-west of Lismore in Co. Waterford, Eire. It was a Gothic house started by R.E. Gumbleton in c.1814, which became a Cistercian convent in 1930 and was badly damaged by fire in 1973.

See: "Craig Castle".

"Castle Toward" (D75)

This pattern is now known to have been made by John Hall & Sons. It is illustrated here on a teabowl and saucer, together with the original source print from John Preston Neale's *Views of the Seats of Noblemen and Gentlemen in England and Wales, Scotland and Ireland*.

The Cat and the Mice (New)

This fable was used by Minton, Hollins & Co. as part of a set printed on Tiles (qv).

A house was infested by mice so a cat was brought in and it caught and ate many of them. The survivors decided they would stay on an upper shelf. The cat feigned death but an old mouse said: "I would not trust myself with you, though your skin were stuffed with straw".

A burnt child dreads the fire.

Cathedral Series (D76)

Careys. An additional view is:
 "Bath & Bristol Cathedrals"

"Cattle" (New)

Turner & Tomkinson. A pattern recorded on dinner wares.

"Castle Toward". John Hall & Sons. Printed ribbon cartouche with title and makers' name. Teabowl and saucer, diameter of saucer 5½ ins:14cm.

"Castle Richard". Griffiths, Beardmore & Birks. Light Blue Rose Border Series. Two views of sauce tureen. Printed title cartouche on base only. Overall length 7ins:18cm.

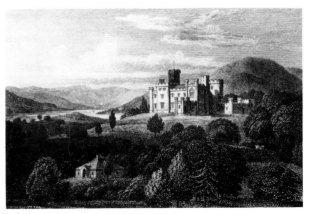

"Castle Toward". Source print taken from John Preston Neale's "Views of the Seats of Noblemen and Gentlemen in England and Wales, Scotland and Ireland".

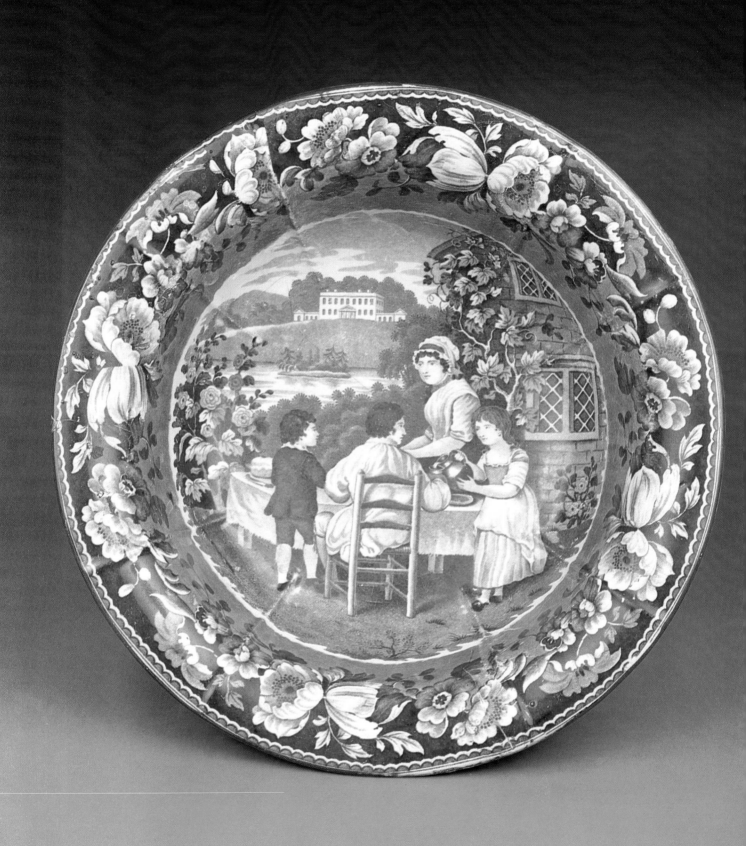

Colour Plate VI. The Cottage Door. *Edward & George Phillips. Impressed Staffordshire knot with "PHILLIP'S" above and "LONGPORT" (with reversed N) beneath. Washbowl. 12½ins:32cm.*

Colour Plate VII. The Cottage Door. *Early colour engraving after the painting by Francis Wheatley.*

"**Cavendish**". *Machin & Potts. Printed trumpeter holding ribbon marked with title and scroll inscribed "PATENT" with makers' initials. Plate 10½ins:27cm.*

"**Cavendish**". *Machin & Potts. Printed title mark from plate.*

"Cattle Scenery" (D76)

This title has been noted on gadrooned ironstone soup plates made by William Adams and also on a dish with a rural scene made by Thomas Fell & Co. The rural scene by Thomas Mayer listed in the *Dictionary* is, however, one of a series which is actually titled "Cattle & Scenery" (see below).

"Cattle & Scenery" (New)

The pattern title used by Thomas Mayer noted in the *Dictionary* as "Cattle Scenery" is incorrect and actually appears as "Cattle & Scenery". It may cover several different scenes on dinner wares, one example noted on a drainer having three cattle and two sheep, two yokels, one mounted on a horse, in the centre, and a bridge with figures in the left background.

"Cavendish" (D77)

A second potter used this title:

(ii) Machin & Potts. A romantic-style scene featuring a tall column printed within a border of floral trelliswork with four similar pagoda reserves. The printed mark is in the form of a scroll, held by a female trumpeter, which bears the title, the makers' initials, and also the word "PATENT". This is found on most printed wares from this factory, referring to the printing process invented by William Wainwright Potts (qv).

"Celeste" (New)

John Alcock. A chinoiserie pattern with a floral border.

Celeste means sky-blue, but the pattern title may have been inspired by Madame Celine Celeste (1814-1882) who was a French dancer and actress. She was a success as a child in Paris, appeared in New York in 1827, and was first seen in London in 1830. Later she became manageress of the Adelphi Theatre and of the Lyceum. Her last appearance was in 1878.

Challice, A. (D77)

The use of a name printed in a border reserve is a practice known to have been employed by traders who used the wares in their business (see, for example, the entry for the fishmonger James Quinn), and it is possible that the dish with the name "A. Challice" served a similar purpose. There was a butcher named Anthony Challis listed at 1 Spectacle Alley, Whitechapel, in a London directory for 1826, and this is certainly the correct period for items from the Rock Cartouche Series. Little significance can be attached to the various spellings of names in the 19th century.

Challinor, Edward (D77)

There is some confusion between the Edward Challinor who worked in Tunstall, and a potter of the same name who worked at Burslem. They may have been one and the same, but there was certainly a separate business at the Over-House works in Burslem, which according to Jewitt were taken over from Bathwell & Goodfellow in 1819 and rebuilt in 1869. The factory had, however, been operated by other partnerships since at least 1856 and probably considerably earlier. It was this Edward Challinor at Burslem who was responsible for the "Oriental Sports" Series, a copy of Spode's Indian Sporting Series.

Chantilly Sprig (D77)

This Spode floral pattern is catalogued by Drakard & Holdway as P810. It is also illustrated in Whiter 39; S.B. Williams 153.

"Charenton, near Paris" (D78)

This view by an unknown maker in the Pineapple Border Series was also used inside a soup tureen.

"The Charioteers" (New)
Thomas Mayer. "Olympic Games" Series. Dish 15½ins:39cm.

Cheese Coaster (D79)
Blue-printed cheese coasters are rare and very few examples have been noted. One alternative name is a cheese cradle. An ornate Spode example printed with the Forest Landscape pattern is illustrated in Drakard & Holdway S191.

"Chen Si" (D79)
This title refers to Chensi, a province in the north-west of China, which was described by Walker in 1810 as containing "Eight cities of the first rank and 106 of the second and third, besides many forts on the great wall. The air is temperate, the soil fertile, and it abounds in wheat and millet. They have also honey, wax, rhubarb, musk, cinnabar and coal mines; a great number of muskgoats, deer, bears, wild bulls and other animals".

Cherub Medallion Border Series (D80)
Herculaneum. Previously recorded views illustrated in this volume are:
 "Canterbury" *
 "Chester" *
 "Edinburgh" *
 "York" *
Additional views are:
 "Conway Castle" *
 "Darsie Castle" *
 "Dumfries" *
 "Greenwich" *
 "Kilkenny" *
 "Knaresborough" *
 "Lancaster" (a second view) *
 "Scarborough" *

"Chester" (D80)
A dish from the Cherub Medallion Border Series by Herculaneum is illustrated here.

"Chester". Herculaneum. Cherub Medallion Border Series. Printed title mark and impressed "HERCULANEUM". Dish 13ins:33cm.

Chetham. Impressed "CHETHAM". Oval arcaded and pierced stand 9ins:23cm.

Chetham (& Son) (D80)
A pierced stand printed with a pattern of assorted fruit and bearing the impressed mark "CHETHAM" is illustrated here.

"Chian" (New)
Flacket & Toft. A romantic chinoiserie scene within a leafy border noted on dinner wares. The title "CHIAN" is printed in an octagonal frame with the makers' initials F. & T. beneath.

Chian is a town in the Kiangsi province of China, on a tributary of the Kan River.

Children at Play (New)
A name which has become accepted for patterns showing children playing various games, printed on toy tea and dinner services. Two blue-printed plates are illustrated overleaf, but the wares were also produced in green. Three scenes are known, each found on a variety of shapes:
 (i) A girl in a wheelbarrow pushed by a boy. Ill: Milbourn 53 & 135.
 (ii) Two girls with a large dog. Ill: Milbourn 135.
 (iii) Two boys with a bird's nest. Ill: FOB 54.

Children's Pets (New)
A title which has been used to describe scenes of children with their pet dog and rabbit, illustrated overleaf on a small ornate wash bowl and ewer. Although these pieces are unmarked, the border is the same as that used by Maddock & Seddon for their "Fairy Villas" designs.

Children at Play. Maker unknown. Unmarked. Pair of miniature plates, each 4¼ ins: 11cm.

Children's Pets. *Attributed to Maddock & Seddon. Unmarked. Ewer, height 8¼ ins: 21cm, and basin, diameter 9¼ ins: 23cm.*

The Chinaman of Rank (D81)
This rare Spode pattern has now generally become known by the title Chinese of Rank (qv).

"Chinese Bells" (D81)
One example of this toy pattern has been noted with an impressed seal mark inscribed "Improved Stone China" (qv), believed to have been used by Charles Meigh.

"Chinese Bird" (New)
Maker unknown. A pattern recorded on wavy-edged dessert wares and illustrated here on a shell-shaped dish. It shows an exotic bird amongst flowers, marked with a cartouche in the form of a vase inscribed "CHINESE / BIRD" together with the word "OPAQUE" beneath.

"Chinese Dragon" (D82)
A further example of this design by an unknown maker is illustrated here on an oval soup tureen with leaf scroll handles and a fruit knop.

Chinese Flowers (D82)
This Spode floral pattern is catalogued by Drakard & Holdway as P816. It is also illustrated in Copeland p.147; Whiter 45.

Chinese Garden (New)
An adopted title for a Spode floral chinoiserie pattern which is catalogued by Drakard & Holdway as P631 and illustrated by them on a low Egyptian-shape cream jug in S136.

"Chinese Gem" (New)
E.T. Troutbeck. A design noted on light blue tewares featuring a group of figures in front of a large Chinese pagoda, all within different inner and outer borders. The title appears within a typical printed cartouche. Examples are known with an impressed maker's name and address mark, but some are marked with unidentified initials M.T. & T. Ill: Williams & Weber p.84.

"Chinese Juvenile Sports" (New)
Maker unknown with initial B. A series of patterns showing Chinese children at play, recorded on dinner wares. Ill: P. Williams p.112; Williams & Weber p.525.

"Chinese Landscapes" (New)
Hicks, Meigh & Johnson. A romantic-style chinoiserie scene titled "Chinese / Landscapes" in script within a floral scroll cartouche which includes the makers' initials H.M.J.

"Chinese Marine" (D82)
Other potters who used these designs are George Townsend of Longton and Lewis Woolf of Ferrybridge. A further gadroon edged plate with the unidentified initials B. & G. is known. Although these initials would fit the Bathwell & Goodfellow partnership (D35), the plate was clearly of significantly later date.

"Chinese Pagoda" (D83)
Examples with this title have now been reported with initials E.K.B. for Elkin, Knight & Bridgwood and B.T.P. Co. for the Bovey Tracey Pottery Company. They may differ from the design listed in the *Dictionary* as maker unknown. The Elkin, Knight & Bridgwood version is illustrated on an ornate jug in Williams & Weber p.85.

"Chinese Pagoda and Bridge" (New)
Maker unknown. A typical Chinese landscape design, rather similar to the common "Chinese Marine" patterns, marked with the title in a pair of crossed ribbons framed by leafy scrolls. Some examples have gadrooned edges, and the pattern was also printed in black. Ill: Williams & Weber p.87.

"Chinese Pastimes" (New)
Davenport. A scene including two fishermen with a building and a tower with a cross.

"Chinese Bird". *Maker unknown. Printed vase cartouche inscribed "CHINESE / BIRD" and "OPAQUE". Shell dish 8 ¾ ins: 22cm.*

"Chinese Dragon". *Maker unknown. Printed mark of a dragon with "CHINESE" on one wing, "OPAQUE" on the other, and "DRAGON" on the body. Soup tureen 17ins:43cm.*

Chinese of Rank (New)

The rare Spode pattern which was illustrated in the *Dictionary* as The Chinaman of Rank (D81) is catalogued by Drakard & Holdway under this alternative title as P632. It is also illustrated in Copeland p.155, and both references record that the source of the pattern is an aquatint titled "A Chinese of Rank" by Thomas and William Daniell which appeared in *A Picturesque Voyage to India by the way of China* (1810). Two further unmarked examples are illustrated here, but the egg stand illustrated in the *Dictionary* remains the only known marked specimen.

Chinese of Rank. Attributed to Spode. Unmarked. Broth bowl and cover 6¾ ins:17cm, and mug 4¼ ins:11cm.

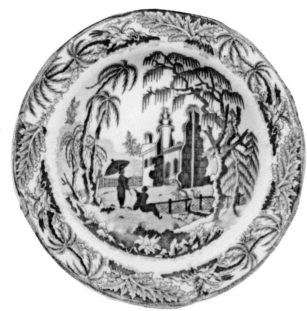

Chinoiserie Ruins. Job Ridgway. Impressed mark "J. RIDGWAY" over a beehive. Soup plate 9½ins:24cm.

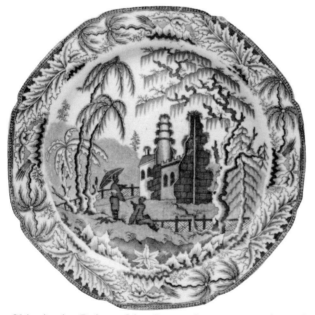

Chinoiserie Ruins. John Rogers. Impressed maker's mark. Octagonal plate 8ins:20cm.

"Chinese Scenery" (New)

Maker unknown with initial M. This pattern is marked with a printed cartouche very similar to that used by Minton and other potters for the popular "Chinese Marine" patterns. In this case the cartouche contains the title "Chinese Scenery" in script with the maker's initial M in a reserve beneath and "OPAQUE CHINA" at the base. The Minton factory usually printed their initial in cursive script. Otherwise, it is normally ascribed to John Maddock but he did not commence potting until 1842 and this pattern is known on a presentation jug dated 1828 made for a former public house at Newbury in Berkshire, called the "Queen Caroline" (qv).

"Chinese Sports" (New)

Maker with initials T.F. & Co., possibly Thomas Fell & Co. or Thomas Furnival & Co. A pattern featuring Chinese acrobats and dancers.

"Chinese Villa" (New)

Maker unknown with initials E.N. & N. A romantic chinoiserie design with a simple geometric border, noted on dinner wares. The printed cartouche mark shows a Chinaman in a small villa, and includes both the title "CHINESE VILLA" and the unidentified initials E.N. & N.

Chinoiserie Bridgeless Pattern (D83)

A plate in this pattern has been reported with a small impressed mark "STEVENSON". Apart from a few very minor details it is identical to the common Davenport design.

Chinoiserie Ruins (D83-84)

In earlier copies of the *Dictionary* the illustrations on pp.83-84 both show the John Rogers plate. The photographs showing the plates by Job Ridgway and Rogers are reprinted correctly here.

"Chintz" (New)

Minton & Boyle. A striped pattern used on dinner wares.

The word chintz comes from the Sanscrit *chintra*, originally the name for pieces of printed calico from India. It means spotted, or variegated.

"Chip Chase" (D84)

Chip Chase, usually called Chipchase Castle, lies six miles south-east of Bellingham in Northumberland. It started life as a fortified tower in 1415. In 1621 a Jacobean mansion was added, and there were later additions and alterations in 1784 and in 1819 by the architect John Dobson.

Chocolate Pot (New)

See: Coffee Pot.

"Choura Jantely Berkham Pore" (New)

Maker unknown. Parrot Border Series. Vegetable dish. Ill: FOB 51.

Berhampore lies about 50 miles west of the Ganges, some 160 miles north of Calcutta.

Christ's Hospital (New)

Wares bearing the coat-of-arms of Christ's Hospital were ordered from at least three different potters. A plate illustrated here was made by George Jones & Sons between 1891 and 1924. A similar plate made by Copeland in 1887, but with the addition of "No. 10" indicating the number of the dining room, can be seen in Copeland 2, p.27, where the name "Louis Quatorze" is given for the border design. Other Copeland examples are described in the Spode Society *Review*, Vol.1 (November 1986). There is an entry for the coat-of-arms in a surviving badge book at the Spode factory which refers to invoices as early as 1846, so presumably wares were first made in the Copeland & Garrett period. In the early years of the 20th century, wares were ordered from Furnivals with the school's badge added to their flow blue "Bombay" pattern.

Christ's Hospital is a public school which was founded in 1552 by Edward VI for the education of London's sick and poor. It originally occupied the premises of the Grey Friars, vacant following the dissolution of the monasteries, but a new building, designed by John Shaw, Senior (1776-1832), was erected in 1825. There was a separate boys' preparatory school at Hertford from 1682, which also housed the girls' school which moved out of London after 1697. The main school transferred from London to Horsham in 1902, into a new building designed by Sir Aston Webb, where it was joined by the younger boys from Hertford. The girls remained at Hertford until 1985. It is known as the Blue-Coat School, after the 16th century costume, and the site at Horsham has been likened to a small town. Famous pupils have included Coleridge, Leigh Hunt, and Charles Lamb.

"Ciala Kavak" (New)

Maker unknown. Ottoman Empire Series. Plate 8¼ ins:21cm and shaped dish 9ins:23cm. Ill: P. Williams p.228; FOB 32.

This is the correct title for the entry which appeared in error in the *Dictionary* as "Cialka Kavak". The view is illustrated here on a dessert plate.

Kavak is a Turkish town, some 20 miles north-east of Gallipoli on the Dardanelles.

"Cialka Kavak" (D85)

See previous entry.

"Circassia" (D85)

This romantic pattern by John & George Alcock has also been recorded in very dark blue and with an impressed trade name "ORIENTAL / STONE". Ill: Williams & Weber p.93.

Christ's Hospital. *George Jones & Sons. Printed and impressed makers' monogram marks. Plate 9ins:23cm.*

"Ciala Kavak". *Maker unknown. Ottoman Empire Series. Printed title mark. Plate 8¼ ins:21cm.*

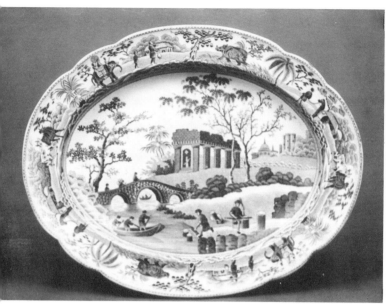

Citadel near Corinth. *Spode. Caramanian Series. Impressed "Spode". Oval dish 11¾ ins:30cm.*

Cistern (New)
See: Water Cistern.

Citadel near Corinth (D85)
A dish with the mirrored version of this view in the Caramanian Series by Spode is illustrated here.

Cities and Towns Series (D85)
Charles Harvey & Sons. An additional view is:
"Worcester"

"City of Benwares" (sic) (D86)
The size of the deep dish in the "Oriental Scenery" Series by an unknown maker is 8¼ ins:21cm, but it is believed to be incorrectly titled since the pattern shows tombs at Boglipore.

"City of Canterbury" (D86)
A vegetable dish from the Grapevine Border Series by Enoch Wood & Sons is illustrated here.

"Clare College" (New)
A soup plate with no maker's mark has been reported with a titled view of Clare College, Cambridge. The scene is printed within a union wreath border, and is marked "CLARE COLLEGE. BRADFORD". The significance of the name "Bradford" is not known, but as with other college wares, it may be the name of the caterer or bursar.

"Clarendon" (New)
John Ridgway. A geometric floral pattern bearing a printed Royal coat-of-arms mark beneath which are the initials J.R. and the title "CLARENDON".

The title for this pattern was probably inspired by the 4th Earl of Clarendon (1800-1870) who was Lord Privy Seal in Melbourne's ministry of 1840, became Lord Lieutenant of Ireland in 1847, and Foreign Minister in 1853. The Clarendon Press at Oxford had the Royal patent to publish the Bible.

"Classical Antiquities" Series (D86)
Joseph Clementson. One previously recorded scene is illustrated in this volume:
"Ulysses at the Table of Circe" *
Additional scenes are:
"Homer Invoking the Muses"
"Juno's Command"
"Penelope Carrying the Bow to the Suitors"
"Ulysses Following the Car of Nausicaa"
"Ulysses Weeps at the Song of Demodocus"
The printed title marks all include a registration diamond for 13th March 1849, but the records of the Design Registry contain only a segment of the border and the central scene "Phemius Singing to the Suitors". The series was also printed in pale green.
See: Classical Figure Patterns.

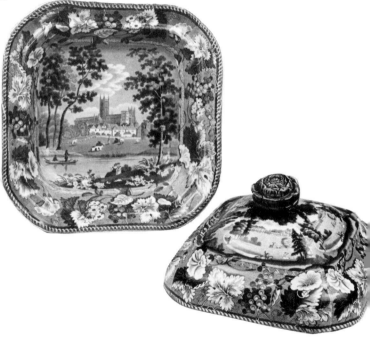

"City of Canterbury". *Enoch Wood & Sons. Grapevine Border Series. Printed title mark and impressed makers' eagle mark on dish only. Vegetable dish and cover, length 9¾ ins:25cm.*

Classical Figure Patterns (New)
Several blue-printed designs were based on paintings from Greek, Roman and Etruscan vases in the collection assembled by Sir William Hamilton (1730-1803) (D169). They are often wrongly grouped together as Greek Patterns (D162), and although Greek influences were strong, many of the vases were brought to Britain from Etruria and from the Kingdom of the Two Sicilies.

Vases from the Hamilton Collection were sold to the British Museum in 1772 and aroused considerable public interest. He wrote several books on antiquities which were published in French between 1766 and 1791. Edited English editions appeared in the first decade of the 19th century and attracted particular attention, an interest which was soon reflected in

designs on blue-printed pottery. Many romantic scenes include a classical vase, and several patterns specifically feature the famous Warwick Vase (D394). At least six potteries manufactured series with classical figure patterns:

(i) Joseph Clementson. This was the only firm which named both the series and the individual patterns. They are listed as the "Classical Antiquities" Series (qv and D86).

(ii) Elkin, Knight & Bridgwood and their successors Knight, Elkin & Co. produced a series under the title "Etruscan" (qv and D130), a description also used by other potters in their titles (D130-131).

(iii) Herculaneum. This Liverpool pottery is believed to have produced a series of patterns in which the same two chariot scenes always appear on either side of a central reserve containing a stylised wreath. Pairs of classical figures appear in oval reserves in a key border, and the edges are painted with ochre. The attribution of these wares is traditional but no marked specimens have yet been recorded. See: Greek Patterns (qv and D162).

(iv) Spode. The Spode so-called Greek patterns have central classical figure scenes surrounded by a wide border with reserves of smaller similar scenes, alternate reserves being urn-shaped. Some of the central scenes have been identified, and they are listed under the generally accepted title of Greek Patterns (qv).

(v) Wedgwood & Co. of the Ferrybridge Pottery. This pottery issued classical figure patterns during the period from 1796 to 1801 when Ralph Wedgwood was a partner there. One example called the Greek Altar pattern for want of an exact identification, can be seen in Coysh 2 35, and some parts of the surviving factory pattern book are reproduced in FOB 8.

(vi) Maker unknown. A series of classical figure patterns printed within a frame of stylised anthemion, all within a continuous strip border of further groups of figures. They are listed here as the Kirk Series (qv), since they are known to be derived from engravings by Thomas Kirk (qv).

The patterns in the Kirk Series and many of Spode's Greek Series are based on engravings in *Outlines from the Figures and Compositions upon the Greek, Roman and Etruscan Vases of the Late Sir William Hamilton, with engraved borders. Drawn and engraved by the late Mr. Kirk* (1804). Another source was William Hamilton's *Collection of Engravings from Ancient Vases, mostly of pure Greek workmanship in sepulchres in the Kingdom of the Two Sicilies, but chiefly in the neighbourhood of Naples*. This was published in three volumes by W. Tischbein between 1791 and 1795.

This subject clearly presents an opportunity for further detailed research.

See: Greek Patterns; Kirk Series.

Clementson, Joseph (D87)
An informative article by Pat Halfpenny, 'Joseph Clementson: A Potter "Remarkable for Energy of Character"', can be seen in the *Journal of the Northern Ceramic Society*, Vol. 5 (1984).

"Cleopatra" (New)
Francis Morley & Co. A flow blue pattern featuring a romantic style scene of a temple with obelisks printed within a floral border on dinner wares. The printed cartouche mark shows one large obelisk and a tablet inscribed with the title "CLEOPATRA". The pattern was registered in May 1845, the first year of the firm's existence, and some examples have flowers clobbered in purple and added gilding.

The obelisks were erected at Heliopolis by Thothmes III in about 1450 BC but were taken to Egypt in 23 BC where they became associated with Cleopatra who had recently died. They were offered to George IV in 1820 and to William IV in

1831 but both monarchs declined. They remained a subject for discussion for many years until one was eventually brought to London in 1878 and set up in its present position on the Embankment, where it is generally known as Cleopatra's Needle. The other is now in Central Park, New York.

Clews, James & Ralph (D87)
Although commonly referred to as James and Ralph Clews, there are a significant number of references which list this partnership as Ralph and James. In addition, several marks include their initials in the order R. & J.

An uncommon pattern featuring a river scene with a fort is illustrated here.

See: Mirror Transfers.

Clews, James & Ralph. *River scene with fort. Impressed crown above "CLEWS / WARRANTED / STAFFORDSHIRE". Plate 6½ ins:17cm.*

"Clumber" (D88)
The house at Clumber in Nottinghamshire was built for the 2nd Duke of Newcastle-under-Lyme by Stephen Wright between 1768 and 1778. It incorporated an earlier hunting lodge, with wings added on either side, and lay on the northern edge of the park. It was demolished in 1938. The gardens owed much to the famous botanist Samuel Curtis (1779-1860), who spent five years working there.

Coach Pot (New)
An alternative name for a bourdaloue (D52). An example from the "British Scenery" Series is illustrated overleaf, and another blue-printed example by Wedgwood decorated with landscapes and a rose border is shown by R. Reilly & G. Savage in *The Dictionary of Wedgwood*, p.53.

"Cobham Hall" (D88)
The view in the "Baronial Halls" series by Knight, Elkin & Co. is illustrated on a plate with a blue border and black centre in NCS 57, p.31. The engraver's name is given as Jesse Austin, not Felix.

Coach Pot. *Attributed to Ridgway. Unidentified view from the "British Scenery" Series. Unmarked. Coach pot or bourdaloue. Length 9½ins:24cm.*

Coffee Pot (New)

Coffee pots were made in a variety of different shapes and blue-printed examples survive from several factories, although many are unmarked. There is some discussion amongst collectors about differentiation between coffee pots and chocolate pots, one school of thought proposing that a strainer is fitted behind the spout in a coffee pot but not in a chocolate pot. Two such pieces are illustrated in Colour Plates IV and V.

"Colonna" (D89)

This pattern may have been named after one of two towns called Colonna, one in Compagna di Roma, Italy, and the other in the part of Dalmatia which was held by the Venetians at the end of the 18th century. It may alternatively derive from the name of one of the oldest and most illustrious families of Italy, which has produced popes, cardinals, princes and generals.

A Colossal Vase near Limisso in Cyprus (New)

Spode. Caramanian Series. Vegetable dish cover. Ill: FOB 45.

Limassol, to give Limisso its modern name, is a seaport in Akrotiri Bay on the south coast of Cyprus.

Comb Bank, Kent (D91)

The view on the dish illustrated in Colour Plate I of the *Dictionary* is now believed to be another view of Comb Bank in Kent. See: "British Views" Series.

Comb Bank, known today as Combe Bank, was built for Colonel John Campbell by Roger Morris in c.1726. The house is described in detail by John Newman in the volume covering West Kent and the Weald in the series *The Buildings of England* (1969).

Commemorative Series (New)

Maker unknown. A title adopted here for a series consisting mostly of commemorative designs which have small central portraits within wide floral borders featuring the rose, thistle and shamrock. Several of the designs have inscriptions around the portrait and the following have been recorded.

(i) "The Queen of England". A portrait of Queen Caroline. Ill: FOB 53.

(ii) "Sacred to the Memory of George III. Who died 29 Jan^y. 1820". Ill: May 51.

(iii) "I hope the time will come when every poor child in my Dominions will be able to read the Bible". A design showing George III handing a book to a child. Ill: FOB 37.

(iv) "Robert Burns" *. Two different versions with portraits of the Scottish poet. Ill: FOB 37.

(v) "The Robert Bruce" *. A ship launched at Greenock c.1817. Ill: FOB 37.

Other items have been reported which have simple central designs such as a basket of fruit, flowers, or a collection of shells. Although the borders are the same, there are variations in the bands of stringing which surround the central pictures. Some of the central portrait designs are also known on moulded children's plates without the wide floral border. Examples are illustrated in Little 113 (design (ii) above), and May 50 (design (iii) above).

It has been suggested that the jug featuring "Her Majesty, Caroline, Queen of England" and "H. Brougham, Esq. M.P." illustrated in the *Dictionary* (D294), may also form part of this series, although all other known patterns are found only on a single size of plate. The series is often attributed to the Caledonia Pottery at Glasgow.

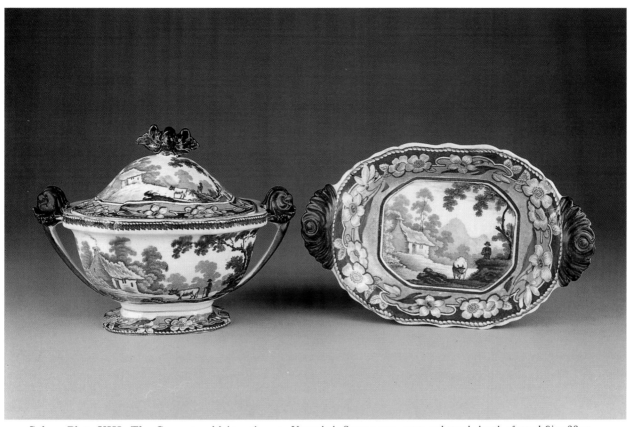

Colour Plate VIII. The Cowman. *Maker unknown. Unmarked. Sauce tureen, cover and stand, length of stand 9ins:23cm.*

Colour Plate IX. Coursing Scene. *Toft & May. Impressed "TOFT & MAY". Dish 13¼ins:34cm.*

"Compton Verney" (D92)
The view under this title by Henshall & Co. can be seen on the dish in Colour Plate II of the *Dictionary*. It was probably marked "British Views" in error. The same view was used by Enoch Wood & Sons on a plate in their Grapevine Border Series (see D92). The figures and dogs in the foreground of the Henshall dish were originally taken from a painting by James Northcote, R.A. entitled "Grouse Shooting in the Forest of Bowland", but they are printed in reverse. These figures were copied by many potters for use on printed and sprigged wares. Their use on a Spode bat print together with the original picture can be seen in Drakard & Holdway P362.

Convolvulus (New)
An adopted title for a rare Spode floral pattern which is also sometimes called the Sunflower pattern. It is illustrated here on a liner from a vegetable dish, and catalogued by Drakard & Holdway as P819. It is also illustrated in Whiter 49.

Convolvulus. *Spode. Printed "SPODE" mark. Liner for vegetable dish 9¾ins:25cm.*

"Conway Castle" (New)
Herculaneum. Cherub Medallion Border Series. Deep dish 9ins:23cm.

This feudal fortress, with walls over 12 feet thick and eight large towers, was built by Edward I in 1284 to check the Welsh. Conway lies at the mouth of the Conway river in Caernarvonshire, now Gwynedd, four miles south of Llandudno.

Copper Plate (D93)
See: Willow Pattern Makers.

"Corean" (D93)
An early spelling of Korean, meaning of or from Korea.

"Corinth" (New)
(i) James Edwards. A romantic scene printed in blue or sepia on ironstone dinner wares. A printed shield-shaped cartouche contains the pattern title "CORINTH" and the maker's name "JAS EDWARDS". Ill: P. Williams p.242; Williams & Weber pp.568-569.

(ii) Thomas Fell & Co. A romantic scene which was registered in 1845 and printed on ironstone dinner wares. Ill: R.C. Bell, *Maling and other Tyneside Pottery*, p.19.

(iii) George Phillips. Another typical romantic scene, printed also in red. Ill: P. Williams p.243; Williams & Weber p.570.

Various potters produced printed wares inspired by the great 19th century interest shown in the ancient city of Corinth; see, for example "Corinthia" and "Corinthian" (D94). It was described by Walker in 1810 as "now decayed, the inhabitants not exceeding 1400; there still remain, however, ruins of temples and other marks of its former magnificence".

"Corinthian" (D94)
Another potter used this title:
(ii) Minton. A floral pattern printed on dinner wares with moulded rims. The inscription "Corinthian / Opaque China" appears in script within a floral scroll cartouche with the cursive initial M beneath.

"Corrella" (New)
Probably Barker & Son. A classical scene featuring a prominent statue and several vases in the foreground with a large villa behind. A printed scroll cartouche contains the title "CORRELLA" and the makers' initials B. & S.

Corella, as it is spelt today, is a small town in northern Spain in the upper valley of the River Ebro.

"Conway Castle". *Herculaneum. Cherub Medallion Border Series. Printed title mark and impressed "HERCULANEUM". Deep dish 9ins:23cm.*

"Coterie" (New)
John Ridgway. A simple geometric pattern of tiny stylised flowers. A printed pre-Victorian Royal arms mark includes the title and also an inscription "No. 106, 19 Nov. 1839". Ill: Williams & Weber p.345.

The word coterie originally meant a group of peasants jointly holding land from a lord, but it later became used particularly to describe an exclusive and fashionable circle of people in society, a set or clique. It is seldom used today but was fashionable in the 19th century. De Quincey wrote of "Clodius and some of that coterie" in his *Murder Considered as one of the Fine Arts* (1827); Cunningham described "a certain coterie of men skilful with the mystery of good painting" in *Lives of the Most Eminent British Painters* (1829-1833); and Charles Merivale wrote "In vain had Tiberius chafed under the jeers of the licensed coterie" in his *History of the Romans under the Empire* (1850-1864).

The Cottage Door (New)
Edward & George Phillips. A genre scene, printed in dark blue on washbowls, which shows a man in a smock seated on a ladder back chair at a table covered with a white cloth. He is being waited on by a woman, a girl, and a small boy. Behind the woman is the lattice window of a cottage and in the distance, beyond a lake, stands a mansion on a hill. Some examples have an impressed Staffordshire knot with "PHILLIP'S" above and "LONGPORT" with the letter N reversed beneath (see similar mark on D282).

The pattern is copied from one of a pair of paintings by Francis Wheatley (qv) which were engraved for colour prints by George Keating and published by Charlotte & George Keating on 1st January 1798. The full titles were "The Family Dinner at the Cottage Door", which was dedicated to Lady Georgiana Cavendish, and "Tenderness Persuading Reluctance at the School Door". The pattern is a very close copy of the original painting except for the omission of a tree on the left and the addition of the mansion in the distant background. A marked bowl is illustrated together with an early colour engraving of the source picture (see Colour Plates VI and VII).

Country Scene (D95)
This rare Spode rural scene is catalogued by Drakard & Holdway as P704. No marked examples have yet been recorded although it has been found on a dinner plate, a large saucer, a very rare pilgrim flask, and the tea plate which is illustrated here. Other examples can be seen in FOB 44; Whiter 62; S.B. Williams 161.

Coursing Scene (D96)
The maker of this uncommon series of hunting scenes has now been identified as Toft & May. A marked dish is illustrated in Colour Plate IX.

The original coursing scene from which the series was named, illustrated in Little 118, is now known to be derived from a painting by Philip Reinagle, R.A. (qv). It was probably adapted by several engravers, including Howitt as previously listed, but also by J. Nichols and J. Bluck under the title "Up to the Hare". It is not possible to state which actual engraving was used by the potter.

"Covent Garden Theatre, London" (D96)
A plate from the Tams' Foliage Border Series is illustrated here.

"Cow Boy" (New)
Maker unknown. A pattern noted on a washbowl marked with the title "COW BOY" in a rock cartouche. The central scene features a boy riding a mule and driving a cow, with a ruined abbey to the right and a village in the left background, all within a floral scroll border.

Cow Creamer (New)
A cream or milk jug moulded in the form of a cow, with the mouth forming a spout, the tail looped to make a handle, and a small lid fitted on the cow's back. Cow creamers were extremely popular and are avidly collected. Many forms of decoration were used, and some examples were rather incongruously printed with the standard Willow pattern.

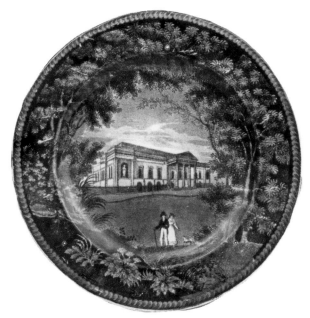

"Covent Garden Theatre, London". *Tams & Co. Tams' Foliage Border Series. Printed title mark and impressed wheel symbol. Plate 7¾ ins:20cm.*

Country Scene. *Attributed to Spode. Unmarked. Plate 6¾ ins:17cm.*

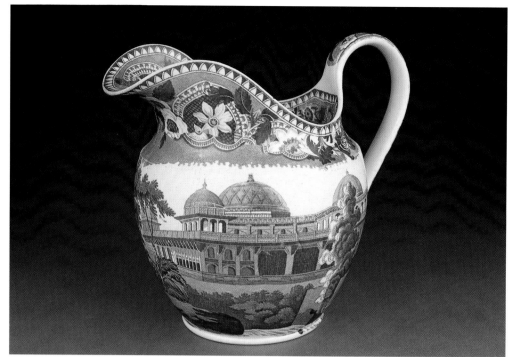

Colour Plate X. **Daniell, Thomas**. *Unidentified view. Maker unknown. Unmarked. Ewer 8ins:20cm.*

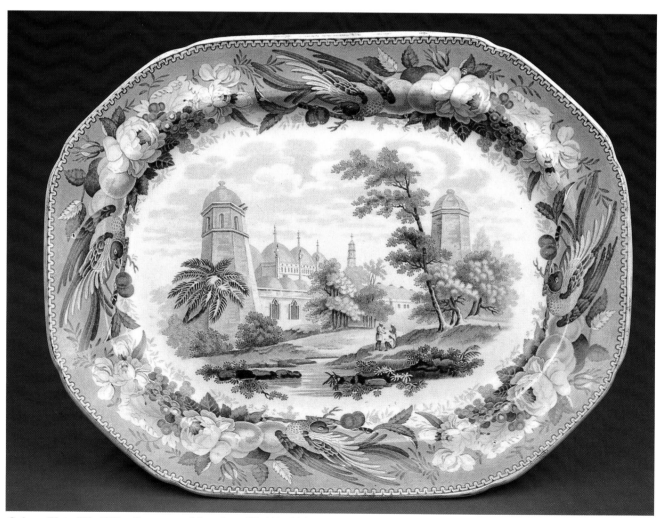

Colour Plate XI. **"The Cuttera at Maxadavad"** *(sic). Maker unknown. Parrot Border Series. Printed title mark. Dish 15ins:38cm.*

The Cowman (D96)

This rural scene by an unknown maker is shown in Colour Plate VIII on a sauce tureen, cover and stand, with distinctive ornately-moulded handles. The scenes on the tureen and the cover differ slightly from the recorded pattern in that both the cow and the man are facing to the left, and the man is no longer standing behind a bank. The scene inside the tureen is different again, with no cow and the man walking towards the right.

Cows Crossing Stream (D96)

A variant of this Swansea pattern has been noted on a large platter with an impressed upper case Davenport anchor mark. In this case the usual central scene was enclosed within a different floral border which had been printed more than once to cover the large size of the dish.

Cracked Ice and Prunus (D96)

This is an alternative name for the Spode sheet floral pattern catalogued by Drakard & Holdway as Marble (qv). It is sometimes also known as Mosaic.

"Craig Castle" (D96)

This title was used by Elkin, Knight & Co. in their Rock Cartouche Series but all examples noted to date are printed with a view identified as Castle Richard (qv) in Waterford, Ireland. It would appear to be an engraver's error, rather than a mistake by the printer. A dish is illustrated here together with the source print from John Preston Neale's *Views of the Seats of Noblemen and Gentlemen in England and Wales, Scotland and Ireland.*

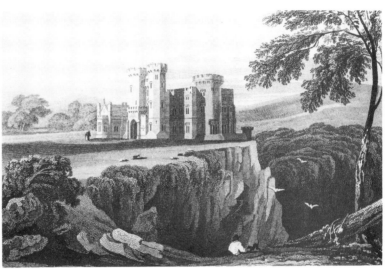

"Craig Castle". *Source print of Castle Richard, Waterford, taken from John Preston Neale's "Views of the Seats of Noblemen and Gentlemen in England and Wales, Scotland and Ireland".*

"Craig Castle". *Elkin, Knight & Co. Rock Cartouche Series. Incorrect printed title mark, the view is Castle Richard in Waterford. Dish 12¾ ins: 33cm.*

"Crescent" (New)

John Rogers & Son. A floral pattern noted on wavy-edged dinner wares. The title appears in script within a scroll cartouche, and examples bear the impressed makers' mark "ROGERS"

Cricket (New)

An early game of cricket appears in the foreground of the view titled "Windsor Castle" in the "Metropolitan Scenery" Series by Goodwins & Harris. It has been identified as a challenge match with a purse of 1,000 guineas, played on the first Lord's Ground at Marylebone between teams representing the Earls of Winchelsea and Darnley in 1793. The game was won by Lord Winchelsea's side.

See: "Windsor Castle".

Crown (New)

An impressed mark consisting of a crown with small initials G. and R. at either side is found on several different patterns, some of which are now attributed to John Meir. The mark can be seen illustrated in this volume on a plate printed with the "Flora Pattern" (qv), and patterns on which it has been noted include:

Crown Acorn and Oak Leaf Border Series
"Flora Pattern"*
Fortune Teller, or Beggar Woman
"Oriental Scenery" Series
Pineapple Border Series

Further evidence is desirable before these wares can all be attributed with confidence.

Crown Acorn and Oak Leaf Border Series (D97-98)

Previously recorded views illustrated in this volume are:

"Amport House, Hampshire" *
"Wakefield Lodge, Northamptonshire" * (Colour Plate XXIII).

Additional views are:

"Barlborough Hall, Derbyshire"
"Moxhull Hall, Warwickshire"

A further unmarked view, subsequently identified as Worstead House in Norfolk, is illustrated on a sauce tureen stand in FOB 39.

A comport of very distinctive shape printed with the view of "Wakefield Lodge, Northamptonshire" is illustrated together with another comport of identical shape printed with the River Fishing pattern and marked "MEIR" (see Colour Plates XXII and XXIII). Further evidence that the series was made by John Meir has been accumulating, including other distinctively shaped dessert dishes, and a meat dish has now been reported with the view of "Lowther Castle, Westmorland" bearing an impressed mark "I. MEIR" with the additional wording "Warranted Staffordshire" and a crown with the initials G.R.

"Crusaders" (D98)

This pattern has also been noted on a cup and saucer marked with the title in script within a simple oval frame of tiny stars. No maker's name appears, and it may have been made by some firm other than Deakin & Bailey.

"Crystal Palace" (D98)

The pattern by J. & M.P. Bell & Co. is illustrated on an oval dish by Williams & Weber p.163.

Custard Cup. *Spode. Pail-shaped custard cup with border design from the Caramanian Series. Printed "Spode". Height 2½ins:6cm.*

Cupid Patterns (D100)

The pattern by Enoch Wood & Sons known as Cupid Imprisoned is illustrated on a deep saucer by Williams & Weber p.346.

Custard Cup (D100)

A pail-shaped custard cup printed with the border from Spode's Caramanian Series is illustrated here. A Copeland & Garrett bell-shaped custard cup from the "Aesop's Fables" Series is illustrated in this volume (see "The Fox and the Grapes").

"The Cuttera at Maxadavad" (sic) (New)

Maker unknown. Parrot Border Series. Dish 15ins:38cm and toilet box. Ill: D276 (on a toilet box). See also Colour Plate XI in this volume.

The title appears to be incorrectly engraved, since it should read Muxadabad, which was the seat of Jaffir Cawn, Nabob of Bengal. He was a popular ruler who had many learned visitors, and he built the Cuttera in the early years of the 18th century. Each of the smaller domes covered a separate apartment, rather like a monastery, all surrounding a large square.

"Cyprian Bower" (New)

Middlesbrough Pottery. The printed cartouche mark for this pattern is illustrated by Mary Williams in *The Pottery That Began Middlesbrough*. It shows a group of buildings framed by columns, with the title "CYPRIAN BOWER" in scrolls above, and "MIDDLESBRO' POTTERY" on a panel beneath.

"Dacca" (D101)
The pattern by Minton & Boyle is illustrated on a plate and a dish by Williams & Weber pp.164-165.

"Daffodil" (New)
David Methven & Sons. A pattern printed on toilet wares, featuring large sprays of daffodils enclosing reserves depicting a castle. The title is printed with the makers' initials D.M. & Sons within concentric circles.

Dagger Landscape (D101)
The three Spode chinoiserie patterns known under this title are catalogued by Drakard & Holdway as P603, P604 and P605. Copeland refers to the three variants under alternative titles of Temple with Panel, Lake, and Mandarin. They are shown in Copeland pp.83-87, pp.98-99, and pp.45-52 respectively, and are also illustrated in Whiter 4, 6 and 15; S.B. Williams 107.

"Dahlia" (New)
Cork & Edge. A pattern of flowers and leaves recorded on a mug marked with the makers' initials C. & E.

The dahlia is a tuberous-rooted half-hardy perennial plant derived from a species of Mexican origin.

Daisy (D101)
This Spode sheet floral pattern is catalogued by Drakard & Holdway as P805. It is also illustrated in Whiter 35.

Daisy and Bead (New)
An adopted name for a Spode sheet floral pattern which is catalogued by Drakard & Holdway as P827. It has been recorded only on toy dinner wares.

Dale, Deakin & Bayley (New) **fl.c.1823-c.1827**
A blue-printed jug of Dutch shape decorated with a rural scene and floral border has been noted with a prominent printed mark consisting of a large crown with "WATERLOO" above, a ribbon with this partnership name below, and the word "WARRANTED" beneath. This particular partnership is unrecorded in directories of the period but Batkin, Thomas & Deakin are listed at Waterloo Place, Lane End in 1818, followed by Batkin, Dale & Deakin in 1822. By 1828 the firm had become Deakin & Bailey (qv), but note the different spelling of the name Bayley. The firm was trading as Deakin & Son from about 1833. The jug would appear to date from the mid-1820s and there were obviously several changes in the firm around that period.

"Damask Border" (D102)
This title used by the South Wales Pottery is now known to relate to a single scene used on all items in a dinner service. The central scene features two figures in a romantic classical landscape with a prominent viaduct in the background.

The word damask originated with the rich figured silks of Damascus. Today it is used for cloth of many kinds suitable for use as tablecloths, curtains and upholstery.

Daniel, Walter (New) **fl.c.1786-c.1810**
Newport Pottery, Burslem, Staffordshire. This pottery was established by Walter Daniel in about 1786 and was operated by him until its acquisition by John Davenport in c.1810. Daniel produced some early chinoiserie-style blue-printed wares, one example of which, with a rare impressed mark "W. DANIEL", can be seen in Coysh 2 21.

Daniell, Thomas (D102)
Thomas Daniell's *Oriental Scenery* was also used as the source for a pattern by the Leeds Pottery (qv).

A ewer by an unknown maker illustrated in Colour Plate X is decorated with a scene featuring a prominent Indian-style building, and it has been reported that it is copied from a Daniell print, although the source is not in *Oriental Scenery*. An alternative suggestion is that it shows an early design for extensions to the Brighton Pavilion, several of which were inspired by Daniell's work. However, detailed research has not yet substantiated either claim.

"Darsie Castle" (New)
Herculaneum. Cherub Medallion Border Series. Plate 6¼ ins:16cm.

Despite extensive research, it has not yet proved possible to locate this building, the proper name of which could possibly be d'Arcy Castle.

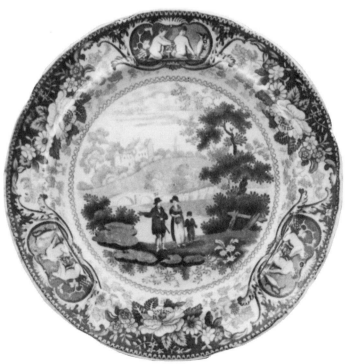

"Darsie Castle". *Herculaneum. Cherub Medallion Border Series. Printed title mark. Plate 6¼ ins:16cm.*

Davenport (D102)

Four further untitled Davenport patterns are illustrated here, two on miniature plates, one on a vase, and one on a drainer. The latter is one of a series of detailed views, generally thought to be on the River Rhine, which were printed within at least two different borders. One view described as a Swiss fishing scene, which can be seen in Lockett 29, has a simple blue toned border. Another with a border featuring floral sprigs is shown in Godden BP 323.

Following the closure of the Davenport factory in 1887, the copper plates were offered for sale or hire by A. Wenger of Hanley in 1888. The titles included were:

Alpine, Amusements, Arabesque, Bird and Berry, Bird and Star, Bramble, Ceres, Chinese Scenery, Citron, Crosslet, Cyprus, Danish, Delaware, Eastern Bird, Fan, Festoon and Bird, Flora, French Fan, Garland, Genoa, Grapes, Hop, Iolanthe, Italian Honeysuckle, Lily, Madras, Marbles, Nectarine, Nile, Old Florida, Pastoral, Pekin, Ribbon, Rocailles, Scots, Spanish Rose, Squirrel, Sunflower, Syrian, Tendril, Versailles, Woodland.

It is important to note that these may have been factory names not marked on the wares, and that they may have been printed in colours other than blue. Some could also have been outline designs normally decorated with enamel colours.

Davenport, Banks & Co. (New) fl.1860-1873

Castlefield Pottery, Hanley, Staffordshire. This partnership used a castle trade mark, with initials D.B. & Co., sometimes also including the place name Etruria. It was succeeded by Davenport, Beck & Co. in 1873.

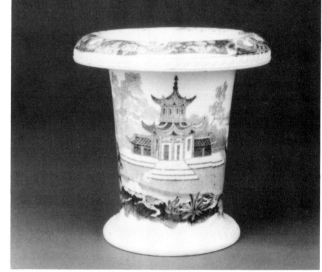

Davenport. *Vase. Printed scenic cartouche featuring two Chinamen and an anchor with maker's name "DAVENPORT", and impressed maker's anchor mark. Height 4¼ins:11cm.*

Davenport. *Two miniature plates. Both with printed "DAVENPORT" mark and impressed maker's anchor mark for 1836. Diameters 4ins:10cm and 3¾ins:9cm.*

Davenport. *Unidentified continental view. Printed "DAVENPORT" and impressed maker's anchor mark with indistinct date numerals. Drainer 13¼ins:34cm.*

Davis, D. *Printed retailer's mark.*

Davis, D. (D103)
One typical mark as used by the London retailer Daniel Davis is illustrated here. Variations in the addresses listed in the mark are known.

Deakin & Bailey (D104)
According to directories of 1828 and 1830 the address of this partnership was the Waterloo Factory at Lane End. The partnership name Deakin & Son appears at the same address in directories from 1835 with a change of address to the Waterloo Works, Stafford Street, Longton, in 1842. A related partnership under the name of Dale, Deakin & Bayley (qv) was of earlier date.

"Delft" (D105)
This design was registered by Minton in 1871.

"Delphi" (New)
William Adams & Sons. A series of romantic scenes with ruins and figures within a border of stylised flowers and scrolls. The printed cartouche mark shows a vase on a tombstone inscribed with the title "DELPHI". Ill: P. Williams p.251; Williams & Weber p.573.

The Greek town of Delphi, now known as Kastri, on the southern slopes of Mount Parnassus, was celebrated for its oracles. These were sung by a priestess on Apollo's birthday. In the 19th century, the town was the subject of much interest and speculation in Europe, and in 1880 it was excavated by French archaeologists.

"Denon's Egypt" (D105, 107)
One of the designs with this title was made by both Elijah Jones (Ill: FOB 31) and C.T. Maling (Ill: Copeland 2 p.24). A different central scene can be seen on a plate in FOB 40, and another is shown on a dish by R.C. Bell in *Maling and other Tyneside Pottery*, p.4. The printed mark used by Elijah Jones is in the form of a sphinx in front of pyramids with the pattern title on its plinth and initials E.J. beneath. The mark used by Maling is similar but without any initials.

"Denton Park" (D107)
The dessert plate from the Light Blue Rose Border Series illustrated here is 8¾ins:22cm. The maker is now known to be Griffiths, Beardmore & Birks.

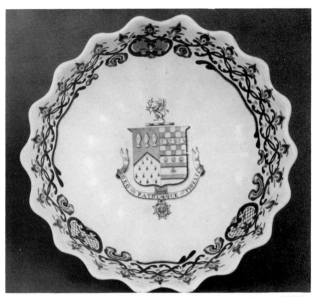

"**Deo Patrieque Fidelis**". *Spode. Arms of General Fagan, KCB. Printed and impressed "SPODE". Deep bowl with pedestal foot, 10¼ins:26cm.*

"Deo Patrieque Fidelis" (New)
Faithful to God and my country. A motto used by the Fagan family.

A blue printed dinner service bearing this motto was made by Spode for General Fagan, KCB, an example being illustrated here on a bowl. Ill: Drakard & Holdway P957.

See: Armorial Wares.

"Derwentwater" (D107)
This view in the "British Lakes" Series by C.J. Mason & Co. was printed on a dinner plate. It features a mounted drover with two cows in the foreground.

"**Denton Park**". *Griffiths, Beardmore & Birks. Light Blue Rose Border Series. Printed title mark. Plate 8¾ins:22cm.*

"Deus Nobis Haec Otia Fecit". *Herculaneum. Arms of the Liverpool Corporation. Impressed "HERCULANEUM". Tureen, overall length 13½ ins:34cm.*

"Deus Nobis Haec Otia Fecit" (New)

God hath given us this tranquillity. A motto used by several families and also the City of Liverpool.

Wares printed in blue with the Net pattern with reserves containing printed and enamelled arms including this motto were made by the Herculaneum Pottery for Liverpool Corporation in the early 19th century. A tureen is illustrated here, and a dish dated 1809 can be seen in A. Smith's *The Illustrated Guide to Liverpool Herculaneum Pottery*, 150.

See: Armorial Wares.

"Devon" (D107)

The pattern listed in the *Dictionary* was also printed in blue by the Middlesbrough Pottery. The title "Devon" was also used by Ford & Sons of Burslem for a flow blue floral pattern produced after 1893.

Dixon, Austin & Co. (D108)

According to J.C. Baker in *Sunderland Pottery* (1984), this partnership was succeeded by Dixon, Austin, Phillips & Co. in about 1826 or 1827, and subsequently by Dixon, Phillips & Co. (qv) sometime between 1834 and 1839. It is possible that the marks used may overlap these dates, particularly in the case of printed marks, and caution should be exercised in dating such wares.

The unmarked eel plate illustrated here is printed with a genre scene which appears on a marked example in Colour Plate XI of Baker's *Sunderland Pottery*.

See: "Lady of the Lake".

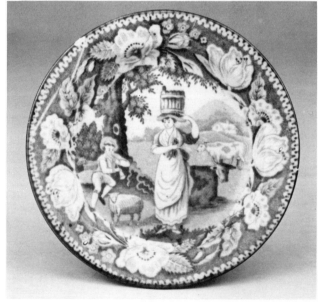

Dixon, Austin & Co. *Unmarked. Eel plate 4¼ ins:11cm.*

Dixon, James, & Sons (New) fl.1805 et seq.

Sheffield. A firm of Britannia metal manufacturers who had an extensive trade making metal lids and other fittings for jugs and similar wares. An interesting printed cartouche mark is illustrated in this volume on a Hot Water Plate (qv) which was made by Ridgway, Morley, Wear & Co. and intended to be fitted with a metal water container. The paradox is that the mark would normally have been obscured by the container.

Dixon, Phillips & Co. (New) fl.c.1839-1865

Garrison Pottery, Sunderland, Co. Durham. A partnership which succeeded Dixon, Austin & Co. or Dixon, Austin, Phillips & Co. some time in the period between 1834 and 1839 although the exact date is unclear. They continued until the closure of the pottery in 1865. Their most common mark consists of the name Dixon, Phillips & Co. impressed around an anchor, but others are known. They also included their full name in some printed marks with pattern titles such as "Australia".

"Domestic Cattle" (D111)

Maker unknown. Additional scenes are:

(v) A man holding out a top hat towards two horses, a pony in the foreground, and a rural dwelling on the right. Dish 13ins:33cm.

(vi) A design featuring two white rabbits. Plate 5½ ins:14cm.

(vii) Deer grazing in front of a country house. Dish 21ins:53cm.

(viii) A woman with two goats and a lamb. Plate 8¾ ins:22cm.

"Domine Dirige Nos" (D111)

O Lord direct us. The motto of the City of London.

Research by Frank Allen reported in FOB 42 has identified the building shown on this pattern, previously thought to be the Guildhall, as the City of London Tavern in Bishopsgate. The Royal National Lifeboat Institution was founded there in March 1824, and it was subsequently the headquarters of the Methodist Missionary Society and the London office of the National Bank of India.

Donovan, James (D113-114)

Another plate decorated with the early chinoiserie pattern, illustrated D114 as maker unknown but with the impressed retailer's mark "DONOVAN", has been reported with an impressed mark "DAVENPORT".

Another marked Donovan plate, this time in the Giraffe and Camel Willow Pattern, has also been recorded.

Dorgan, Lawrence (New) fl.c.1814-1840

A very large display jug in the Castle Museum, York, bears a circular reserve beneath the spout with the inscription "Lawrence Dorgan, China & Earthenware Manufacturer, Aldersgate Street, LONDON", and also has the date 1826 amongst the floral decoration. It was almost certainly produced for display in the window of Dorgan's shop. One relief-moulded jug of c.1840 is known with an impressed Dorgan mark, and marked blue-printed wares may also exist.

Lawrence Dorgan is first listed in a London directory for 1814 as a Glass Cutter at 178 Aldersgate Street where he remained until c.1827. By 1828 he had moved to 38 Minories and, apart from a change of premises to number 127 in 1831, he remained in business there until a final entry at numbers 128 and 129 in 1840. He is first listed as a China, Glass and Earthenware Dealer in 1822, and the listings as a Glass Cutter cease in 1826. This could be the year he decided to concentrate on the pottery business, a possible explanation for the date on the large display jug recorded above. All subsequent entries list him as a pottery dealer except for 1835 when he appears, possibly in error, as a Wine Merchant.

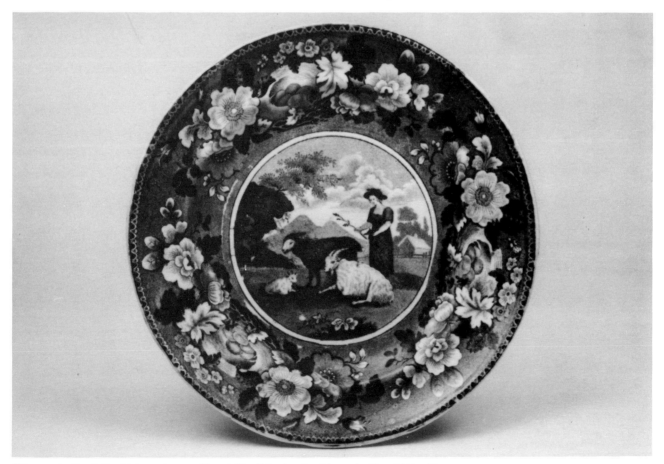

"Domestic Cattle". Maker unknown. View (viii). Printed series title mark. Plate 8¾ ins:22cm.

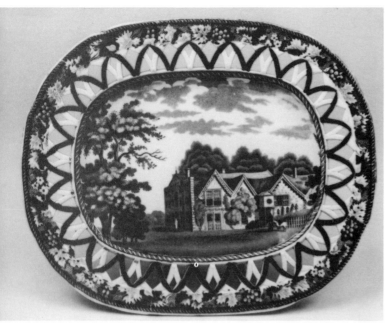

"Dorney Court, Buckinghamshire". *Enoch Wood & Sons. Grapevine Border Series. Impressed makers' eagle mark. Pierced basket stand 10¼ ins:26cm.*

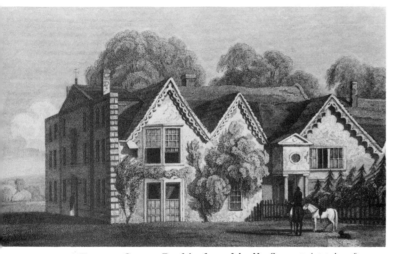

"Dorney Court, Buckinghamshire". *Source print taken from John Preston Neale's "Views of the Seats of Noblemen and Gentlemen in England and Wales, Scotland and Ireland".*

"Dorney Court, Buckinghamshire" (D114)

A pierced basket stand from the Grapevine Border Series by Enoch Wood & Sons is illustrated here together with the source print taken from John Preston Neale's *Views of the Seats of Noblemen and Gentlemen in England and Wales, Scotland and Ireland*.

Double Transfers (New)

See: Mirror Transfers

Dragons (D115)

This title has also been adopted for two Spode patterns catalogued by Drakard & Holdway as P626 and P627 and shown by them in S148 and S149, but they appear to have been printed only on bone china. They are also illustrated in Copeland pp.145-146; Whiter 27; S.B. Williams 131.

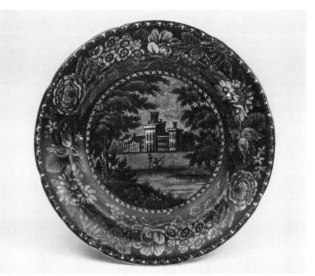

"Dreghorn House, Scotland". *Ralph Hall. "Picturesque Scenery" Series. Printed titles and maker's mark. Plate 6½ ins:16cm.*

"The Drama" Series (D115-116)

John Rogers & Son. An additional scene is:
 "As You Like It, Act 4, Scene 3" *

"Dreghorn House, Scotland" (D116)

The plate from the "Picturesque Scenery" Series by Ralph Hall is illustrated here.

Dresden Border (D116)

This Spode geometrical pattern is catalogued by Drakard & Holdway as P719. It is also illustrated in Whiter 71. The title in the *Dictionary* was given as plural in error.

"Dresden Vase" (D116)

This pattern by an unknown maker is illustrated here on an arcaded dessert plate.

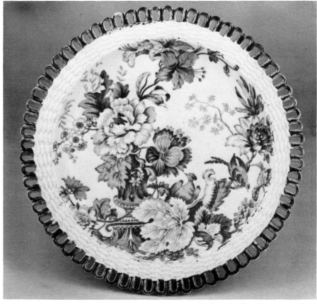

"Dresden Vase". *Maker unknown. Printed floral cartouche inscribed "DRESDEN VASE / OPAQUE / CHINA". Arcaded plate 7¼ ins:18cm.*

"Driving a Bear out of Sugar Canes" (D116)

A further illustration of this Spode Indian Sporting Series pattern on a drainer appears in FOB 33.

Du Croz, John C. (D117-118)

A second armorial pattern bearing a Du Croz retailer's mark is illustrated here. In this case it is printed with an unidentified crest, and although it would appear to be from the same factory as the Salters' Company plate illustrated in D320, the printed mark consists only of the retailer's name and address without the Hicks, Meigh & Johnson Royal arms mark (ascribed to Hicks & Meigh in error in the caption on D118).

Another mark of this retailer has been noted on plates made by John & William Ridgway.

See: "Sal Sapit Omnia".

"Dumfries" (New)

Herculaneum. Cherub Medallion Border Series. Vegetable dish.

Dumfries, sometimes referred to as "Queen of the South", is a Royal and parliamentary burgh on the banks of the River Nith. It has a long history but is celebrated the world over for its connections with Robert Burns, the poet, who moved to Dumfries with his family in 1791 and became an excise officer. He died there in 1796 and was buried in St. Michael's churchyard. Midsteeple, in the High Street, was once the courthouse where Effie Dean was tried, an event described in Walter Scott's *The Heart of Midlothian* (1818).

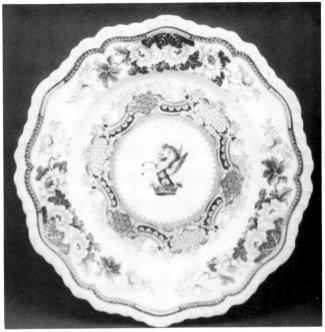

Du Croz. Unidentified crest. Maker unknown. Printed retailer's mark "Du Croz / Skinner Street London". Plate 10½ins:27cm.

Du Croz. *Printed retailer's mark on plate.*

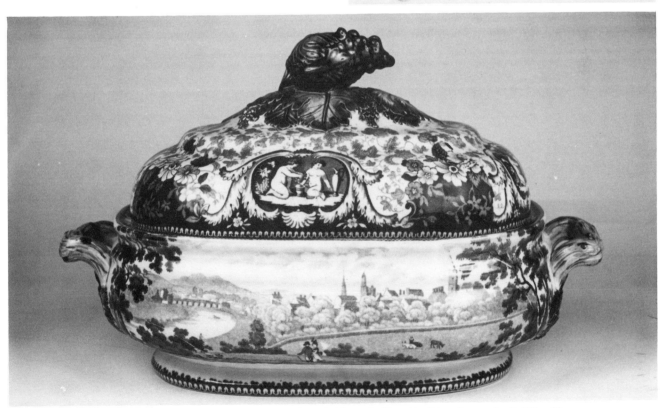

"Dumfries". *Herculaneum. Cherub Medallion Border Series. Printed title mark. Vegetable dish and cover, length 13ins:33cm.*

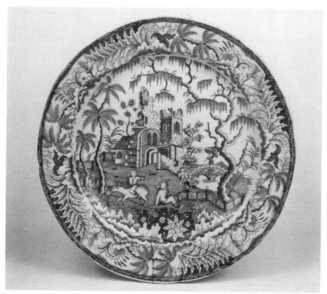

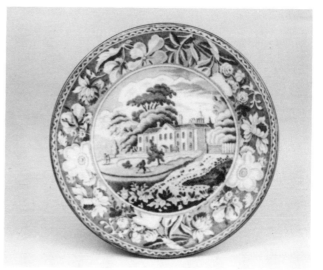

Dunderdale, David (& Co). *Ruins pattern. Impressed "D.D. & Co. / CASTLEFORD / POTTERY". Plate 9¼ ins:24cm.*

Dunderdale, David (& Co). *Unidentified view. Impressed "D.D. & Co. / CASTLEFORD / POTTERY". Plate 6ins:15cm.*

Dunderdale, David (& Co.) (D118)

A detailed account of the Castleford Pottery operated by David Dunderdale & Co. can be found in Diana Edwards Roussel's book *The Castleford Pottery 1790-1821* (1982). Their most common printed design was a Buffalo and Ruins pattern, produced both in brown and blue. It is illustrated here together with a previously unrecorded country house scene.

Durham Ox Series (D119-120)

Maker unknown. An additional scene is:

(viii) A cowman with a stick tending a group of three cows and two calves. Dish 12½ ins:32cm and arcaded plate 7½ ins:19cm. Ill: FOB 52 and FOB 55.

The dish illustrated here with this scene bears a printed mark in the form of a leafy cartouche enclosing the name "WITHERS" (qv), the significance of which has not yet been established.

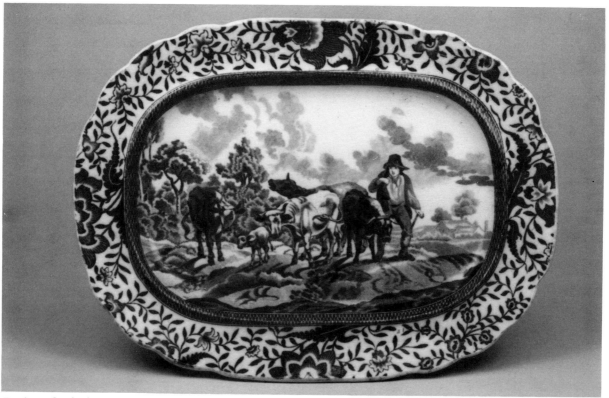

Durham Ox Series. *Maker unknown. Printed name "WITHERS" in a leafy frame. Dish 12½ ins:32cm.*

Eastern Port (New)

Ridgway. A pattern previously unattributed which shows an Eastern port scene within a floral border featuring several crowns flanked by thistles and roses. An unmarked plate is illustrated here but another example bearing the rare impressed lower case "Ridgway" mark has now been reported. The same border is also found on a pattern bearing the London motto "Domine Dirige Nos" (qv).

"Eaton Hall, Cheshire, Earl Grosvenor's Seat" (D121)

The dish from the Titled Seats Series by Careys is illustrated here.

"Edinburgh" (D121-122, 124)

The dish from the Cherub Medallion Border Series by Herculaneum is illustrated overleaf. The size should read 16½ ins:42cm.

Egg Cups (D125)

See: Snow Scenes.

Elephant (D125-126)

A version of the Elephant pattern by John Rogers & Son was made by the Plymouth Pottery. A teapot is illustrated by Norman Stretton in his article "Plymouth and its Potteries in the 19th Century", *Antique Collecting*, October 1982.

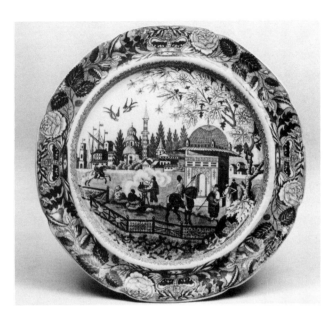

Eastern Port. *Possibly Ridgway. Unmarked. Plate 9¾ ins:25cm.*

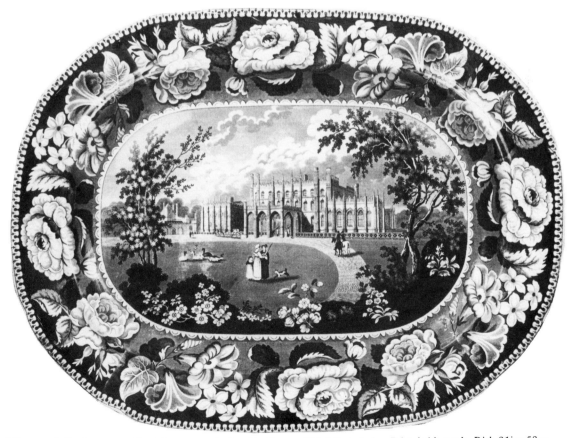

"Eaton Hall, Cheshire, Earl Grosvenor's Seat". *Careys. Titled Seats Series. Printed title mark. Dish 21ins:53cm.*

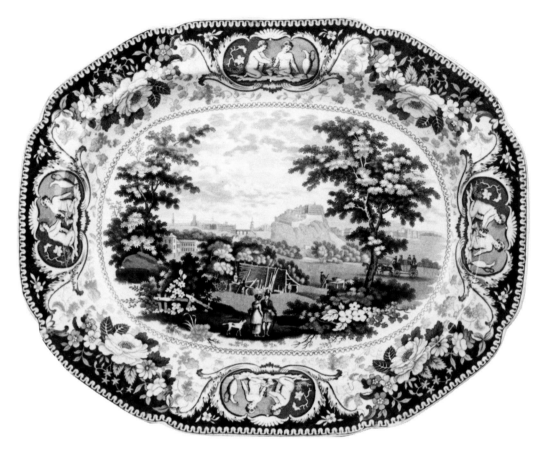

"Edinburgh". Herculaneum. Cherub Medallion Border Series. Printed title mark and impressed "HERCULANEUM". Dish 16½ ins:42cm.

Emmerson, A. (New)
This name appears let into the top of the border on a soup tureen stand printed with the view of "Valle Crucis Abbey, Wales" from the Pineapple Border Series (see Colour Plate XIII). There is no Emmerson with this initial in the London directories between 1815 and 1840, the period when this piece must have been made, and its significance is not yet known.

"Empress" (D127)
The potters probably adopted this title following the proclamation of Queen Victoria as Empress of India in 1876.

"The English Alphabet" (New)
Maker unknown. This title appears on the face of an unmarked mug printed beneath a complex monogram-like arrangement of all the letters of the alphabet (see Colour Plate XII). The inner rim is printed with a chinoiserie-type border, and the mug would appear to date from the early years of the 19th century. It was presumably intended as an educational puzzle.

"English Scenery" (D129)
Two further views have been identified in this series by an unknown maker. The well-and-tree dish illustrated opposite shows Windsor Castle, and although the view on the outside of the sauce tureen remains unidentified, the interior is printed with a view of Faulkbourn Hall in Essex.

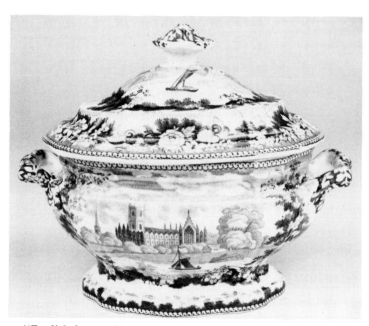

"English Scenery". Maker unknown. Unidentified view (but with Faulkbourn Hall inside). Printed series title mark. Sauce tureen and cover, length 7¼ ins:18cm.

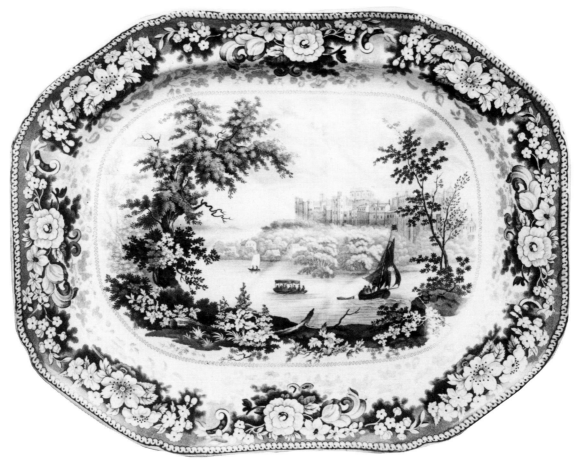

"**English Scenery**". *Maker unknown. View identified as Windsor Castle in Berkshire. Printed series title mark. Well-and-tree dish 20½ ins:52cm.*

English Sprays (D129)
This Spode floral pattern is catalogued by Drakard & Holdway as P815 and illustrated by them on a teacup and saucer in S152. It is also illustrated in Whiter 44.

"Entrance to the Liverpool & Manchester Railway"
(D129)
This commemorative design by an unknown maker was printed on both mugs and jugs in blue, black and purple, and also on a flower pot in blue. It shows the famous tunnel entrance and an early train, and would have been issued when the railway was opened in 1830. Ill: May 243; FOB 33.

"Eon" (New)
George Wooliscroft. A series of romantic-style patterns showing windmills in rural landscapes. Examples bear a printed registration mark for 10th February 1853, together with the name "IRONSTONE", the title "EON", and the maker's name in full. The patterns were also printed in a combination of colours such as mulberry and blue. Ill: P. Williams p.257; Williams & Weber p.577.

An eon, or aeon, is an age of the universe, or an immeasurable period of time, or eternity. It would be a strange title and it is possible that the pattern was named after Éon de Beaumont (1728-1810) who was employed by Louis XV on diplomatic missions in Russia, Austria and England. He dressed as a woman on his first mission and lived as a woman when he returned to France. He visited England for a second time in 1785 and lived there permanently after the French revolution until his death in London in 1810, when the moot question of his male sex was settled by a post-mortem examination. *Memoirs* bearing his name were published in 1837 and attracted a good deal of public interest and gossip, but were later proved not to be genuine.

"Erica" (New)
Davenport. A typical romantic scene printed within an open tendril border with floral reserves. Ill: Copeland 2 p.24 and Williams & Weber p.99.

Erica is the shortened generic name for over 500 evergreen shrubs with bell-shaped flowers, the British species including heathers and heaths.

"Ermine Border" (New)
Maker unknown. A floral pattern with the title printed within a typical floral cartouche, noted with an impressed trade name "OPAQUE PORCELAIN" in an octagonal frame. This mark is often attributed to Charles Meigh & Son but it may have been used by other potters.

The ermine is an animal of the weasel family whose coat is brown in summer and white in winter. It is one of the most valued furs, widely used in heraldry and particularly for the robes of judges and peers. It is also a symbol of purity.

"Etruscan". *Elkin, Knight & Bridgwood. Two views of a pierced lid. Unmarked. Diameter 5½ ins:14cm.*

Eskimo (New)
See: Snow Scenes.

"Eton College" (D130)
Other potters who used this pattern include Joseph Twigg of Swinton, Thomas Nicholson of Castleford, Stephen & James Chappell of Leeds, Sydney Woolf and Poulson Brothers, both of Ferrybridge, and also an unidentified factory with initials F.R. & Co.

"Etruscan" (D130-131)
This series of classical figure patterns is usually marked with a printed title cartouche containing the initials E.K.B. for Elkin, Knight & Bridgwood, but one example noted on a wash bowl bears the initials K.E. & Co. for Knight, Elkin & Co. There was overlap between these various Elkin partnerships, but the forms starting with Elkin are believed to be earlier.

An interesting pierced lid illustrated here is shown with one of the patterns printed on both sides. Its function is obscure, but it may have been an inner cover from a pot-pourri vase.
See: Classical Figure Patterns.

"Etruscan Vase" (D131)
Another pattern with this title by an unknown maker, consisting of an idealised vase amongst scattered feathery sprigs, is marked with a cartouche featuring a beehive amongst flowers. Ill: Williams & Weber p.63.

Europa (D132)
The figures in the foreground of the Europa pattern by John & Richard Riley are now known to have been copied from Claude's painting of the same title, now in the Royal collection. A marked Riley plate and an early engraving of the picture are illustrated here, together with details showing just the figures.

Europa. *Detail of figures from plate.*

Europa. *Detail of figures from print.*

Europa. *John & Richard Riley. Printed garter mark with "RILEY'S / Semi China". Plate 10ins:25cm.*

Europa. *Source print engraving of Claude's painting, now in the Royal collection.*

"Ex Fumo Dare Lucem" (New)

A motto which has no exact translation but approximates to From smoke gives light. It appears on an armorial soup plate with a Mintons date mark for 1897 which is illustrated here. The owner of the motto and coat-of-arms has not yet been identified, but the main shield itself is the same as that used by Baronet Kemp of Norfolk, whose motto was Lucem Spero, meaning I hope for light. In view of the similarity of mottoes, it seems possible that this plate was made for another branch of the Kemp family.

See: Armorial Wares.

"EYAOPIA" (New)

This word appears engraved on a pennant within an unusual heraldic border on a plate made by the Don Pottery (see detail here, and also Colour Plate II). It is probably intended to represent a Greek name, in which case the P could be the Greek capital letter gamma, but it does not appear to translate to anything that can be recognised and its significance is not yet known. Ill: Little 102.

Eye Bath (D132)

An eye bath printed with segments from the standard Willow pattern is illustrated in Colour Plate XVII.

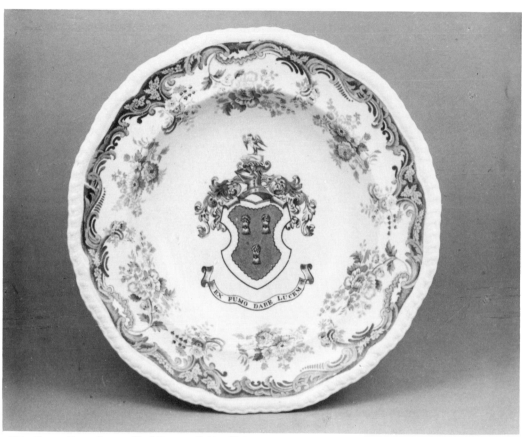

"Ex Fumo Dare Lucem". Mintons. Unidentified coat-of-arms. Printed maker's globe mark and impressed marks "MINTONS", "Rd. No. 267588" and date mark for 1897. Soup plate 10¼ ins:26cm.

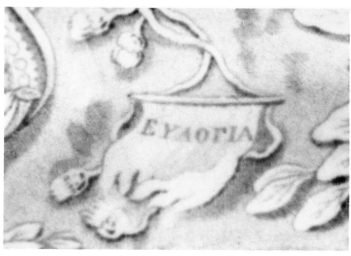

"EYAOPIA". Detail from border of Don Pottery plate in Colour Plate II.

Faience Wares. *Maker unknown. Unmarked. Jug 5 ¾ ins:15cm.*

Faience Wares (New)

Blue-printed wares are sometimes found with a thick tin glaze covering a red clay body, similar to the faience wares of France and Italy. The body is revealed when the wares are worn or chipped. Such wares were probably produced by continental potters, certainly by David Johnston & Co. of Bordeaux, and his successors Jules Vieillard & Cie.

"Fairy Villas" (D133)

One example of this pattern has been reported bearing a very clear impressed mark "MEIR & SON" and this must throw doubt on the previous attribution to Maddock & Seddon which was based on the initials M. & S. in the printed mark.

Falis Blue (New)

Almost certainly the name of an experimental printing ink
See: Returning Woodman.

"Faulkbourn Hall" (D134)

The plate from the Rose Border Series by Andrew Stevenson is illustrated here together with the source print taken from Grey's *The Excursions Through Essex*.

An untitled view has also been noted printed inside a sauce tureen in the series titled "English Scenery" (qv).

"February" (New)

See: "Seasons"; Seasons Series.

Fence (D135)

This Spode chinoiserie pattern is catalogued by Drakard & Holdway as P809. It is also illustrated in Copeland pp.137-139; Coysh 2 97; Drakard & Holdway S144; Whiter 38; S.B. Williams 132-133.

Ferrybridge Pottery (D136)

Subsequent proprietors of this factory were:
Lewis Woolf & Son 1856-1883
Poulson Bros. (Ltd.) 1884-1895

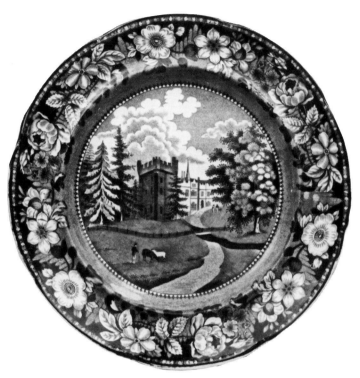

"Faulkbourn Hall". *Andrew Stevenson. Rose Border Series. Printed title mark and impressed maker's circular crown mark. Plate 10 ¼ ins:26cm.*

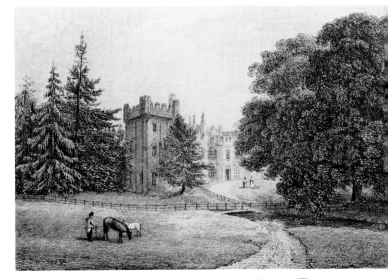

"Faulkbourn Hall". *Source print taken from Grey's "The Excursions Through Essex".*

Colour Plate XII. "The English Alphabet". *Maker unknown. Unmarked. Mug 3¾ins:10cm.*

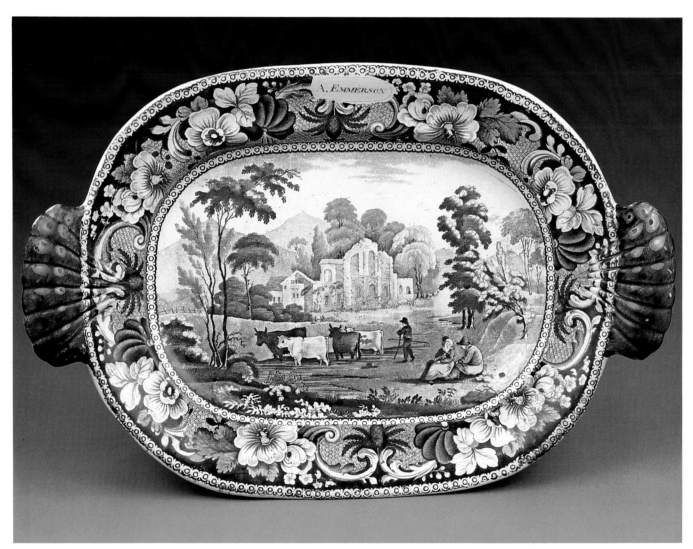

Colour Plate XIII. Emmerson. *Maker unknown. Pineapple Border Series. Printed title mark with name of view "VALLE CRUCIS ABBEY, WALES" and reserve with name "A. EMMERSON" in border. Soup tureen stand, length 16¼ins:41cm.*

"Fibre" (New)

Maker unknown. A simple pattern of fern or seaweed-like sprays noted on children's tea wares. The title appears in script within a printed cartouche mark.

Filigree (D136)

This Spode floral pattern is catalogued by Drakard & Holdway as P818 and illustrated by them on a range of different shapes. It is also illustrated in Coysh 1 121; Whiter 47; S.B. Williams 142. Another example of the pattern has been noted with an impressed monogram normally ascribed to Thomas Dimmock & Co.

Fisherman Series (D137-138)

Davenport. Additional scenes include:

Fisherman and Woman with Basket. Dinner plate.
Resting Fisherman and Friend with Package on Head. Dessert plate.
Fisherman, Old Man with Stick, and Fence. Plate 5½ ins:14cm.
Seated Fisherman, Man with Stick, Boat on River. Well-and-tree dish.

The last of these has the same foreground as the pattern listed in the *Dictionary* as Fisherman's Advice, but the background is notably different.

Documentary evidence has survived to show that this series was in production by 1812, when a dinner service was purchased by Richard Beech of Eccleshall, Staffordshire, to celebrate the christening of his daughter Mary. Some of the service is still owned by the family but the major part, consisting of 161 pieces, was sold at auction in 1935. A selection of pieces was illustrated in an article by Geoffrey Masefield in *Country Life*, 6th October 1961, including a supper set and a pierced dessert basket in addition to dinner wares. The sale catalogue listed the following pieces:

"42 dinner plates, 12 soup, 15 supper, 35 muffins, 22 dishes, 2 soup tureens, one stand and ladle, 6 sauce boats and stands with 5 ladles, centre dish, cheese stand, 4 square dishes and covers, steak dish, 7 baking dishes, 3 baskets and stands, salad, 2 trifle dishes, 6 sandwich dishes, comport, gravy boat".

There would probably have been well over 200 pieces when the service was new. It is interesting to note the mixture of dinner and dessert wares, and also the inclusion of a cheese stand, which would probably be a circular footed stand about 12 ins. in diameter rather than a boat-shaped cheese coaster. These stands are often described as cake stands today.

"Fishers" (D138)

These miniature dinner wares by Cork, Edge & Malkin were also printed in dark green. Ill: Milbourn 147.

Fitzhugh (D138)

This is an alternative name for one of the Spode patterns which are catalogued by Drakard & Holdway as Trophies (qv).

Flacket & Toft (New) **fl.c.1857**

Church Street, Longton, Staffordshire. A partnership about which few details are recorded. They were succeeded in 1857 by Flacket, Toft & Robinson, who appear to have survived for no more than a year. A pattern titled "Chian" has been noted with the initials F. & T.

Fleur-de-lys (New)

An interesting printed mark in the form of a fleur-de-lys is known on a plate with the pattern usually titled "Scotch View" (qv).

"Flora" (D139)

Two other potters used this title:

(iii) John Rogers & Son. A floral pattern noted on a large dish.

(iv) Maker unknown. An all-over pattern with sprays of flowers and butterflies, noted on gadrooned wares.

Flora was the goddess of the flowers and of the springtime.

"Flora Pattern" (New)

Maker unknown. A flamboyant still-life design featuring flowers and fruit with a vase on a pedestal, noted on dinner wares. The pattern covers the entire face of the plates except for a narrow outer band of scrolling. The title appears printed on a ribbon cartouche, illustrated here together with an impressed crown flanked by the initials G.R. This crown mark has recently been noted on wares known to have been produced by John Meir, but it would be premature to make a firm attribution.

See: Crown.

"Flora Pattern". Maker unknown. Printed title ribbon cartouche and impressed crown with initials G.R. Plate 9¾ ins:25cm.

"Flora Pattern". Printed cartouche and impressed crown mark.

"Floral" (D139)

Four centres from the Spode series of floral patterns are catalogued by Drakard & Holloway as P901-1 to P901-4 and another one is illustrated by them on a sauce tureen in S102. Examples are also illustrated in Whiter 48 and 95; P. Williams p.39.

"Floral Scroll" (New)

Maker unknown with initials W. & B. A floral pattern thought to be too early for the initials to relate to Wood & Brownfield. The initials could also have been used by Wood & Brettel, Wood & Baggaley, and Wood & Bowers.

"Floral Sketches" (New)

Brameld. A pattern with a floral pedestal in a landscape setting surrounded by hanging flower baskets. A printed cartouche sometimes appears which has the title and the trade name "GRANITE CHINA" surrounding a small basket of flowers. Ill: Cox 41 (and Mark 59).

"Florence" (D139)

The pattern by William Adams & Sons is a romantic scene featuring an ornate ferry boat on a lake or river and a large three storey building with towers in the background. The border is of mossy sprigs and a floral scroll cartouche contains the title "FLORENCE" with the makers' name in full, "W. ADAMS & SONS", above. Ill: Williams & Weber p.178-179.

"Florentine China" (New)

A trade name often encountered as part of a printed cartouche in the form of a beehive on a pedestal surrounded by flowers, with a pattern title above. This mark is believed to belong to Samuel Alcock & Co. It has been recorded on wares printed in various colours, including patterns titled "Abbeville", "Blenheim", "Forest", "Manilla" (sic), "Maryland", "Pearl", "Royal Star", and "Toronto".

Flower Cross (D140)

This Spode floral pattern is catalogued by Drakard & Holloway as P804. It is also illustrated in Coysh 1 159; Drakard & Holloway S120 and S190; Whiter 34.

Flowers and Leaves Border Series (D141)

William Adams. One previously recorded view is illustrated in this volume:
"Gracefield, Queen's County, Ireland" *
Additional views are:
"Beckenham Place, Kent" *
"Polesden, Surrey"
"Warleigh House, Somersetshire" *

Flying Pennant (D142)

This Spode chinoiserie pattern is catalogued by Drakard & Holloway as P610. It is also illustrated in Copeland pp.90-91; Whiter 13; S.B. Williams 104.

"Foliage" (D142)

This design by an unknown maker is a sheet pattern and has been noted on London shape tewares, marked with the title in script within an oval cartouche.

Foliage and Scroll Border Series. *William Adams. Unidentified view. Impressed maker's eagle mark. Plate 10¼ ins:26cm.*

Foliage Border Series (D142)

Maker unknown. Previously recorded views illustrated in this volume are:
"Holme Pierrepont, Nottinghamshire" *
"Wistow Hall, Leicestershire" *

Foliage and Scroll Border Series (D142)

William Adams. One of the unidentified views from this series is illustrated here.

"Font" (New)

Edward Challinor. Another version of Spode's Girl at the Well design, marked in this case with a ribbon cartouche bearing the single word "FONT" together with the maker's initials E.C. The title Font has also been used for the original Spode pattern which is catalogued by Drakard & Holloway as Girl at the Well (qv). See also "The Font" (D144).

"Fonthill Abbey, Wiltshire" (D144)

There is a sixth view with this title:
(vi) Maker unknown. "Antique Scenery" Series. This view is known to exist only by virtue of an incorrect title mark noted on a small dished plate, actually printed with the view of "Wingfield Castle, Suffolk".

Foot Bath (D144)

An early straight-sided foot bath printed with a design from Wedgwood's Blue Rose Border Series is illustrated here. The view shows the Thames and the Tower of London (qv).

Ford, John, & Co. (New) fl.c.1891-1926

A retailer's mark for "John Ford & Co., China & Glass Showrooms, 39 Princes Street, Edinburgh" has been reported on a small plate printed with a "Humphrey's Clock" pattern. These toy wares are later reproductions, using patterns originally introduced by William Ridgway in about 1840.

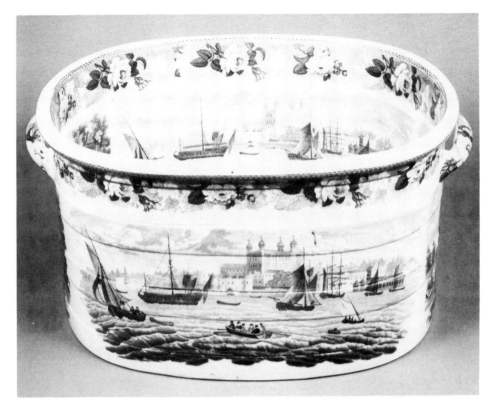

Foot Bath. *View of the Tower of London.*
Wedgwood. Blue Rose Border Series.
Impressed "WEDGWOOD".
Length 17½ ins:44cm.

"Forest" (New)

John Allason. A simple design of tree branches recorded on teawares with the title "FOREST" printed in a cartouche formed by two branches. A cup and saucer with the impressed mark "JOHN ALLASON / SEAHAM POTTERY" are illustrated by J.T. Shaw (ed.) in *Sunderland Ware: The Potteries of Wearside* (1973), figure 35, and by John C. Baker in *Sunderland Pottery* (1984), figure 43. The same design was printed in other colours by Samuel Alcock and by Joseph Clementson.

Forest Landscape (D144)

Three variants of this Spode chinoiserie pattern are catalogued by Drakard & Holdway as P607-1, P607-2, and P607-3, and a sauce tureen with the Forest Landscape Second pattern is illustrated here. Other examples can be seen in Copeland pp.82-84; Drakard & Holdway S105 and S191; Whiter 7 and 8; S.B. Williams 106.

Forrest, C.R. (New)

Forrest was a Lieutenant-Colonel who served in India, and on his return published *A Picturesque Tour Along the Rivers Ganges and Jumna in India* (1824). The aquatints in the book were engraved by G. Hunt and T. Sutherland, and were copied by the Godwins for their Indian Scenery Series, by both makers of the two "Oriental Scenery" Series, and by the maker of the Parrot Border Series.

"Fort of Allahabad" (D145)

The size of the plate in the "Oriental Scenery" Series by an unknown maker is 8½ ins:22cm. Some references list the title in error as "Fort at Allahabad". Ill: FOB 47.

Forest Landscape. *Spode. Printed "SPODE". Sauce tureen and cover, length 7¼ ins:18cm.*

"Fortiter Defendit Triumphans" (D145)

A plate with the coat-of-arms of Newcastle-upon-Tyne has been reported with the mark of Copeland & Garrett, who presumably made some replacements for the earlier Spode service.

"Fortuna Sequatur Ne Nimium" (sic) (New)

Let fortune follow, not too much. A composite motto formed from the two mottoes used by the Gordon and Hamilton-Gordon families, the first as the Earls of Aberdeen.

A blue-printed plate with an impressed Spode mark has been recorded with the crest of the Earls of Aberdeen surrounded by concentric circles containing these two mottoes, all within a sheet tendril pattern. This is not a known Spode design, and it may have been copied by Spode to match existing wares. Ill: FOB 39.

Fortune Teller. *Maker unknown. Impressed crown with initials G.R. Soup plate 10ins:25cm.*

Fortune Teller (New)

An adopted title used for a genre scene by an unknown maker which is printed within a floral border and shows an older woman, apparently telling fortunes by reading the palms of two younger women. An alternative interpretation is that the older woman is begging, and the title Beggar Woman has also been suggested.

The pattern is illustrated here on a soup plate which is marked with an impressed crown flanked by the initials G.R. This crown mark has recently been noted on wares known to have been produced by John Meir, but it would be premature to make a firm attribution.

See: Crown.

"Fountain of Elisha at Jericho" (New)

Thomas Mayer. "Illustrations of the Bible" Series. Plate 9½ins:24cm.

"No one who has visited the site of Jericho can forget how prominent a feature are the two perennial springs which rise at the base of the steep hills of Quarantania behind the town. One of the springs was noxious at the time of Elisha's visit. At the request of the men of Jericho he remedied this evil. He took salt in a new vessel, and cast it into the water at its source in the name of Jehovah. From the time of Josephus to the present, the tradition of the cure has been attached to the large spring north-west of the present town" (Smith's *Dictionary of the Bible*, 1865).

This book also points out that the "fountain of living water" distinguishes a spring from the "artificially sunk and enclosed well".

"Fountain Scenery" (D145)

One other potter used this title:

(iii) Samuel Alcock & Co. A flow blue romantic scene marked with the title "Fountain Scenery" in script in a cartouche with the makers' name and address "S. ALCOCK & Cᴼ. / HILL POTTERY BURSLEM" beneath. Ill: Williams & Weber p.183.

"The Fox and the Grapes" (New)

Spode/Copeland & Garrett. "Aesop's Fables" Series. Custard cup. Ill: Sussman, *Spode/Copeland Transfer-Printed Patterns*, p.23.

The Copeland & Garrett custard cup illustrated here is not titled, and no title mark has yet been recorded for this scene.

A hungry fox tried to reach some grapes on a vine, but they were too high. "Let who take them" says he, "they are but green and sour".

Sour grapes.

"The Fox and the Grapes". *Copeland & Garrett. "Aesop's Fables" Series. Printed makers' mark (no title). Custard cup, height 2½ins:6cm.*

"Franklin's Morals" Series (D147)

Davenport. An additional moral is:

"If You Would Know the Value of Money, Try to Borrow Some."

It is sometimes assumed that Franklin was the author of these morals but many of them were widely used earlier. "Many a little makes a mickle", for example, was used by Camden in 1605 and in the *Spectator* of 1712, when Franklin was only six years of age. His "morals" are, in fact, simply a collection.

Freemasonry (D147-148)

The building illustrated under this title (D148) may well be the Freemasons' Charity for Female Children, instituted in St. George's Fields in 1788. Leigh's *New Picture of London* (1818) describes its purpose as "to clothe, maintain, and educate the female children and orphans of indigent ancient freemasons".

French Birds (New)

An adopted title for a rare Spode pattern featuring two birds, printed within a floral border in either blue or pink. It is illustrated here on a miniature plate and catalogued by Drakard & Holdway as P718. They also show it on a tazza in S110.

"Fruit Basket" (D148)

This design by William Smith & Co. was also printed entirely in blue, and in sepia or green.

Fruit and Flower Border Series (D149)

Henshall & Co. One previously recorded view is illustrated in this volume:

"Saxham Hall" *

The view of "Compton Verney" can be seen on the dish illustrated in Colour Plate II of the *Dictionary* which appears to have been marked "British Views" in error.

Fruit and Flowers (D149)

The Spode floral pattern known by this adopted title is catalogued by Drakard & Holdway as P817. It is also illustrated in Drakard & Holdway S139 and S153; Whiter 46.

"Fuchsia" (New)

Minton & Co. A simple pattern with a central fuchsia spray and two narrow borders of trailing fuchsias. The title appears in script within a printed floral cartouche mark which also includes "No." (with no actual number given), and the makers' initials M. & Co. in script at the base.

French Birds. *Spode. Printed and impressed "SPODE". Plate 4¼ins:11cm.*

"Fulham Church, Middlesex" (D149)

This view would appear to show the four-storey tower of the Parish Church of All Saints, built in the 14th century.

"Furness Abbey, Lancashire" (D149)

The untitled view by William Mason is based on a print taken from Britton and Brayley's *The Beauties of England and Wales*. It is illustrated here along with an unmarked dish. A soup tureen with this view inside but unidentified views outside and on the lid is illustrated in FOB 48.

Furnival, Jacob & Thomas (New) fl.c.1843

Miles Bank, Hanley, Staffordshire. A very short-lived partnership which was succeeded by Thomas Furnival & Co. (see next entry). They used their initials J. & T.F. printed below a Royal arms mark, and are known to have produced flow blue dinner wares.

Furnival, Thomas, & Co. (New) fl.c.1844-1846

Miles Bank, Hanley, Staffordshire. A short-lived partnership which succeeded Jacob & Thomas Furnival in c.1844 and was in turn succeeded by Furnival & Clark, who traded until 1851. Printed wares marked with the initials T.F. & Co. are known but similar initials were also used by Thomas Fell & Co. of Newcastle-upon-Tyne, and it is not always easy to attribute wares without further evidence. See, for example, the pattern "Chinese Sports".

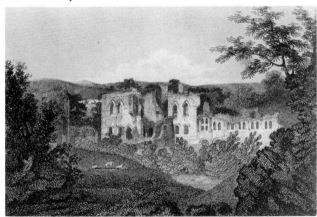

"Furness Abbey, Lancashire". *Source print used by William Mason taken from Britton and Brayley's "The Beauties of England and Wales".*

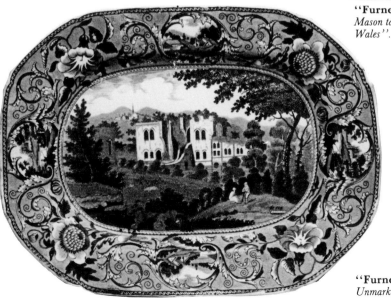

"Furness Abbey, Lancashire". *Attributed to William Mason. Unmarked. Dish 12ins:31cm.*

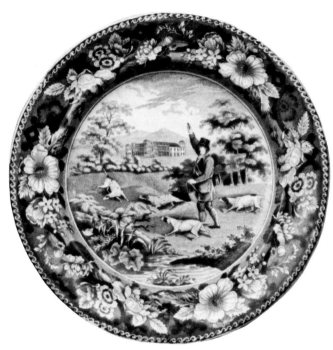

"**Game Keeper**". *Maker unknown. Printed title mark in the form of a buckled belt. Plate 9¾ins:25cm.*

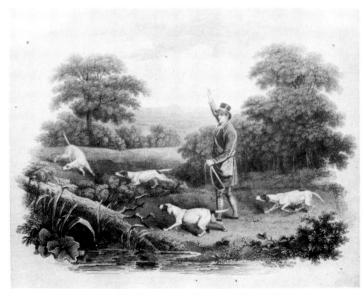

"**Game Keeper**". *Source print after a painting by J. Landseer.*

"Game Keeper" (D150)

This view by an unknown maker is now known to be copied from a print which appeared in a book of rural sports by the Reverend W.B. Daniel published in three volumes between 1805 and 1812. The picture was drawn by J. Landseer and engraved by H.B. Chalon, and the print is dated 4th June 1812. The pottery engraver has added a view of Goodwood House in Sussex to fill a space in the middle distance.

Goodwood House is on the southern slopes of the chalk downs, north-east of Chichester. It was built for the Duke of Richmond by James Wyatt between 1790 and 1800. It is perhaps best known today for the racecourse, laid out in 1802.

"Garden Scenery" (New)

T.J. & J. Mayer. A series of different romantic scenes printed in light blue within a border of regularly spaced leaf sprigs on a patterned ground. The title is printed beneath an armorial crest, with the makers' name and address below. Ill: P. Williams p.268; Williams & Weber p.583.

Garden Seat (New)

Pottery garden seats, following the basic design of Chinese originals, were made in earthenware decorated with transfer prints in blue, but examples are rare. A Spode garden seat printed with a combination of the Group, Gothic Castle, and Lattice Scroll patterns is shown in Whiter 100, and two further examples are illustrated by Drakard & Holdway; one with the Italian pattern (S212) and the other with two different Caramanian Series scenes (Plate XIV). All three of these Spode seats are the same height, 19ins:48cm; presumably only one size was produced. One other seat by an unknown maker has been noted.

"Gardiner" (New)

See: "Assher Dure".

"Gateway & Tomb at Secundra" (New)

Maker unknown. Parrot Border Series. Dish 19ins:48cm and well-and-tree dish 21ins:53cm. Ill: FOB 47.

This is the correct title for the entry which appeared in error in the *Dictionary* as "Gateway & Tomb of Secundra".

"Gateway & Tomb of Secundra" (D151)

See previous entry.

Gazebo (D151)

The pattern known by collectors under the title Gazebo has now been identified as a view of Wiseton Hall, Nottinghamshire (qv). Ill: Coysh 2 66.

"Gem" (New)

(i) Samuel Barker & Son. Typical romantic patterns printed in light blue within a border of bell-flower sprays. Ill: P. Williams p.269; Williams & Weber p.584.

(ii) John Carr & Sons. A romantic scene printed in light blue on dinner wares, titled within a Royal arms printed mark which includes the makers' name. Ill: R. C. Bell, *Maling and other Tyneside Pottery*, p.25.

"Geneva" (D151)

Two other potters used this title:

(ii) John King Knight. A typical romantic design printed on dinner wares. The printed cartouche mark includes the title "GENEVA" and the maker's initials J.K.K. One example has been noted with an impressed mark of a shield with lion and unicorn supporters, bearing the inscription "OPAQUE GRANITE CHINA" and indistinct initials which appear to be W.R. & Co. It is possible that Knight bought some wares in the white from William Ridgway & Co. and printed them himself, a practice which was not uncommon in the Potteries.

(iii) John Wedg Wood. A series of romantic scenes printed in light blue within a border of dark flower sprays and light flowery scrolls on a ground of concentric circles. Ill: P. Williams p.272; Williams & Weber p.585.

"Genevese" (D151)

This Minton design was continued by their successors and examples are known with the cursive initials M. & B. for Minton & Boyle. It was also used by Reed, Taylor & Co.

The Gentle Shepherd (New)

A jug by Watson & Co. of Prestonpans illustrated in Godden BP 320 bears a scene from Allan Ramsay's *The Gentle Shepherd* (1725) with a four line quotation from Act II, Scene III on the rim. See: *Scottish Pottery Historical Review*, No.5, 1980, pp.28-29.

George III (D151)

George III is featured on two different plates from a series of commemorative designs which have small central portraits within wide borders with prominent rose, thistle and shamrock. Ill: May 51.

See: Commemorative Series.

Geranium (D152)

This Spode floral pattern, which was produced with two alternative central flower sprays depending on the shape of each article, is catalogued by Drakard & Holloway as P821 and shown by them on a range of different items. The pattern is also illustrated in Whiter 51; S.B. Williams 139-140.

"Ghaut of Cutwa" (D152)

The plate from the "Oriental Scenery" Series by John Hall & Sons is illustrated here.

Gibson, Thomas (New)

A miniature plate is illustrated here with the border from the standard Willow pattern but with the central inscription:

THOMAS GIBSON
WHOLESALE & RETAIL GLASS CHINA
AND
EARTHENWARE MERCHANT
WAREHOUSE & SHOW ROOM
49 CHAPEL STREET
SOUTHPORT

This was almost certainly intended for use as an advertising give-away. Several other similar small plates are known.

The maker of this plate is unknown but Gibson had some similar items made by W.T. Copeland & Sons, an entry in a record book which survives at the Spode factory noting that the design was engraved on 24th February 1882. The Copeland wording is similar but the address is 35 Chapel Street, and an advertisement for Thomas Gibson with wording almost identical to the above, also with the address 35 Chapel Street, appeared in the *Southport Trades Director* for 1894.

See: Trade Card.

"Ghaut of Cutwa". John Hall & Sons. "Oriental Scenery" Series. Printed titles mark with makers' name. Plate 8¾ ins: 22cm.

Gibson, Thomas. Maker unknown. Unmarked. Miniature advertising plate 3ins: 8cm.

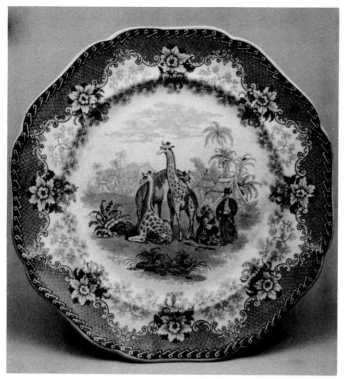

"**Giraffe**". *John Ridgway. Printed title and maker's mark with date of publication. Plate 10ins:25cm.*

"**Giraffe**". *John Ridgway. Printed publication mark.*

"Giraffe" (D152)

This pattern by John Ridgway is illustrated here, together with the printed publication mark dated 30th August 1836. It was also printed in sepia, and a slightly simplified version has been noted on an unmarked miniature plate.

Giraffe and Camel Willow Pattern (D154)

A plate in this pattern has been recorded with the mark of the Dublin merchant James Donovan, but no maker has yet been identified.

Girl Holding a Parrot (New)

This title was first used for a pattern described by Pamela D. Kingsbury in an article on "Enoch Wood Earthenware Found in St. Paul's Church, Burslem", reprinted by P. Atterbury in *English Pottery and Porcelain*. The pattern was illustrated on a red printed saucer but it has also been recorded printed in blue on marked teawares made by Samuel Moore & Co. of Sunderland. The two firms could have used the same, as yet unidentified, source print, but Moore probably copied the Wood pattern.

Girl Musician (D154)

The figures and the group of cows in the foreground of this pattern by John & Richard Riley are now known to have been taken from a Claude painting of "Landscape with Shepherds".

Girl at the Well (D153-154)

Another potter used this design:

(vi) Edward Challinor. Printed ribbon cartouche bearing the single word "FONT" together with the maker's initials E.C.

The original Spode pattern, sometimes also called Font, was continued by their successors Copeland & Garrett, and is catalogued by Drakard & Holdway as P701. It is also illustrated in Coysh 1 116; Drakard & Holdway S111, S170, and S208: Whiter 59; S.B. Williams 160.

"Give Thanks to God" (New)

A motto on an armorial plate by an unknown maker (see Colour Plate XIV). The owner of these arms has not yet been identified but the crest depicts St. Lawrence holding a gridiron, and gridirons also appear on the central shield.

St. Lawrence is said to have been born at Huesca in Spain and became a deacon at Rome. During the persecution of Valerian in about AD 258, being called on to deliver up the treasures of the church, he produced the poor and the sick. Following persistent refusals to co-operate, he was condemned to be broiled on a gridiron. The meteorites which often appear about the time of his festival on 10th August are popularly known as the tears of St. Lawrence.

See: Armorial Wares.

Glamorgan Pottery (New)

See: Swansea's Glamorgan Pottery (qv and D355).

Gloucester (D155)

This Spode floral pattern is catalogued by Drakard & Holdway as P811. It is also illustrated in Copeland p.148-151; Whiter 40.

"Gloucester Cathedral" (D155)

The dish from the Bluebell Border Series by James & Ralph Clews is illustrated here.

"Goat" (D156)

A saucer with the design by John & Robert Godwin is illustrated here.

"God is Our Strength" (D156)

A Minton dinner plate bearing the coat-of-arms of the Ironmongers' Company, including this motto, has been noted with a printed mark including the name "BIRKETT". Members of the Birkett family were Masters of the Company in 1871, 1892, 1911 and 1946.

A later dinner service was made for the Company by Mintons, but with the Master's name "GARDINER" and the alternative motto "Assher Dure" (qv).

"**Gloucester Cathedral**". *James & Ralph Clews. Bluebell Border Series. Printed title mark and impressed makers' crown mark. Dish 21½ ins:55cm.*

"**Goat**". *John & Robert Godwin. Printed title cartouche with makers' initials. Child's saucer 4½ ins:12cm.*

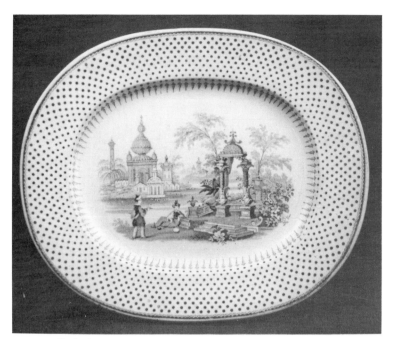

Godwin, John & Robert. *Untitled romantic-style pattern. Impressed initials ''B.B. / J. & R.G.'' Dish 10¼ ins:26cm.*

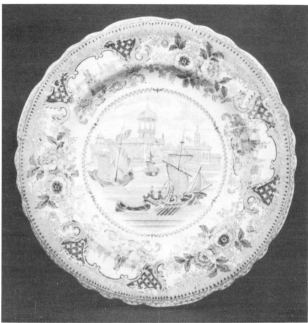

''Gondola''. *Maker unknown. Printed title in scroll frame. Plate 7½ ins:19cm.*

Godwin, John & Robert (D156)

As recorded in the *Dictionary*, the Godwin brothers produced very many printed toy tea services. One pattern titled ''Goat'' is illustrated overleaf, and others such as ''Fruit Girl'', ''Juvenile Sports'' and ''Peacock'' are also commonly found. Most of these wares were, however, usually printed in green or brown rather than blue.

Full size wares were also produced, and a dish is illustrated here with a simple romantic-style pattern which is not titled but marked only with impressed initials ''B.B. / J. & R.G.'' The initials B.B. were also often used by Minton to indicate ''Best Body'' wares.

''Going to Market'' (D158-159)

The engraving on which this pattern by J. & M.P. Bell & Co. was based is a copy of a painting by Sir Augustus Wall Callcott (qv), a popular artist who was knighted on the accession of Queen Victoria in 1837. The painting was in the collection of R. Vernon and was engraved in the *Art-Union*, March 1841, and also in the *Art Journal*, June 1850, under an alternative title of ''Crossing the Stream''.

''Gondola'' (D160)

Two plates from a dinner service by an unknown maker, both marked with this title, are illustrated here. They are printed with two different romantic harbour scenes featuring sailing boats against a background of Italianate buildings, neither of which is the same as the pattern previously listed by the Clyde Pottery Co. The floral border incorporates repeated C-scroll reserves containing a sculpture and three figures in front of some buildings. The title ''GONDOLA'' appears in a simple rectangular frame.

''Goodall's Yorkshire Relish'' (New)

See: ''Yorkshire Relish''.

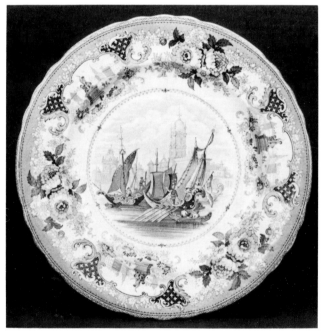

''Gondola''. *Maker unknown. Printed title in scroll frame. Plate 10½ ins:27cm.*

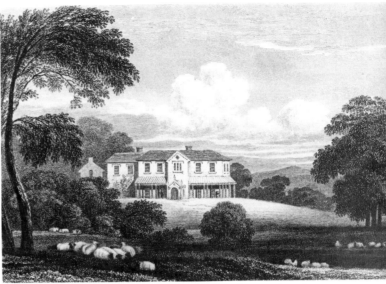

"**Gracefield, Queen's County, Ireland**". *Source print taken from John Preston Neale's "Views of the Seats of Noblemen and Gentlemen in England and Wales, Scotland and Ireland".*

"**Gracefield, Queen's County, Ireland**". *William Adams. Flowers and Leaves Border Series. Printed title mark and impressed maker's eagle mark. Plate 10 ¼ ins: 26cm.*

Goodfellow, Thomas (D160)

Details of the sale at Thomas Goodfellow's factory following his death in c.1860 have been reported by Rodney Hampson in NCS 65, pp.33-35. An auction notice in the *Staffordshire Advertiser* for 5th January 1861 offered, amongst other things, "the very valuable stock of engraved copper plates known as: Willow, Wildrose, Lucerne, Chaplet, Rural Scenery, Polish Star, Arcade, Basket, Grecian Temple, Tyrian, Formosa, Singan, Indian, Alleghany, Colonna, Moselle, Rhone, Marine, Broseley, Royal Persian".

Several of these patterns could have been printed in blue, but note that the wares themselves may not have borne title marks.

Of the names listed, Willow, Wildrose, and Broseley are all well known, and Rural Scenery probably refers to the series by Bathwell & Goodfellow, presumably inherited when that partnership ended. Of the remainder, only Colonna is listed in the *Dictionary* as a Goodfellow product, and 11 others have not yet been recorded printed in blue. Perhaps the most interesting is Royal Persian, a relatively distinctive title commonly found on a floral pattern, previously unattributed. It may possibly be a Thomas Goodfellow product.

Goodwood House, Sussex (New)

See: "Game Keeper".

"Gothic" (D160)

This general pattern title was used by several potters for a variety of printed patterns although many of them would have been in colours other than blue. Jacob Furnival & Co. are known to have made one such design with this title in flow blue, and another pattern with the same title has been noted on a flow blue miniature plate with a Davenport mark for 1844. This design can be seen on a tureen stand in Williams & Weber, p.188. A further romantic-style design with the

same title was made by Dixon of Sunderland. Ill: J.T. Shaw (ed.), *Sunderland Ware: The Potteries of Wearside* (1973), figure 28.

Gothic Castle (D161)

This Spode pattern is catalogued by Drakard & Holdway as P708. It is also illustrated in Coysh 1 158; Drakard & Holdway S158 and S188; Whiter 65 and 100; S.B. Williams 128-129.

"Gothic Ruins" (New)

Charles Meigh. A romantic scene of ruins within a border of scrolls and stylised flowers. The printed cartouche mark bears the title in script between columns with the maker's initials C.M. beneath.

"Gracefield, Queen's County, Ireland" (D161)

The plate from the Flowers and Leaves Border Series by William Adams is illustrated here together with the source print taken from John Preston Neale's *Views of the Seats of Noblemen and Gentlemen in England and Wales, Scotland and Ireland*.

Grapevine Border Series (D161-162)

Enoch Wood & Sons. Previously recorded views illustrated in this volume are:

"Armitage Park, Staffordshire" *
"Bickley, Kent" *
"City of Canterbury" *
"Dorney Court, Buckinghamshire" *
"Maxstoke Castle, Warwickshire" *
"Orielton, Pembrokeshire" (Colour Plate I)

Grasshopper (D162)

This Spode pattern is catalogued by Drakard & Holdway as P621. It is also illustrated in Copeland p.143; Coysh 1 110; Whiter 22; S.B. Williams 126-127.

Grazing Rabbits (D162)

An unmarked plate with this pattern is illustrated here but another plate has been reported with an underglaze blue-printed name Linan (qv). The same name has also been recorded impressed on a small chinoiserie pattern plate but its significance is not yet known.

Hugh Stretton has reported finding an unglazed shard of this pattern on the site of James Keeling's works at New Street, Hanley.

Grazing Rabbits. Maker unknown. Unmarked. Plate 9¾ ins:25cm.

"Grecian Figures" (New)

Probably Chetham & Robinson. A pattern recorded on teawares marked with the initials C. & R. These initials are not unique, they could have been used also by Chesworth & Robinson, but site excavations have proved their use by Chetham & Robinson on another design known as Parkland Scenery (D275).

"Grecian Gardens" (D162)

This title was used by Job & John Jackson for a series of very similar romantic-style patterns, marked with the title "GRECIAN GARDENS" and the makers' name "Jacksons Warranted" in script, sometimes in a floral cartouche. A further example is illustrated in Williams & Weber p.587.

"Grecian Scenery" (D162)

A third potter used this title:

(iii) Maker unknown. A series of romantic scenes, one illustrated here on a dinner plate, within an open floral border with two scenic reserves repeated three times. The title is printed in script in a scroll cartouche with "STONE CHINA" above. Other scenes are shown in P. Williams pp.286-287.

"Grecian Statue" (D162)

The romantic-style pattern attributed to Wood & Brownfield has been recorded within two different borders. Ill: Williams & Weber p.65.

"Grecian Vases" (New)

Maker unknown. A pattern noted on a plate with a large vase as the central motif. In view of the fact that the title is plural, and that the Royal arms mark encloses "No. 10", it would seem to be one of a series of similar patterns.

"Grecian Scenery". Maker unknown. Printed scroll cartouche containing title, with "STONE CHINA" above. Plate 10½ins:27cm.

Greek Patterns. *Maker unknown. Unmarked. Dish 20ins:51cm.*

Greek Patterns (D162-163)

Although traditionally referred to as Greek patterns, several of these designs are copied from Roman and Etruscan vases and they would perhaps better be described as Classical Figure Patterns (qv). However, both the Spode and Herculaneum patterns are listed here.

Seven centres from the Spode Greek Series are catalogued by Drakard & Holdway as P906-1 to P906-7, and different parts of the wide border are shown by them on various shapes in S96, S119, and S130. Examples are also illustrated in Coysh 1 115; Whiter 74 and 91-92; S.B. Williams 143-146. Spode based their patterns on engravings in two different publications: *Outlines from the Figures and Compositions upon the Greek, Roman and Etruscan Vases of the Late Sir William Hamilton, with engraved borders. Drawn and engraved by the late Mr. Kirk* (1804), and Hamilton's *Collection of Engravings from Ancient Vases, mostly of pure Greek workmanship in sepulchres in the Kingdom of the Two Sicilies, but chiefly in the neighbourhood of Naples* (1791-1795). Many of the central scenes have been identified or named by Margaret Buxton (see FOB 52 and FOB 53), and currently known scenes include:

Artemis drawn by a Griffin and Lynx. Dish 18½ins:47cm. Ill: Drakard & Holdway P906-5 (with a variant without the lynx on a square bowl in P906-4); Whiter 92 (centre).

Artemis with two Lynxes. Dish 14½ins:37cm. Ill: Whiter 91 (top right).

Bellerophon's Victory over the Chimaera. Dish 12½ins:32cm. Ill: Whiter 91 (lower centre).

Centaurs Battling Theseus. Dish 16½ins:42cm. Ill: Whiter 91 (top left).

A Domestic Ceremony. Comport 10ins:25cm. Ill: FOB 52.

Four Figures in Battle. Oval centrepiece 8½ins:22cm. Ill: FOB 52.

Heracles Fighting Hippolyta. Plate 7ins:18cm. Ill: Drakard & Holdway P906-3.

Iphigenia told of Death of Agamemnon. Dish 10¼ins:26cm. Ill: Drakard & Holdway P906-6.

Offerings to Demeter. Supper dish lid. Ill: FOB 52.

Refreshment for Phliasian Horseman. Soup plate 10ins:25cm. Ill: Whiter 91 (lower right).

Row Boat Fishermen. Sauce tureen stand and supper set insert. Ill: S.B. Williams 144.

Sacrifice to Dionysus. Supper dish lid, and supper dish. Ill: S.B. Williams 146.

A Wreath for the Victor. Plate 8ins:21cm. Ill: Drakard & Holdway P906-2; Whiter 91 (lower left).

Zeus (or Jupiter) in his Chariot. Plate 10ins:25cm. Ill: Coysh 1 115; Drakard & Holdway P906-1; Whiter 74; S.B. Williams 145.

Other items with scenes not yet identified can be seen in D163; Drakard & Holdway P906-7; S.B. Williams 143. Two further unmarked examples, one of which has an ochre border and may not be of Spode manufacture, are illustrated here.

The source for the series attributed to Herculaneum has not yet been identified, but they do not appear to be taken from the Kirk engravings used by Spode. A dish is illustrated overleaf together with a supper set and a fitted centrepiece, complete with egg cups and salt cellar.

See: Kirk Series.

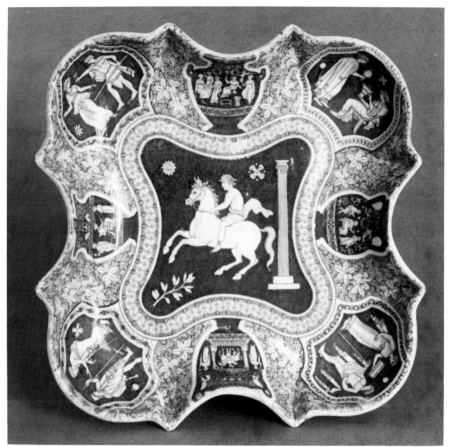

Greek Patterns. *Attributed to Spode. Unmarked. Cruciform dish 7½ ins:19cm.*

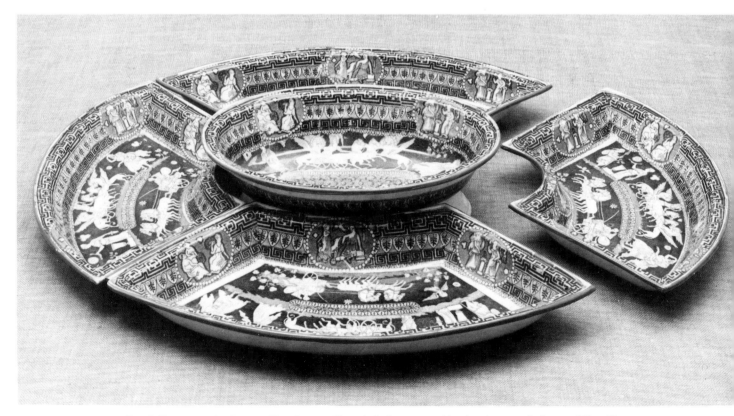

Greek Patterns. *Attributed to Herculaneum. Unmarked. Supper set with ochre rim, overall diameter 21ins:53cm.*

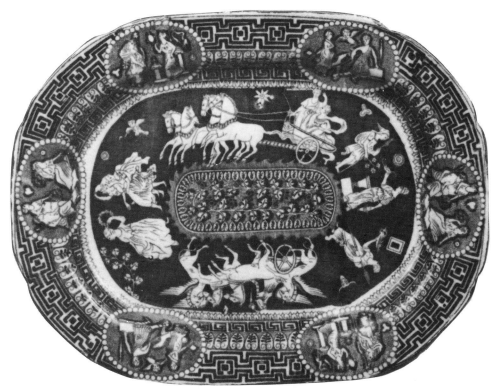

Greek Patterns. *Attributed to Herculaneum. Unmarked. Dish with ochre rim 9½ ins:24cm.*

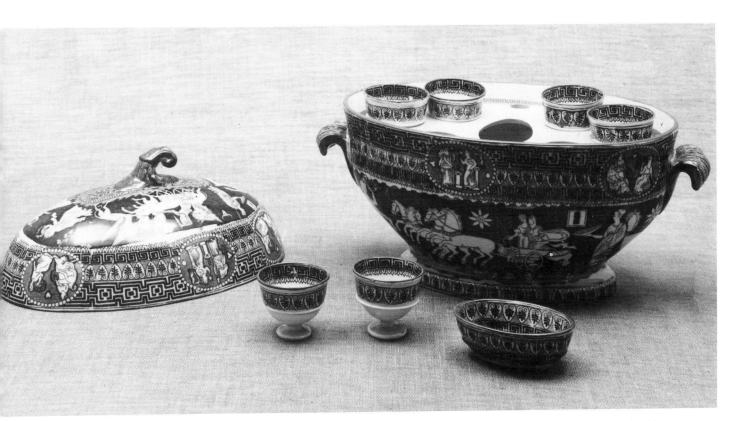

Greek Patterns. *Attributed to Herculaneum. Unmarked. Fitted centrepiece with egg cups and salt cellar, ochre rim, overall length 12ins:30cm.*

Green, T.G., & Co. (New) fl.c.1864 et seq.

Church Gresley Pottery, Derbyshire. Green took over the Church Gresley Pottery on the death of Henry Wileman in c.1864. Jewitt does not mention printed wares among the products, but a pattern titled "Ming" has been noted and printed marks show a church with the word "GRESLEY" beneath.

"Greenwich" (D163-164)

Another potter used this title:

(ii) Herculaneum. Cherub Medallion Border Series. Soup tureen stand 14¼ins:36cm.

The second untitled view listed, which was illustrated on a mug (D164), is now known to be titled "Greenwich Hospital" (see following entry).

"Greenwich Hospital" (New)

Maker unknown. A view of the hospital from the far bank of the River Thames was illustrated on a mug in D164 and is shown again here on a jug. The full print includes at its base a title "GREENWICH HOSPITAL" which was clipped off when fitting the transfer on to the mug.

A similar untitled view has been noted on a Wedgwood toilet box and cover from the Blue Rose Border Series.

Greenwich Hospital was originally built as a palace but is now part of the Royal Naval College. It includes a fine painted hall and an impressive chapel.

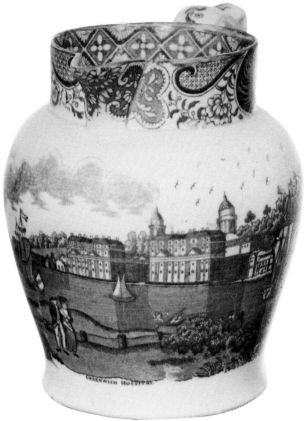

"Greenwich Hospital". *Maker unknown. Titled beneath view, otherwise unmarked. Jug 7½ins:19cm.*

"Greenwich". *Herculaneum. Cherub Medallion Border Series. Printed title mark. Soup tureen stand 14¼ins:36cm.*

98

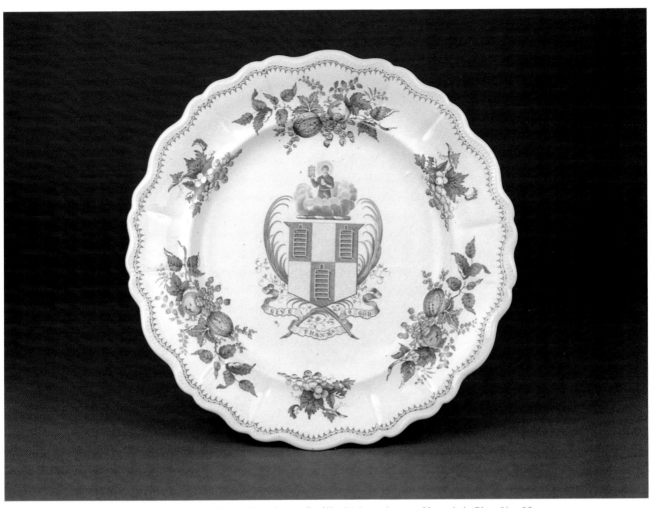

Colour Plate XIV. **"Give Thanks to God"**. *Maker unknown. Unmarked. Plate 9ins:23cm.*

Colour Plate XV. **Guillotine**. *Attributed to Swansea. Unmarked. Mug 4¾ ins:12cm.*

Gresely. *Impressed "GRESELY". Plate 7ins:18cm.*

Gresely (New)

A chinoiserie plate with a pattern very similar to one used by Walter Daniel (see Coysh 2 21) but with an impressed mark "GRESELY" is illustrated here. It has been suggested that it may have been made at the end of the 18th century by a pottery at Church Gresley in Derbyshire.

Griffiths, Beardmore & Birks (New) fl.c.1830

Flint Street, Lane End, Staffordshire. Little is recorded about this short-lived partnership except that they succeeded Thomas Griffiths & Co., listed in directories for 1828 and 1830, and were in turn succeeded by Beardmore & Birks who were certainly in operation by 1834 and potted until about 1843. They are known to have used a large pre-Victorian Royal arms mark bearing a ribbon inscribed "STAFFORDSHIRE IRONSTONE CHINA" and with their initials G.B. & B. in script at its base. This mark has been noted on a dish with a view of "The Rukery" from the Light Blue Rose Border Series (qv) and Godden records its use on a Willow pattern dish.

"Grotto of St. Rosalie near Palermo" (D164)

This scene in the Named Italian Views Series by the Don Pottery was also printed as the main pattern on a pickle set (qv).

Group (D164)

This Spode floral pattern is catalogued by Drakard & Holdway as P814. It is also illustrated in Copeland pp.146-147; Coysh 2 99; Whiter 43 and 100.

Grouse (New)

An attributed title used for a pattern on a 6¼ins:16cm plate in the Ornithological Series by Andrew Stevenson. Ill: FOB 42.

Guest & Dewsberry (New) fl.1869-c.1927

See: South Wales Pottery.

"The Guildhall, London" (D164)

The second design mentioned in the *Dictionary* is now known to show the City of London Tavern. See: "Domine Dirige Nos".

Guillotine (New)

Several examples are known of unmarked mugs printed with a scene showing a guillotine and including the inscription:

> View of LA GUILLOTINE or the modern
> Beheading Machine at Paris.
> By which LOUIS XVI, late
> King of Franee (sic)
> was Beheaded
> Jan, 21 1793

The mugs are usually attributed to Swansea although a Liverpool origin has also been suggested. See: Colour Plate XV.

The guillotine is named after Joseph Guillotin (1738-1814) who introduced it to France, where it was first used in April 1792. It became a symbol of the French Revolution (1789-1799) and is often thought of as a French invention although similar machines had been used elsewhere in Europe as early as the 13th century. The execution of Louis XVI was justified by Danton, one of the revolution's leaders, when he said "The coalesced kings threaten us; we hurl at their feet, as gage (sic) of battle, the head of a king". As a king, Louis has been described as being "deficient in every necessary quality except that of well-meaning".

"**Guy's Cliff, Warwickshire**". *Maker unknown. Unmarked except for impressed fraction 7 over 3 on soup plate. Soup plate and a pair of salt cellars, diameter of plate 9¾ ins:25cm.*

"The Guitar" (New)

This is the third scene to be recorded in the series titled "Terni", produced by either Chetham & Robinson or Chesworth & Robinson. The pattern appears on an ornate handled sauce tureen stand and shows a pair of figures, the man playing a guitar to the girl, in a romantic Italianate setting.

"Guy's Cliff, Warwickshire" (D167)

One other maker produced a view with this title:
 (ii) Belle Vue Pottery. Belle Vue Views Series. Soup plate.
 The untitled view by an unknown maker illustrated in D167 is now known to be copied from an engraving which is taken from Volume III of Storer and Greig's *The Antiquarian and Topographical Cabinet* (1808). The print is illustrated here together with an unmarked soup plate and a pair of ornate salt cellars.

"**Guy's Cliff, Warwickshire**". *Source print for the view by an unknown maker, taken from Storer and Greig's "The Antiquarian and Topographical Cabinet".*

101

Hackwood Partnerships (D168)

Although miniature wares with the impressed mark "HACKWOOD" are commonly found, marked full-size wares are uncommon. A miniature plate with a pattern including exotic birds is illustrated here.

The Haining, Selkirkshire (New)

A view of this house has been identified on a sauce tureen and stand from the so-called "Irish Scenery" Series by Elkins & Co. It is illustrated here together with the source print taken from John Preston Neale's *Views of the Seats of Noblemen and Gentlemen in England and Wales, Scotland and Ireland.*

The Haining is a seat about one mile south of Selkirk in the Borders. The house was enlarged in about 1820 for John Pringle by Archibald Elliot, a leading Edinburgh architect.

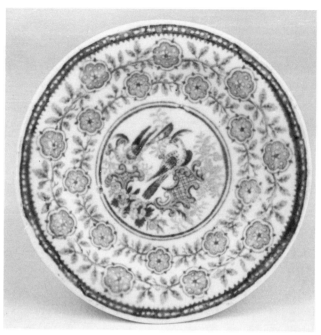

Hackwood Partnerships. *Exotic Birds. Impressed "HACKWOOD". Toy plate 3¼ ins:8cm.*

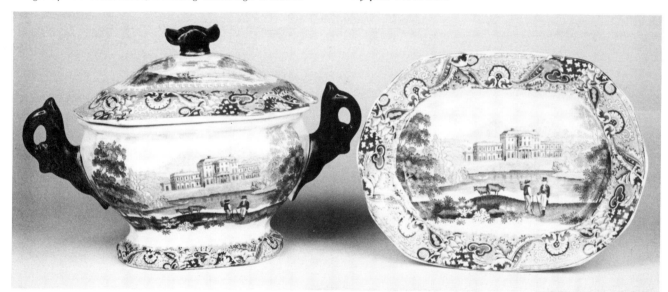

The Haining, Selkirkshire. *Elkins & Co. "Irish Scenery" Series. Printed Royal arms mark with series title and makers' name (on base and stand). Sauce tureen, cover and stand, length of tureen 8½ ins:22cm.*

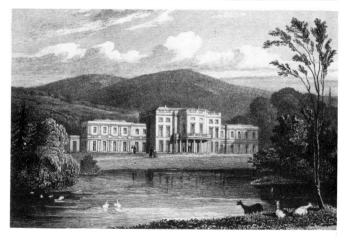

The Haining, Selkirkshire. *Source print taken from John Preston Neale's "Views of the Seats of Noblemen and Gentlemen in England and Wales, Scotland and Ireland".*

"Hannibal Passing the Alps" (D170)
There are several variants of the central scene used for this design by Elkin, Knight & Co. Examples have also been recorded printed in red and sepia. Ill: P. Williams p.725; Williams & Weber pp.283-285.

"Hanover Lodge, Regent's Park" (D171)
The plate from the "London Views" Series by Enoch Wood & Sons is illustrated here together with the source print taken from Elmes' *Metropolitan Improvements*.

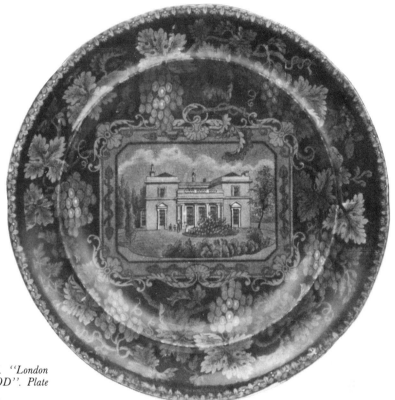

"Hanover Lodge, Regent's Park". *Enoch Wood. "London Views" Series. Printed titles mark and impressed "WOOD". Plate 9 ¼ ins:23cm.*

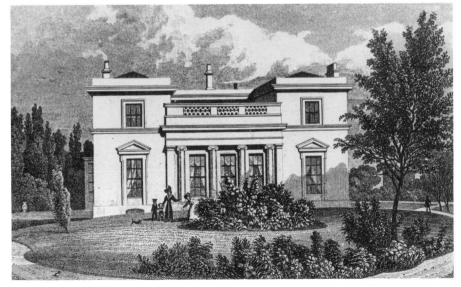

"Hanover Lodge, Regent's Park". *Source print taken from Elmes' "Metropolitan Improvements".*

"The Hare and the Tortoise" (D171)

This fable was also used by Minton, Hollins & Co. as part of a set printed on Tiles (qv).

"Hawking" (D172)

The pattern by J. & M.P. Bell & Co. is illustrated on a soup plate by Williams & Weber p.286.

Hawkins, Stephen, & Co. (New) fl.c.1822-1829

A water closet with an inscription referring to the patentee S. Hawkins is illustrated in FOB 53. It is decorated with scenes and the border from Enoch Wood & Sons' Grapevine Border Series and bears an oval reserve containing the Royal arms and the inscription:

By his Majesty's Royal Letters Patent
Granted to
S. HAWKINS
for an Improvement upon
WATER CLOSETS &c &c
No. 167 Fleet Street

The reserve also includes small titled sketches suggesting usage as a slop pail, common privy, water closet or for chamber use. The example is still fitted in an original metal container and a mahogany case, and includes a ceramic cover to the drain hole, which is printed with a similar inscription and is hinged with a lead counter-weight.

Stephen Hawkins & Co. first appear at 167 Fleet Street in a London directory for 1822, which refers to "Hawkins & Co's. newly invented Patent Self-Acting Air Trap". Stephen Hawkins took out patent number 4595 on 18th October 1821, covering "traps for privies, waterclosets, close-stools, or chamber conveniences to which the same may be applicable". The firm is listed as water closet manufacturers at the same Fleet Street address until 1829.

Hawley Bros. (Ltd.) (New) fl.1868-1903

Northfield Pottery, Rotherham, Yorkshire. William & George Hawley started potting together from 1863 but traded as Hawley Brothers from 1868. They used the initials H.B. within printed marks. The firm became a limited company in 1897, and the factory eventually closed down in 1929. Production included the common "Asiatic Pheasants" design.

"Heart of Midlothian" (D172)

An untitled version of this pattern was made by Thomas & Benjamin Godwin. It is clearly based on the same engraving as the "Scott's Illustrations" scene by Davenport but there are slight variations; the two figures are set against a different background and the scene is printed within a trellis border.

"Henry IV, Act 5, Scene 4" (D173)

The scene in "The Drama" Series by John Rogers & Son was printed on a dish 12½ ins:32cm.

Herculaneum Pottery (D173)

Two patterns from a series of rural scenes are illustrated here on an arcaded dessert plate and a vegetable dish.

Heron, Robert (& Son) (New) fl.c.1850-1929

Fife Pottery, Kirkcaldy, Scotland. A pottery which produced typical blue printed wares with titles such as "Hawking" and "Temple". See: *Scottish Pottery Historical Review*, No.7, 1982, pp.54-55.

Hillcock, Robert (& Son) (D175)

Another impressed mark, this time "HILLCOCK" with two letter Ls, is illustrated in FOB 38 on a version of the Long Bridge pattern. Both these marks probably relate to the retailer Robert Hillcock.

Herculaneum Pottery. *Rural scene. Impressed "HERCULANEUM" around a crown. Arcaded plate 10ins:25cm.*

Herculaneum Pottery. *Rural scene. Impressed "HERCULANEUM" around a crown. Vegetable dish 10¼ ins:26cm.*

Hollins, Thomas & John. *Thomas & John Hollins. Impressed "T. & J. HOLLINS". Three views of a vase with silver rim, height 8ins:20cm.*

Hillcock and Walton (D175)

The rural scene described in the *Dictionary* with a Hillcock and Walton mark is now known to be the pattern previously entered under the title Hospitality, more correctly listed as the Benevolent Cottagers (qv).

"Hindoo Ghaut on the Ganges" (D177)

This view by an unknown maker in the "Oriental Scenery" Series was used on a shaped dessert dish.

"Hindoo Pagodas" (New)

Maker unknown. "Oriental Scenery" Series. Sauce tureen, overall length 7ins:18cm.

This title has also been noted on a sauceboat, but the view was different and the mark was probably transferred in error. The subject of this view is Pagodas at Azimabad near Barrackpore.

"Hindoo Village on the Ganges" (D177)

This view by an unknown maker in the "Oriental Scenery" Series was produced on a dish 14¾ins:37cm. It is illustrated in FOB 47 where the scene has been identified as a village near Ambooah.

"Hindoostan" (New)

A flow blue floral pattern noted on dinner wares marked with initials W. & B. These could relate to Wood & Baggaley of Burslem, but there were other potters who used the same initials.

Hindoostan is the area covering the upper valley of the River Ganges, and incorporates the North-West Provinces, Oude, and Bihar. The name is sometimes loosely used for the whole Indian peninsula.

See: "Bell Tavern, Lower Thames Street".

Hodges, William (New) 1744-1797

Hodges was a draughtsman in Captain Cook's second expedition. He painted views in India under the patronage of Warren Hastings, and his *Travels in India* (1793) was used as the source for some patterns in the "Oriental Scenery" and Parrot Border Series.

Holdcroft, Hill & Mellor (New) fl.1860-1870

High Street and Queen Street, Burslem, Staffordshire. A firm who produced the common "Asiatic Pheasants" design on dinner wares. They used their initials H.H. & M. in printed marks.

Holland, W.T. (New) fl.1858-1869

See: South Wales Pottery.

Hollins, Thomas & John (D178)

Marked blue-printed wares from this factory are rare, but a vase decorated with an early chinoiserie pattern and fitted with a silver mount is illustrated here. The pattern features a man fishing from some high steps at the end of a bridge, and also includes a prominent butterfly.

Hollinshead & Kirkham (New) fl.1870-1956

New Wharf Pottery, Burslem (until 1876), then Tunstall, Staffordshire, where they took over Wedgwood's Unicorn Pottery in c.1890. Jewitt states that they produced "printed ware of the kinds required for the home, Russian, Italian, and French markets". The initials H. & K. appear as part of printed marks on patterns such as "Lahore".

"Hollywell Cottage, Ireland, Lord Tara's Seat" (New)

Careys. Titled Seats Series. Dish 9¾ins:25cm and interior of soup tureen. Ill: FOB 44.

This view is illustrated here together with the original source print, titled "Holywell Cottage, Cavan", taken from John Preston Neale's *Views of the Seats of Noblemen and Gentlemen in England and Wales, Scotland and Ireland*.

"Hollywell Cottage, Ireland, Lord Tara's Seat". *Careys. Titled Seats Series. Printed title mark. Dish 9¾ins:25cm.*

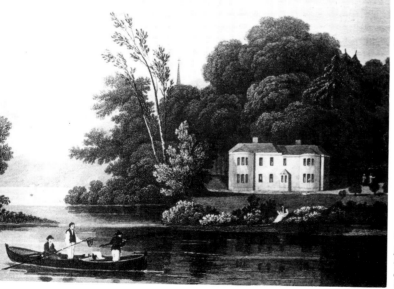

"Hollywell Cottage, Ireland, Lord Tara's Seat". *Source print used by several potters, taken from John Preston Neale's "Views of the Seats of Noblemen and Gentlemen in England and Wales, Scotland and Ireland". The Neale print is titled "Holywell Cottage, Cavan".*

"Holme Pierrepont, Nottinghamshire" (D179)
The view by an unknown maker in the Foliage Border Series is illustrated here on a cup plate printed in dark blue, almost certainly made for the American market.

The view shows the early 16th century gatehouse range, and the spire is of a church detached from the house. A more recent similar view can be seen in Pevsner's *The Buildings of England: Nottinghamshire* (1957).

"Holy Bible" Series (New)
A series of biblical views by Job & John Jackson printed in light blue. The series mark consists of an open book inscribed "HOLY BIBLE" with the makers' name "Jacksons Warranted" below. Some individual scenes are titled above the book but only one such sub-title has so far been recorded:
 "Tadmor in the Desert"
One example has been reported with the Jacksons' name replaced by a single initial H., the significance of which is not yet known.

"Homer Invoking the Muses" (New)
Joseph Clementson. "Classical Antiquities" Series. Teabowl and saucer, and dished plate. Ill: Williams & Weber p.60.

Along with other patterns from the series, this design is marked with a registration diamond for 13th March 1849.

Homer, or Homerus, the great epic poet of Greece, was universally regarded by the ancients as the author of the two great poems, the *Iliad* and the *Odyssey*. The nine Muses were daughters of Jupiter and the goddesses of literature, poetry, music, dancing and the liberal arts. It is said that no poet would ever begin to write without a solemn invocation to the goddesses who presided over verse. In Homer's case this would include particularly Calliope, the goddess of epic poetry.

Honeysuckle and Parsley (New)
An adopted title for a Spode sheet floral pattern catalogued by Drakard & Holdway as P829.

"The Hospital near Poissy, France" (D182)
The plate from the "Select Views" Series by Ralph Hall is illustrated here.

Hospitality (D181-182)
The pattern which was illustrated and given the title Hospitality in the *Dictionary* is now known to have been based on a painting by Sir Augustus Wall Callcott (qv) called "The Benevolent Cottagers".

See: Benevolent Cottagers.

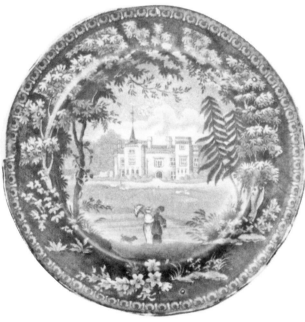

"Holme Pierrepont, Nottinghamshire". *Maker unknown. Foliage Border Series. Printed title mark. Cup plate 4¾ ins:12cm.*

"The Hospital near Poissy, France". *Ralph Hall. "Select Views" Series. Printed titles and maker's mark. Plate 6½ ins:16cm.*

Hot Water Plate. *Ridgway, Morley, Wear & Co. Ornate printed cartouche with inscription "MANUFACTURED BY / R.M.W. & Co. / For / JAMES DIXON & SONS. / HOT WATER PLATE". Plate 10½ins:27cm.*

Hot Water Plate. *Printed cartouche mark.*

Hot Water Plate (D182)

A plate, designed for use as a hot water plate fitted with a lower Britannia metal container, is illustrated above. This example was made by Ridgway, Morley, Wear & Co. and bears an interesting printed mark relating to the Sheffield-based metal mounting firm of James Dixon & Sons (qv).

Howitt, Samuel (New) 1756-1822

A painter, etcher, and aquatint engraver who married the sister of Thomas Rowlandson. He specialised in sporting and animal subjects, and his engravings are included in *Oriental Field Sports, Wild Sports of the East* (1805-1808), used by Spode for the basis of their Indian Sporting Series, and *Fables of Aesop and Phaedras* (1809-1811), used by Minton, Hollins & Co. later in the century for designs on blue-printed Tiles (qv). Other patterns were almost certainly based on Howitt's paintings or engravings, including one Coursing Scene (qv and D96) after an original painting by Philip Reinagle.

Hudson (D182)

This name also appears on blue-printed wares as a pattern title used by Thomas Edwards for a romantic scene. Ill: P. Williams p.295; Williams & Weber p.589.

Hulse, Nixon & Adderley (New) fl.1853-1869

Longton, Staffordshire. A factory which produced blue-printed wares marked with initials H.N. & A. as part of cartouche marks. One typical romantic-style design was titled "Mycene" and it continued in production for some time by the succeeding partnerships of Hulse & Adderley and W.A. Adderley (qv).

"Humulus" (D183)

This pattern was also made by Edge, Barker & Co. who were presumably predecessors of William & Samuel Edge. Their initials E.B. & Co. appear in the printed mark.

Hunting a Buffalo (D183-184)

This scene by Spode in the Indian Sporting Series was also used on a dish 12ins:30cm.

"Hydrographic" (New)

Davenport. A simple six-pointed geometric centre within a border with scroll reserves alternately containing birds and flowers. The title "HYDROGRAPHIC" and the maker's name "DAVENPORT" are printed in a scroll and floral vase cartouche mark.

Hydrographic, meaning pertaining to or related to hydrography, describes the study and mapping of the waters of the earth. The Hydrographic Department of the British Admiralty was established in 1795 to undertake the making of charts showing the position of seas, lakes and rivers, but it was known as the Hydrographical Department until 1854.

"Hylands, Essex" (D185)

This view by an unknown maker in the Crown Acorn and Oak Leaf Border Series was also used on a drainer 15ins:38cm. Ill: FOB 38.

"If You Would Know the Value of Money, Try to Borrow Some" (New)
Davenport. "Franklin's Morals" Series. Plate 6¼ins:16cm.
 Benjamin Franklin used this maxim in *Poor Richard's Almanack* for 1754, where it is printed as "If you'd know the Value of Money, go and borrow some".

"Illustrations of the Bible" Series (D186)
Thomas Mayer. An additional scene is:
 "Fountain of Elisha at Jericho"
 The series was also printed in purple.

Imperial Measure (New)
In 1824 the Weights and Measures Act established the Imperial standards for measuring quantities and many mugs and jugs conforming to this standard were made with transfer-printed decoration. They are usually marked with wording such as "Imperial Measure" or "Imperial Quart", often accompanied by the Royal coat-of-arms.
 Two unmarked blue-printed jugs are illustrated, below and overleaf. Both have the inscription "IMPERIAL MEASURE" and the Royal coat-of-arms beneath the spout. One has a view identified as Newstead Abbey, Nottinghamshire, the other features Bear Forest, Cork, Ireland, copied from a John Preston Neale print.
 A Davenport mug with prominent Victorian arms and

initials V.R., with a flower and scroll border, is illustrated in NCS 62, p.30. Mugs made by John Tams of the Crown Pottery, Longton, printed in blue with a hunting scene and marked "IMPERIAL QUART", have been recorded (D356).

"Imperial Quart" (New)
See: Imperial Measure.

"Improv'd Canton China" (New)
A trade name printed in an oval cartouche surrounded by stylised acanthus leaves. The maker is not known.

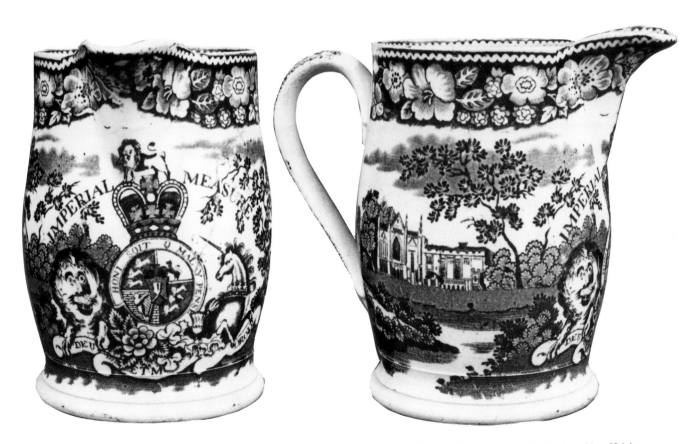

Imperial Measure. *Maker unknown. Unmarked. Two views of a jug including a scene identified as Newstead Abbey, Nottinghamshire. Height 5ins:13cm.*

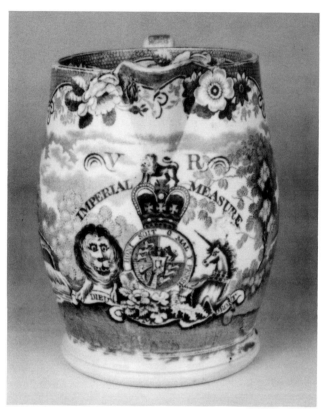

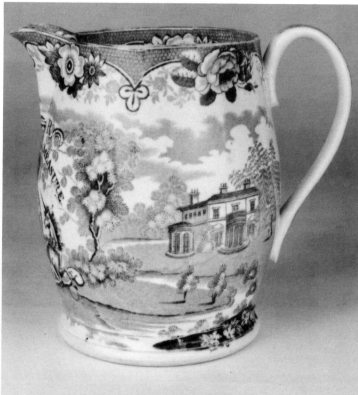

Imperial Measure. *Maker unknown. Unmarked. Two views of a jug (handle restored), including a scene identified as Bear Forest, Cork, Ireland. Height 6ins:15cm.*

"Improved Stone China" (D186)
The confusion over impressed seal marks with this wording appears to have been resolved. A larger version, illustrated here, is some 0.9in:23mm. long and appears on marked wares by Job Meigh & Son, and was presumably also used by their successor Charles Meigh. This mark has additional lettering in the framing, apparently the name "MEIGH" at the top and "HANLEY" at the base, but the words are unclear. A smaller mark without any lettering but otherwise similar, only 0.7in:18mm. long, appears on known Minton wares.

"In The Wood" (New)
See: Little Red Riding Hood.

India (D187)
This Spode pattern is catalogued by Drakard & Holway as P623. It is also illustrated in Copeland p.144; Coysh 1 113; Drakard & Holway S87 and S97; Whiter 24; S.B. Williams 114-118.

"India" (New)
Brameld. This has commonly been known as the Twisted Tree pattern, but examples are sometimes marked with a cartouche in the form of a Chinese figure with an urn on a bench inscribed "INDIA / STONE CHINA". Ill: Cox 47 (and Mark 60).

The same pattern was produced by James Reed of Mexborough under the title "Tapestry". He obtained the copper plates at the Rockingham Works sale in 1843.

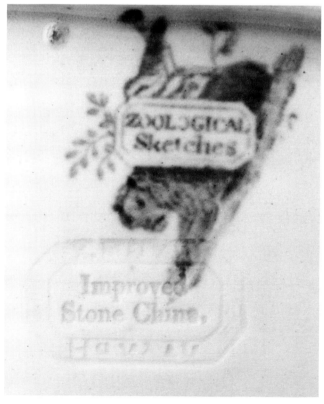

"Improved Stone China". *Impressed seal mark together with printed "Zoological Sketches" Series mark used by Job Meigh & Son.*

"India Temple" (D187)

The source of this pattern made by John & William Ridgway has been identified by Pat Latham in a short article titled 'Two Sources of Underglaze Blue Prints on Early 19th Century Pottery' in the *Transactions of the English Ceramic Circle*, Vol. 12, Part 1 (1984). He illustrates the original painting which was shown by Leo Heaps in *The Log of the Centurion* (1974). The *Centurion* was the ship in which Captain George Anson circumnavigated the world in 1740-1744. His *Voyage Round the World* was published in 1748.

"India Vase" (New)

Maker unknown. A predominantly floral design featuring a large vase of flowers, two birds, and a relatively early form of romantic-style background. The floral border has white semicircular panels with sprays of flowers alternating with a single rose on a net background. The printed cartouche mark is in the form of two leaves inscribed "INDIA VASE, OPAQUE CHINA". The pattern is illustrated here on a moulded stand, and similar moulding can be found on some wares made by Marsh (D239).

"Indian Jar" (New)

Jacob & Thomas Furnival. A flow blue floral pattern featuring a large vase within a chinoiserie-type border of scrolls on net backgrounds. The pattern was also produced in sepia.

"Indian Ornament" (New)

T.G. & F. Booth. A pattern of stylised flowers arranged in dome-shaped reserves forming a circle. The printed mark includes the makers' initials T.G. & F.B.

"Indian Scenery" (New)

Maker unknown with initial H. A romantic-style Indian sporting scene within a floral border. A small cartouche mark includes the title "INDIAN SCENERY" with the single initial H. at its base.

Indian Scenery Series (D187)

Thomas & Benjamin Godwin, and also Cork, Edge & Malkin and Edge, Malkin & Co. Additional views are:

"Musque of Mustopha Khan, Beejapore" (sic)
"Pagoda below Patna Azimabad"
"Sicre Gully Pass, Bengal"
"The Taj Mahal, Tomb of the Emperor" *
"Village & Pagoda on the Ganges"

A view of Lucknow has also been reported but the actual title used has not yet been confirmed. See: "Luckuow" (sic).

Examples have been noted where the initials in the printed mark have been modified by removal of the B to leave just the initials T.G. This suggests that Thomas Godwin continued to produce the series after the end of his partnership with Benjamin in 1834, and he presumably passed the copper plates on to Cork, Edge & Malkin. The Godwins also produced the series in pink and two different shades of green, and in addition they used the central scenes printed in black on dessert wares within a border of sea shells printed on a yellow ground.

Detailed research by Pat Latham reported in FOB 47 has identified two sources for the views in this series: C.R. Forrest's *A Picturesque Tour Along the Rivers Ganges and Jumna in India* (1824), and the Reverend Hobart Caunter's book, featuring drawings by William Daniell, *The Oriental Annual or Scenes from India* (1834). The first of these source books was also used by other potters for similar views, including the two "Oriental Scenery" Series and the Parrot Border Series.

"India Vase". *Maker unknown. Printed leaf spray title mark with "OPAQUE CHINA". Sauce tureen stand 7½ ins:19cm.*

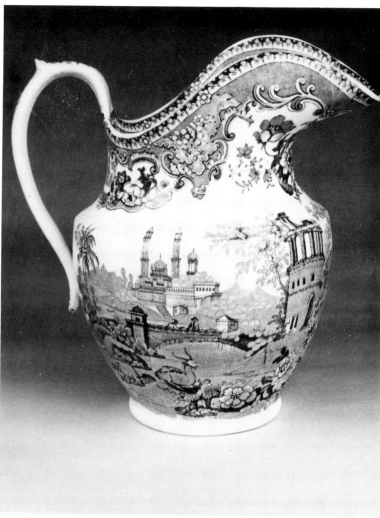

"Indian Temple". Elkin, Knight & Bridgwood. Printed scroll cartouche containing title and makers' initials. Ewer, height 8¾ ins:22cm.

Indian Sporting Series (D187-188)
Spode. An additional untitled scene is:
 Koomkies Leaving the Male Fastened to a Tree
 All known views in this series and several of the source prints are illustrated in Drakard & Holdway P904-1 to P904-21.

"Indian Temple" (D188)
A ewer which would form a set with the wash bowl mentioned in the *Dictionary* is illustrated here. The title is printed in script within a scroll cartouche with the initials E.K.B. for Elkin, Knight & Bridgwood.

"Indian Temples" (New)
Careys. A series of romantic-style Indian temple scenes within a floral border featuring rococo scrolls. The cartouche mark is similar to the border and contains the title "Indian Temples" in script with the makers' name "Careys" beneath.

"Indus" (New)
Ridgway, Sparks & Ridgway. A design featuring a heron and other birds among bulrushes, all printed within an open floral border on dinner wares. The printed mark has the title "INDUS" and the makers' initials R.S.R. above a registration diamond for 15th June 1877.
 The River Indus rises in Tibet and flows through Kashmir and Pakistan to the Arabian Sea south of Karachi. It is 1800 miles long and has a huge delta covering an area of 3000 square miles. It passes through many cities, the largest of which is Hyderabad.

Initial Marks (D188)
Several additional initial marks have now been recorded and they are listed in Appendix II. In many cases it has not proved possible to trace the makers to which they refer.

Institution (D189)
Examples of this Hackwood pattern have been noted with the impressed mark of their successors, Cockson & Harding.

"Interlachen" (D189)
The soup plate from the Byron Views Series by Copeland & Garrett is illustrated here together with the source print taken from Finden's *Landscape and Portrait Illustrations to the Life and Works of Lord Byron* (1832-34).

"Irish Scenery" Series (D190-191)
Elkins & Co. Additional identified views are:
 Castle Richard, Waterford
 The Haining, Selkirkshire *
 The view of Castle Richard, Waterford (qv) is the first Irish view to be identified; all the others are in England or Wales. The source for the views appears to be John Preston Neale's *Views of the Seats of Noblemen and Gentlemen in England and Wales, Scotland and Ireland*. The series was also printed in green and in mulberry.
 One blue-printed tea plate has been recorded with the usual printed mark but with the name Elkins & Co. replaced by the initials H.W. No firm of appropriate date has yet been traced with these initials.

"Irish Views" Series (D191)
Careys. Additional views are:
 "Black Rock Castle, Near Cork" *
 "The Upper Lake of Killarney"

"Isola Bella" (D191)
This pattern title, noted in the *Dictionary* under William Adams & Sons, was also used by Davenport. It means beautiful island.
 In addition to the Isola Bella on Lake Maggiore, there is another off the coast of Taormina in Sicily.

Italian (D191-192)
This famous Spode pattern is catalogued by Drakard & Holdway as P710 and illustrated by them on a wide range of different shapes. It is shown on page 114 on a large divided serving dish, the lower section designed to be filled with hot water to keep food in the upper section warm, and is also extensively illustrated elsewhere, including Copeland p.156; Coysh 1 103; Whiter 66; S.B. Williams 94. Another version of the pattern can be seen on a presentation jug dated 1820 which bears a printed inscription "British Cobalt Blue" (qv).

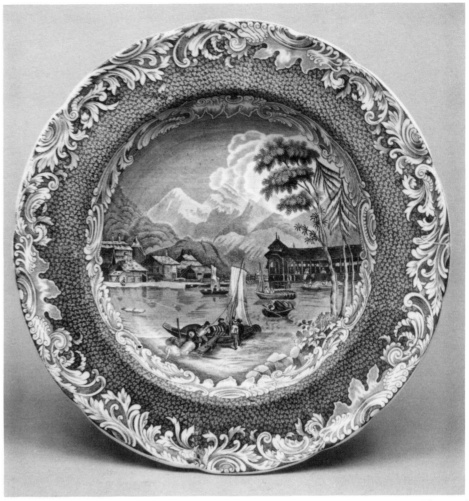

"Interlachen". Copeland & Garrett. Byron Views Series. Printed title and makers' mark and impressed makers' mark. Soup plate 10¼ ins:26cm.

Italian Church (D191)

This Spode pattern is catalogued by Drakard & Holdway as P709 and is also illustrated in Coysh 1 108; Drakard & Holdway S144; Whiter 63; S.B. Williams 95. Since the central scene has now been identified as a view of the church at the village of Waterloo, the alternative title of Waterloo (qv) has become more widely used.

"Italian Scenery" (D193-195)

Another potter used this title:

(iv) Maker unknown. A romantic-style harbour scene within a border of scrolls, flowers and sea shells which is illustrated overleaf on a dinner plate. It may be one of a series of similar scenes. The title is printed in script within a scroll cartouche.

"Italian Seaport" (New)

Maker unknown. A harbour scene with sailing ships, a promontory with white two-storey buildings, and a tower topped with a dome and spire in the foreground is illustrated overleaf on a saucer. The title is printed in a floral cartouche.

"Interlachen". Source print used by Copeland & Garrett taken from Finden's "Landscape and Portrait Illustrations to the Life and Works of Lord Byron".

113

Italian. Spode. Printed and impressed "SPODE" on both pieces. Divided serving dish, overall length 15ins:38cm.

"Italian Scenery". *Maker unknown. Printed scroll cartouche with title. Plate 9¾ins:25cm.*

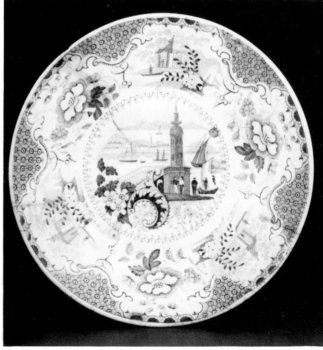

"Italian Seaport". *Maker unknown. Printed floral cartouche with title. Deep saucer 6¾ins:17cm.*

"January" (New)
See: Seasons Series.

Japan (D197)
The Spode floral pattern is catalogued by Drakard & Holdway as P625. It is also illustrated in Copeland p.149; Drakard & Holdway S161; Whiter 26; S.B. Williams 121.

Jasmine (D198)
This Spode floral pattern is catalogued by Drakard & Holdway as P820 and shown by them on ladles and a ewer and basin in S103 and S174. It is also illustrated in Whiter 50; S.B. Williams 155. The border was also used with various armorial centres, examples of which can be seen in Coysh 1 122; Drakard & Holdway P820; Whiter 50; S.B. Williams 156.
 See: Armorial Wares; "Spectemur Agendo".

"Java" (D198)
The pattern by Charles Meigh & Son shows a floral spray within a border of flowers and beading. Ill: Williams & Weber p.33.

"Jessamine" (New)
Maker unknown. A floral pattern with a border composed of flowers in framed reserves. The title appears in script within a floral cartouche.
 Jessamine is another name for jasmine, a family of shrubs with white or yellow flowers.

"John Gilpin" (New)
Maker unknown. A small mug illustrated here is printed with scenes derived from *The Diverting History of John Gilpin*, a poem by William Cowper (1731-1800), first published in *The Public Advertiser* in 1782. The title is printed within a simple vesica-shaped frame. The poem begins:

John Gilpin was a citizen
Of credit and renown,
A train-band Captain eke was he
Of famous London town.

It goes on to describe Gilpin's abortive journey to join his wife at the Bell Inn, Edmonton, for dinner on their twentieth wedding anniversary. His horse bolts and takes him all the way through Edmonton to Ware. On the way the toll gates are opened for him when the keepers think he is in a race:

'Twas wonderful to view
How in a trice the turnpike-men
Their gates wide open threw.

The scene on the mug shows Gilpin galloping past a toll gate with the keeper waving him on, but an imaginative engraver has added some "Man Traps" beside a wall by the gate.

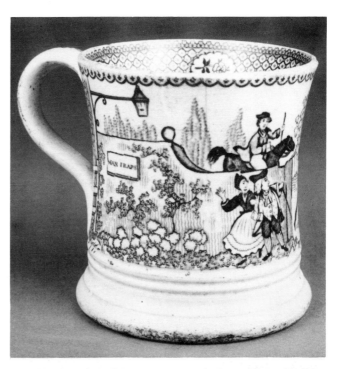

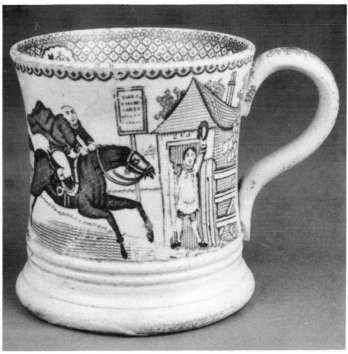

"John Gilpin". *Maker unknown. Printed title in vesica-shaped frame. Two views of a mug, height 3½ ins:9cm.*

115

Johnston, David, & Co. (New) fl.1834-1845

Bordeaux, France. David Johnston was born of British parents in Bordeaux in 1789 and later became Mayor of the city from 1838 to 1842. He founded a pottery in 1834 and produced blue-printed wares for the French market. In 1844 he was in financial difficulties and appointed Jules Vieillard as Technical and Commercial Director. In 1845 Vieillard bought the factory and continued to make the printed wares, some of which appear to be a form of faience. The works eventually closed in 1895.

Both printed and impressed marks were used with the full name "DAVID JOHNSTON", sometimes also with "& Co." or the French equivalent "& Cie.". A device composed of three interlaced crescents, illustrated here, often forms part of both printed and impressed marks. Blue-printed patterns are much in the style of English products, one being very similar to the "Medina" pattern by Thomas Godwin. A small bowl printed with a sheet floral pattern and a large covered pot of sucrier form are illustrated here.

Johnston, David, & Co. *Printed triple crescent mark.*

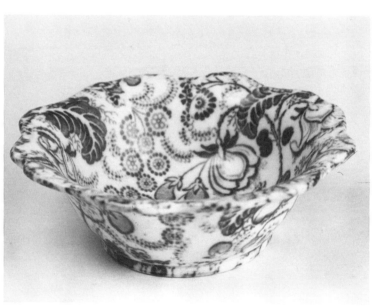

Johnston, David, & Co. *Sheet floral pattern. Printed triple crescent makers' mark. Shaped bowl, diameter 4½ ins:12cm.*

Jumping Boy (D199)

This is an alternative name for the Spode pattern catalogued by Drakard & Holdway as Lanje Lijsen (qv). It is also sometimes known as Long Eliza.

"June" (New)

See: Seasons Series.

"Jungara Pagoda" (New)

Maker unknown. Parrot Border Series. Plate 6½ ins:17cm and shaped dish 6½ ins:17cm.

It has not yet proved possible to identify the location of this view.

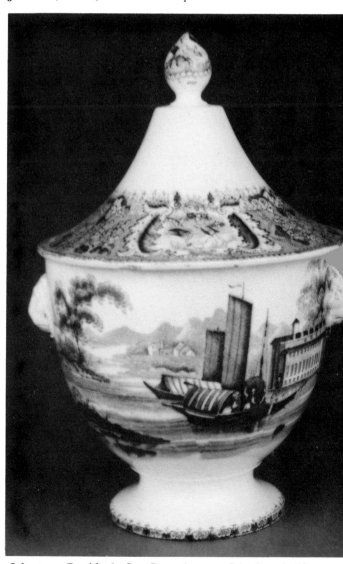

Johnston, David, & Co. *Romantic scene. Printed mark "D. JOHNSTON & Cie. / MI - PORCELAINE", and impressed mark with "DAVID JOHNSTON" in a curve over triple crescents. Large sucrier-shaped pot, height 8ins:20cm.*

"Juno's Command" (New)

Joseph Clementson. "Classical Antiquities" Series. Dished plate. Ill: Williams & Weber p.60.

Along with other patterns from the series, this design is marked with a registration diamond for 13th March 1849.

Juno was a Roman goddess, wife of Jupiter. Under the name of Lucina she was the goddess of women, watching over the female sex and presiding over their marriages and childbirth. She was also known as Moneta, the giver of counsel, and one of her temples housed the Roman mint, giving rise to the modern word money. Juno's power extended over all the gods, and she made use of the goddess Iris as her messenger. As Halcyone was waiting for the return of her husband Ceyx, who unbeknown to her had died in a storm in the Aegean, she prayed to Juno for his safe return. Juno was so touched by her prayers that she despatched Iris to command Somnus, the king of sleep and dreams, to send a dream to Halcyone to let her see her husband's fate.

"Juvenile" (New)

Wood & Brownfield. A pattern showing a small girl feeding a rabbit printed on children's teawares. Examples are marked with a cartouche enclosing the title "Juvenile" in script and incorporating the makers' initials W. & B. A plate is illustrated here.

"**Juvenile**". *Wood & Brownfield. Printed title cartouche with makers' initials. Plate 5¼ins:13cm.*

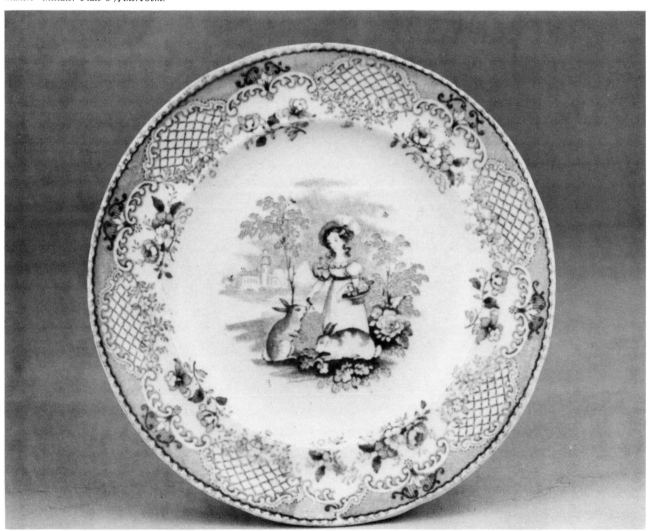

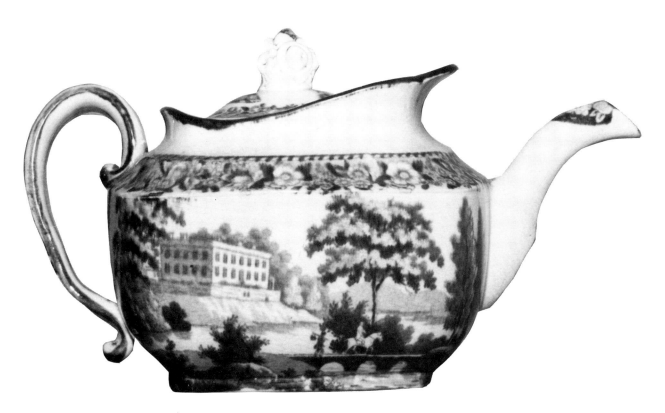

Keeling, James. *Unmarked. Teapot, overall length 11ins:28cm.*

Keeling, James (D200)
No marked wares by James Keeling have been recorded, but shards collected from the site of his pottery in New Street, Hanley, by Hugh Stretton are assisting in the attribution of several patterns. One country house view which is illustrated here on an unmarked teapot is matched by shards of the same shape and pattern. The *Staffordshire and Pottery Mercury* dated 22nd November 1828 contains a reference to Keeling's introduction of the series "Views in Mesopotamia" (qv).

"Kenelworth Priory" (sic) (D200)
The plate from the Minton Miniature Series is illustrated here together with the source print taken from the title page of Storer and Grieg's *Antiquarian and Topographical Cabinet*.

"Kilkenny" (New)
Herculaneum. Cherub Medallion Border Series. Soup tureen
 Kilkenny is the capital of County Kilkenny in the Irish province of Leinster. It is a market town with a historic cathedral. Swift and Congreve both received their education at the local grammar school.

"Kilruddery Hall, Wicklow, Earl of Meath's Seat" (New)
Careys. Titled Seats Series. Soup tureen. Ill: FOB 44.
 Kilruddery Hall lies two miles to the south of Bray in County Wicklow, and was one of the earliest Elizabethan Revival houses in Ireland. It was built for the 10th Earl of Meath to a design by Sir Richard Morrison which incorporated an existing 17th century building.

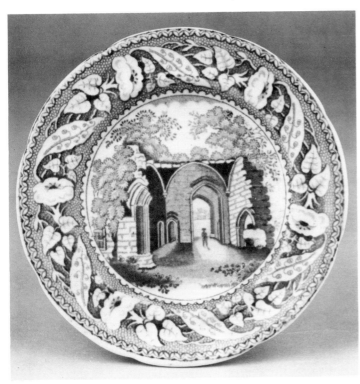

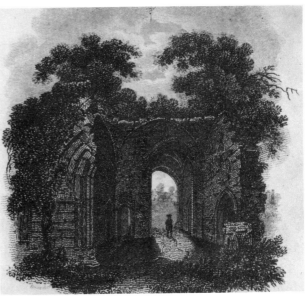

"Kenelworth Priory". *Source print taken from the title page in Volume I of Storer and Greig's "Antiquarian and Topographical Cabinet"*.

"Kenelworth Priory". *Minton. Minton Miniature Series. Printed title mark. Miniature plate 3¾ ins:9cm.*

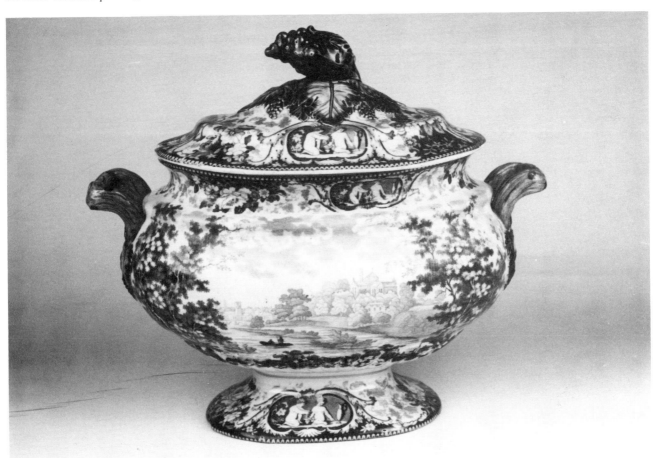

"Kilkenny". *Herculaneum. Cherub Medallion Border Series. Printed title mark. Soup tureen and cover, length 12¾ ins:32cm.*

"Kings Arms Inn, Stoke" (New)

A presentation jug printed in light blue, with a view of mountainous scenery, has been recorded with the following inscription printed under the glaze on the front beneath the spout:

KINGS ARMS INN
STOKE
BY THOMAS SHAW

There have been many changes in Stoke-on-Trent, with areas being completely redeveloped and several streets being renamed or renumbered, but the King's Arms still stands at 17 Hill Street, on the corner with what is now Consort Street, previously King Street. In the 19th century it used to face the Town Hall and the Market Place, but this area is now taken by a medical boarding centre. It has not proved possible to identify the exact dates when Thomas Shaw was the landlord, but entries from Staffordshire directories give the following sequence:

1818-1822: Richard Walker
1828-1830: Eleanor (or Ellen) Walker
1834-1835: Josiah Fearnyhough (or Ferneyhough)
1841-1846: Thomas Shaw
1853: Charles Turner
1860-1861: Alexander McClure
1870-1872: John Fordham

The jug was possibly one of a set made for use in the bar.

"Kioto" (sic) (New)

Brownhills Pottery Co. A pattern in the Japanese manner noted on a biscuit barrel with plated mounts. It features stylised flowers within geometric panels and is marked with the makers' initials B.P. Co. together with a registration diamond for 1879.

This pattern was named after Kyoto, capital of the Japanese Empire until 1868 when it was replaced by Tokyo. After this date, the feudal system became a thing of the past and British and American advisers were brought in to help reconstruction. The city is full of fine buildings including the Imperial Palace, rebuilt in 1855.

Kirk Series (New)

Maker unknown. A title adopted here for a series of classical figure patterns which John Worrall identified in FOB 59 as being copied from engravings by Thomas Kirk in *Outlines from the Figures and Compositions upon the Greek, Roman and Etruscan Vases of the Late Sir William Hamilton, with engraved borders. Drawn and engraved by the late Mr. Kirk* (see entry below). Groups of classical figures are printed in octagonal central panels surrounded by a pattern of stylised anthemion, all contained within a strip border assembled from further groups of figures. The patterns recorded to date, with central subjects where known, are:

(i) Unidentified scene (illustrated here). Plate 7¼ ins:18cm.
(ii) Unidentified scene (illustrated here). Plate 8¼ ins:21cm.
(iii) Unidentified scene (illustrated here). Soup plate 9¼ ins:24cm.
(iv) Ceres Holding a Mirror. Drainer. Ill: FOB 59.
(v) Unidentified scene. Dish. Ill: FOB 59.
(vi) Iphigenia told of Death of Agamemnon. Plate. Ill: FOB 59.

The strip border is composed of several scenes, and is different on each piece. Jupiter (or Zeus) in his Chariot, and Sacrifice to Bacchus (or Dionysus) have been identified, and the source prints for these and for two of the items listed above are also shown in FOB 59. Several of the patterns, including all three shown here, incorporate a small added panel of Masonic-like emblems, the significance of which is not yet known.

See: Classical Figure Patterns; Greek Patterns.

Kirk, Thomas (New) d.1797

An artist and engraver who was responsible for the prints in *Outlines from the Figures and Compositions upon the Greek, Roman and Etruscan Vases of the Late Sir William Hamilton*, published after his death in 1804. This was used as the source for their so-called Greek patterns by Spode, and also by other potters for similar classical figure patterns.

See: Classical Figure Patterns; Greek Patterns.

Kirk Series. *Maker unknown. Unmarked. Soup plate 9¼ ins:24cm.*

Kirk Series. *Maker unknown. Unmarked. Plate 8¼ ins:21cm.*

"Kirkham Priory Gateway, Yorkshire". *Maker unknown.
Pineapple Border Series. Printed title mark. Plate 5¾ ins:14cm.*

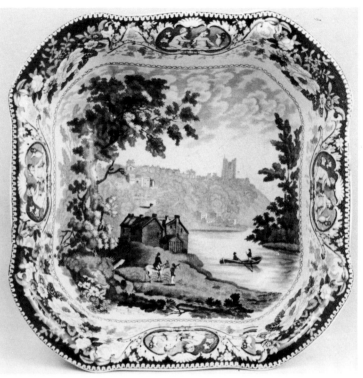

"Knaresborough". *Herculaneum. Cherub Medallion Border
Series. Printed title mark. Deep footed bowl 9½ins:24cm.*

Kirk Series. *Maker unknown. Unmarked. Plate 7¼ins:18cm.*

"Kirkham Priory Gateway, Yorkshire" (D204)
The piece printed with this view in the Pineapple Border
Series by an unknown maker is now known to be a plate
5¾ins:14cm. It is illustrated here.

"Knaresborough" (New)
Herculaneum. Cherub Medallion Border Series. Square deep
footed bowl.

Described in 1810 as "a town in the N. Riding of Yorkshire
containing about 500 houses. It is pleasantly situated on the
River Nidd, over which it has a stone bridge... It is famous
for its medicinal springs, near each other, and yet of different
qualities; the sweet spa or vitriolic well; the stinking, or
sulphurous and very foetid spa; St. Mungoe's well, a cold
bath; and the dropping well, supposed to be the most
petrifying spring in England. The adjacent fields are also
noted for liquorice".

Koomkies Leaving the Male Fastened to a Tree (New)
Spode. Indian Sporting Series. Base of vegetable dish. Ill:
Drakard & Holdway P904-20.

This scene appears on the sides of a vegetable dish fitted
with a cover and inner liner which bear other scenes from the
Indian Sporting Series. It is not titled on the wares.

A koomkie is a wild female elephant.

"Lady of the Lake". *Untitled version by Dixon, Austin & Co. Impressed makers' name in a curve, under lid and inside base. Toilet box, length 7¼ ins:18cm.*

"Lady of the Lake" (D208-209)

A scene which bears strong similarity to the Careys' "Lady of the Lake" pattern illustrated in D208 is shown here on a toilet box and cover made by Dixon, Austin & Co. of Sunderland. This version is untitled and although all three figures are different to those in the *Dictionary*, the general layout is the same, and there can be little doubt that it is intended to represent the same story.

"Lahore" (New)

Hollinshead & Kirkham. A pattern marked with initials H. & K.

Lahore, now in northern Pakistan, was originally a Mogul capital and became the capital of the Punjab, known as the "country of the five rivers", the eastern branches of the Indus. By 1810 it was "the capital of the Seiks (sic), a new power, whose name, even as a sect, was hardly known until the rapid decline of the Mogul's empire". It was noted for cotton cloth and carpets.

Lake (New)

An alternative name for a Spode chinoiserie pattern catalogued by Drakard & Holdway as Dagger Landscape (qv).

"Lake" (D209)

Two views from this series are illustrated by Williams & Weber, pp.205-206, where the maker is noted as Francis Morley and the succeeding firms of Morley & Ashworth and G.L. Ashworth & Bros.

"Lake of Como" (New)

Wood & Challinor. A romantic-style scene printed within a floral border, which forms part of a series of views, another of which is titled "Viege" (qv), and a third may be "Bacharach" (qv). A printed scroll cartouche contains the title "LAKE OF COMO" and the makers' monogram W. & C. appears in a reserve beneath. This pattern has also been recorded printed in black, and the border also appears on an unmarked Pap Boat (qv). Ill: Williams & Weber p.207.

The lake at Como lies at the foot of the Alps in north-west Lombardy. It has always been an important tourist centre, with several resorts on its shores including Bellagio, on a promontory which divides two arms of the lake; Cadennabia, with its 18th century Villa Carlotta famous for its gardens; and Cernobbio, with its 18th century Villa d'Este.

Lakeside Meeting (D209)

This title was adopted in the *Dictionary* for a well-known pattern by an unknown maker. Shards decorated with the design have been found on the site of James Keeling's pottery in New Street, Hanley.

Lakin, Thomas (& Son) (D209)

The impressed mark "Lakin" has been recorded on items printed with Spode's Tiber or Rome pattern. An informative article by Harold Blakey, 'Thomas Lakin: Staffordshire Potter 1769-1821', in the *Journal of the Northern Ceramic Society*, Vol.5 (1984), illustrates several marked pieces. One particularly impressive design features a lion and crown above the Prince of Wales' feathers and crown, flanked on the left by roses and on the right by thistles.

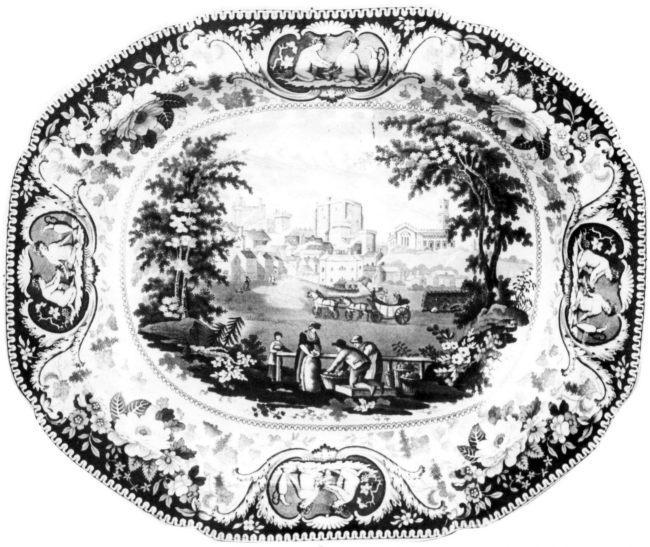

"Lancaster". *Herculaneum. Cherub Medallion Border Series. Printed title mark and impressed "HERCULANEUM". Well-and-tree dish 18½ ins:47cm.*

"Lancashire Asylum" (New)
The name of this institution has been recorded on a jug with a light blue chinoiserie scene.

The mental hospital near St. Helens was built between 1847 and 1851 to a design by Harvey Lonsdale Elmes. It was originally known as the Lancashire County Lunatic Asylum.

"Lancaster" (D212)
The Cherub Medallion Border Series by Herculaneum includes two different views titled "Lancaster"; the second is illustrated here on a well-and-tree dish 18½ ins:47cm.

The untitled view by John Rogers & Son is illustrated on a soup tureen from the Rogers Views Series (qv).

"Landscape" (New)
See: Robinson.

"Langley Park" (D214)
This house was originally built in 1599 but major changes were made for Sir Peter Burrell (later Lord Gwydyr) by Joseph Bonomi in 1790. The gardens were laid out by Humphry Repton. The house was destroyed by fire in 1913.

Lanje Lijsen (D214)
This Spode pattern, occasionally spelt Lange Lijzen and also sometimes known as Jumping Boy or Long Eliza, is catalogued by Drakard & Holdway as P622. It is also illustrated in Copeland pp.143-144; Coysh 1 111; Drakard & Holdway S99, S130, and S195; Whiter 23 and 101; S.B. Williams 108-113.

Large Scroll Border Series (D214-215)
John & Richard Riley. One previously recorded view is illustrated in this volume:
 "Orielton, Pembrokeshire" *
An additional view is:
 "Alton Abbey, Staffordshire" *

Lattice Scroll. Spode. Printed *"SPODE" in a frame. Arcaded plate 7¼ ins:19cm.*

Lattice Scroll (D215)

This Spode floral pattern is catalogued by Drakard & Holdway as P803 and illustrated here on an arcaded dessert plate. As with the Rome or Tiber pattern, examples usually bear an uncommon printed mark with the normal name "SPODE" enclosed within a frame. The pattern is also shown in Copeland pp.138-139; Coysh 1 102; Drakard & Holdway S98, S117, and S123; Whiter 33 and 100; S.B. Williams 157.

Lavatory Pan (D216)

An example of a lavatory pan has been noted with an inscription referring to the patentee Robert Wiss (qv). Some pans were made as portable water closets; one example made by Davenport bears an inscription referring to the patentee Henry Marriott (qv), and a similar one made by Enoch Wood & Sons bears an inscription relating to the patentee Stephen Hawkins (qv).

"Lavinia" (D216)

Lavinia was the daughter of Latinus and the second wife of Aeneas, having previously been betrothed to Turnus. She is mentioned in a poem by Milton.

Leaf (D217)

This Spode sheet pattern is catalogued by Drakard & Holdway as P806. It is also illustrated in Whiter 36; S.B. Williams 158.

Leeds Pottery (D217-218)

The chinoiserie design numbered (i) is usually referred to as the Long Bridge pattern. A rare and interesting pattern noted on a small tea plate is based on a view entitled "Near Currah, on the River Ganges" which appeared in Thomas Daniell's *Oriental Scenery* (Part I, 21). This is a very early use of a Daniell print, and almost certainly predates their use by the Herculaneum Pottery and others.

"Leomington Baths". Maker unknown. Passion Flower Border Series. Unmarked. Drainer 13¼ ins:34cm.

"Leomington Baths" (sic) (D217)

This view by an unknown maker in the Passion Flower Border Series was also used on a drainer, illustrated opposite. Another similar but untitled view appears on a dish by an unknown maker in the "British Scenery" Series (qv).

In the early 19th century Leamington was a small and relatively undeveloped town. The baths were built in 1814 and still exist more or less in their original form.

"The Leopard and the Fox" (New)

Spode/Copeland & Garrett. "Aesop's Fables" Series. Scalloped edge footed bowl. Ill: Drakard & Holdway P907-8; Sussman, *Spode/Copeland Transfer-Printed Patterns*, p.28.

The leopard placed great value on his spots, sure that no other beast had so beautiful a skin. The fox, nothing daunted, challenged him, saying that he was mistaken and that people of judgment were not used to form an opinion of merit from outside appearance but by the good qualities and endowments with which the mind was stored.

Handsome is that handsome does.

Light Blue Rose Border Series (D219)

This series is now known to have been produced by the little-known Lane End partnership of Griffiths, Beardmore & Birks. Dishes printed with a view titled "The Rukery" have been noted with a large printed pre-Victorian Royal arms mark incorporating the makers' initials G.B. & B., and a ribbon inscribed "STAFFORDSHIRE IRONSTONE CHINA". The dishes also bear the usual title mark, an example of which is shown here. One previously recorded view is illustrated in this volume:

"Denton Park" *
Additional views are:
"Castle Richard" *
"The Rukery"

The latter was listed in D313 but was not recognised as part of this series.

Light Blue Rose Border Series. *Griffiths, Beardmore & Birks. Typical printed mark.*

Lily (New)

An adopted title for a Spode idealised floral pattern catalogued by Drakard & Holdway as P801 and shown by them on a covered chocolate cup in S160. It is also illustrated in Copeland p.149; Whiter 31.

Linan (New)

The name Linan appears impressed in small lower case letters on a small plate with a chinoiserie pattern of the 1810-30 period. It has also been reported printed in underglaze blue on a plate with the Grazing Rabbits pattern. No maker or retailer of this name can be traced, and its significance is not yet known.

"Lind" (New)

Pountney & Goldney. A design featuring Chinese figures in a setting of very large flowers, much in the style of the patterns titled "Mandarin Opaque China" (qv). The title "LIND" appears in a cartouche with the makers' initials P. & G. beneath.

The title could have been inspired by the popularity of the singer Jenny Lind, the Swedish Nightingale, although this bears no relationship to the subject of the design.

Lings & Keith. *Copeland & Garrett. Underglaze green printed makers' mark. Flat oval plaque printed overglaze in blue, length 3¾ ins: 10cm.*

Lings & Keith (New) fl.c.1848

A flat oval plaque in white earthenware is illustrated here with an overglaze blue-printed inscription:

PATENT
LINGS & KEITH
MANUFACTURERS
11 PRINCES S^T. LEICESTER S^Q.
LONDON.

The plaque also bears a green-printed Copeland & Garrett mark.

The short lived firm of Lings & Keith appears only in a London directory for 1848, where they are listed as Ice Machinists & Patentees at 11 Princes Street, Soho. It was a partnership between John Lings, previously a wholesale cheesemonger, and George Keith, a furnishing and manufacturing ironmonger. Lings invented an ice safe and took out patent number 10,781 on 21st July 1845, covering "apparatus for the preservation of provisions", and it may be that the business was set up to exploit this invention. In 1852 Keith is listed alone at 36 Piccadilly as an Ice Merchant, Manufacturer of Freezing Powder, & Ice Safe Maker.

During much of the 19th century ice was imported from Scandinavia. The first patent for a refrigeration machine in Great Britain was granted in 1834.

"The Lion, the Bear & the Fox". *Spode. "Aesop's Fables" Series. Printed titles mark with maker's name. Impressed "SPODE". Octagonal plate 8¼ins:21cm.*

Little Red Riding Hood. *"Pull The Bobbin". Maker unknown. Unmarked. Toy plate 4¼ins:11cm.*

Livesley, Powell & Co. *Impressed square frame with "BEST" and makers' initials (on plate only). Toy comport and plate, diameter 3ins:8cm.*

"The Lion, the Bear & the Fox" (New)

Spode/Copeland & Garrett. "Aesop's Fables" Series. Octagonal plate 8¼ins:21cm. Ill: Sussman, *Spode/Copeland Transfer-Printed Patterns*, pp.22 and 34.

The lion and the bear fought over the carcase of a fawn until they were exhausted. A fox passed by and seized the booty.

Grasp all, lose all.

"The Lioness and the Fox" (New)

Spode/Copeland & Garrett. "Aesop's Fables" Series. Ill: Sussman, *Spode/Copeland Transfer-Printed Patterns*, p.30.

The lioness and the fox discussed their breeding and the fox taunted the lion because she did not produce litters. The lioness replied "I indeed have but one at a time, but you should remember that this one is a lion".

In many words there is folly, but a word in season is like apples of gold in pictures of silver.

Little Red Riding Hood (New)

A series of scenes from the children's story *Little Red Riding Hood* was used by an unknown maker to decorate a child's tea service. Scenes recorded to date are:

"In the Wood". Saucer

"Pull the Bobbin". Plate (illustrated here)

"Starting Off to See Granny". Cup

Other scenes almost certainly exist on matching items from the tea service.

The nursery story *Little Red Riding Hood* is derived from the French *Le Petit Chaperon Rouge*, probably itself based on an Italian original. It is also common in Sweden and Germany. Sir Henry Cole (1808-1882) expressed dissatisfaction with the standard of children's books, and under the pseudonym Felix Summerly he issued a *Home Treasury of Books* in the 1840s in collaboration with the publisher Joseph Cundall and the printer Charles Whittingham. *Little Red Riding Hood* was issued in 1843 with hand-coloured illustrations. The story was very popular and illustrations appeared on Christmas cards in 1868.

Livesley, Powell & Co. (New) fl.1851-1866

Stafford Street Works, Hanley, Staffordshire. Livesley, Powell & Co. took over these works from Furnival & Clark in 1851 and were in turn succeeded by Powell & Bishop in 1866. They used an impressed mark featuring their initials L.P. & Co. together with the word "BEST". Blue-printed wares were produced including some miniature pieces decorated with a sheet pattern.

"Llanarth Court, Monmouthshire". *Ralph Hall. "Picturesque Scenery" Series. Printed titles and maker's mark. Plate 10ins:25cm.*

"Llanarth Court, Monmouthshire" (D222)

The plate from the "Picturesque Scenery" Series by Ralph Hall is illustrated above.

Llandig's Blackberry (D222)

The designer of this pattern was a Brameld factory artist who specialised in painting fruit and flowers. His name is variously quoted as Llandig, Llandeg, Llandegg or Landeg, and his dates are given as 1809-1836 in Cox. The pattern was printed in blue, black and green, and was also used on porcelain teawares. Ill: Cox 85.

Lockett, John & Thomas (New) fl.c.1835-c.1852

King Street, Longton, Staffordshire. There were many Lockett family firms potting in Lane End and Longton in the first half of the 19th century, and the brothers John & Thomas Lockett succeeded John Lockett & Sons in 1835 or 1836, and traded until shortly after 1852.

A small shaving mug, illustrated in FOB 49, is decorated with a country house view and marked with the title "MELTON" inside two concentric circles with the makers' initials J. & T.L. beneath.

"Lombardy" (D224)

This pattern by Joseph Heath & Co., together with the printed cartouche mark, is illustrated on a cup plate by Williams & Weber p.595.

Lombardy is a part of Italy, so named from Longbardi, or Lombards, who founded the kingdom in the middle of the 6th century.

"London" (D224)

Another potter used this title:
 (iv) Middlesbrough Pottery.

"London Views" Series. *Enoch Wood & Sons. Typical printed mark with impressed maker's mark "WOOD".*

"London Views" Series (D226)

Enoch Wood & Sons. One previously recorded view is illustrated in this volume:
 "Hanover Lodge, Regent's Park" *
 A typical printed mark is illustrated above.

Long Bridge (D226)

No marked Spode examples of this chinoiserie pattern have yet been recorded but it is catalogued by Drakard & Holdway as P619. It is also illustrated in Copeland pp.117-124.

Long Eliza (New)

This is an alternative name for the Spode pattern catalogued by Drakard & Holdway as Lanje Lijsen (qv). It is also sometimes known as Jumping Boy.

"Long Live the King" (New)

Joshua Heath. A design featuring a wreath containing the inscription "LONG LIVE THE / KING" beneath a crown and ribbon, all within an early chinoiserie-style border. There are several events it may have been made to commemorate, such as the silver jubilee of the reign of George III in 1785. Ill: P. Williams p.642.

The Lord's Prayer (New)

Brameld. A rare child's plate with a moulded fruiting vine border, the centre printed with the Lord's Prayer in a circular frame. Ill: Cox 55.

"Louvre" (New)

Herculaneum. A romantic-style scene featuring statuary, marked with a printed cartouche in the form of a tablet with a lion and Hercules as supporters. Ill: FOB 39; Williams & Weber p.66.

The Louvre in Paris was started in 1541 but the buildings were not completed until the 19th century when it became a series of galleries filled with pictures, sculptures, and Egyptian, Greek and Roman antiquities. It is the largest national gallery in the world.

Love Chase (D228)

This uncommon Spode pattern is catalogued by Drakard & Holloway as P717.

Loving Cup (D229-230)

The loving cup printed with a Palladian Mansion scene in D230 is now known to show Wanstead House in Essex, copied from an engraving which appeared in Grey's *The Excursions Through Essex*, published in 1818.

See: "British Scenery" Series.

Lowe, John (New)

An impressed mark "JOHN LOWE" has been noted on a child's mug with a double interlaced strap handle, similar to handles found on creamwares at the end of the 18th century. There appears to be no record of any potter of this name, but a partnership W. & J. Lowe is listed at Lane End in a Staffordshire directory for 1818. Several members of a Lowe family are believed to have potted at Longton in the 19th century.

Lowe, William (New) fl.1874-1930

St. Gregory's Pottery or Sydney Works, Longton, Staffordshire. Jewitt states that William Lowe produced "all the usual varieties of articles in useful ordinary earthenware... principally for the home trade". Marked Willow Pattern wares have been noted.

Lucano (D231)

This Spode pattern is catalogued by Drakard & Holloway as P712 and also shown by them on a dessert centrepiece in S109. It is also illustrated in Coysh 1 105; Whiter 68; S.B. Williams 90-93.

See: Bridge of Lucano.

"Lyme Castle". *Maker unknown. Printed scroll cartouche with title and incomplete initials L... at base. Jug 6ins:15cm.*

"Lucerne" (D232)

One other potter used this title:

(ii) J.W. Pankhurst & Co. A typical romantic scene printed within a foliated scroll border with four vignette reserves. A leafy cartouche contains the title "LUCERNE" and has the makers' initials J.W.P. & Co. at the base. Ill: P. Williams p.321; Williams & Weber p.598.

"Luckuow" (sic) (New)

Maker unknown. "Oriental Scenery" Series. Sauce tureen stand 8ins:20cm.

The same view was used by Thomas & Benjamin Godwin on a comport in their Indian Scenery Series but the title they used has not yet been confirmed.

Lucknow was described by Walker in 1810 as "an ancient city of Hindoostan, Capital of Oude. It is an extensive place but poorly built; the houses are chiefly of mud, covered with thatch; and many consist of mats and bamboos; and are thatched with leaves of the cocoa-nut, palm tree and sometimes with straw... The palace of the Nabob is seated on a high bank near the Goomty River".

"Lumley Castle, Durham" (D232)

The view from the Bluebell Border Series by James & Ralph Clews was also used on a circular soup tureen stand illustrated here.

"Lyme Castle" (New)

Maker unknown. A view illustrated here on a jug with strainer spout, possibly a toast water jug. It is marked with the title in a printed scroll cartouche which has the incomplete initials L... at its base.

This is probably a view of Lympne Castle, Kent (see D232).

Lyre (New)

An adopted title for a rare Spode geometric floral pattern catalogued by Drakard & Holloway as P802 and shown by them on a trio in S145. It is also illustrated in Copeland pp.152-153; Whiter 32.

"Lumley Castle, Durham". *James & Ralph Clews. Bluebell Border Series. Printed title mark and impressed makers' crown mark. Soup tureen stand 13ins:33cm.*

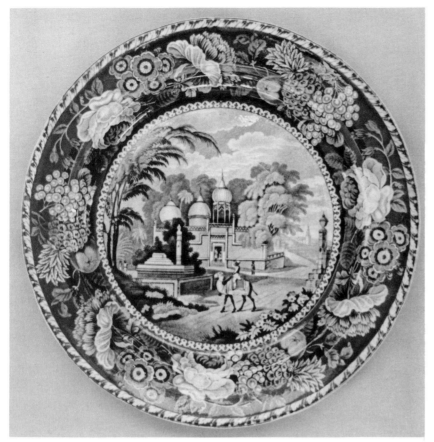

"**Mahomedan Mosque & Tomb**". *John Hall. "Oriental Scenery" Series. Printed titles mark with maker's name. Plate 9¾ ins:25cm.*

Machin & Potts (D233)

Further information about William Wainwright Potts and his partnership with William Machin can be found in an article by Nancy Gunson in NCS 68, pp.6-11. Two dishes printed in blue with a sheet floral pattern with the rare St. George's Pottery mark are illustrated by Gunson, as is another more ornate sheet pattern with a later Machin & Potts variant of the mark. Other marks from this partnership include the word "PATENT", referring to their printing process. See, for example, the pattern "Cavendish".

See: William Wainwright Potts.

"Madras" (New)

Davenport. A simple open pattern of flowers and leaves printed in flow blue on dinner wares. Ill: Williams & Weber p.35-36.

Madras, or Fort of St. George, called by the Indian community China-Patan, was built in the reign of Charles II by order of the English East India Company. It was the principal settlement of the English on the east side of the peninsula.

"Mahomedan Mosque and Tomb" (sic) (New)

Maker unknown. "Oriental Scenery" Series. Soup tureen, overall length 13½ins:34cm.

Note the slight typographical variation from the similar title used by John Hall & Sons in their series of the same name (see following entry).

"Mahomedan Mosque & Tomb" (sic) (D233)

The plate from the "Oriental Scenery" Series by John Hall is illustrated here. See previous entry for a similar view.

Maidstone (New)

An untitled view of the city of Maidstone in Kent has now been identified on a soup tureen in the Rogers Views Series (qv).

"A considerable borough of Kent; which contains above 6000 inhabitants. It is a large place, consisting of 4 principal streets, which intersect each other at the market cross, with a jail and a county hall... By means of the Medway it enjoys a brisk trade in exporting timber, flour, apples, nuts and particularly hops, of which there are numerous plantations around it" (Walker, 1810).

Malayan Village (New)

An alternative name for a Spode chinoiserie pattern catalogued by Drakard & Holway as Trench Mortar (qv). It is also sometimes known as Pearl River House.

"Malgré L'Envie" (New)

In spite of envy. A motto used by the Ferrers family.

A blue-printed armorial dinner service bearing this motto was made by Spode for Earl Ferrers. Ill: Drakard & Holway P956.

See: Armorial Wares.

Maling (D233)

An interesting account of this family firm, covering both Robert Maling and his son Christopher Thompson Maling, can be found in R.C. Bell's booklet *Maling and other Tyneside Pottery* (1986).

Mandarin (D235)

This Spode chinoiserie pattern is catalogued by Drakard & Holdway as Dagger Landscape (qv).

"Mandarin Opaque China" (D235)

Additional designs are:

(v) A Chinese man with a rifle holding the hand of a small girl.

(vi) Two Chinese ladies, one holding on to a small tree (D235).

(vii) A Chinese man with a bow, accompanied by a youth holding a parasol.

(viii) A Chinese man with a spear stands in front of a seated figure and a coolie smoking a pipe.

(ix) A Chinese man accompanied by a peasant holding a basket and a tray of fruit.

(x) A Chinese warrior with a forked rifle holding the hand of a child.

(xi) A Chinese family group of five figures on a small grassy mound.

(xii) A Chinese man seated on a mound accompanied by a dog and a standing couple with a lantern on a cross.

(xiii) Two Chinese men stand in conversation next to an urn on a pedestal.

(xiv) A single standing Chinese man.

A dish decorated with one of these patterns has been noted with a small frame containing the name and address of a London fishmonger, "QUINN / 40 HAYMARKET", let into the top of the border. See: James Quinn.

"Mangoena" (New)

A miniature advertising plate which is illustrated here shows a scene of elephants drinking from bottles, and bears the registered trade mark "MANGOENA". The system of registering such marks was set up by the Trade-Mark Act of 1862 and this plate probably dates from the end of the 19th century.

Despite the survival of the records relating to such marks, the system of indexing makes it extremely difficult to trace them from a single name, and it has not yet proved possible to locate this particular mark.

"Mangoena". *Maker unknown. Unmarked. Miniature advertising plate 2½ ins:6cm.*

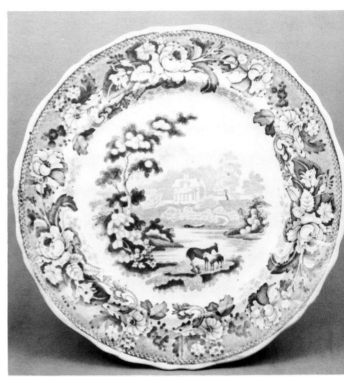

Mare and Foal. *Davenport. Impressed maker's anchor mark for 1846. Plate 9½ ins:24cm.*

"Mansion" (New)

(i) James & Thomas Edwards. A series of romantic scenes printed on dinner wares and marked with the title "MANSION" in an oval frame. Examples impressed with the name "EDWARDS" are known. Ill: P. Williams p. 324; Williams & Weber p.599-600.

(ii) Thomas Shirley & Co. A typical romantic landscape scene within a border featuring baskets of flowers printed in light blue on dinner wares. The printed mark is in the form of a beehive and anchor with the title "MANSION" and the makers' initials T.S. & Co. Ill: FOB 55.

Marble (D237)

This Spode sheet floral pattern is catalogued by Drakard & Holdway as P807. An alternative authentic factory name is Mosaic and it has also been called Cracked Ice and Prunus. It is also illustrated in Copeland pp.138-141; Coysh 2 102; Drakard & Holdway S146 and S198; Whiter 37; S.B. Williams 119-120.

Mare and Foal (D237)

An additional scene is:

(v) Five cows on the near bank of a river, with a large cottage on the far side. Illustrated on a pink-printed pierced dessert basket in NCS 60, pp.20-21.

A blue-printed dinner plate with the scene numbered (i) is illustrated here.

"Marina" (New)

Cork, Edge & Malkin. A romantic scene within a mossy border, featuring a large vase of flowers in the left foreground, printed on dinner wares and octagonal shaped dishes. The mark includes the title "Marina", the trade name "IRONSTONE", and the makers' initials C.E. & M.

The word was first used in the 19th century for a port or for a holiday or bathing resort, e.g. Marina di Carrara and Marina di Massa.

Marriott, Henry. *Portable water closet manufactured by Davenport. Printed maker's "STONE CHINA" anchor mark. Diameter 12ins:30cm.*

"Marine" (D237)

One other potter used this title:

(iv) Davenport. A central design of an intertwined crown and anchor, surmounted by a ribbon inscribed "MARINE" and with a wreath below, is printed within an open rope border. A detailed printed mark is in the form of an armorial anchor above a garter inscribed "DAVENPORT, LONGPORT, STAFFORDS" enclosing a panel with the two addresses "30 CANNING PLACE / LIVERPOOL / 82 FLEET STREET / LONDON". This mark does not appear to have been recorded previously. The London address was Davenport's own retail establishment in the City.

Marine Pavilion, Brighton (New)

See: Brighton Pavilion.

"Marino" (New)

A series of romantic scenes used by several potters including Cork, Edge & Malkin and their successors Edge, Malkin & Co., Thomas Godwin, George Phillips, Thomas Phillips & Son, and Thomas Till & Son. Most of these firms used the same cartouche mark of a flower pot with the title in Gothic script on a pedestal, the appropriate makers' name or initials beneath, and the word "IRONSTONE" above. One example has been noted with the initials C.E. & M. for Cork, Edge & Malkin, but with an impressed mark "EDGE, MALKIN & CO.". Ill: P. Williams p.327; Williams & Weber p.601.

Marino is a small town in the hills 13 miles south-east of Rome containing the ruins of the famous Colonna Palace which was destroyed in the Second World War. It is noted for the famous Frascati wine and has an annual wine festival. Young men on the Grand Tour would go to Albano to visit the Cardinal Duke of York, brother of the Pretender, who was born in Rome, became Bishop of Frascati, and insisted that everyone addressed him as "Your Royal Highness".

"Mario" (New)

Clyde Pottery Co. This pattern title was incorrectly recorded in the Dictionary as "Merio".

Giovanni Mario (1810-1883) was an Italian singer, considered to be the greatest operatic tenor of his time. He appeared in London in 1839, and retired from the stage in 1867.

Marriott, Henry (New) **fl.c.1808-c.1848**

Three rare examples of portable water closets made by Davenport are known with an inscription referring to the patentee Marriott. The example illustrated above (see also Colour Plate XVIII), decorated with a geometric and floral trelliswork pattern, bears a shield shaped reserve with the pre-Victorian Royal arms above an inscription printed in iron-red:

MARRIOTT
PATENTEE
26 LUDGATE HILL and
89 FLEET ST.
LONDON

It is marked with an arched cartouche inscribed "DAVENPORT / STONE CHINA" around an anchor.

Another example in the Castle Museum at York is still fitted in an original leather case and includes a ceramic cover to the drain hole which again is printed with the Royal arms and a further inscription:

BY HIS MAJESTY'S ROYAL LETTERS PATENT
MARRIOTT'S
PORTABLE WATER CLOSETS

The museum dates its example to c.1824, probably because Henry Marriott was granted his patent for water closets under number 5,014 on 14th October 1824. A third similar example has been noted in which the reserve and inscription are in blue, possibly a slightly later, simplified and cheaper product.

Henry Marriott is first listed as a Furnishing Ironmonger at

36 Chiswell Street in a London directory for 1808. From 1809 his address is given as 64 Fleet Street, and in 1822/1823 he is listed as a Furnishing Ironmonger, Patentee of the Dial Weighing Machine and Improved Cooking Apparatus, at 89 Fleet Street. In 1825 the description refers for the first time to Portable Water Closets, and in 1826 two additional addresses are given, 26 Ludgate Hill and 46 Cornhill. Similar entries without the Cornhill address continue until 1842 when the firm is listed as Marriott & Crowe and a further address at 74 Old Broad Street is given. The name reverts to just Henry Marriott from 1846 when the Ludgate Hill premises are dropped. By 1851, Henry had been succeeded by William Adolphus Marriott, presumably his son, who continued to trade from the Fleet Street address only until 1859. In 1861 an entry appears under ''Marriott's, late Wm. (George Davies)''. Subsequent entries list only Davies at 89 Fleet Street.

The Davenport water closets recorded above were probably made between 1826 and 1842.

''Masaniello'' (New)

Brameld. A romantic-style rural scene showing three fishermen on a river bank, within a border of roses and drapes. Ill: NCS 63, pp.25-26.

Research by Terry Lockett has revealed that Masaniello, whose full name was Tomaso Aniello (c.1622-1647), was a Neapolitan fisherman and fruit seller who led a revolt against taxes imposed by the Spanish viceroy, the Duke of Arcos, in July 1647. The revolt was successful but ended in Aniello's assassination. The production of this pattern was almost certainly inspired by the opera ''La Muette de Portici'' by Auber and Delavigne, produced in England under the title ''Masaniello'' in 1829.

''Mausoleum of Kausim Solemanee at Chunar Gur''. *Maker unknown. Parrot Border Series. Printed title mark. Plate 10¼ ins:26cm.*

Mason, Charles James, & Co. (D239)

See: Opium Smokers; Sharpus.

Mason, G.M. & C.J. (D239)

A moulded dessert dish of typical ornate shape decorated with a chinoiserie landscape and impressed with the early ''MASON'S PATENT / IRONSTONE CHINA'' mark is illustrated here. The design is similar to Spode's Temple pattern.

''Mausoleum of Kausim Solemanee at Chunar Gur'' (D241)

A dinner plate from the Parrot Border Series by an unknown maker is illustrated here. The view was produced on both a plate 10¼ ins:26cm and a soup plate 10ins:25cm.

Chunar was a settlement on the south side of the Ganges, 19 miles south of Benares.

Mausoleum of Sultan Purveiz, near Allahabad (D240-241)

A plate printed with this pattern is illustrated in FOB 47 where two dishes with the blue printed mark ''WALSH'' are reported. This mark was previously recorded in the *Dictionary* (D392) on a dish with the View in the Fort, Madura (D380), where it was suggested that it might be a retailer's or printer's mark. It is now believed to be the mark of the Burslem potter William Walsh (qv).

The procession illustrated in this pattern is that of the Moghul, or Mohammedan, Governor of Delhi, and not that of the Governor General.

''Maxstoke Castle, Warwickshire'' (D241)

The plate from the Grapevine Border Series by Enoch Wood & Sons is illustrated here.

Mason, G.M. & C.J. *G.M. & C.J. Mason. Printed makers' crown and drape mark and impressed ''MASON'S PATENT / IRONSTONE CHINA''. Moulded dessert dish 9½ ins:24cm.*

"**Maxstoke Castle, Warwickshire**". *Enoch Wood & Sons. Grapevine Border Series. Printed title mark. Plate 8½ ins:21cm.*

"**Medici**". *Mellor, Venables & Co. Printed registration diamond for 5th July 1847, and impressed "IRONSTONE" in a curve. Cup plate 4ins:10cm.*

"**Melrose Abbey, Roxburghshire**". *Maker unknown. "Antique Scenery" Series. Printed titles mark. Plate 9¾ ins:25cm.*

"**May**" (New)
See: Seasons Series.

"**May Blossom**" (New)
Thomas Booth & Co. A pattern marked with initials T.B. & Co.

"**May Morn**" (D241)
This attractive genre pattern by J. & M.P. Bell & Co. is illustrated in Colour Plate XIX on a jug which matches the bowl shown in D241.

Mayer Partnerships (D242)
The name of the third brother in the T.J. & J. Mayer partnership should read Jos and not Joseph.

"**Mayfield**" (New)
Maker unknown. An irregular open floral pattern noted on dinner wares. The title "MAYFIELD" appears within a simple floral cartouche. Ill: Williams & Weber p.367 (pattern) and p.368 (mark).
 Mayfield is a village in Sussex which was a market town in the middle ages. The old 14th century palace became the St. Leonards-Mayfield School, a cathedral boarding school for girls.

"**Medici**" (D242)
This pattern was registered by Mellor, Venables & Co. on 5th July 1847 and the printed mark is illustrated by Williams & Weber p.603 together with a soup plate. A slight variant on a cup plate is illustrated here. Examples are often impressed with the name of the body "IRONSTONE" in a curve.

"**Melrose Abbey, Roxburghshire**" (D244)
An additional pattern with this title is:
 (ii) Maker unknown. "Antique Scenery" Series. Plate 9¾ ins:25cm.

Colour Plate XVI. "Muleteer". *Davenport. Unmarked. Pepper pot, height 5ins:13cm.*

Colour Plate XVII. Eye Bath. *Maker unknown. Willow pattern. Unmarked. Height 2¼ins:6cm.*

MARRIOTT
PATENTEE
26 LUDGATE HILL and
89 FLEET ST
LONDON

Colour Plate XVIII. Marriott, Henry. *Portable water closet manufactured by Davenport. Printed maker's "STONE CHINA" anchor mark. Diameter 12ins:30cm.*

"Melton" (New)

John & Thomas Lockett. A view of a country house appears on a small shaving mug illustrated in FOB 49 marked with the name "MELTON" inside two concentric circles with the makers' initials J. & T.L. beneath.

This view probably depicts Melton Hall at Melton Constable in Norfolk, a late 17th century house much altered. The house was linked in 1810 with an Elizabethan service range. The view on the mug shows extensions to the main building.

"Memento Mori" (New)

Remember you must die. An inscription which appears on a tombstone in the foreground of a pattern based on an engraving by Thomas Bewick (qv).

"Merio" (D246)

This entry was incorrectly titled. It should read "Mario" (qv).

Mess Wares (New)

Wares made for use in ships' messes were commonly printed in blue with the number of the mess as part of the design. Mess plates (D246) are relatively common, but large tea bowls were also made. They resemble the slop basins in ordinary tea services, but are made of heavy pottery less liable to slide about in rough seas. They were held in both hands when drinking, and contained the equivalent of several ordinary cups of tea. They were inverted for storage when the mess number could be read instantly.

"The Messenger" (New)

Edward & George Phillips. "Polish Views" Series. Wavy edge dessert plate.

"Metropolitan Scenery" Series (D246-247)

Goodwins & Harris. One previously recorded view is illustrated in this volume:
 "Windsor Castle" *
Additional views are:
 "Near Highgate Rd."
 "Osterley Park"
The second of these was previously only known unmarked.
Copper plates listed under the title Metropolitan Scenery were included in the 1828 sale of equipment belonging to John Denton Bagster (qv). It is possible that he was the original manufacturer, but that the plates were acquired and re-used by the Goodwin partnership.

See: Cricket; "Windsor Castle".

"Mezieres" (New)

(i) Cork, Edge & Malkin. A floral pattern used on dinner wares marked with the title "MEZIERES" in a scroll cartouche with the body name "IRONSTONE" above and the makers' initials C.E. & M. below.

(ii) Thomas Godwin. A blue-printed piece made by Thomas Godwin and marked with this title has been excavated on the Craigston Estate in Grenada, West Indies.

Mezieres was described by Walker in 1810 as "a town in the department of Ardennes, seated on the River Meuse, 12 miles north-west of Sedan and 127 miles north-east of Paris".

Middlesbrough Pottery (D247)

The history of this pottery is covered by Mary Williams in her booklet *The Pottery That Began Middlesbrough* (1985).

An interesting printed mark in the form of a small vignette scene of the pottery and its bottle ovens, overprinted with the name "MIDDLESBROUGH POTTERY", has been noted on a small plate printed in light blue with a scene of Chinese figures. Other similar marks were used bearing pattern titles such as "Orient" and "Cyprian Bower".

"Milan" (New)

South Wales Pottery. This pattern was produced over many years from c.1840.

The city of Milan was once the capital of the duchy of the same name. It was noted for textiles: "Silk and velvet stuffs, stockings, handkerchiefs, gold and silver laces, and embroideries, woollen and linen cloths, glass and earthen ware in imitation of china" (Walker, 1810).

"Milanese Villas" (New)

Richard Davies & Co. A pattern title reported on a tea plate bearing a printed cartouche mark including unclear initials, and with the impressed mark "DAVIES & CO.", usually attributed to the Tyne Main Pottery of Newcastle.

Mess Wares. *Bovey Pottery Co. Ltd. Printed cartouche frame with makers' initials. Mess bowl, diameter 6½ ins:16cm.*

Milkmaid. *Maker unknown. Unmarked. Teapot, overall length 9¾ins:25cm.*

Milkmaid (D247)

There has been much confusion caused by the use of this title for several similar patterns, each with a cow and milkmaid as the main feature. The title is correctly used for the original Spode pattern which utilises their Tower pattern border and was introduced c.1814. It is catalogued by Drakard & Holdway as P702 and shown by them on several different shapes. Spode examples are also illustrated in Coysh 2 100; Whiter 60 and 98-99; S.B. Williams 134-135.

The Spode pattern shows a girl wearing a hat and coat, kneeling to milk a cow. There are flowers in the foreground and to the right of the cow are two recumbent sheep, one white and the other black. The same basic design was copied with variations by several other potters, including:

(i) Davenport. Here the milkmaid has a hat but no coat, and two small plants grow between the cow and the sheep or lambs. Cups have a print of lambs inside. The border is similar though not the same as that used by Spode.

(ii) Belle Vue Pottery, Hull. This version was discovered when the site of the factory was excavated in 1970. The milkmaid wears a hat and the foliage behind the cow is more luxuriant. The border has large flowers against a dark ground. Ill: Lawrence p.160.

(iii) Don Pottery. There are no available illustrations of this version, but Lawrence states that the pattern was used by this Yorkshire firm.

(iv) Thomas Rathbone & Co., Portobello. Excavations on the site of this pottery revealed shards with a Milkmaid pattern, and also of a pattern titled ''Font'' which is a copy of Spode's Girl at the Well design. It appears that both were modified forms of the Spode patterns. Unmarked versions of the Milkmaid pattern thought to originate from this pottery are illustrated opposite and in FOB 39 and 41.

(v) Makers unknown. Unmarked versions differing in several respects turn up fairly frequently. The cow is spotted; the kneeling milkmaid has abandoned her stool which lies on the ground; she rests on her heels and has a small hat but no coat. In the background is a thatched cottage to the left, a mature tree behind the cow, and a church spire to the right. Cups have a print of a cottage inside. The border has fewer flowers than the Spode version and they appear on trailing sprays with serrated leaves on a dark ground.

These patterns were clearly very popular, perhaps because it was a typical country scene, and in the first half of the 19th century many cottagers kept a cow. The subject may have been inspired by *The Dairyman's Daughter*, a novel by a Bedfordshire clergyman which is said to have sold two million copies.

136

Milkmaid. *Maker unknown. Unmarked. Tea cup, diameter 4 ¾ ins:12cm.*

Milkmaid. *Maker unknown. Unmarked. Tea cup, height 2 ¼ ins:6cm.*

Milkmaid. *Attributed to Thomas Rathbone & Co. Unmarked. Teabowl and saucer, diameter of saucer 5 ½ ins:14cm.*

"The Miller" (D247)
See: "The Progress of a Quartern Loaf".

Milsey (New)
An old-fashioned name for a small circular strainer, sometimes with handle, designed to rest on a tea cup, two examples of which are illustrated here. Before the days of refrigeration milk was often boiled to keep it from turning sour. A skin would form on its surface and the milsey was used to strain this off when adding the milk to the liquid tea. The word is believed to be a contraction of milk-sieve, and was also used for larger strainers where a cloth was used. James Thomson is attributed with writing in 1801: "It minds me o' a milcie-clout, nae sooner filled than it runs out".

"Minaret" (New)
Maker unknown. A pattern featuring an exotic bird with long tail feathers flying over two tall buildings which are repeated in oval reserves within a geometric border.

"Ming" (New)
T.G. Green & Co. A dark blue romantic-style pattern.

This pattern was almost certainly named after the famous Ming dynasty in China, which lasted from 1368 to 1644.

"The Minstrel" (New)
Maker unknown with initials I.W. A borderless pattern with a title mark incorporating the unidentified maker's initials I.W.

Minton Miniature Series (D249)
Minton. Previously recorded views illustrated in this volume are:
 "Abbey Mill" *
 "Kenelworth Priory" *
 "Tewkesbury Church" *
Additional untitled views are:
 Asgill House, Richmond
 Brandenburg House
 All the views listed in the *Dictionary*, together with the source prints where known, are illustrated in Milbourn 99-125. The two untitled views listed above are both taken from Cooke's *Views on The Thames* where the two prints are titled Brandenburg House and Villa at Richmond, subsequently identified as Asgill House. There were two editions of the book, published in 1811 and 1822, and whereas the Villa at Richmond view appears in both, the view of Brandenburg House is only in the 1811 edition. The source print for "Lechlade Bridge" appears only in 1822.

Milsey. *Makers unknown. Two unmarked strainers. Diameters 3¾ ins:9cm and 3¼ ins:8cm.*

138

Mirror Transfers. *James & Ralph Clews. Impressed "CLEWS'S WARRANTED" circle mark. Miniature plate 3½ ins:9cm.*

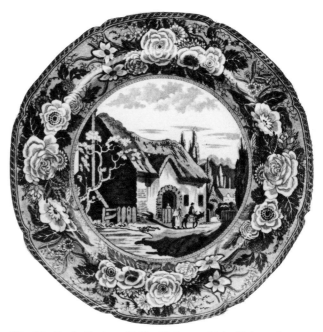

Monk's Rock Series. *Unidentified scene (xiv). Maker unknown. Unmarked. Plate 8¾ins:22cm.*

Mirror Transfers. *Maker unknown. Unmarked. Miniature plate 3¾ins:9cm.*

Mirror Transfers (New)

On cup plates destined for the American market, James & Ralph Clews often printed two halves of the plate with two clipped portions of a larger print in mirror image. The results are sometimes referred to as either mirror transfers or double transfers. Several examples can be seen in David & Linda Arman's *Historical Staffordshire: An Illustrated Check-List, First Supplement* (1977), Richard and Virginia Wood's *Historical China Cup Plates* (n.d.), and P. Williams p.617. They include patterns from the Doctor Syntax and "Wilkie's Designs" Series in addition to some American views.

The technique was not limited to American cup plates, and the small Clews plate illustrated above is known to be from a toy dinner service. Another similar small dish can be seen in Little 21, and both these pieces appear to be derived from the Foliage and Scroll Border Series. Another unmarked toy plate illustrated here shows signs of the same technique, and since the only recorded examples are by Clews, this may also be one of their products.

"Mogul" (D250)

The name Mogul is an Arabic or Persian form of Mongol, usually applied to the Mohammedan empire in India founded in 1526. The emperors of Delhi were styled the Great Moguls and the empire came to an end after the Indian Mutiny of 1858. The last Mogul Emperor died in imprisonment at Rangoon in 1862.

Monk's Rock Series. *Unidentified scene (v). Maker unknown. Unmarked. Plate 7½ins:19cm.*

Monk's Rock Series (D250-251)

Maker unknown. Additional scenes are:

(xi) A Welsh barn with a fence and a covered cart. Ill: FOB 53.

(xii) Castle Gateway. Bourdaloue. Ill: Coysh 2 142.

(xiii) Thatched barn by a pond. Plate 6½ins:16cm.

(xiv) Thatched building with arched doorway. Plate 8¾ ins:22cm.

A jug with one of the unidentified views from this series is illustrated overleaf and a diamond shaped comport can be seen in FOB 40. Shaped wares such as these have a second border design which has helped to identify the Castle Gateway pattern listed above as part of this series. Three different size plates with the views numbered (v), (xiii) and (xiv), and a shell-shaped dessert dish printed with the Watermill scene (i), are also illustrated here and overleaf.

Monk's Rock Series. *Unidentified scene (xiii). Maker unknown. Unmarked. Plate 6½ ins:16cm.*

Monk's Rock Series. *Watermill scene. Maker unknown. Unmarked. Shell dessert dish 8½ ins:22cm.*

Monk's Rock Series. *Unidentified scene. Maker unknown. Unmarked. Jug 7¼ ins:18cm.*

"Mosque &c nr. Benares". *Maker unknown. Parrot Border Series. Printed title mark. Tureen stand 8½ ins:22cm.*

"Morea" (D252)

Several examples of the second pattern by an unknown maker have now been recorded marked with an impressed monogram usually ascribed to Thomas Dimmock & Co.

Mosaic (D253)

This is one alternative name for the Spode sheet floral pattern catalogued by Drakard & Holdway as Marble (qv). It is sometimes also known as Cracked Ice and Prunus.

"Mosque &c nr. Benares" (New)

Maker unknown. Parrot Border Series. Tureen stand, soup plate, and plate 8½ ins:22cm.

Benares is on the north side of the Ganges. "Its appearance from the water is very beautiful; several Hindoo temples embellish the bank of the river, and many other buildings, both public and private, are magnificent... The people most pertinaciously guard against interference from foreigners" (Walker, 1810).

"Moxhull Hall, Warwickshire" (New)
Maker unknown. Crown Acorn and Oak Leaf Border Series. Sauce tureen. Ill: FOB 39.

Moxhull Hall was a house built in the Italian style 4½ miles NNW of Coleshill. It was demolished early in the 1920s.

"Muleteer" (D255)
This title by Davenport covers a series of patterns, mostly featuring the same figures, a muleteer with two aproned women and a child, within a scene showing a Gothic spire and tower with a village beside a lake. Scenes include:

(i) The muleteer mounted preceded by a dog. A waterfall flows from the lake, with the two women standing by the shore. Mug. Ill: Coysh 1 35.

(ii) The muleteer stands with the two women and child. The mule is by the lakeside with another adult and child. Dish 15ins:38cm.

(iii) The mounted muleteer has left the women and proceeds towards the village. Child's chamber pot. Ill: Lockett 28.

(iv) The muleteer and two women walk with the mule alongside a wall by the waterfall. Plate. Ill: P. Williams p.347.

Another scene is illustrated on an unmarked pepper pot (see Colour Plate XVI).

The wares are normally marked with the series title and the maker's name in a scroll cartouche featuring two cornucopia, and sometimes bear date marks, the earliest so far noted being 1836, although the much later example illustrated here is for 1852. Rare items are known with blue borders but black printed centres; four pieces from a dinner service which was supplied in 1840 and priced originally at £37 7s are illustrated in Godden I, Colour Plate V, along with the original invoice on p.116.

It is possible that the various scenes are based on Thomas Morton's play *The Muleteer of Toledo* which became very popular in the middle of the 19th century. It eventually had its London premiere on 9th April 1855 at the Princess's Theatre.

"**Muleteer**". *Davenport. Printed series mark.*

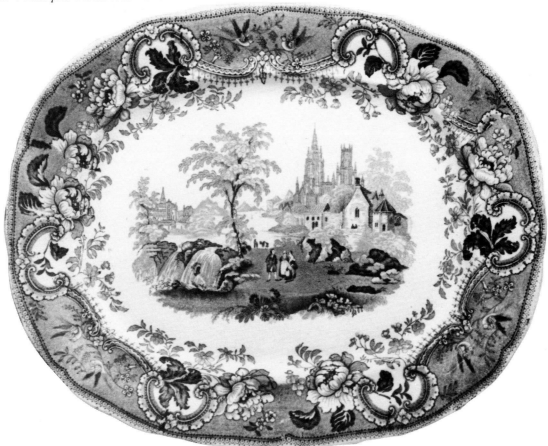

"**Muleteer**". *Scene (ii). Davenport. Printed series title and maker's mark and impressed maker's anchor mark for 1852. Dish 15ins:38cm.*

Mushroom Picker (D255)
This pattern by Herculaneum is illustrated here on a dessert plate marked with an impressed liver bird. It has previously only been recorded on teawares.

Musicians (New)
A rare Spode pattern featuring various musicians catalogued by Drakard & Holdway as P706 and shown by them on a basin, ewer, and candle extinguisher tray in S171, S172, and S197. Parts of the design are also shown on the lid from a toilet box in Coysh 2 86, and on a small covered pot in Whiter 64 where it is called Village Scene. An enamelled version of the central scene with pattern number 4207, dating from about 1826, can be seen in Whiter 115.

Drakard & Holdway state that the pattern has been discovered only on toilet wares but that other shapes may have been used. This can now be confirmed by the marked broth bowl, cover and stand (trembleuse) illustrated here.

Mushroom Picker. *Herculaneum. Impressed liver bird. Plate 8½ ins:22cm.*

Musicians. *Spode. Printed ''SPODE'' on all pieces. Broth bowl cover and stand (trembleuse). Stand 6¾ ins:17cm.*

''Musque of Mustopha Khan, Beejapore'' (sic) (New)
Thomas & Benjamin Godwin. Indian Scenery Series. Dish 14¼ ins:36cm and tureen stand.

Bijapur, to give it the modern name, is in the state of Bombay. It was here in A.D. 1490 that Yusaf Khan established the Adil Shah dynasty of Bijapur kings. The town contains one of the finest collections of Muslim ruins in India. The great hall, the mausoleum of Mohammed Adil Shah (1826-1856), is reputed to be the largest domed space in the world after St. Peter's in Rome.

''Mycene'' (New)
Hulse, Nixon & Adderley, and their successor William Alsager Adderley. A collection of romantic scenes which all contain a prominent two-handled vase. This also appears in the printed mark with the title ''MYCENE'' on its plinth and the initials H.N. & A. or W.A.A. beneath. The designs were also printed in sepia, and combinations of colours such as blue and red. Ill: P. Williams p.73; Williams & Weber pp.516-517.

Mycene, in Greece, was at one time the capital of the kingdom of Morea, but by the 19th century it had declined to become no more than a small village.

Named Italian Views Series (D256)

Don Pottery. One previously recorded view is illustrated in this volume:

"Grotto of St. Rosalie near Palermo" * (see: Pickle Set)

An additional view is:

"Port of Alicata" *

It has not yet proved possible to confirm the existence of the view previously listed as "Port of Ansetta".

Detailed research work carried out by Judith Busby and the late David Evans has now identified the source of the views in this Don Pottery series as *Voyage Pittoresque ou Description des Royaumes de Naples et de Sicile* by the Abbé Jean Claude Richard de St. Non, published in five folio volumes in Paris between 1781 and 1786. A detailed article on this subject by David Evans appeared in FOB 43, and several of the views are illustrated in FOB 39.

See: Pickle Set.

"Napier" (D257)

There were many distinguished men with this name in the 19th century but the pattern title was probably inspired by Admiral Sir Charles H. Napier (1786-1860). He served in the West Indies, the Mediterranean, and the Azores, and was appointed Admiral of the Portuguese fleet in 1833, later being hailed as the Liberator of Portugal. In 1839 he commanded the troops as well as the naval forces in the Levant against Mohammed Ali, and despite being censured for his conduct off Acre, he was knighted in 1840. He became an M.P. in 1841, a Vice-Admiral in 1853, and Admiral in 1858.

"Ne Plus" (New)

Thomas Fell & Co. A typical romantic-style pattern titled in a cartouche with the makers' initials T.F. & Co. Examples with an impressed anchor with "FELL & Co." above have been noted.

The motto means: No more.

"Neapolitan" (New)

Thomas Dimmock & Co. A pattern recorded on a wash bowl marked with a cartouche in the form of a vase including the body name "Stone Ware" and the maker's initial D. Ill: Williams & Weber p.67.

Neapolis was the ancient name for Naples in Italy. A Neapolitan is an inhabitant of the city, but the word is also used to describe colours and flavours, e.g. Neapolitan ice cream.

"Near Caernarvon" (D259)

See following entry.

"Near Carnarvon" (sic) (New)

Maker unknown. Beaded Frame Mark Series. Vegetable dish and sauce tureen.

This is the correct title for the entry which appeared in error in the *Dictionary* as "Near Caernarvon".

Near Currah, on the River Ganges (New)

An aquatint published in November 1796 in Thomas Daniell's *Oriental Scenery* (Part I, 21). It was used by the Leeds Pottery as the basis for one pattern, illustrated here on a small tea plate.

Currah, or Kara, was a sacred place of the Hindus but was taken by the Moslems in 1194. It became the seat of government until the fort and city of Allahabad was built in 1583.

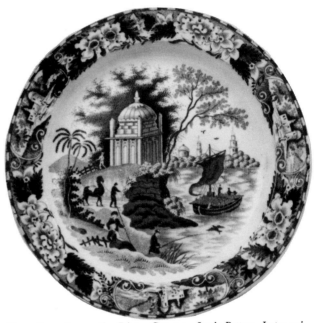

Near Currah, on the River Ganges. *Leeds Pottery. Impressed "LEEDS POTTERY" twice in a cross. Plate 6¼ ins:16cm.*

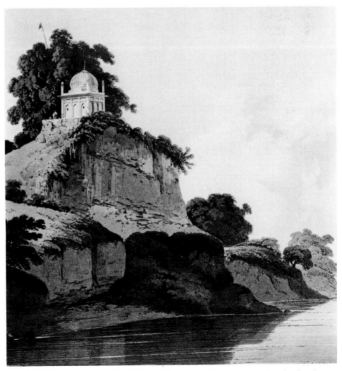

Near Currah, on the River Ganges. *Source print for the Leeds Pottery view taken from Thomas Daniell's "Oriental Scenery".*

"Netley Abbey". *Attributed to William Mason. Unmarked. Plate 10 ¼ ins:26cm.*

"Netley Abbey". *Source print used by William Mason and Andrew Stevenson taken from Britton & Brayley's "The Beauties of England and Wales".*

"Near Highgate Rd." (New)

Goodwins & Harris. "Metropolitan Scenery" Series. Dish.

The area near Highgate Road in north London was marked by much building activity in the period between 1790 and 1830. Several new terraces were erected, the most notable being Grove Terrace. Pevsner describes the dwellings as "with much variety in detail, and nice staircases, plasterwork and fireplaces inside".

Net Pattern (D259)

The Spode version of this pattern is catalogued by Drakard & Holdway as P620. It is also illustrated in Copeland pp.90-91; Coysh 1 114; Whiter 21; S.B. Williams 87 and 123-125.

The Herculaneum version was used as the basis for armorial wares supplied to the Liverpool Corporation. See: "Deus Nobis Haec Otia Fecit".

"Netley Abbey" (D259-260)

The view by an unknown maker in the Beaded Frame Mark Series appears on a sauce tureen stand which matches the sauce tureen with the view of "Near Carnarvon" (sic).

The untitled views by William Mason and Andrew Stevenson which were listed separately are, in fact, the same. There is no convolvulus in the Mason border. They are both based on a print in *The Beauties of England and Wales* subtitled "View towards the East from the Transept" and not "The Chapel and South Transept" as originally stated. It was drawn by Francis Nicholson and engraved by James Storer, and is illustrated here together with an unmarked plate.

Nettle (New)

A title adopted by Drakard & Holdway for a newly discovered Spode chinoiserie-style floral pattern which they catalogue as P826. They consider that the pattern may have been engraved to print replacements for an original Chinese service.

Newstead Abbey, Nottinghamshire (New)

An untitled view of this house has been identified on a jug printed with the Royal coat-of-arms and the wording "Imperial Measure" (qv). See also D263.

Nicholson, Francis (New)　1753-1844

Born in Yorkshire, Francis Nicholson became a drawing master and travelled on sketching tours throughout Britain. He produced many topographical views, including examples for *The Beauties of England and Wales*.

Nicholson, Thomas, & Co. (New)　fl.c.1854-c.1869

Mere Pottery, Castleford, Yorkshire. This trading style was adopted by the partners Thomas and Richard Nicholson and Thomas Hartley when they succeeded the earlier firm of Nicholson & Wood. According to Lawrence the partnership was dissolved in January 1865, but it appears that the trading style remained in use for a short time. Marks included initials T.N. & Co. / C. The firm produced the "Wild Rose" pattern.

"No." Marks. (New)

Some potters chose to identify their patterns by a number rather than a title, and such numbers occasionally appear in printed marks. One example frequently encountered is a romantic scene by an unknown maker which is marked "No. 67" in a scroll cartouche. Another example illustrated here is strange in that the mark has "No." but with no actual number included. The basic form of this crown and garter mark was often used by John Ridgway, but other similar examples have been noted with the initials of the Bovey Tracey Pottery Co., so this piece cannot be attributed with certainty.

A printed cartouche mark used by Minton & Co. for their floral pattern titled "Fuchsia" also incorporates "No." with no actual number appended.

"Non Pareil". *T.J. & J. Mayer. Impressed oval makers' lion mark. Miniature dished plate 4 ¾ ins:12cm.*

"No." Marks. *Maker unknown. Printed mark with crown above garter containing "No.", and "IRON STONE CHINA" on a ribbon beneath. Dish 13 ¼ ins:34cm.*

"Non Nobis Domine" (New)
Rare blue-printed examples of the Herculaneum scene of View in the Fort, Madura, are known with the text and music for Psalm 115 "Non Nobis Domine" printed in puce on the base. The title translates to Not for Ourselves, O Lord.

"Non Pareil" (D264)
A second potter used this title:
(ii) T. & J. Mayer. A series of romantic scenes, featuring different mosques or temples with figures in the foreground, within a border of fern-like fronds. The title "NON PAREIL" is printed in a cartouche supported by the figure of Britannia with an armorial leopard above and the potters' name and address "T. & J. MAYER / LONGPORT" below. The designs were produced in blue, brown, green and sepia. Ill: P. Williams p.350; Williams & Weber pp.611-612.

The French phrase non pareil, literally meaning none similar, was originally used for a printing typeface, referring to the exceptional skill required for the final cutting of so small a character. It came to mean unrivalled, or unique, and was used by the potters to indicate that their wares were of the highest quality.

Northcote, James (New) **1746-1831**
A painter and author who originally lived in Plymouth and was apprenticed to a watchmaker. He moved to London in 1771 and became assistant to Sir Joshua Reynolds. Following a visit to Italy where he studied old masters, he returned to a successful career, being elected R.A. in 1787. He specialised in animal painting and produced a book called *One Hundred Fables*, which he illustrated with 280 wood engravings of animals and country scenes.

The figures which are grouped in the foreground of a view of "Compton Verney" in the Fruit and Flower Border Series by Henshall & Co. are taken from a Northcote painting titled "Grouse Shooting in the Forest of Bowland".

"Norwich Cathedral, Norfolk" (D264)
The dish from the "Picturesque Scenery" Series by Ralph Hall is illustrated in Colour Plate XXI.

"Oakle Street Hotel" (New)

An inscription printed in black within an oval surround noted on a quart jug printed in pale blue with a "Genevese"-style pattern.

It has not proved possible to trace the hotel but the hamlet of Oakle Street lies about six miles to the west of Gloucester. Streets of the same name also exist in Churcham and Minsterworth, both in the same area between Oakle Street itself and Gloucester.

"Oatlands, Surrey" (D265)

The owner of Oatlands was, in fact, Edward Ball Hughes, who was known as the Golden Ball. He married a Spanish dancer who left the King's Theatre just before a performance. Two lines by Henry Harrison Ainsworth sum up this dramatic event:

"The Damsel is gone; and no wonder at all
That, bred to the dance, she is gone to the Ball"

"Observatory, Oxford" (D265)

The vegetable dish from the Oxford and Cambridge College Series by John & William Ridgway is illustrated here.

Ointment Pot (New)

A small pot used by doctors, chemists and apothecaries for the supply of various patent or proprietary ointments. They usually bear appropriate inscriptions printed in black, but one blue-printed example made to contain a product called "Poor Man's Friend" (qv) has been noted.

"**Observatory, Oxford**". *John & William Ridgway. Oxford and Cambridge College Series. Printed title and makers' mark. Vegetable dish and cover, 9½ins:24cm.*

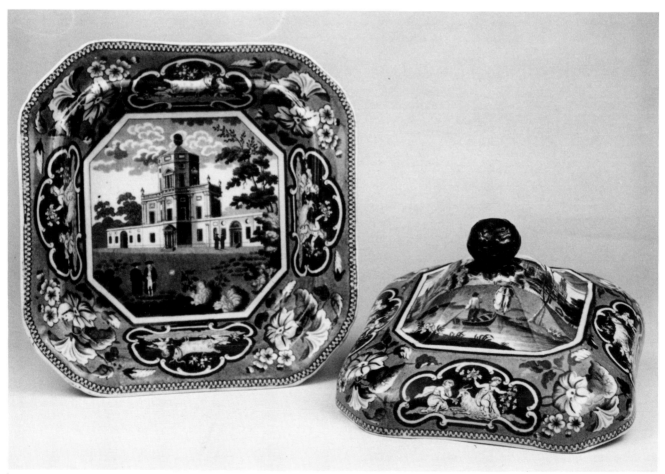

"Old Mortality" (New)

Davenport. "Scott's Illustrations" Series. Sauce tureen stand 7½ins:19cm. Ill: M. Pulver, "The Scott's Illustrations Series by Davenport", *Antique Collecting*, March 1986.

Old Mortality was the second of Sir Walter Scott's *Tales of My Landlord*, published in 1816. The title is the nickname of Robert Paterson, a Scot who cared for the graves of the Cameronian Covenanters at the end of the 18th century.

"Old Octagon" (New)

An impressed name recorded on a drainer from the "British Scenery" Series (qv). Its significance is not yet known, although it is probably a trade name.

Old Peacock (D265)

This title is used for a Spode Oriental-style floral pattern by Whiter and also by Drakard & Holdway who catalogue it as P624. The use of the name can be traced back to S.B. Williams. However, Copeland prefers to use it for a different unmarked pattern which itself is titled Oriental Birds (qv) by Drakard & Holdway, and he calls this design Phoenix (see Copeland pp.152 and 154). It is also illustrated in Coysh 2 87; Whiter 25; S.B. Williams 130.

"Olympic Games" Series (D265)

Thomas Mayer. Additional sports are:
 "The Charioteers"
 "Running"

Opium Smokers (D266)

A rare marked sauce tureen with this pattern is illustrated here together with an unmarked dinner plate.

"Orielton, Pembrokeshire" (D266)

A moulded dessert dish from the Large Scroll Border Series is

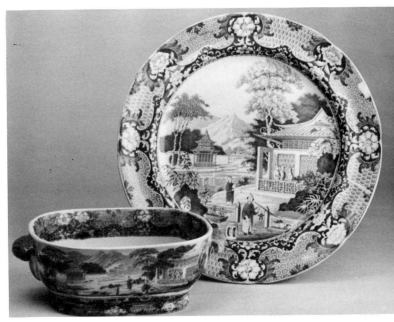

Opium Smokers. C.J. Mason & Co. Printed mark "MASON'S / SEMI-CHINA / WARRANTED" on tureen only. Sauce tureen, length 7¼ins:19cm, and plate 10ins:25cm.

illustrated here. This is one of the examples where the name "RILEY" has been replaced by "WARRANTED" in the printed title mark, so it may not be of Riley manufacture.

The view by Enoch Wood & Sons in their Grapevine Border Series seems to have been reserved for use on large items, since it has also been recorded on a water cistern and a bidet (see Colour Plate I). Ill: FOB 37.

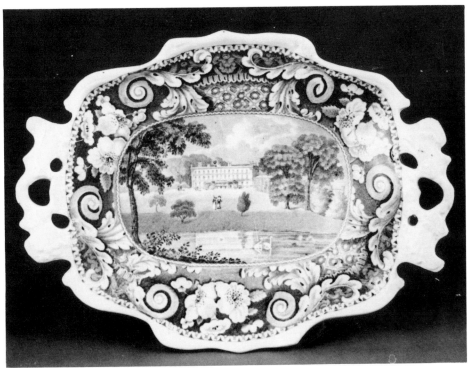

"Orielton, Pembrokeshire". Maker unknown. Large Scroll Border Series. Printed title mark with "WARRANTED". Moulded dessert dish 11½ins:29cm.

"Orient" (New)

Middlesbrough Pottery. This pattern is marked with the title and the name of the pottery around a cartouche showing a vignette of the potbanks.

"Oriental" (D266)

Three other potters used this title:
 (iv) William Adams.
 (v) Don Pottery.
 (vi) W.T. Holland, South Wales Pottery.

"Oriental Barge" (New)

Maker unknown. A title which is recorded on dinner wares marked with a cartouche including the trade name "OPAQUE CHINA".

"Oriental Beauties" (D266)

This pattern by Jones is very similar to the common "Chinese Marine" designs. A vegetable dish and cover, together with the printed cartouche mark, is illustrated by Williams & Weber pp.109-110.

Oriental Birds (New)

An adopted title for a pattern featuring two large birds which is attributed to Spode and catalogued by Drakard & Holdway as P633, who also show it on an oval dish in S84. Copeland prefers to switch the two titles Oriental Birds and Old Peacock (q.v.) and calls this design Old Peacock (see Copeland pp.152 and 154).

"Oriental Scenery" Series (D267)

Previously recorded views from the series by John Hall & Sons illustrated in this volume are:
 "Ghaut of Cutwa" *
 "Mahomedan Mosque & Tomb" (sic) *
 "Tomb of the Emperor Shah Jehan" * (Colour Plate XXVII)

A typical printed cartouche mark is illustrated below. It is of the same form as the mark found on the other series of the same title, except for the presence of the makers' name.

Additional views in the second series by an unknown maker are:
 "Hindoo Pagodas"
 "Luckuow" (sic)
 "Mahomedan Mosque and Tomb" (sic)
 "Sacred Tank & Pagodas near Benares" *
 "A Village on the Ganges"

In addition, the title previously listed as "Tomb of the Emperor Acber" was incomplete, and should read "Tomb of the Emperor Acber at Secundra" (sic).

A soup tureen with the view "Mahomedan Mosque and Tomb" has been noted with an impressed crown flanked by the initials G.R., a mark which has been attributed to John Meir. The series was also printed in brown.

Detailed research by Pat Latham reported in FOB 47 has identified three sources for these views: C.R. Forrest's *A Picturesque Tour Along the Rivers Ganges and Jumna in India* (1824), Thomas and William Daniell's *Oriental Scenery* (1795-1808), and William Hodges' *Travels in India* (1786). These source books were also used by other potters for similar views, including the Parrot Border Series as well as the Indian Scenery Series first produced by Thomas & Benjamin Godwin.

"Oriental Shells" (New)

Hicks, Meigh & Johnson. An open floral pattern with boats and shells recorded on a bowl 10¾ins:27cm.

"Oriental Sports" (D267-268)

This title is found on two different printed marks which appear on copies of Spode's Indian Sporting Series scenes. The dish which is illustrated here with the scene showing a Battle Between a Buffalo and a Tiger bears one of these together with an impressed mark of Edward Challinor of Burslem. Note that this mark features the royal initials G.R. which do not appear in the second mark, which is otherwise broadly similar. Wares with this second mark were probably made by some other maker, as yet unknown. An engraver's error has been noted on one mark titled "ORIENTAL SPORT", without the final S.

"Orissa" (New)

Davenport. A romantic pattern including a vase of flowers.

Orissa was the name of a province of Hindoostan, one district of which was closely connected with the East India Company. It was badly hit by famine in 1866 when a million people died.

Ornate Pagodas (D267-268)

A dish with this pattern has been reported with the unidentified impressed initials T.H. & Co., which have been attributed to Taylor, Harrison & Co. of Castleford.

Ornithological Series (D267-268)

Andrew Stevenson. Additional patterns are:
 Grouse. Plate 6¼ins:16cm. Ill: FOB 42.
 Stone Curlew, Pied Flycatcher and Snipe. Plate 8½ ins:22cm.
 Turkey and other birds. Dish.
 Woodcock. Plate 7½ins:19cm.

"Ornithology" (New)

John Meir & Son. A series of patterns featuring birds, examples of which have been reported on a meat dish and matching drainer, a large water jug, and a covered sugar bowl. Ill: P. Williams p.652.

Osterley Park (D269-270)

The view by Goodwins & Harris in the "Metropolitan Scenery" Series has now been recorded with the title "Osterley Park" within the usual series cartouche.

"Oriental Scenery". *John Hall & Sons. Typical printed mark.*

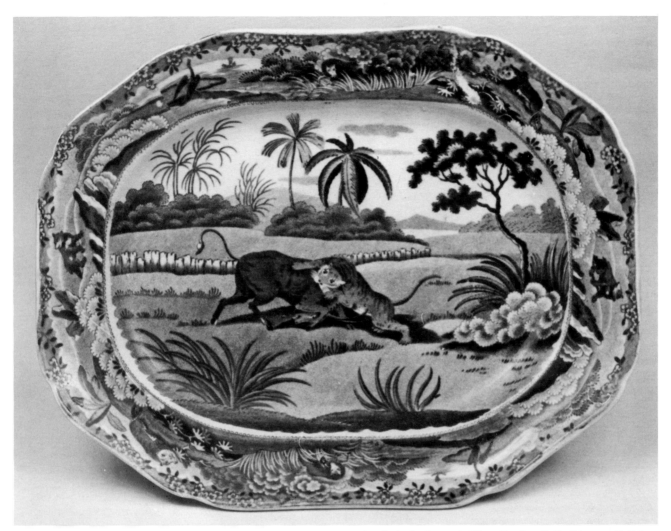

"Oriental Sports". *Edward Challinor. Printed series title mark and impressed maker's circular mark. The subject is a Battle Between a Buffalo and a Tiger. Dish 9¾ ins:25cm.*

"Oriental Sports". *Edward Challinor. Printed series mark with impressed maker's mark and the royal initials G.R. on dish above.*

"Oriental Sports". *Maker unknown. Printed series mark.*

Ottoman Empire Series (D270)

Maker unknown. Previously recorded views illustrated in this volume are:

"Ciala Kavak" * (not Cialka Kavak as previously listed)
"Tchiurluk" *

An additional view is:

"Caravansary at Kustchiuk Czenege"

An unidentified and untitled view is illustrated here on a sauceboat.

Recent research, based particularly on shapes, has suggested that this series may have been made by John & William Ridgway. A detailed article on this topic by Doreen Otto can be seen in FOB 35.

Overseas Dealers (New)

Printed wares specifically ordered by overseas customers are sometimes found with special retailers marks. Examples recorded include:

F.J. Blair, Milwaukee, U.S.A.
David Brandon, Kingston, Jamaica
John Greenfield, New York, U.S.A.
Henderson & Gaines, New Orleans, U.S.A.

J.C. Huntington & Co., Cincinnati, U.S.A.
T.T. Kissam, New York, U.S.A.
John Y. Rushton, Philadelphia, U.S.A.
Stiffel Brothers, Odessa, Russia
Wright & Pike, Philadelphia, U.S.A.
Gebr. Zwakenberg, Holland

Similar marks with names which relate either to the customer or some business partner rather than a retailer include:

Almacen de Gamba y Co., Habana, Cuba
J.B. Cappellemans Aîné, Brussels, Belgium

"Oxford" (D270-271)

The view in the "River Thames" Series by Pountney & Allies and Pountney & Goldney was also used for a chocolate pot, illustrated in Colour Plate IV.

Oxford and Cambridge College Series (D271)

John & William Ridgway. One previously recorded view is illustrated in this volume:

"Observatory, Oxford" *

Ottoman Empire Series. *Unidentified view. Maker unknown. Unmarked. Sauceboat, length 6½ ins:17cm.*

Colour Plate XIX. "May Morn". *J. & M.P. Bell & Co. Printed title in floral creeper cartouche. Wash jug, height 12¼ ins: 31cm.*

Pagoda (New)
A factory title listed by Una des Fontaines in her paper "Wedgwood Blue-Printed Wares 1805-1843" for the Wedgwood pattern illustrated below on a dessert plate. It is known to have been in production by 1812 and was also printed on bone china tewares.

A pagoda was originally a Chinese or Indian sacred building, usually in the form of a tower, but the word has become commonly used to describe an ornate imitation of such a building.

"Pagoda in the Montpellier Gardens" (D272)
It is perhaps relevant to record that there were once Montpellier Gardens in Cheltenham, opposite the Spa built for Henry Thompson by George Allan Underwood in 1817 and now occupied by Lloyds Bank. The gardens were laid out by Underwood in 1825. However, there appears to be no record of a pagoda there, and the subject of this pattern is still in doubt.

Pagoda. *Wedgwood. Impressed "WEDGWOOD". Dessert plate 7¼ins:18cm.*

"Pagoda below Patna Azimabad" (D272)
A second potter used this scene:
(ii) Thomas & Benjamin Godwin. Indian Scenery Series. Dish. Ill: FOB 47.
Patna, the capital of Bihar in India, lies on the River Ganges 300 miles north west of Calcutta. It was given the name Patna Azimabad by the Emperor Aurangzeb (1659-1707) in honour of his grandson Azim.

"Pagodas near Barrackpore" (New)
Maker unknown. Parrot Border Series. Dish 12¾ins:32cm and footed comport 12½ins:32cm. Ill: FOB 47.
Barrackpur (the modern spelling) is in Bengal, the eastern province of India, and lies on the Hooghly river some 15 miles north of Calcutta.

Paint Palette (New)
An unusual blue-printed palette has been noted in the form of a set of six stacking cylindrical dishes which could be taken apart to provide small containers for the paints. The pattern, mainly geometrical with a few scrolling motifs, has also been noted on a toast rack.

"Palace of the King of Delhi" (D272)
A second potter used this title:
(ii) Maker unknown. Parrot Border Series. Handled sauce tureen. Ill: FOB 38.

"Palestine" (D272)
This pattern title was used by Ralph Stevenson for a series of chinoiserie patterns printed in dark blue. Two plates together with the printed scroll cartouche mark are illustrated in Williams & Weber pp.116-117.

Palladian Porch (D273)
The source for the main building in this scene by an unknown maker has now been identified as a print of an Ancient Sepulchre near Macri taken from Luigi Mayer's *Views in the Ottoman Empire* (1803), the source used by Spode for the Caramanian Series.

Colour Plate XX. The Picnic. *Possibly Ridgway. Unmarked. Cream tureen, height 9½ins:24cm.*

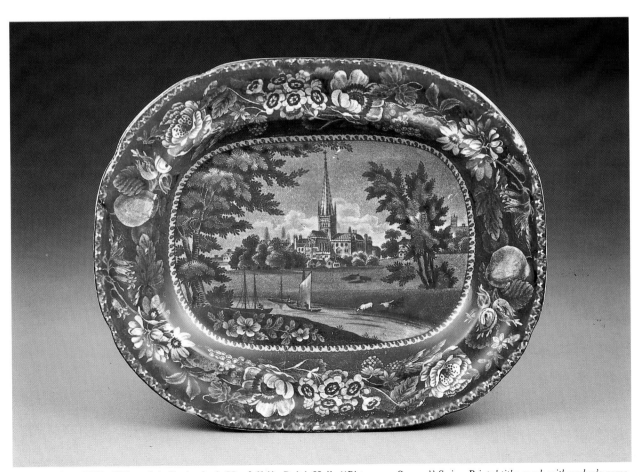

Colour Plate XXI. ''Norwich Cathedral, Norfolk''. *Ralph Hall. ''Picturesque Scenery'' Series. Printed titles mark with maker's name, and impressed ''HALL''. Dish 10¾ins:27cm.*

Pap Boat. *Wood & Challinor. Unmarked. Length 4½ ins: 12cm.*

"Pantheon" (New)

Ridgway & Morley. A series of typical romantic scenes, all including ruined temples. They are marked with a vignette of a temple entrance inscribed with the title "PANTHEON" in front of which is a fallen stone engraved "OPAQUE / CHINA" with the makers' initials R. & M. Ill: P. Williams p.361; Williams & Weber pp.614-615.

The title was clearly inspired by the famous temple erected in Rome by the Emperor Hadrian.

Pap Boat (D274)

A blue-printed pap boat of typical shape is illustrated here. This example is unmarked but is printed with the border from a series of continental views by Wood & Challinor which include "Lake of Como" and "Viege" (qv).

Parasol Figure (D274)

This Spode chinoiserie pattern is catalogued by Drakard & Holdway as P606. Whiter also uses the same name but Copeland prefers to call it Temple Landscape, variation Parasol (see Copeland pp.96-98). It is also illustrated in Whiter 5; S.B. Williams 102.

"Parma" (New)

Edward Challinor. A romantic scene with a detailed flowery border featuring four animal reserves showing goats, cows, deer, and ponies. The title appears in a scroll cartouche with the maker's initials E.C.

Parma was described in 1810 as a province of Italy "bounded on the north by the Po, on the north-east by the Mantuan, on the east by the Duchy of Modena, on the south by Tuscany and Genoa, and on the west side by the territory of Pavia. The soil is fertile in corn, wine, oil, hemp, chesnuts [sic] and fruits".

Parrot Border Series (D275-276)

Maker unknown. Previously recorded views illustrated in this volume are:

"Mausoleum of Kausim Solemanee at Chunar Gur" *
"Surseya Ghaut, Khanpore" *

Additional views are:

"Choura Jantely Berkham Pore"
"The Cuttera at Maxadavad" (sic) * (Colour Plate XI)
"Jungara Pagoda"
"Mosque &c nr. Benares" *
"Pagodas near Barrackpore"
"Palace of the King of Delhi"
"Part of the City of Maushadabad"

"Parma". *Edward Challinor. Printed title cartouche with maker's initials. Plate 9ins: 23cm.*

Parrot Border Series. *Maker unknown. Typical printed mark.*

"Tombs near Etaya"

In addition, the view previously listed as "Gateway & Tomb of Secundra" should read "Gateway & Tomb at Secundra". One untitled scene on the lid of a vegetable dish is illustrated in FOB 51, and the unidentified scene shown on a toilet box, D276, is now known to be the view listed above as "The Cuttera at Maxadavad". A typical printed mark is illustrated here.

Detailed research by Pat Latham reported in FOB 47 has identified three sources for these views: C.R. Forrest's *A Picturesque Tour Along the Rivers Ganges and Jumna in India* (1824), Thomas and William Daniell's *Oriental Scenery* (1795-1808), and William Hodges' *Travels in India* (1786). These source books were also used by other potters for similar views, including the two "Oriental Scenery" Series and the Indian Scenery Series first produced by Thomas & Benjamin Godwin.

"Part of the City of Maushadabad" (New)

Maker unknown. Parrot Border Series. Dish 16¾ins:43cm and drainer.

See following entry.

"Part of the City of Moorshedabad" (D275)

The size of the dish in the "Oriental Scenery" Series by an unknown maker is 12½ins:32cm. Ill: FOB 47.

The name of this city is spelt today as either Maishidabad or Murshidabad, but in earlier days it was Maushadabad or Moorshedabad. It lies a few miles north of Berhampur, west of the river Ganges.

Passion Flower Border Series (D277)

Maker unknown. One previously recorded view is illustrated in this volume:

"Leomington Baths" (sic) *

Additional views are:

"Ragland Priory"

"The Rookery" *

"Woburn Abbey"

The view titled "The Rookery" had previously only been recorded on a plate mismarked "Gubbins Hall".

Patterson & Co. (D278)

The firm operating under this name at the Sheriff Hill Pottery, Gateshead, actually continued until 1904, not the 1890s as previously stated.

Pavillion (sic) (New)

A factory title listed by Una des Fontaines in her paper "Wedgwood Blue-Printed Wares 1805-1843" for the Wedgwood pattern illustrated here on a small cup plate. It is known to have been in production by 1822 and precedes the more common but similar series of landscapes listed as the Blue Rose Border Series (qv).

"Peacock" (New)

Benjamin Godwin. A pattern reported on children's wares marked with the maker's initials B.G.

Pavillion (sic). Wedgwood. Impressed "WEDGWOOD". Cup plate 4¼ins:11cm.

"The Peacock and the Crane". Spode. "Aesop's Fables" Series. Printed titles mark with maker's name. Sauceboat, length 6½ins:17cm.

"The Peacock and the Crane" (New)

Spode/Copeland & Garrett. "Aesop's Fables" Series. Gravy boat. Ill: Sussman, Spode/Copeland Transfer-Printed Patterns, p.29.

The peacock and the crane met and the peacock erected his tail, displaying the gaudy plumage. However, the crane said it was a much nobler thing to be able to fly about the clouds than strut upon the ground.

By outward show let's not be cheated.

Pearl River House (New)

An alternative name for a Spode chinoiserie pattern catalogued by Drakard & Holdway as Trench Mortar (qv). It is also sometimes known as Malayan Village.

"Pekin" (D278)

Another potter used this title:

(v) Davenport. A flow blue floral pattern.

"Pelew" (D278)

This pattern was probably named after the Pelew Islands, a small group in the Pacific surrounded by a coral reef and forming part of the Caroline Islands. They are more commonly known today as the Palau Islands.

"Penelope Carrying the Bow to the Suitors" (New)

Joseph Clementson. "Classical Antiquities" Series. Rectangular octagonal bowl. Ill: FOB 48.

Along with other patterns from the series, this design is marked with a registration diamond for 13th March 1849.

Penelope was the wife of Ulysses, King of Ithica. When he did not return after ten years at the Trojan war, she was besieged by suitors who tried to persuade her of his death and vied for her favours. She promised to make her choice from them when she had finished work weaving a shroud for her father-in-law, Laertes, but they were continually frustrated by a lack of progress, since she worked at night to undo all that had been achieved in the day. After some 20 years' absence, Ulysses finally returned in disguise as a beggar just as Penelope was being forced to select one of the suitors. This she proposed to do by measuring their skill with a bow, but none of them had the strength to draw it. After their failure, Ulysses himself passed the test, and then turned the bow on the suitors and they were all slain.

"**Pheasant**". *Wood & Challinor. Printed vase with title on plinth and makers' initials in a Staffordshire knot beneath. Plate 10¼ ins:26cm.*

Peony (D280)
This title has also been adopted for a Spode sheet floral pattern which is catalogued by Drakard & Holdway as P808.

Peplow (D280)
This Spode floral pattern is catalogued by Drakard & Holdway as P812. It is also illustrated in Copeland p.151; Whiter 41.

"Persian Bird" (D282)
Another example of this Davenport flow blue design is illustrated by Williams & Weber p.374.

"Peruvian Hunters" (D282)
A dish in this series by Goodwin & Ellis is illustrated in FOB 39, together with a plate of similar design but with a different border by R.A. Kidston & Co.

"The Pet Goat" (New)
Maker unknown with initials E. & Co., possibly Elkins & Co. A pattern printed on teawares consisting of a girl with a goat against a background of trees within an octagonal reserve surrounded by a sheet pattern. The printed mark has the title "THE PET / GOAT" within a cartouche with the makers' initials E. & Co. beneath. A very similar pattern was made by Edge, Malkin & Co. with the title "Pet Goat" but with a different border. Ill: P. Williams p.554.

"Pheasant" (D282)
The Wood & Challinor pattern with this title is similar to the design used by Ridgway & Morley. It was previously only recorded in purple but is illustrated here on a blue-printed plate.

Phillips, Thomas, & Son (New) fl.c.1845-1846
Furlong Pottery, Burslem, Staffordshire. A firm known to have produced printed wares, including one pattern titled "Marino".

Phoenix (New)
An alternative name for a Spode pattern also known as Old Peacock (qv).

"Piccolo Bent" (D283-284)
The scene on the view in the Ottoman Empire Series is thought to be one of the ancient dams which lie to the east of Khaibar, 150km north of Medina in Saudi Arabia. They were built of granite blocks for flood control, and the largest of them is known as Sadd-el-Bent.

Pickle Set (New)
A set of small dishes for pickles, usually fitted into a larger dish. Two different pickle sets are illustrated here. One is by an unknown maker and consists of a handled dish fitted with four small corner dishes and a narrow central tray, all printed with The Beemaster pattern. The other is from the Named Italian Views Series by the Don Pottery and consists of a diamond shaped dish fitted with four small corner dishes designed to fit around a missing centrepiece.

"Pickwick" (New)

Thomas Fell & Co. A pattern reported on a cup and saucer which shows the Dickens character with another man seated at a table in the garden of a thatched house in front of a lake. The title appears in a printed mark together with the makers' initials T.F. & Co.

The Pickwick Papers narrate the comic adventures of four members of the Pickwick Club, Tupman, Winkle, Snodgrass, and Pickwick himself. They were illustrated by the young Hablot Knight Browne (known by the pseudonym Phiz), and first published in serial form between April 1836 and November 1837. The first volume edition also appeared in 1837.

"Pic-Nic" (New)

Maker unknown. A series of patterns printed in either blue or brown on dinner wares. The design on one large dish shows elegant ladies and gentlemen playing music and standing around with typical picnic food laid out on a cloth in the foreground. The soup plate bears a similar but simpler scene. The title is printed on a cartouche in the form of a picnic basket with what appears to be a pottery in the background.

The word "Pic-Nic", more usually written today as picnic, was derived from the 18th century French word piquenique.

The Picnic (New)

A title adopted here for a pattern illustrated on an unmarked cream tureen (see Colour Plate XX). This tureen is of an unusual shape, similar to one which has been noted with a view from the "British Scenery" Series. In the light of the fact that the latter is now attributed with some certainty to Ridgway, this pattern of The Picnic may also be a Ridgway product.

Pickle Set. *Don Pottery. Named Italian Views Series. Central scene is "Grotto of St. Rosalie near Palermo". Impressed "C.v." on various pieces. Length of dish 11½ ins:29cm.*

Pickle Set. *Maker unknown. The Beemaster pattern. Unmarked. Length of dish 11¼ ins:29cm.*

"Picturesque Asiatic Beauties" (D283)
This pattern by Jones was also printed in brown.

"Picturesque Scenery" Series (D285)
Ralph Hall. Previously recorded views illustrated in this volume are:
"Dreghorn House, Scotland" *
"Llanarth Court, Monmouthshire" *
"Norwich Cathedral, Norfolk" * (Colour Plate XXI)

Pineapple Border Series (D285)
Maker unknown. Previously recorded views illustrated in this volume are:
"Caerfilly Castle, Glamorganshire" *
"Kirkham Priory Gateway, Yorkshire" *
"Roche Abbey, Yorkshire" *
"Slingsby Castle, Yorkshire" *
"Valle Crucis Abbey, Wales" * (Colour Plate XIII)
An additional view is:
"Wenlock Abbey, Shropshire" *
A further untitled view which is thought to show Tintern Abbey has been reported on the lid of a soup tureen.

Pinwheels (New)
A name adopted by American collectors for a version of the Tendril pattern featuring several large idealised circular flowerheads. A sauceboat with an ochre rim is illustrated here, and a segment from a supper set can be seen in FOB 43.
The name is derived from the similarity of the flowerheads to the American fireworks called pinwheels, known as Catherine wheels in England.

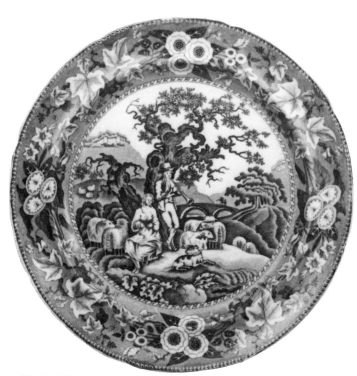

Piping Shepherd. Maker unknown. Unmarked. Plate 9¾ins:25cm.

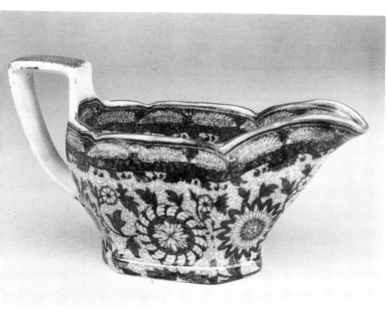

Pinwheels. Maker unknown. Unmarked. Sauceboat with ochre rim. Length 6¾ins:17cm.

Piping Shepherd (D285)
This pattern is illustrated here on an unmarked dinner plate. No further marked examples have yet emerged.

"Plas-Newydd, Wales, Marquess of Anglesey's Seat" (New)
Careys. Titled Seats Series. Dish, approximately 18ins:46cm.

"The Ploughman" (New)
See: "The Progress of a Quartern Loaf".

Plymouth Pottery (D286) fl.c.1810-1863
Sutton Road, Cattedown, Plymouth, Devon. This pottery was in Coxside, next to the gas works in Sutton Road. It was operated by William Alsop until 1852 when directories indicate that it was owned by William Bryant & Co. Few marked pieces have been traced but an early blue printed teapot with a version of the Elephant pattern has been noted with the impressed mark "PLYMOUTH POTTERY" in a small circle, and a "Wild Rose" pattern dish in Plymouth Museum bears an oval mark with "P.P. Coy. L. STONE CHINA" surrounding a Victorian Royal coat-of-arms. Details of the pottery are given in an article by Norman Stretton: "Plymouth and its Potteries in the 19th Century", *Antique Collecting*, October 1982.

"Polesden, Surrey" (New)
William Adams. Flowers and Leaves Border Series. Plate.
Polesden, known as Polesden Lacey today, was a Regency villa built by Joseph Bonomi under the supervision of Thomas Cubitt in 1824. Since then it has been considerably altered with the addition of many Edwardian features. It lies near the village of Great Bookham, about five miles west of Leatherhead, and is now owned by the National Trust.

"Polish Views" (D286)

Edward & George Phillips. An additional scene is:
"The Messenger"

The cartouche mark used for the series includes the pattern and series titles and the makers' name "E. & G. PHILLIPS". Examples printed in green have been reported.

In the period when this series was produced there must have been considerable public sympathy for the Poles. Napoleon had rallied round him an army of patriots to fight against Austria and Russia, promising to reconstitute Poland. In fact, all he did was to establish the Duchy of Warsaw.

"Pomerania" (D287)

Two dishes from this series of scenes by John Ridgway are illustrated here. They are both marked with a floral scroll cartouche containing the title and are clearly from the same factory, despite the fact that only one of the marks includes the maker's initials J.R. The mark would have to be engraved on each copper plate, and the initials were clearly not always included.

"Pomona" (D287)

The title for this pattern was more probably inspired by Pomona, the goddess of fruit.

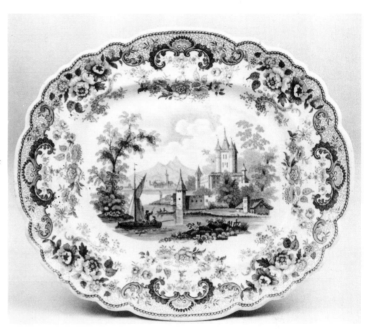

"Pomerania". John Ridgway. Printed title cartouche with maker's initials. Dish 10½ ins:26cm.

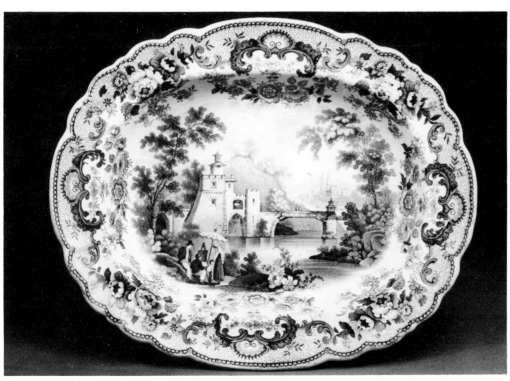

"Pomerania". John Ridgway. Printed title cartouche (without maker's initials). Deep dish 11½ ins:29cm.

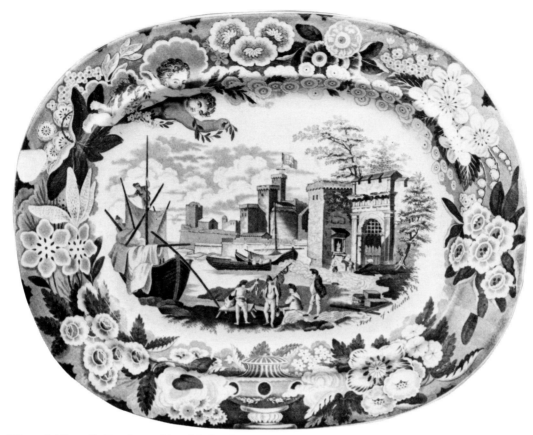

"**Port of Alicata**". *Don Pottery. Named Italian Views Series. Printed title below view. Printed maker's mark. Dish 14¾ ins:38cm.*

Ponte Molle (D287-288)

A plate with the mark of J. & W. Handley has been reported.

"Ponte del Palazzo" (D287)

Palazzo is a town in southern Italy in Basilicata, some 23 miles north-east of Potenza.

"Ponte Rotto" (D287)

The view by an unknown maker has now been reported on an oval two-handled tureen with a very clear impressed mark "LOCKETT & HULME". The previous very tentative attribution to Rogers must now be discarded.

"Poor Man's Friend" (New)

A blue-printed Ointment Pot (qv) has been noted with the wording "Poor Man's Friend / Price 1/1½" and "Prepared only by Beach & Barnicott, successors to the late Dr. Roberts, Bridport".

Dr. Roberts was an experimental chemist who studied the influence of herbs and minerals on the human body. In about 1788 he established a shop in Bridport, Dorset, where he prepared a famous ointment under the title "The Poor Man's Friend", claimed to cure ulcers, cuts, bruises, scalds, corns, pimples and many other ailments. It was soon sold all over Britain and also by 1830 in Canada and the U.S.A. Dr. Roberts died in 1834 and the business was taken over by Beach & Barnicott. The shop still exists but is no longer a chemist. A short article by V.J. Adams, "The Poor Man's Friend", appeared *The Countryman* in 1959, where it was noted that the ointment itself was still produced in small quantities, mainly for export to South Africa.

"Poppy" (New)

Maker unknown with initials B. & B. A floral pattern featuring a realistic spray of poppies within a floral scroll border, noted on toilet wares. The printed mark is in the form of a crown with the title "POPPY" and initials B. & B. beneath. There were several Staffordshire potters with these initials operating in the 19th century, including Baggerley & Ball (1822-1836), Bailey & Batkin (1814-c.1827), Bates & Bennett (1868-1895) and Blackhurst & Bourne (1880-1892).

"Port of Alicata" (New)

Don Pottery. Named Italian Views Series. Dish 14¾ ins:38cm.

Alicata, known today as Licata, is a seaport on the south coast of Sicily which trades particularly in sulphur.

Portable Water Closet (New)

See: Henry Marriott.

Porter Mug (New)

A term widely used to describe a large cider or ale mug holding upwards of two pints. Although now generally accepted to mean a large mug, the phrase appears in Spode's 1820 Shape Book where it is listed with eight sizes, which implies that it was a term used for any normally shaped mug as distinct from a "low mug" or an "upright mug".

Porter was a dark brown beer brewed from malt browned by drying at high temperatures. It was very popular in the 18th and 19th centuries, particularly in London, where establishments serving it became known as porter houses, and the food they supplied included what we know today as porterhouse steaks.

Portland Vase (D287)
This Spode pattern is catalogued by Drakard & Holdway as P720. It is also illustrated in Whiter 76.

Potter, Paulus (New) **1625-1654**
Paulus Potter was one of the most famous of Dutch animal painters. His best known picture depicting "The Bull", signed and dated 1647, can be seen in The Hague. This painting is now known to be the source for part of a pattern marked "Semi-China Warranted", illustrated D328.

Potts, William Wainwright (New)
William Wainwright Potts is mentioned in the *Dictionary* in connection with his partnership in the Burslem firm of Machin & Potts. His earlier career with his brother John Potts and a third partner Richard Oliver was concerned primarily with calico printing at St. George's Works, New Mills, Derbyshire. It was from there that a first patent in the names of Potts, Oliver & Potts was obtained in 1831 for transfer-printing on pottery.

A rare printed mark refers to "W.W. POTTS'S PATENT / Printed Ware / St. George's Potteries / NEW MILLS / DERBYSHIRE" and is found only on dinner wares printed with a sheet floral pattern in blue. These are thought to have been decorated at New Mills but there are doubts as to the origins of the wares themselves. Potts joined William Machin at Burslem in c.1833 and the partnership survived until c.1842. Three further patents, all connected with machine printing for pottery, were obtained in 1835, 1836, and 1838. Further details are given by Nancy Gunson in NCS 68, pp.6-11, where the printed mark and sheet pattern mentioned above are both illustrated.

"Pratt's Italian". *Printed cartouche mark.*

Poulson Bros. (Ltd.) (New) **fl.1882-c.1895**
Ferrybridge and Castleford, Yorkshire. The brothers Thomas and Edward Llewellyn Poulson operated three separate potteries; the Calder Pottery at Castleford (c.1877-c.1893), the West Riding Pottery at Ferrybridge (1882-1925), and the Ferrybridge Pottery itself (1884-1895). Some authorities give 1897 as the date they vacated the Ferrybridge Pottery. Heather Lawrence states that they traded as Poulson Brothers at all three, and although they are known to have operated as a limited company, the date the company was registered is not recorded. Thomas Poulson died in 1893 but his brother continued the West Riding Pottery until his own death in 1925. The brothers used initial marks P.B. and P.Bros.

Amongst other products were dinner wares printed with the "Asiatic Pheasants" design.

"Pratts Italian" (New)
A romantic Italianate scene which is illustrated in this volume on an unusual Candleholder (qv). The title is printed within a crowned floral cartouche mark illustrated here. As with the similar title "Pratt's Native Scenery" the quality of the wares suggests a late 19th or early 20th century date.

"The Pretty Doves" (New)
Maker unknown. A pattern printed on a toy plate with the title on the front. It is almost certainly one of a set which also includes "The Sheep Shearer" (qv).

"The Pretty Doves". *Maker unknown. Unmarked. Toy plate 3¼ ins:8cm.*

Primavesi, F. *Printed retailers' mark from a mug dated 1881.*

Primavesi, F. (& Son) (D290)

A mark of this Cardiff and Swansea retailer which appears on a commemorative mug dated 1881 is illustrated here. The addition of ''& Son'' is thought to date from c.1860, but note that the name is given on the mug as ''F. PRIMAVESI & SONS'', a plural form apparently previously unrecorded. This mark also mentions only Cardiff, but other similar examples are known which include both towns, see for example Godden M 3168.

See: ''Avito Viret Honore''.

''Princess Royal'' (New)

Maker unknown. Queen Victoria's first child was born on 22nd November 1840 and christened Victoria Adelaide Mary Louise, although she was to be known by her title of the Princess Royal. A framed portrait of her as a young girl, with the title ''PRINCESS ROYAL'' within the framing, appears on an unmarked jug made for the Jamaican importer David Brandon. Ill: J. May, *Victoria Remembered*, 150.

''Pro Deo, Rege et Patria'' (New)

For God, my king, and my country. A motto illustrated here on a plate by Brown-Westhead, Moore & Co. The owner of the coat-of-arms has not yet been identified.

See: Armorial Wares.

''Progress of the Loaf'' (New)

Maker unknown. A series of six scenes printed on children's wares. See the following entry.

''The Progress of a Quartern Loaf'' (D291)

Maker unknown. The pattern depicting ''The Miller'', D247, is now confirmed to be one of a series of six scenes depicting the various stages in the production of bread. The source has been identified as illustrations and accompanying verses taken from a children's book by Mary Elliott, *The Progress of the Quartern Loaf* (1820). In the book, the six scenes each appear with two verses, but only one verse was used on each of the plates. Five of the inscriptions are:

''THE PLOUGHMAN''
The Ploughman's labour first prepares
The bosom of the earth for seed;
This done he has no further cares,
Then, other labourers succeed.
''THE SOWER''
With steady hand the sower throws
That seed on which so much depends;
Following the plough's deep track he goes,
And plenty every step attends.
''THE THRASHER''
And so another friend appears
With active flail the corn to thrash,
To separate the clustering ears
And tear the Grain from sulk & trash.
''THE MILLER''
It is now the Miller's turn we find,
Who into Flour the Corn must grind.
The Husk, or shell, is used as Bran,
The Flower as general Food for Man.
''THE BAKER''
With Yeast the Baker forms the dough,
Kneading it into loaves of Bread;
When baked their use we too well know,
To need much comment on this head.

The inscription used for ''THE REAPER'' has not been recorded.

Unlike many children's wares, these plates are crisply printed in blue and have a finely moulded border of flowers. ''THE PLOUGHMAN'' and ''THE BAKER'' are illustrated here. Examples of ''THE SOWER'' and ''THE REAPER'' have been reported with an indistinct impressed mark, thought to be ''BRAMELD'' (See: FOB 50).

The same scenes also appear on children's wares of much lesser quality, almost certainly made by a different factory. They are marked with the title ''Progress of the LOAF'', sometimes within the pattern itself, and the titles appear as simply ''BAKER'', ''MILLER'', etc. In many cases, particularly on the cups and mugs, the verses are omitted. The ''PLOUGHMAN'' and the ''THRASHER'', both without the accompanying verses, are illustrated on a small cup in FOB 50 and a small mug in FOB 42. The ''PLOUGHMAN'', ''THRASHER'', ''MILLER'' and ''BAKER'' have all been noted on saucers, and a complete set was almost certainly made.

''Pull the Bobbin'' (New)

See: Little Red Riding Hood.

Pulteney Bridge, Bath (D292)

This pattern is now known to have been produced by Baker, Bevans & Irwin of the Glamorgan Pottery, Swansea. A jug and a basin, both with impressed marks, are in the Royal Institution of South Wales at Swansea.

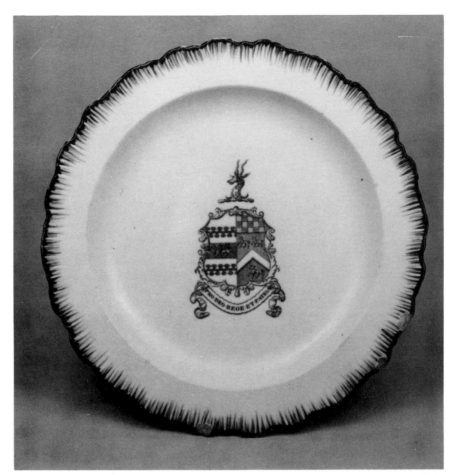

"Pro Deo, Rege et Patria". *Unidentified coat-of-arms. T.C. Brown-Westhead, Moore & Co. Impressed makers' name mark and printed retailer's mark in the shape of a plate inscribed "Farquhar Shape, Mortlock's, Oxford Street, Orchard Street". Plate 8¼ ins:21cm.*

"The Progress of a Quartern Loaf". *Maker unknown. Children's plates with "The Baker" and "The Ploughman". Size and marks unknown.*

"Quadrupeds" Series (D293)

John Hall. The animals featured in the wide border medallions on some of these designs have been identified:

Bullmastiff (plate 6¾ins:17cm) with horses, water vole, squirrel, and sheep.

Dalmatian (plate 6ins:15cm) with weasel, stoat, and duck-billed platypus.

Lion (plate 10ins:25cm) with deer, zebra, goats, and Shetland ponies.

Moose (dish 15¼ins:39cm) with beaver, bear, goats, and racoons.

Otter (plate 8¾ins:22cm) with hedgehogs, rabbits, seal, and racoons.

"Queen Caroline" (New)

The very large presentation jug seen here is in the Newbury District Museum, Berkshire. It is decorated with a pattern titled "Chinese Scenery" (qv) and bears a heart-shaped reserve below the spout with the inscription illustrated.

William Bowles and Judith Challis were married at St. Nicholas' Church, Newbury, on 26th April 1815, and had four daughters followed by three sons. William Bowles was described as a bargeman until 1824 but by 1826 this had changed to a publican. It is possible that their home was known as Water-Man's House while he was a bargeman but they converted it to an inn in about 1825 and later, in 1828, renamed it the Queen Caroline when public sympathy for the Queen was at its height. The buildings on the north side of the market place back on to the Kennet and Avon Canal, which is still used by pleasure barges. The Queen Caroline was listed in the Market Place at Newbury in a directory for 1847, when Mrs. Judith Bowels is given as the proprietress.

Queen Charlotte (D294)

This Spode chinoiserie pattern is catalogued by Drakard & Holdway as P612 and shown by them on a wide range of shapes. Whiter uses the same name, stating that it is an old factory one, but Copeland prefers to use the name Bridge (see Copeland pp.92-96). It is also illustrated in Coysh 2 84; Whiter 17.

"The Queen of England" (New)

Maker unknown. This title appears on the face of a plate which is one of a series of commemorative designs with small central portraits within wide borders featuring the rose, thistle and shamrock. Ill: FOB 53.

See: Commemorative Series.

Quinn, James (New) fl.c.1835-1851

A dish from the series titled "Mandarin Opaque China" (qv) has been recorded with a small reserve containing the name and address "QUINN / 40 HAYMARKET" let into the top of the border.

James Quinn was a shell fishmonger who is first listed in the London directories at 49 Great Windmill Street for a short period around 1826. The next entry is in 1835 at 40 Haymarket, at the junction of Piccadilly and Coventry Street, where he traded until his death in c.1851. Thereafter the business was continued by his widow Mrs. Margaret Quinn until 1868, when it appears that she also died and was succeeded by Albion Quinn, presumably their son, who had operated a separate oyster warehouse at 9 Mill Street, Hanover Square, between 1846 and 1852. The Haymarket business had ceased trading by 1872.

Quintal Flower Horn (New)

An 18th century name for a vase in the shape of five horns moulded together (see frontispiece). The name appears in a Leeds Pottery catalogue dated 1783 and the shape is also shown in similar publications from the Don Pottery and the Castleford Pottery (see, for example, the catalogue reproduced by Diana Edwards Roussel in *The Castleford Pottery 1790-1821*). Creamware examples are by no means common and blue-printed examples are very rare. The one illustrated in the frontispiece is of later date, probably the 1830s, and is marked Minton.

"**Queen Caroline**". *Detail of inscription in panel beneath spout on presentation jug.*

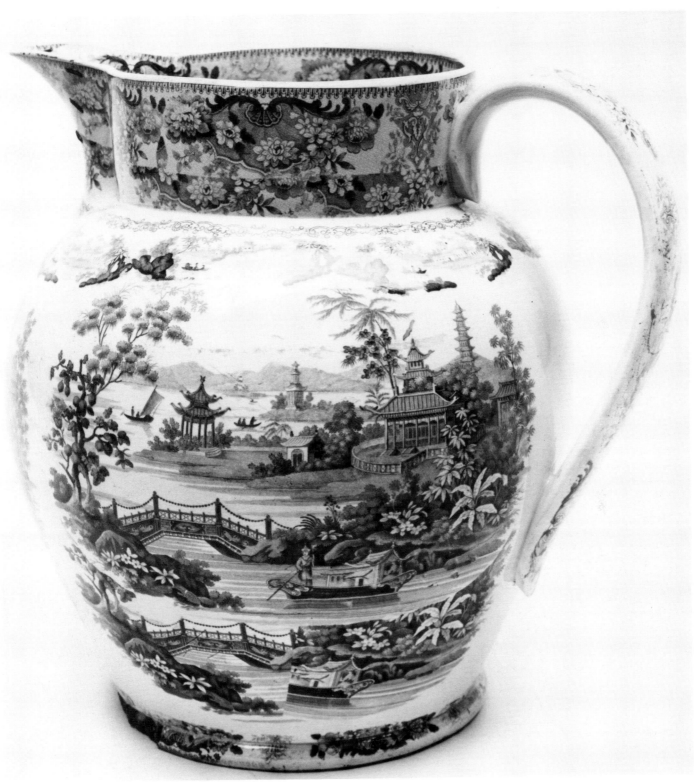

"Queen Caroline". *Maker unknown. Printed cartouche mark with pattern title "Chinese Scenery" and maker's initial M. Presentation jug 15ins:38cm.*

"Ragland Priory" (New)
Maker unknown. Passion Flower Border Series. Vegetable dish. Ill: FOB 40.

It has not so far proved possible to locate this building. There is a castle at Raglan, seven miles WSW of Monmouth, but no record of any priory.

Rainforth & Co. (D296)
A marked blue-printed mug with a Nelson commemorative design, probably dating from shortly after the Battle of Trafalgar in October 1805, has been recorded in NCS 47. It features a portrait of "Lord Nelson", surrounded by naval accoutrements and ribbons inscribed "Britannia Rules the Waves" and "England Expects Every Man Will Do His Duty".

"Rajah" (New)
Maker unknown. A romantic Indian procession scene with two elephants, one drawing an ornate rococo-styled carriage, and several mounted horsemen. The floral border features four identical elephant vignettes, and the pattern title "RAJAH" appears in a simple printed scroll cartouche.

The title Rajah was borne by Hindu princes and was usually hereditary, but men of great valour or wisdom were also elected Rajahs. Their sovereignty was often recognised by the British government and they were allowed to rule over their own territories.

"The Reaper" (New)
See: "The Progress of a Quartern Loaf".

"Reapers" (D297)
A saucer with this pattern by William Smith & Co. is illustrated here. The pattern title appears printed on a ribbon superimposed on a shield-shaped cartouche inscribed with the makers' name. As with many other wares from this factory, it is impressed "WEDGEWOOD".

"Rajah". *Maker unknown. Printed title cartouche. Soup plate 10½ ins: 27cm.*

"Reapers". *William Smith & Co. Printed shield cartouche with makers' name, and title on a superimposed ribbon. Impressed "WEDGEWOOD". Saucer 4¾ ins: 12cm.*

Reed, J. (New) fl.c.1843-1873
Rock Pottery, Mexborough, Yorkshire. This pottery was operated by James Reed following a partnership as Reed & Taylor. James Reed died in 1849, and was succeeded by his son John who in turn died in 1870. The pottery was continued by executors until sold to Sydney Woolf in 1873. The impressed mark "REED" was used, and printed marks with the name "J. REED", which could relate to father or son, also occur.

Copper plates and moulds were bought at the Rockingham works sale in 1843 and a version of Brameld's Twisted Tree design with a blue-printed mark "TAPESTRY / J. REED" has been reported. The pottery also produced the common "Wild Rose" pattern.

Regent's Park Series (D297)
William Adams. One previously recorded view is illustrated in this volume:
"St. Paul's School, London" *

Regout, Petrus (D298-299)
Regout's early unsuccessful attempts to emulate British printed wares are described in an article by Howard Davis "Nineteenth Century Design Links Between Staffordshire and Maastricht" in NCS 64, pp.15-20. From 1853, Regout purchased copper plates directly from Staffordshire engravers, including James Barlow, John Heath, Elisha Pepper, Thomas Toft, and Hugh Wood. Many pattern names are also given by Davis.

Reinagle, Philip (New) 1749-1833
An artist who painted landscapes and portraits, but abandoned the latter in favour of animal paintings from about 1785. He was elected R.A. in 1812. His work was copied from engravings for several printed patterns including a coursing scene and also a water dog in the foreground of a "British Views" Series dish by an unknown maker. Engravers of his work, which appeared regularly in *The Sportsman's Cabinet,* included Howitt, Scott, Nichols and Bluck.

"Remains of Covenham" (D300)
See following entry.

"Remains of Covet Hall, Essex" (New)
Andrew Stevenson. Rose Border Series. Plate 6½ins:16cm, and cup plate 4½ins:11cm.

This is the correct title for the entry which appeared in error in the *Dictionary* as "Remains of Covenham".

Covet Hall was the name given early in the 19th century to Colville Hall at White Roding or Roothing, a village about ten miles west of Chelmsford in Essex. It is an early Tudor two-storey house of brick and timber with two gabled wings, which for many years now has been a farmhouse.

Returning Woodman (D300)
It is now believed that the authentic Brameld title for this pattern was Peasant, a name which appears in a factory invoice for 1823. It was usually printed in blue, but black was also used, and an example printed on-glaze in red is illustrated in Cox 37. A plate in blue with an incised inscription "Jany. 1st -1820 / With 4 of Falis Blue" is recorded in NCS 57. This documentary piece proves that the pattern was in existence by 1820, and the inscription was almost certainly an instruction to a printer during trials of different inks.

"Rhodes" (D301)
Another potter used this title:
(ii) Thomas Dimmock & Co. "Select Sketches" Series. Dished plate. Ill: Williams & Weber p.228.

"Rhone" (New)
Maker unknown. A typical romantic scene printed within a border of mossy sprigs and regularly spaced flowerheads. The mark is in the form of a garter surmounted by a crown and includes the body name Stone China. Ill: Williams & Weber p.229.

The River Rhône rises in Switzerland in a glacier on Mount St. Gothard in the Bernese Alps. It flows through the lake and city of Geneva, and thence into France, via Lyons, Avignon and Arles, down to the Mediterranean at the Gulf of Lyons. Some 504 miles in length, it had to be crossed at some stage by all travellers to Italy who entered the country through the Alpine passes.

"Richmond Bridge" (D301)
An additional view with this title has been noted on a washbowl by an unknown maker. The central pattern shows a coach and four passing over the bridge with several large houses on the slopes behind and a punt with two figures on the river in front of the bridge. The wide floral border incorporates prominent scrolled panels. The printed mark is in the form of a leaf around which twines a ribbon inscribed with the title. Ill: FOB 39.

A further untitled view of the same scene has been identified in the Rogers Views Series on a shaped dessert dish with rose-moulded handles. Ill: FOB 39.

"Richmond, Yorkshire" (New)
Maker unknown. Beaded Frame Mark Series. Moulded dessert dish and dish 9¼ins:24cm.

Note that this scene is different from the one marked "Richmond" in the same series, which shows a view of the town in Surrey on the River Thames.

Ridgway, Sparks & Ridgway (New) 1873-1879
Shelton, Staffordshire. This partnership succeeded E.J. Ridgway & Son at the Bedford Works, Shelton, in 1873. Marks with their initials R.S.R. have been recorded. See William Ridgway (D302).

Riley, John & Richard (D302)
A history of the Riley company compiled by Roger Pomfret, "John & Richard Riley — China & Earthenware Manufacturers", appeared in the *Journal of Ceramic History*, Vol.13 (1988). It features much historical information, including illustrations of several Riley blue-printed patterns, and also reproduces the surviving factory recipe book.

River Fishing (D303)
This pattern by John Meir is illustrated in Colour Plate XXII on a marked comport of very distinctive shape which matches another identical comport printed with the view of "Wakefield Lodge, Northamptonshire" from the Crown Acorn and Oak Leaf Border Series (Colour Plate XXIII).

"River Thames" Series (D303)
Pountney & Allies/Pountney & Goldney. One previously recorded view is illustrated in this volume:
"Oxford" * (Colour Plate IV)

"Rob Roy" (D304)

The scene by Davenport in the "Scott's Illustrations" Series was also used inside a sauce tureen. Ill: M. Pulver, "The Scott's Illustrations Series by Davenport", *Antique Collecting*, March 1986.

"The Robert Bruce" (D304)

Maker unknown. This title appears on the face of a plate which is now known to be one of a series of commemorative designs with small central portraits within wide borders with prominent rose, thistle and shamrock. The title refers to the vessel illustrated, believed to have been launched at Greenock c.1817, rather than the famous Scottish Earl of Carrick, better known as Robert the Bruce. Ill: FOB 37.

See: Commemorative Series.

"The Robert Bruce". Maker unknown. Commemorative Series. Unmarked. Plate 10¼ ins:26cm.

"Robert Burns" (New)

Maker unknown. This title appears on the face of two different plates which form part of a series of commemorative designs with small central portraits within wide borders with prominent rose, thistle and shamrock. Ill: FOB 37.

See: Commemorative Series.

"Robin Hood and the Butcher" (New)

Maker unknown. See the following entry.

"Robin Hood and the Sheriff" (New)

Maker unknown. This title has been noted printed beneath the scene on one side of an unmarked child's mug, with a similar scene on the other side titled "Robin Hood and the Butcher".

Robin Hood was a famous outlaw in the time of Edward II, and although he was probably only a Nottinghamshire yeoman, some historians have identified him with Robert, Earl of Huntingdon. His exploits in Sherwood Forest are recalled in many old English ballads and folk tales, which almost invariably describe him as a folk hero, outwitting the rich and helping the poor.

"Robert Burns". Maker unknown. Commemorative Series. Unmarked. Plate 10¼ ins:26cm.

Robinson (New)

The previously unrecorded impressed mark "ROBINSON" appears on a plate illustrated here with a Temple Parkland pattern. This pattern is often found on unmarked wares, and has also been reproduced in recent years by W.R. Midwinter of Burslem under the title "Landscape". The mark may relate to either of two factories who were operating at the appropriate period:

John Robinson is thought to have set up on his own after leaving Sadler & Green of Liverpool in 1786. He subsequently traded with his sons as Robinson & Sons, and they would appear to have continued in business together after his death. John & Christopher Robinson are listed at the Hill Works, Burslem, in a directory for 1818, and John Robinson is listed alone at the same address in 1822. There are no entries in 1828 by which time the firm had presumably ceased trading. Their Hill Works were later incorporated into the large factory run by Samuel Alcock & Co.

Noah Robinson of Shelton, Staffordshire appears in directories for 1828 and 1830. In 1832 he started the firm of Robinson & Wood and they later admitted their traveller William Brownfield into partnership in 1836 and moved to Cobridge. The new firm of Robinson, Wood & Brownfield was almost immediately disrupted by Noah Robinson's death in the same year, and eventually became Wood & Brownfield and subsequently William Brownfield (& Sons).

"Rocaille" (New)

Davenport. A romantic-style design noted on a circular sauce tureen featuring boats in a landscape within a rococo-scroll frame. A similar cartouche mark contains the title and has the maker's name "DAVENPORT" beneath.

The word rocaille is synonymous with rococo, used to describe the style of decorative art evolved in France early in the 18th century. It combined motifs based on shell and rock forms, foliage and flowers, and scrolls mainly in the form of a "C".

Robinson. *Temple Parkland. Impressed "ROBINSON". Plate 10ins:26cm.*

"Roche Abbey, Yorkshire". *Maker unknown. Pineapple Border Series. Printed title mark. Plate 10ins:26cm.*

Rogers Views Series.
John Rogers & Son. Unidentified view. Unmarked. Sauceboat, length 7¼ins:18cm.

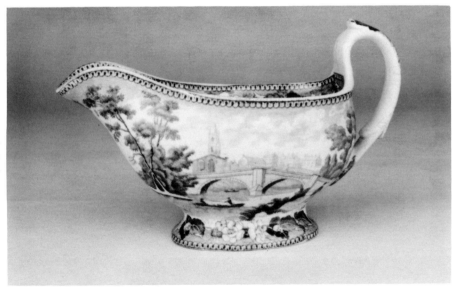

"Roche Abbey, Yorkshire" (D304)

A plate from the Pineapple Border Series by an unknown maker is illustrated here.

Rock (D305)

This Spode chinoiserie pattern is catalogued by Drakard & Holdway as P608. It is also illustrated in Copeland pp.45-52; Whiter 9.

Rock Cartouche Series (D305)

Elkin, Knight & Co. One previously recorded view is illustrated in this volume:

"Craig Castle" *

Note, however, that this view is incorrectly titled and actually shows Castle Richard in Waterford.

Rogers Views Series (D306)

John Rogers & Son. Another view has now been identified:
 Richmond Bridge

Two further unidentified views are illustrated above and overleaf, one on an unmarked sauceboat and the other on the interior of the soup tureen. The outside of the tureen has the view of Lancaster, also shown overleaf.

The scene on the side of another soup tureen (Ill: Godden I 502) has also now been identified as a view of the city of Maidstone in Kent. It is copied from an engraving inscribed "Drawn from Nature and on Stone by J.D. Harding. Printed by C. Hullmandel. London. Published by Rodwell and Martin, New Bond Street, Oct. 10 1822". James Duffield Harding (1797-1863) was noted for developing the medium of lithography in his *Sketches at Home and Abroad* (1836).

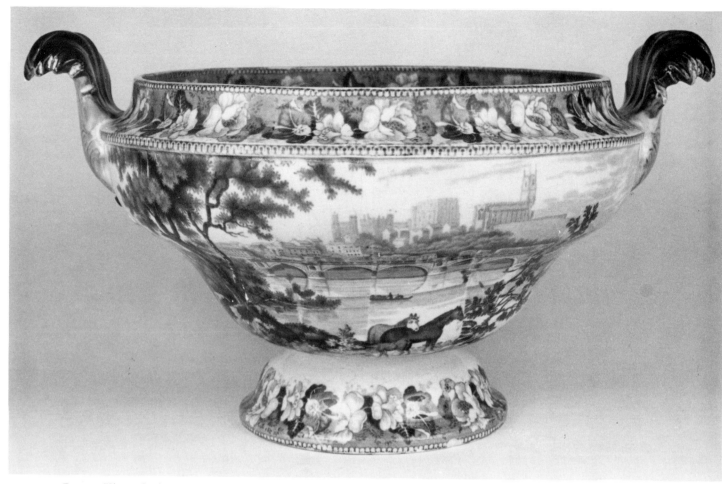

Rogers Views Series. *John Rogers & Son. View identified as Lancaster. Unmarked. Soup tureen, length over handles 15ins:38cm.*

Rogers Views Series. *John Rogers & Son. Unidentified view from interior of soup tureen.*

"A Romantic District of Italy". *Chetham & Robinson or Chesworth & Robinson. "Terni" Series. Printed titles mark with makers' initials C. & R. Plate 10½ ins:27cm.*

"A Romantic District of Italy" (D308)

The plate from the "Terni" Series by Chetham & Robinson or Chesworth & Robinson is illustrated here.

Rome (D308)

This Spode view of Rome is catalogued by Drakard & Holdway as P713 and shown by them on a wide range of shapes. Rome is believed to be the original factory name and is now generally preferred to the other widely used title of Tiber (qv). Spode examples are extensively illustrated elsewhere, including Coysh 1 106; Whiter 69; S.B. Williams 73-78. A version produced by Thomas Lakin was recorded in D362, and another has now been noted with an impressed mark "STUBBS" for Joseph Stubbs of Longport.

"The Rookery" (New)

Maker unknown. Passion Flower Border Series. Plate 7½ ins:19cm.

This is the correct title and item for the third view listed in D308 under "The Rookery, Surrey" (see following entry).

"The Rookery, Surrey" (D307-308)

The third item listed, in the Passion Flower Border Series, is now known to be titled simply "The Rookery" (see previous entry).

Rose Border Series (D308)

Andrew Stevenson. One previously recorded view is illustrated in this volume:

"Faulkbourn Hall" *

Another view was listed in error as "Remains of Covenham"; the correct title is "Remains of Covet Hall, Essex" (qv).

At least two of the views in this series, Faulkbourn Hall and Wanstead House, are now known to be taken from engravings in Grey's *The Excursions Through Essex* (1818). It is possible that views from the series in Suffolk were copied from a companion volume *The Excursions Through Suffolk*.

"Roselle" (D309)

This typical romantic scene by John Meir & Son has also been noted on a washbowl and jug. The printed mark consists of a registration diamond for 26th August 1848, with a crown and "IRONSTONE" above, and the title and makers' name "ROSELLE / J. MEIR & SON" below.

Roselle is a small Italian village which lies south of Florence in the valley of the river Ombrone. It would have been visited by tourists on their way to Rome.

"Ross Castle, Monmouthshire" (D309)

It has been suggested that the scene with this title in Enoch Wood & Sons Grapevine Border Series, illustrated D309, actually shows Kirkstall Abbey in Yorkshire. It has still not proved possible to locate Ross Castle.

Rotunda (New)

This is an attributed title for a Spode design which is catalogued by Drakard & Holdway as P707. No examples have been recorded, but its existence is known by virtue of marked copper plates at the Spode factory, and it would probably have been printed in blue. It has been identified as a view of the Rotunda at Ranelagh Gardens and Drakard & Holdway also illustrate the original source print from *London and its Environs Described* (1766).

"Rousillon" (New)

John Goodwin. A romantic scene, recorded in two slight variants, registered on 16th December 1846.

Rousillon is an ancient province of France whose capital Perpignan is on the route into Spain. It lies between the east of the Pyrenees and the Mediterranean.

"Royal Cottage" (D310)

Two other potters used this design:

(v) Cork & Edge, the predecessors of Cork, Edge & Malkin. Examples were printed in green.

(vi) Thomas Till & Son, eventual successors to Barker & Till.

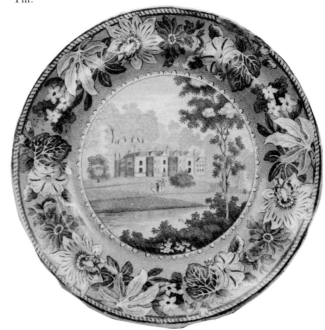

"The Rookery". *Maker unknown. Passion Flower Border Series. Printed title mark. Plate 7½ ins:19cm.*

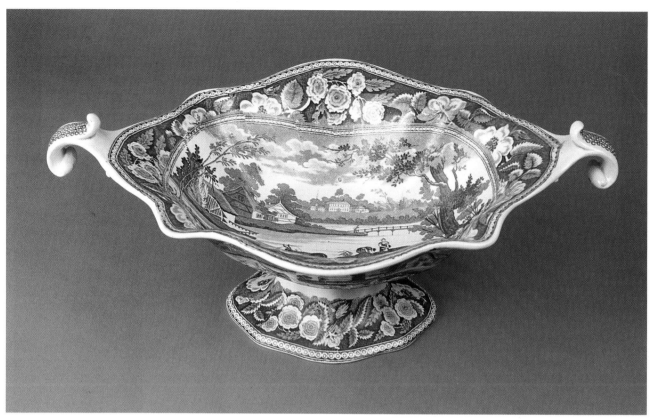

Colour Plate XXII. River Fishing. *John Meir. Impressed "MEIR". Comport, length 13¾ ins:35cm.*

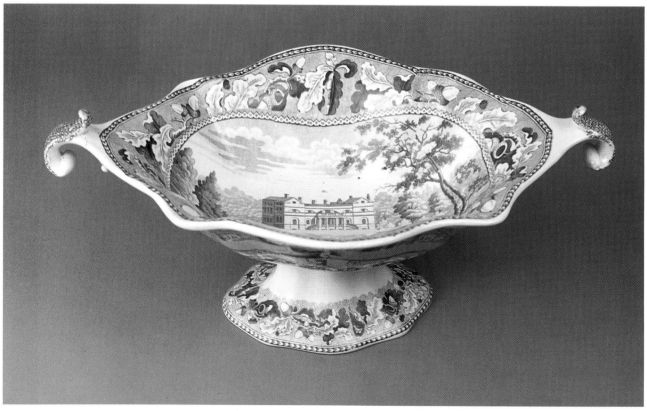

Colour Plate XXIII. "Wakefield Lodge, Northamptonshire". *Attributed to John Meir. Crown Acorn and Oak Leaf Border Series. Printed title mark. Comport, length 13¾ ins:35cm.*

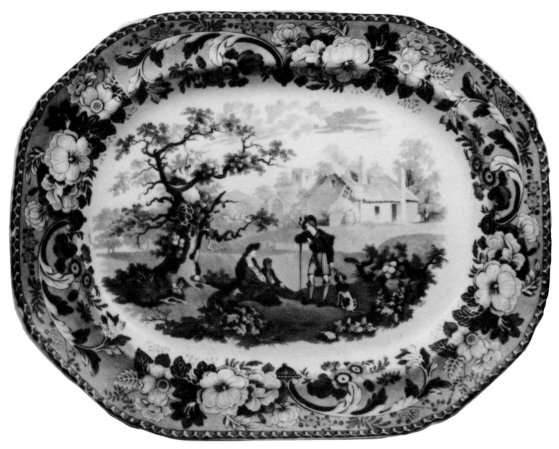

"Rural Scenery" Series (Bathwell & Goodfellow). *Printed series title mark. Dish 19¼ins:49cm.*

"Royal Sketches" (D313)
Maker unknown. The view identified as the Royal Pavilion at Brighton is illustrated in Colour Plate XXIV on an ornate covered jug which, in view of its cover and strainer behind the spout, may have been intended for serving toast water to invalids.

See: Brighton Pavilion.

"Royal Vitrescent Rock China" (New)
Maker unknown. This inscription appears on a cartouche mark in the form of a large scroll held by an attendant angel trumpeter, recorded on a romantic-style pattern featuring a boy seated beneath a tree, apparently busy writing. The pattern is printed in light blue within a wide and rather fussy open floral border.

The inscription in the mark is a trade name. The word vitrescent describes the glaze as being transparent and hard, like glass.

"The Rukery" (D313)
Griffiths, Beardmore & Birks. Light Blue Rose Border Series. Dish.

This view was recorded in the *Dictionary* but was not recognised as part of this series. Examples have been noted with the standard series title mark together with an additional Royal arms mark incorporating the makers' initials G.B. & B.

The view is now confirmed as The Rookery, near Dorking in Surrey, and the pattern was based on the same John Preston Neale print used by John & Richard Riley, Wedgwood and Enoch Wood & Sons amongst others (see D307).

"Running" (New)
Thomas Mayer. "Olympic Games" Series.

The Rural Lovers (New)
A name adopted for a pattern showing a couple under a tree, based on an engraving by François Vivares (1709-1780), after Gainsborough. Ill: FOB 45.

"Rural Scenery" Series (Bathwell & Goodfellow) (D315)
Additional scenes are:

(vi) Conversation. A man leans on a stick and talks to a seated woman and child. A dog sits nearby. Dish 19¼ins:49cm. Ill: FOB 46.

(vii) Resting Farm Girl. A girl rests by a stile beneath a tree, a wooden bucket by her side. Dished plate. Ill: Williams & Weber p.236.

The source for view (i) known as the Firewood pattern has been identified as an engraving titled "Hop Picking" which was taken from *Microcosm; or a Picturesque Delineation of the Arts, Agricultures, Manufactures, &c. of Great Britain*, first published between 1802 and 1807 by William Henry Pyne (1769-1843).

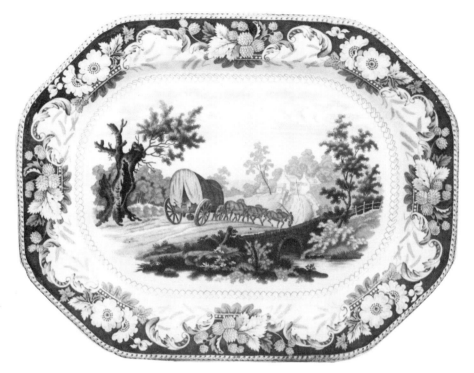

"Rural Scenery" Series (John & William Ridgway). *Printed mark with series title and makers' initials. Dish 16¾ ins:42cm.*

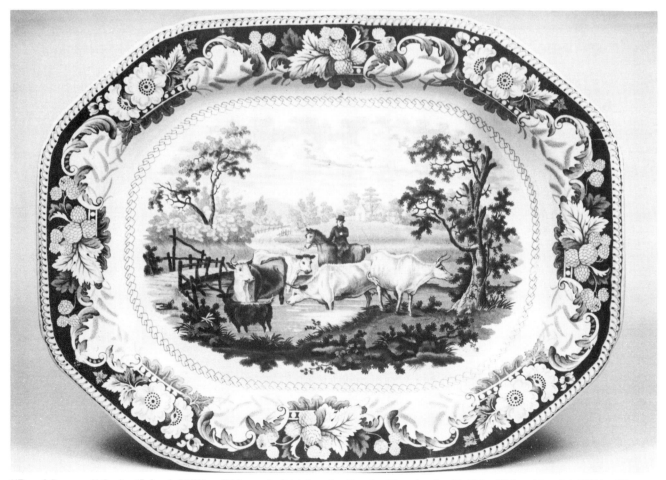

"Rural Scenery" Series (John & William Ridgway). *Printed mark with series title and makers' initials. Well-and-tree dish 20½ ins:52cm.*

"Rural Scenery" Series (John & William Ridgway) (D315-316)

Additional scenes are:

Man with horse pulling a harrow. Tea plate. Ill: FOB 50.

Horse drawn covered wagon crossing a bridge (illustrated). Dish 16¾ins:42cm.

Horseman with four cows and a goat in a ford (illustrated). Well-and-tree dish 20½ins:52cm.

"Rustic Scenery" (New)

Joseph Clementson. A pattern registered on 2nd December 1842 which has a small rural vignette scene surrounded by a circle of leaves within a leafy border featuring six further vignettes. The ornate printed cartouche mark is in the form of the Royal arms but with the central shield replaced by a scrolled panel inscribed "RUSTIC SCENERY / GRANITE / OPAQUE / PEARL", with the maker's name "J. CLEMENTSON" on a ribbon beneath. Ill: Williams & Weber pp.238-239.

Rustic Scenes Series (D317)

Davenport. Additional scenes are:

(v) Milking time. A thatched cottage with two cows, one being milked, in the foreground. Tureen stand 7ins:18cm. Ill: FOB 44.

(vi) Cottage and bridge. A cottage on the left is partly hidden by a three-arched bridge. To the far right a man rides a horse towards the edge of the scene, followed by a dog. A large pine tree leans across the foreground. Plate 4¾ ins:12cm.

(vii) Watermill scene 2. A large watermill on the left with two fishermen in the foreground. A tree fills the centre and a village with a church is in the right background. Plate. Ill: FOB 48; FOB 57.

(viii) Watermill scene 3. Exactly as above but the tree is different and the village is replaced by a windmill. Plate. Ill: FOB 48.

(ix) Thatched farm. Extensive thatched farm buildings behind some water. On the near bank are a moored boat and a group of figures, one holding a sail. Oval tureen. Ill: FOB 48.

(x) The drover. A man drives a cow and calf in front of a gnarled tree with a cottage in the right background, and a woman and child in the distance. Dish. Ill: FOB 48.

(xi) Man on cart-horse. A man mounted on a large horse talks to another man seated beneath a tree near a rustic fence. In the left background is a large country house. Vegetable dish. Ill: FOB 48.

(xii) Castle gateway. Two gentlemen walk with their dog in front of a large rock or mound. To the left is a castle gateway. Plate. Ill: FOB 48.

(xiii) Thatched farmshed. A cow stands in water in front of a thatched farmshed with tall tree-trunk posts. In the background is a building on a hill. Plate 9¾ins:25cm. Ill: FOB 48.

(xiv) Returning home. A man with a stick, a bundle on his shoulder, and holding a young girl by the hand, walks towards a three-storey thatched farm with two circular oast houses or hay ricks behind. Plate. Ill: FOB 48.

(xv) Resting time. Two men, one seated, the other standing, lean on sticks while their dog lies nearby. Two cows are in front of a cottage in the middle distance on the right. Tureen lid. Ill: FOB 48.

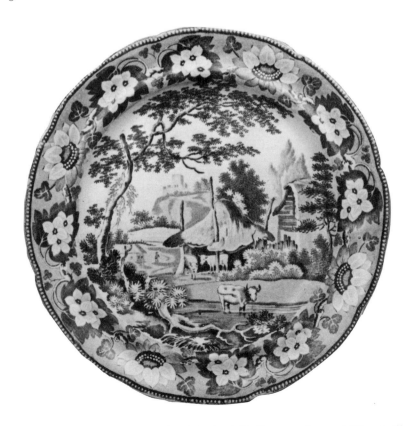

Rustic Scenes Series. *Thatched farmshed, view (xiii). Davenport. Impressed "Davenport" in a curve. Plate 9¾ins:25cm.*

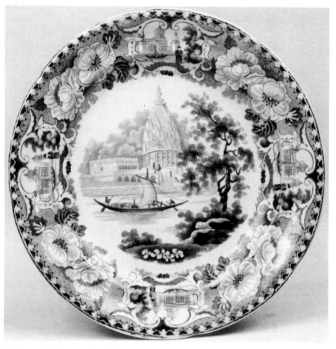

"Sacred Tank & Pagodas near Benares". *Maker unknown.*
"Oriental Scenery" Series. Printed titles mark. Plate 7¼ ins:19cm.

"Sacred Tank & Pagodas near Benares" (New)
Maker unknown. "Oriental Scenery" Series. Plate 7¼
ins:19cm.

The Indian word tankh is a name for a pool, and in this case
probably refers to a bathing place by the banks of the Ganges,
the sacred river which flows through Benares (Varanasi).
Thousands of pilgrims are attracted each year to bathe in the
sacred waters.

St. Alban's Abbey, Hertfordshire (New)
Maker unknown. An untitled view identified as St. Alban's
Abbey is illustrated here on an unmarked soup plate which is
one of a series of rural scenes. The view is printed within a
wide border featuring tulips among other flowers, and a girl
in the foreground appears to be balancing a plank of wood on
her head.

"St. Pauls" (New)
Charles Meigh. "British Cathedrals" Series. Dish 19¼
ins:49cm. Ill: FOB 39.

"St. Paul's School, London" (D319)
The plate from the Regent's Park Series by William Adams is
illustrated here together with the source print taken from
Elmes' *Metropolitan Improvements*.

The school was originally founded in 1509 by Dr. John
Colet, Dean of St. Paul's, and situated on the east side of St.

Paul's Churchyard. It was instituted under the regulations of
the Mercers' Company, which appointed the trustees. "The
school consists of eight classes. In the first the children learn
the rudiments. From thence, according to their proficiency,
they are advanced until they reach the eighth class, from which
they are removed to the universities, where many of them
enjoy exhibitions" (from Leigh's *New Picture of London*, 1818).
The new school, shown on the plate, was built by George
Smith in 1823-24, and demolished in 1884.

"Sal Sapit Omnia" (D320)
At least one of the plates made by Hicks, Meigh & Johnson
for the Salters' Company and supplied through the retailer
John Du Croz is known with the border enriched with
coloured enamels.

Salt Cellar (D321)
An early footed salt cellar printed with a chinoiserie-type
border by an unknown maker is illustrated here. Another pair
of ornate salt cellars is illustrated alongside a matching plate
printed with a view of Guy's Cliff, Warwickshire (qv).

Sarcophagi and Sepulchres at the Head of the Harbour at Cacamo (D322)
Two slightly different engravings of this Spode pattern are
known, one with and the other without a flock of birds in the
sky.

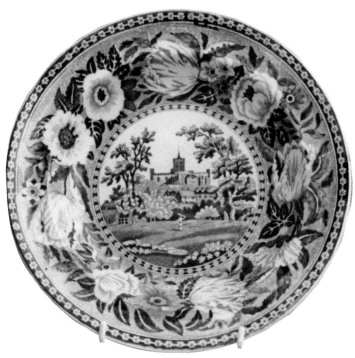

St. Alban's Abbey, Hertfordshire. *Maker unknown. Unmarked. Soup plate 9ins:23cm.*

Salt Cellar. *Maker unknown. Unmarked. Height 2 ¾ ins:7cm.*

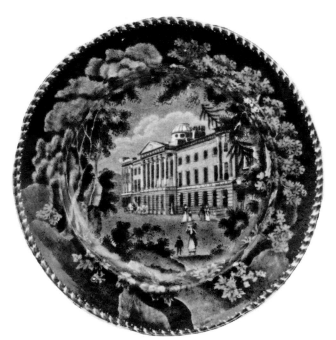

"St. Paul's School, London". *William Adams. Regent's Park Series. Printed title mark and impressed maker's eagle mark. Plate 7 ¾ ins:20cm.*

"St. Paul's School, London". *Source print taken from Elmes' "Metropolitan Improvements".*

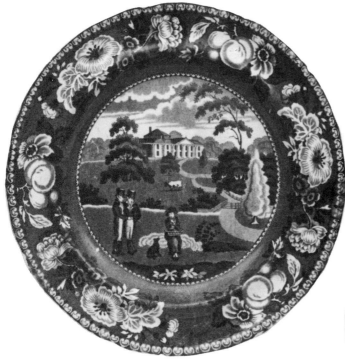

"Saxham Hall". *Henshall & Co. Fruit and Flower Border Series. Printed title mark and impressed fractional date mark for July 1824. Plate 8½ ins:22cm.*

"Saxham Hall" (D323)

A plate from the Fruit and Flower Border Series by Henshall & Co. is illustrated here.

"Saxony Blue" (New)

A trade name used by James Edwards, sometimes included within printed cartouche marks.

"Scarborough" (New)

Herculaneum. Cherub Medallion Border Series. Sauceboat.

"An ancient, large, and well-built town in the N. Riding of Yorkshire. . . . This place is greatly frequented on account of its spa well, the waters of which are a compound of vitriol, iron, alum, nitre and salt, and are both purgative and diuretic, as also for sea bathing" (Walker, 1810).

"Scotch View" (D323)

This view by an unknown maker is illustrated below on a dinner plate printed with an interesting fleur-de-lis mark, the significance of which is not yet known. The title mark usually found on this pattern is not present. The view is now thought to show MacDuff's Castle at East Wemyss in Fife.

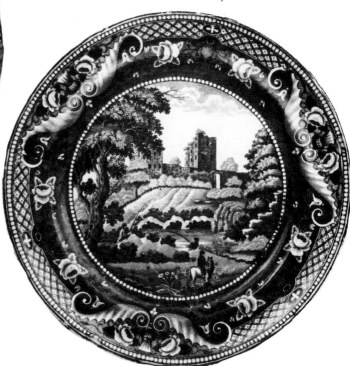

"Scotch View". *Maker **unknown**. Printed fleur-de-lis (no title). Plate 10ins:25cm.*

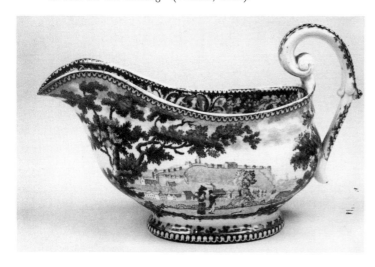

"Scarborough". *Herculaneum. Cherub Medallion Border Series. Printed title mark. Sauceboat, length 7¼ ins:18cm.*

"Scotch View". *Fleur-de-lis mark printed on untitled plate.*

Scott Brothers & Co. (New)
See: Southwick Pottery (D343)

"Scott's Illustrations" Series (D324-325)
Davenport. An additional scene is:
 "Old Mortality"
 The scene illustrated on D325 is now known to be mismarked and actually shows a second scene from "Bride of Lammermoor". A further unidentified scene on the lid of a sauce tureen is illustrated by Martin Pulver in "The Scott's Illustrations Series by Davenport", *Antique Collecting*, March 1986.

Seacombe Pottery (D324)
A detailed account of this pottery by Helen Williams has been published in the *Journal of Ceramic History*, "The Seacombe Pottery 1852-1864" (No.10, 1976). Note that the final date is given as seven years earlier than in the *Dictionary*.

"Seasons" (New)
Three potters used this title:
 (i) William Adams & Sons. A series of patterns featuring a man at different times of the year, found printed in blue, black, pink, or sepia. The backgrounds include castles, and the name of the season appears as part of the central pattern, "WINTER" and "FEBRUARY" being recorded to date. The border contains vignettes emblematic of the seasons, appropriately titled "SPRING", "SUMMER", "AUTUMN", and "WINTER". The title "SEASONS" is printed on a circular cartouche. Ill: P. Williams pp.523-524; Williams & Weber p.648.
 (ii) Thomas Godwin. A rural scene printed within a border of leafy tracery. A title cartouche includes the maker's name in full. Ill: Williams & Weber p.241.
 (iii) Maker unknown. Floral patterns bearing a printed mark in the form of a crown with "SEASONS" above and "NEW STONE CHINA" below.
 See also "Thomson's Seasons".

Seasons Series (D326)
Copeland & Garrett. An additional titled view is:
 "Windsor Castle" (with "September")
 Further untitled views have been recorded on a rectangular vegetable dish with "May", and a sauce tureen stand with "January". The following months have been recorded to date:

January	— Untitled
February	— "The Alps"
April	— Untitled
May	— Untitled
June	— "Italian Garden"
August	— "Italian Garden"
September	— "Windsor Castle"

and the following seasons:

Spring	— "Richmond Hill"
Autumn	— "Vintage of Sorrento"

Other months and seasons are illustrated by Lynne Sussman in *Spode/Copeland Transfer-Printed Patterns*, pp.194-203. They include May, July, October, November and Summer, but it is not absolutely clear which titles accompany them. The title "Italian Garden" was used to cover several formal garden arrangements and not just a single scene. The series was reissued by Copelands at the end of the 19th century.

"Select Sketches" Series (D326)
Thomas Dimmock & Co. An additional view is:
 "Antwerp"

"Select Views" Series (D327)
Ralph Hall. One previously recorded view is illustrated in this volume:
 "The Hospital near Poissy, France" *
 A typical printed cartouche mark used for the series is illustrated here.

"Select Views" Series. *Ralph Hall. Typical printed mark.*

"Semi-China" (D327-328)
This trade name has also been reported on a Davenport supper dish segment printed with a view of the Pashkov House in Moscow, taken from the other side of the house to that shown on D276. This trade name has not previously been recorded on Davenport wares.
 The drainer illustrated on D328 is thought to show Kirkstall Abbey and is one of a series of rural scenes featuring ruined abbeys, examples of which have been recorded with the impressed mark "WALLACE & CO." used by James Wallace & Co. of Newcastle. A marked dish with a different ruined abbey in the centre is illustrated by R.C. Bell in *Maling and other Tyneside Pottery*, p.23. A plate with a rural scene within the same border, also marked "Semi-China" is shown in P. Williams p.703.

"Semi-China Warranted". *View (iii). Attributed to Ralph Stevenson. Printed ribbon cartouche titled "SEMI-CHINA / WARRANTED". Dish 14¼ ins:36cm.*

"Semi-China Warranted". *View (ii). Attributed to Ralph Stevenson. Printed ribbon cartouche titled "SEMI-CHINA / WARRANTED". Soup tureen stand 13ins:33cm.*

"Semi-China Warranted" (D328)

The figure and animals on the left hand side on the dish illustrated on D328 are now known to be taken with minor changes from a painting of "The Bull" by the 17th century Dutch artist Paulus Potter (qv). Two further rural scenes from the same series by Ralph Stevenson are illustrated here, and a full list of all currently known scenes is as follows:

(i) The Bull. Dish 18½ins:47cm. Ill: D328.
(ii) Milkmaid and Goats. This has also been called Man with a Rake. Soup tureen stand and sauceboat. Ill: FOB 6.
(iii) Boy and Dogs. Dish 14¼ins:36cm.
(iv) Piping Shepherd Boy. Plate. Ill: FOB 29.
(v) The Three Donkeys. Plate 9¼ins:23cm. Ill: FOB 29.
(vi) Horseman at the Ford. Dish 16ins:41cm. Ill: FOB 50.
(vii) Girl with Sheep and Goat. Plate.

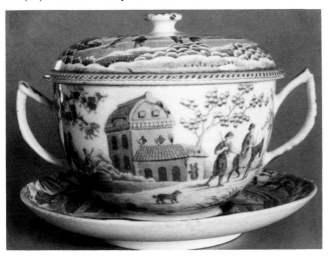

Sepulchre with Annexe. *Spode. Caramanian Series. Printed maker's name mark. Old shape broth bowl, diameter 4ins:10cm.*

Sharpus. *C.J. Mason & Co. Printed maker's crown and drape mark with retailer's mark "SHARPUS / 13 COCKSPUR STREET / LONDON" in a scroll frame. Soup plate 10¼ins:26cm.*

"Sentinel" (New)

Maker unknown. A classical romantic scene noted on a mug with a net-ground floral border. The title "SENTINEL" is printed within a diamond-shaped frame of small flowerheads.

"September" (New)

See: Seasons Series.

Sepulchre with Annexe (New)

Spode. Caramanian Series. Broth bowl.

Unlike the other views in this series, this design is not adapted from a Mayer print, and an adopted title has been used.

Shakespeare, William (New)

An unmarked mug decorated with three prints titled "THE IMMORTAL SHAKESPEAR", "SHAKSPEARE'S BIRTH PLACE" and "NEW PLACE, SHAKSPEARE" is illustrated in FOB 47. The border shows scenes from various plays, and the print of the playwright himself has initials J.S. and P.S. on either side. The fact that two sets of initials appear suggests that it may be a marriage or anniversary mug.

"Shannon" (D330)

Another potter used this title:
(ii) Francis Morley & Co. A pattern recorded with an impressed makers' mark "MORLEY".

The title was probably inspired by the river Shannon in Eire which flows through Lough Allen, Athlone and Limerick into the Atlantic.

Sharpus (D330)

A Mason's ironstone plate which bears a Sharpus retailer's mark is illustrated here, together with its maker's mark. The pattern does not appear previously to have been recorded.

Shaving Mug (New)

A mug fitted with an internal divider designed to be used with hot water and a shaving brush. Examples tend to be of relatively late date but two small blue-printed shaving mugs are illustrated in FOB 49, one by John & Thomas Lockett bearing a title "Melton" (qv).

Sharpus. *Printed retailer's mark with Mason's maker's mark.*

"The Sheep Shearer". *Maker unknown. Unmarked. Toy plate 3¼ ins:8cm.*

Shaw, Thomas (New)
Thomas Shaw was a landlord of the King's Arms at Stoke-on-Trent in the 1840s, and his name has been recorded on a presentation jug.

 See: "Kings Arms Inn, Stoke".

"The Sheep Shearer" (New)
Maker unknown. A pattern printed on a toy plate with the title on the front. It is almost certainly one of a set which includes "The Pretty Doves" (qv).

"Shelter'd Peasants" (D333)
An untitled variant of this pattern by an unknown maker is illustrated here on a teabowl and saucer.

Shepherd (New)
See: Brameld & Co.

Shepherdess (New)
This title is adopted by Drakard & Holdway for a very rare Spode pastoral catalogued as P705. They show a pierced bone china dessert plate and also a matching basket and stand in S113. It is, in fact, a pattern which is well known on wares by Andrew Stevenson, and its presence on so few marked Spode pieces suggests that Stevenson may have acquired some wares in the white from Spode, possibly to fill an urgent order. The Stevenson version can be seen in Little 64.

"Shield" (New)
James Edwards. A continental scene framed by an inner border of flowers and scrolls, and a wider outer border of acanthus scrolls and eagles. The printed cartouche mark includes the title, maker's name in full, and the inscription "SAXONY BLUE". Ill: Williams & Weber p.244.

Shipping Series (D334-337)
Maker unknown. Previously recorded scenes illustrated here and on p.184 are:
 (i) Frigate I. Quatrefoil dish.
 (vi) Fleet Scene I. Sauceboat and sauce tureen.
 (vii) Fleet Scene II. Sauce tureen stand.
 (viii) Approaching Port. Larger mug.
 (ix) Sailing Galley. Soup tureen.
 (xi) Harbour Scene. Smaller mug.
Additional scenes, shown on p.184, are:
 (xii) Harbour Scene II. Drainer 13ins:33cm.
 (xiii) Fishing Dinghy. Leaf pickle dish.
 (xiv) Frigate III. Sauce ladle.
 In addition, a shell from the border is featured within a soup ladle (p.184). Both the maker and the source or sources for all except one of the views remain unknown.

"Shelter'd Peasants". *Pattern variant by an unknown maker. Unmarked. Teabowl and saucer, diameter 4¾ ins:12cm.*

Shipping Series. *Frigate I; scene (i). Maker unknown. Unmarked. Quatrefoil dish 9¼ ins:23cm.*

Shipping Series. *Fleet Scene I; scene (vi). Maker unknown. Unmarked. Sauceboat 6½ ins: 16cm.*

Shipping Series. *Fleet Scene I; scene (vi) tureen. Fleet Scene II, scene (vii) stand. Maker unknown. Unmarked. Sauce tureen, cover and stand, length of stand 7¼ ins: 18cm.*

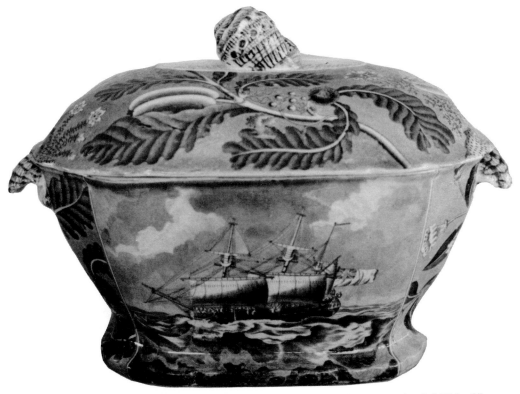

Shipping Series. *Sailing Galley; scene (ix). Maker unknown. Unmarked. Soup tureen, length 14½ ins: 37cm.*

continued

Shipping Series. *Harbour Scene II; scene (xii). Maker unknown. Unmarked. Drainer 13ins:33cm.*

Shipping Series. *Fishing Dinghy; scene (xiii). Maker unknown. Unmarked. Leaf pickle dish 5¼ins:13cm.*

Shipping Series. *Harbour Scene; scene (xi) left. Approaching Port; scene (viii) right. Maker unknown. Unmarked. Mugs, height 4¼ins:11cm and 5¼ins:13cm.*

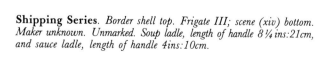

Shipping Series. *Border shell top. Frigate III; scene (xiv) bottom. Maker unknown. Unmarked. Soup ladle, length of handle 8¼ins:21cm, and sauce ladle, length of handle 4ins:10cm.*

"Shirley House, Surrey" (D337)

It has been reported that the building shown on this plate made by Enoch Wood & Sons in their Grapevine Border Series may not be Coombe House, as suggested in the *Dictionary*, but the building which was subsequently converted into the Shirley Park Hotel. It was originally built by John Claxton in 1721, enlarged in 1810, and eventually demolished in 1962.

"Sicilian" (D338)

Several examples of the "Sicilian" pattern have now been reported with impressed marks for Pountney & Allies and their successors Pountney & Goldney of Bristol. Although these marked examples confirm one maker, it is still possible that the same designs were made at other factories.

The title could possibly have been inspired by *The Sicilian Romance* (1790), a very popular Gothic novel by Anne Radcliffe.

"Sicre Gully Pass, Bengal" (New)

Thomas & Benjamin Godwin. Indian Scenery Series. Plate 7¼ins:18cm. See "Sicre Gully Pass" (D339).

"Singanese" (D339)

Another potter used this title:

(ii) Whittingham, Ford & Co. A typical romantic pattern marked with initials W.F. & Co. which was also used by Ralph Hall & Co. (see: P. Williams pp.163-164).

"Slingsby Castle, Yorkshire" (D340)

This view by an unknown maker in the Pineapple Border Series was used on a soup tureen and a large ewer, both illustrated here. The tureen stand illustrated in FOB 10 and recorded in the *Dictionary* is now known to be mismarked and is printed with the view of "Valle Crucis Abbey, Wales" (Colour Plate XIII).

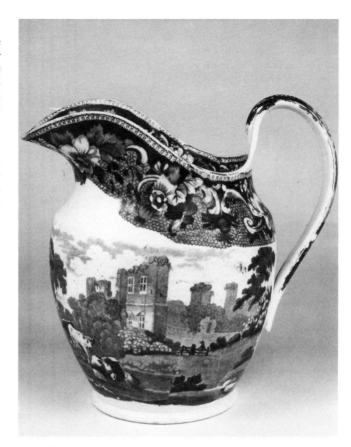

"Slingsby Castle, Yorkshire". *Maker unknown. Pineapple Border Series. Printed title mark. Ewer, height 8½ins:22cm.*

"Slingsby Castle, Yorkshire". *Maker unknown. Pineapple Border Series. Printed title mark. Soup tureen, cover and ladle. Interior view is "Charenton, near Paris", ladle view "Wenlock Abbey, Shropshire". Overall length 12¼ins:31cm.*

Smith, William, & Co. (D340)

A selection of printed teawares by William Smith & Co., some in blue, are illustrated by Gilbert Versluys in NCS 67, pp.14-19. Smith's connection with the Belgian firm of J.B. Cappellemans Aîné is explained by his partnership from 1847 with the three Cappellemans brothers in a pottery at Jemappes. Smith was a director and invested heavily in the undertaking. He also provided moulds, copper plates, and other materials from England. The Belgian firm became bankrupt in 1870.

See: Stafford Pottery.

Snow Scenes (D340)

The two scenes listed as (i) and (ii) are now known to be versions of the same pattern which was illustrated on an egg hoop (D125). The full pattern is illustrated here on a pie plate. The same design has been recorded on a marked Davenport teapot in FOB 49 where it is described as showing an eskimo on snow shoes. The figure could, however, represent a hunter or trapper in the forests of eastern Canada in the winter.

Snow Scenes. *Possibly Davenport. Unmarked. Pie plate 8¼ ins:21cm.*

"The Social Party" (New)

Chetham & Robinson or Chesworth & Robinson. "Terni" Series. Dish, approximately 18ins:46cm.

South Wales Pottery (D341)

This pottery was continued by William Thomas Holland from 1858 to 1869 when it was taken over by Guest & Dewsberry. Printed marks incorporate the respective initials W.T.H. or G. & D. / L., the L signifying Llanelly. In 1878 Jewitt stated that it was "the only blue and white earthenware manufactory now in the principality". Patterns included "Milan" and "Oriental", and there was a considerable export trade to North America.

"The Sow and the Wolf" (D342-343)

This fable was also used by Minton, Hollins & Co. as part of a set printed on Tiles (qv).

"The Sower" (New)

See: "The Progress of a Quartern Loaf".

"Spanish Beauties" (D343)

This romantic-style pattern by an unknown maker was printed on dinner wares. It shows a group of figures, one playing a stringed instrument, within a very detailed floral scroll border incorporating small scenic vignettes. The title is printed in script in a cartouche surmounted by a crown and demi-lion crest. Ill: Williams & Weber pp.245-246.

"Spanish Convent" (New)

William Adams & Sons. A series of romantic religious scenes within a flowery border with scenic reserves. The title is printed in script within a floral scroll cartouche, and items with the impressed mark "ADAMS" have been noted. The patterns were also printed in red, black or green, or a combination of colours. Ill: P. Williams p.420; Williams & Weber pp.629-630.

Special Order Wares (New)

Despite the expense of specially engraved copper plates, potters did produce blue-printed wares to special order. These are typified particularly by Armorial Wares (qv), and by presentation mugs, jugs and plates with suitable inscriptions, but other designs were made marked with clients' names, including caterers, hotels, tradesmen, and private individuals. Of particular interest are the patterns which have a name let into a reserve in the border, examples of which include:

"A. Challice" (qv and D77)
"A. Emmerson" (qv and Colour Plate XIII)
"Erin" (D129)
"Quinn, 40 Haymarket" (see J. Quinn)
"Spaniard Inn" (D343)

With the exception of those which include an address, these often prove difficult to trace.

"Spectemur Agendo" (New)

Let us be viewed by our actions. A motto used by the Thompson family.

A blue-printed armorial dinner service bearing this motto was made by Spode for Alderman Thompson MP, an alderman of the City of London. A cake stand is illustrated opposite and a soup tureen stand can be seen in Drakard & Holdway P954.

See: Armorial Wares.

Sphinx (New)

A distinctive sphinx appears as part of a transitional pattern printed on teawares by an unknown maker. The central design features a pagoda and willow tree on the left, with the sphinx under a large palm tree on the right with pyramids behind. There is a crocodile in the river in the foreground, and the pattern is enclosed within a wide Greek key pattern border. Ill: FOB 44.

Spode, Josiah (D344)

Many Spode patterns were listed in the *Dictionary*, but in some cases existing references differ in the titles adopted. The subject of printed wares from the Spode factory has subsequently been extensively documented by David Drakard and Paul Holdway in *Spode Printed Ware* (1983). It catalogues all Spode patterns known when published, and illustrates very many of the shapes on which they were printed. In view of the fact that this will undoubtedly become the standard reference work, Drakard & Holdway's pattern titles are used in this volume, but in order to assist in other cases, alternative titles have also been listed and cross-referenced as appropriate. This problem is particularly acute in the case of early chinoiserie patterns, and a useful table comparing the various titles is shown by R. Copeland in *Spode's Willow Pattern & other Designs after the Chinese* (1980), p.159. Another useful publication is Lynne Sussman's *Spode/Copeland Transfer-Printed Patterns Found at 20 Hudson's Bay Company Sites* (1979), which illustrates many of the factory's patterns, particularly from the later Copeland period, on pulls from the original copper plates or from pages in surviving factory pattern books.

The Spode Society, formed in 1986 to promote research into the factory and its wares, publishes a *Review* twice a year, as well as the *Recorder* which contains more detailed articles. Both these publications cover the full range of Spode and Copeland wares, but much information of interest to collectors of Spode blue-printed wares is included.

A previously unrecorded Spode product is the dish which is illustrated printed with the Zebra pattern (qv). This pattern is normally marked Rogers, or rarely Toft & May, and since it is not a standard Spode design, one of these firms may have bought some unglazed wares from Spode to help them fulfil an urgent order. Two other unusual items are illustrated here. The sauceboat stand has the Grasshopper pattern combined with the border from the Group pattern, whereas the plate has the Temple pattern with a Nankin inner border.

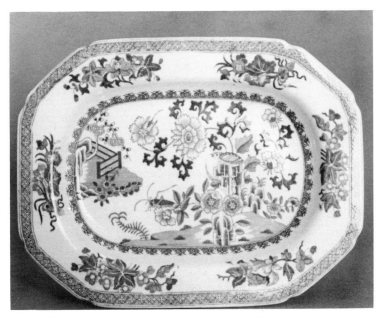

Spode, Josiah. *Grasshopper pattern with Group border. Printed seal mark with ''SPODE'' and ''Stone China''. Sauceboat stand 7½ ins:19cm.*

Spode, Josiah. *Temple pattern with Nankin inner border. Impressed ''SPODE'S NEW STONE''. Plate 9ins:23cm.*

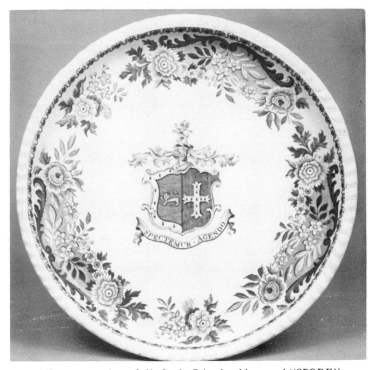

''Spectemur Agendo''. *Spode. Printed and impressed ''SPODE''. Cake stand 11½ ins:29cm.*

Sporting Series (D344)

Enoch Wood & Sons. The soup plate showing a Pointer and Quail is illustrated here. A basket decorated with the Polar Bear Hunting scene can be seen in FOB 35 where it is reported that animals used to decorate the outside are taken from Bewick's *A General History of Quadrupeds*, including a pied goat, common antelope, gnu, and grysbok. An unrecorded scene with no apparent sporting connotations, showing a ram, a sheep and a lamb, was used on a plate 6½ ins:16cm. Ill: FOB 45.

"Sporting Subjects" (D344)

A dessert plate from this series by J. & M.P. Bell & Co. showing a night scene of badger digging is illustrated here. The scene on the soup plate shows foxhunting. The title appears in script as part of an unusual printed mark in the form of a fox's head superimposed on a bridle and hunting accoutrements, with the makers' initials beneath. A similar mark but with the maker's name and address "T. HEATH, BURSLEM" can be found on wares printed with the same patterns. Ill: P. Williams p.527; Williams & Weber p.650.

Sportsman's Inn (D346)

This scene has also been recorded on a jug, and the large house in the background is believed to be Kenwood House near Hampstead Heath. It has been suggested that the inn depicted could be the famous Spaniards Inn, Hampstead, which was well known to Byron, Coleridge, Keats, Shelley and Joshua Reynolds. Dickens included the inn in his *Pickwick Papers* (1836-1837). Ill: FOB 37.

"Spring" (New)

See: "Seasons"; Seasons Series.

Stackpole Court, Pembrokeshire (D347)

The view of this house in the inappropriately titled "Irish Scenery" series by Elkins & Co. is taken from a print by John Preston Neale.

Stackpole Court was built in 1785 in the parish of Petroc, three miles south of Pembroke. It was a large house with over 150 rooms. In 1799 John Campbell, the 1st Lord Cawdor, created an artificial lake on which he kept a collection of ornamental water fowl. During World War II Stackpole Court was requisitioned for military use but unfortunately it later developed dry rot, and was finally demolished in 1965.

Sporting Series. *Pointer and Quail. Enoch Wood & Sons. Impressed makers' mark. Soup plate 10¼ ins:26cm.*

"Sporting Subjects". *J. & M.P. Bell & Co. Printed cartouche of fox's head and riding equipment with series title and makers' initials. Plate 9¼ ins:23cm.*

Colour Plate XXIV. "Royal Sketches". *Maker unknown. View identified as the Royal Pavilion, Brighton. Printed title mark. Ornate covered jug, overall height 7¼ ins:18cm.*

Colour Plate XXV. Swansea's Glamorgan Pottery. *Ship pattern. No mark on base, but initials G.P. Co. / S. appear twice in foreground of pattern. Plate 10¼ ins:26cm.*

"**Stafford Gallery**". *The Rough Sea; scene (iv). Maker unknown. Printed series title mark. Cheese or cake stand 12½ ins.:32cm.*

"Stafford Gallery" (D347)

Maker unknown. Additional patterns are:

(vi) Peasants Picnic. Two men holding a large cloth, one also with a basket, in a rural scene including a cliff and a church. Soup tureen cover.

(vii) Shooting and Fishing. A rural scene including a man fishing and another with a gun and a dog. Soup tureen. Ill: FOB 37.

(viii) Duck Shooting. A rural scene featuring a sportsman with an attendant helper, and a mounted man herding sheep. Feeding bottle. Ill: FOB 37.

The pattern in this series known as The Rough Sea, (iv), is illustrated here on a large cheese or cake stand.

The significance of the title used for this series has not yet been established.

Stafford Pottery (New)

A dinner plate illustrated here is printed with an interesting coat-of-arms mark inscribed "WARRANTED / STAFFORD POTTERY / STONE CHINA". It has been mistaken for a Staffordshire product, but the arms are those of Stockton-on-Tees, and the plate was made at the Stafford Pottery there. This pottery was established at Thornaby, South Stockton, in 1825 by William Smith and traded from 1826 until 1855 as William Smith & Co. Products are usually marked with the full partnership name or with the misleading names Wedgwood, Vedgwood, or Wedgewood. This mark with the name Stafford Pottery is most unusual, and it may be an early piece produced before a decision was made to use the partnership name.

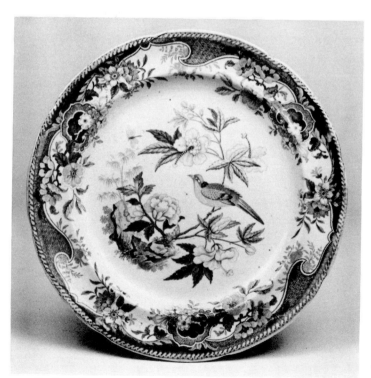

Stafford Pottery. *Bird on Branch pattern. Printed arms of Stockton-on-Tees with "WARRANTED / STAFFORD POTTERY / STONE CHINA" on ribbons above. Plate 10ins:26cm.*

Stafford Pottery. *Printed arms mark on plate left.*

"The Stag Looking into the Water" (New)
Spode/Copeland & Garrett. "Aesop's Fables" Series. Dish. Ill: Sussman, *Spode/Copeland Transfer-Printed Patterns*, p.34.

A stag who had been drinking from a clear spring admired his branching horns but thought his slender legs unsightly. Suddenly, a huntsman and a pack of hounds appeared. He sped away leaving the hunt behind, but entered a thick copse where his horns became entangled. The branches held him fast until the hounds came and pulled him down. In his death pangs he said: "I prided myself on what has been my undoing, and what I so much disliked was the only thing that could have saved me".

Look to use before ornament.

Stanway, Richard (New)
A miniature plate by an unknown maker is illustrated here with the standard Willow pattern but with a superimposed scroll inscribed: "RICHARD STANWAY / NEWCASTLE STAFFS." On the reverse is the further inscription:

CLOTHING
MANUFACTURER
CONTRACTOR & RETAILER
GENTLEMEN'S MERCER
HATTER &c
1879.

This was almost certainly intended for use as an advertising give-away, equivalent to a trade card, and the small hole at the top edge suggests that it may have been attached to garments made by the tailor as a novel form of label. Other small plates of similar design were used by Callard & Callard (qv) and by John Mortlock (D253).

See: Trade Card.

"Starting Off to See Granny" (New)
See: Little Red Riding Hood.

"Statue" (New)
Scott Brothers & Co. A romantic design printed in dark blue on teawares. A printed mark includes both the title and the makers' initials S.B. & Co. Ill: John C. Baker, *Sunderland Pottery*, figure 61.

"Stoke Edith Park, Herefordshire" (New)
A titled view reported in FOB 49 on a sauce tureen stand. The maker and series (if any) are not recorded.

Stoke Edith Park was built for Paul Foley, Speaker of the House of Commons, by William Talman in c.1697. It was sited six miles east of Hereford but was destroyed by fire in 1927.

Storer, James Sargam (New) **1771-1853**
Born in Cambridge, James Storer moved to London and became an engraver of architectural and topographical views. Some of his work appeared in *The Beauties of England and Wales* from which at least one engraving, a view of Netley Abbey (qv), was copied for a printed pattern.

"Stow Hall" (New)
Knight, Elkin & Co. "Baronial Halls" Series. Plate.

There are several Stow Halls in England including two in Norfolk, one in Lincolnshire, and West Stow Hall in Suffolk.

Strainer (D351)
See: Milsey.

Stanway, Richard. *Maker unknown. Printed inscription dated 1879. Miniature advertising plate 3ins:7cm.*

Stanway, Richard. *Printed advertising inscription.*

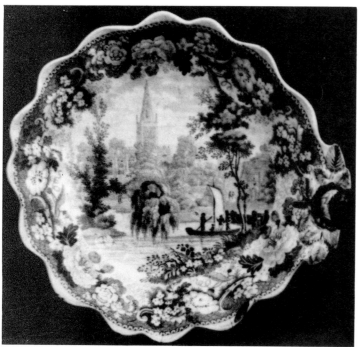

"Stratford upon Avon, Warwickshire". *Maker unknown.* *"Antique Scenery" Series. Printed titles mark. Shell dish, length 9ins:23cm.*

"Stratford upon Avon, Warwickshire" (D351)
This view by an unknown maker in the "Antique Scenery" Series is illustrated here on a moulded shell-shaped dessert dish, a previously unrecorded shape.

"Summer" (New)
See: "Seasons".

"Summer Hall, Kent" (D352)
The subject of this view has still not been located with certainty, but it could be Summer Hill, a seat just outside Tenterden.

Sunflower (New)
An alternative name for the Spode floral pattern which Drakard & Holdway catalogue as Convolvulus (qv).

Supper Set (D352-353)
See: Greek Patterns.

"Surseya Ghaut, Khanpore" (D354)
The view by Thomas & Benjamin Godwin in their Indian Scenery Series was printed on plates, soup plates and hot-water plates, all between 10¼ins:26cm and 10½ins:27cm. Ill: FOB 47

The view by an unknown maker in the "Oriental Scenery" Series has been noted on a large gadrooned soup plate 10¾ins:27cm in addition to the dinner plate which is 10¼ins:26cm and the hot-water plate 10ins:26cm. Ill: FOB 47.

The view by another unknown maker in the Parrot Border Series is illustrated here on a circular vegetable dish, but is more commonly found on the soup plate which is 10ins:25cm.

Swan, Joseph (New) d.1872
A line-engraver of topographical views and botanical subjects. He lived and worked in Glasgow, and is known for his *Select Views on the River Clyde* (1830), which was the source for several patterns in the Belle Vue Views Series (qv).

"Surseya Ghaut, Khanpore". *Maker unknown. Parrot Border Series. Printed title mark. Circular vegetable dish 10¼ins:26cm.*

Swansea's Glamorgan Pottery (D355)
An interesting plate printed with a scene showing a fully rigged frigate in rough seas is illustrated in Colour Plate XXV. Although it has no mark on the base, the factory's initials G.P. Co. / S. appear twice on artefacts which are in the foreground of the pattern. This is a very unusual way for a pottery to mark its wares.

"Sweetheart Abbey" (D355)
This view by Elkin, Knight & Co. in their Rock Cartouche Series is now known to be based on an engraving by Robert Andrew of 13 Hart Lane, Bloomsbury, published in 1796. The print carries the inscription "To Sir Joseph Banks, Bart., President of the Royal Society, this view of Sweetheart Abbey is respectfully inscribed and dedicated". Sir Joseph Banks was President of the Royal Society from 1778 to 1820. He had earlier accompanied Capt. James Cook on his expedition round the world in the *Endeavour*, 1768-1771.

"Swiss Scenery" (D355)
A dinner plate with a romantic scene within a floral trellis border has been noted marked with this pattern name in plain capital letters without any cartouche. It is not known whether it is the same as the pattern previously listed by James Jamieson & Co.

"Syria" (D355)
The printed mark used for this pale blue romantic pattern by Robert Cochran & Co. is in the form of a circular belt with the makers' initials R.C. & Co. at the top and enclosing the title "Syria" in script.

"Tadmor in the Desert" (New)
Job & John Jackson. "Holy Bible" Series. Plate.

Tadmor, which lies between the Euphrates and the Hamath, was the Syrian city of Palmyra which held out against the Romans but was eventually subdued. An oasis in the desert, it was used by caravan traffic between the Red Sea and the Persian Gulf. Walker's gazetteer of 1810 states that "this place, called by the Arabs 'Tadmor in the Desert', appears to have been built originally by Solomon but the architecture of its admired remains is probably Grecian. The stupendous ruins of this ancient city were visited by Messrs. Wood and Dawson in 1751 and a splendid account of them, illustrated with plates, was published by Mr. Wood in 1753". See: Chronicles II, 8, 4.

"The Taj Mahal, Tomb of the Emperor" (New)
Thomas & Benjamin Godwin. Indian Scenery Series. Ornate footed vegetable dish 12¼ ins:31cm.

The Taj Mahal at Agra was built between 1632 and 1643 by the Mogul emperor Shah Jehan as a mausoleum for his favourite wife, Mumtaz Mahal, Elect of the Palace. Built of white marble, the whole complex was not completed until 1654. It also houses the body of the Emperor himself.

Tall Door (D356)
This Spode chinoiserie pattern is catalogued by Drakard & Holdway as P615. It is also illustrated in Copeland p.89; Drakard & Holdway S85 and S136; Whiter 19.

Tams' Foliage Border Series (D356)
Tams & Co. One previously recorded view is illustrated in this volume:

 "Covent Garden Theatre, London" *

"Tapestry" (New)
James Reed. A copy of Brameld's Twisted Tree pattern (qv).

"The Taj Mahal, Tomb of the Emperor". *Thomas & Benjamin Godwin. Indian Scenery Series. Printed title mark with makers' initials. Footed vegetable dish, length 12¼ ins:31cm.*

"Tchiurluk". *Maker unknown. Ottoman Empire Series. Plate 10ins:25cm.*

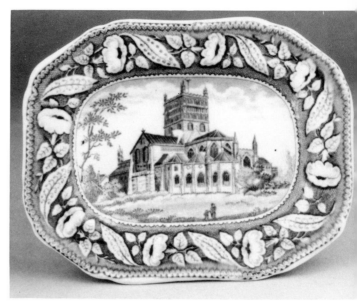

"Tewkesbury Church". *Minton. Minton Miniature Series. Printed title mark. Miniature dish 5¼ins:14cm.*

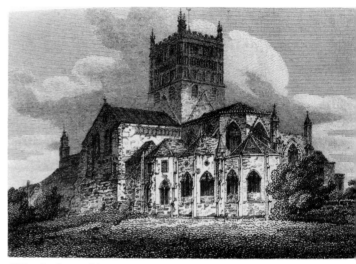

"Tewkesbury Church". *Source print taken from Volume 2 of Storer and Greig's "The Antiquarian and Topographical Cabinet".*

"Tchiurluk" (D357)

The plate from the Ottoman Empire Series by an unknown maker is illustrated here. Its size is now known to be 10ins:25cm.

Temple (New)

This title has been adopted for a Spode chinoiserie pattern which Drakard & Holloway show on several different shapes and catalogue as P613. Whiter also calls it Temple, but Copeland refers to it as Two Temples. It is also illustrated in Copeland pp.53-66; Whiter 16; S.B. Williams 99-100, 103 and 105. It is similar to the Broseley pattern but has an extra figure on a rock close to the bridge, and there are differences in the border. It may have been used only on bone china.

"Temple House" (D360)

The view in the "River Thames" Series by Pountney & Allies/Pountney & Goldney was printed on a circular cake or cheese stand in addition to the plate shown in FOB 17.

Temple Landscape (D360)

These two Spode chinoiserie patterns are catalogued by Drakard & Holloway as P601 and P611. As previously recorded, Copeland uses the name only for the later pattern and calls the earlier one Buddleia (see Copeland pp.81-83 and pp.96-99). Examples are also illustrated in Drakard & Holloway S84, S86, and S204; Whiter 2 and 14.

Temple with Panel (New)

An alternative name for a Spode chinoiserie pattern which Drakard & Holloway catalogue as Dagger Landscape (qv).

"Terni" (D360)

One previously recorded scene from this series by Chesworth & Robinson or Chetham & Robinson is illustrated in this volume:

"A Romantic District of Italy" *

Additional scenes are:

"The Guitar"
"The Social Party"

"Tessino" (New)

Joseph Clementson. A typical romantic scene found on dinner wares marked with a printed registration diamond, the title, and the maker's name in full.

Tessino, usually spelt Tescino, is a river in Italy which rises in Mount Gothard and, running through Lake Maggiore, falls into the river Po at Pavira.

"Tewkesbury Church" (D360)

The dish from the Minton Miniature Series is illustrated here together with the source print taken from Storer and Grieg's *The Antiquarian and Topographical Cabinet*.

"Thomson's Seasons" (New)

Maker unknown with initials A. & Co. A series of rural scenes noted on mugs and jugs, marked with a printed cartouche inscribed "THOMSON'S SEASONS" and the unidentified initials A. & Co. beneath. These could possibly relate to Samuel Alcock & Co., but the wares are certainly too early to have been made by Asbury & Co. who are known to have used these initials.

One scene featuring a ploughman is illustrated here on a mug which has the month "April" incorporated in the pattern. A jug has been noted with "Autumn" on the rim and decorated with another rural scene marked "August" showing two harvesters with scythes, one drinking from a flask and the other with a handful of straw with ears of corn.

Poems by James Thomson (1700-1748) were published on *Winter* (1726), *Summer* (1727), *Spring* (1728), and *Autumn* (1730), when they were brought together in one volume as *The Seasons*. There was a marked revival of interest in this work in what has often been described as "The Romantic Period" — roughly from 1800 to 1830.

"The Thrasher" (New)

See: "The Progress of a Quartern Loaf".

Tiber (D362)

This Spode pattern is catalogued by Drakard & Holdway under its alternative factory name of Rome (qv), a title which now appears to be generally preferred. A version produced by Thomas Lakin was recorded in the *Dictionary* (D362), and another has now been noted with an impressed mark "STUBBS" for Joseph Stubbs of Longport.

"Thomson's Seasons". Printed cartouche mark with unknown makers' initials.

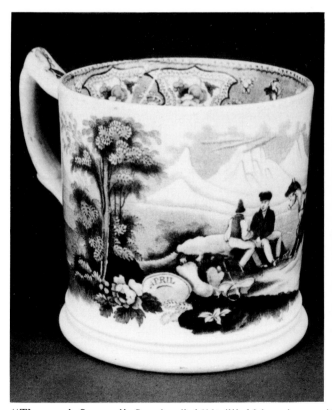

"Thomson's Seasons". Scene inscribed "April". Maker unknown with initials A. & Co. Printed title cartouche with makers' initials. Two views of a mug, height 4ins:10cm.

Tiles (D363)

Four blue-printed tiles from a set made by Minton, Hollins & Co. are illustrated here. The animal fable scenes are copied from prints, drawn and engraved by Samuel Howitt, which appeared in *Fables of Aesop and Phaedras*, published by Edward Orme between 1809 and 1811. The fables shown are:

The Bear and the Bees
The Cat and the Mice
The Hare and the Tortoise
The Sow and the Wolf

Details of the stories can be found in individual entries for each fable. At least two more scenes are known to have been made, forming a set of six or more.

Titled Seats Series (D363)

Careys. One previously recorded view is illustrated in this volume:

"Eaton Hall, Cheshire, Earl Grosvenor's Seat" *

Additional views are:

"Hollywell Cottage, Ireland, Lord Tara's Seat" *
"Kilruddery Hall, Wicklow, Earl of Meath's Seat"
"Plas-Newydd, Wales, Marquess of Anglesey's Seat"

Tiles. *Minton, Hollins & Co. Moulded mark with "MINTON, HOLLINS & CO. PATENT TILE WORKS STOKE ON TRENT". Set of four tiles with animal fables, each 6ins:15cm square.*

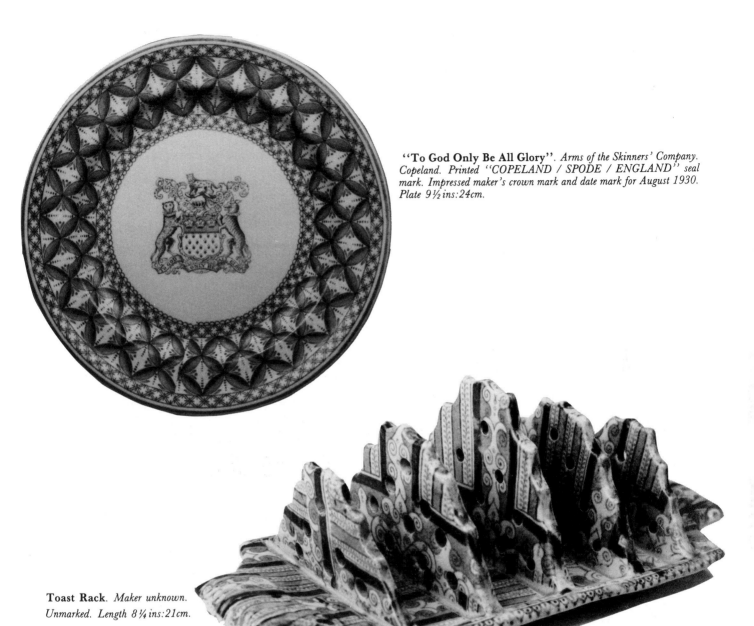

"**To God Only Be All Glory**". *Arms of the Skinners' Company. Copeland. Printed "COPELAND / SPODE / ENGLAND" seal mark. Impressed maker's crown mark and date mark for August 1930. Plate 9½ins:24cm.*

Toast Rack. *Maker unknown. Unmarked. Length 8¼ins:21cm.*

"To God Only Be All Glory" (D365)

Additional dinner wares were made for the Skinners' Company using the original Spode design throughout the 19th century during both the Copeland & Garrett and Copeland periods. A very late Copeland example with a date mark for August 1930 is illustrated here. Some examples were made in pink rather than blue. The company also ordered wares from the Worcester factory, but once again the same design was used.

Toast Rack (D364-365)

An example by an unknown maker is illustrated here, and another has been noted printed with the "Rural Village" pattern (D315). In common with all others seen to date, including the Minton and Spode examples in the *Dictionary*, they both have five vertical dividers.

Toast Water (New)

Toast water was a drink intended for invalids made by pouring boiling water on to toast, allowing it to stand, and then straining off the liquid. The recipe is mentioned by Mrs. Beeton in early editions of her *Book of Household Management*. Jugs which are fitted with a lid and a strainer behind the spout are occasionally described as toast water jugs.

See: "Royal Sketches".

Toft & May (D365)

The impressed mark "TOFT & MAY" appears on a dish printed with a coursing scene illustrated in Colour Plate IX. This is one of a series of patterns, listed under the general title Coursing Scene (qv). Marked wares from this short-lived partnership are rare, the only other recorded example being the Zebra pattern plate shown in Little 67.

Toilet Box. *Maker unknown. Unmarked. Overall length 7¾ ins:20cm.*

Toilet Box. *Maker unknown. Unmarked. Overall length 7ins:18cm.*

Toilet Box (D365)

Two further toilet boxes, both by unknown makers, are illustrated here. Neither pattern has been recorded before and the example with the moulding on the lid surrounded by an acorn and oak leaf border is most unusual. Similar moulding extends around the outside of the box, and the lack of any inner divider has led to a suggestion that it may have been intended as a pen holder for use on a desk.

"Tom Piper" (D365)

This pattern by Marsh & Willet was probably inspired by the character Tom Piper who appears in a traditional morris dance. He is mentioned in a verse by William Browne:

So have I seen
Tom Piper stand upon our village green,
Backed with the May-pole, while a gentle crew,
In gentle motion, circularly threw
Themselves about him.

"The Tomb of Cecilia Metella" (D367)
Note that the actual title of this view appears on the wares with a prefix "The".

"Tomb of the Emperor Acber" (D367)
See following entry.

"Tomb of the Emperor Acber at Secundra" (sic) (New)
Maker unknown. "Oriental Scenery" Series. Well-and-tree dish 18¾ins:48cm. Ill: FOB 47.

This is the correct title for the entry which appeared incompletely as "Tomb of the Emperor Acber" (D367).

Akbar, the greatest of the Mogul emperors, was born in 1542. By the 1570s he had conquered the whole of northern India. Sikandra is about five miles north of Agra.

"Tomb of the Emperor Shah Jehan" (D367)
The view from the "Oriental Scenery" Series by John Hall & Sons is illustrated on a dish 18¼ins:46cm in Colour Plate XXVII. The view of the same title by the unknown maker of the second "Oriental Scenery" Series can be seen in FOB 47 on a dish which is 20¾ins:53cm. The two views are similar, with the same main building, but there are many differences in the foreground.

Shah Jehan, the Mogul emperor from 1627 to 1658, built the Taj Mahal at Agra as a memorial to his love for his wife. Their bodies lie within the magnificent white marble building.

"Tomb at Jeswuntnagurh" (New)
Cork, Edge & Malkin. Indian Scenery Series. Plate 8ins:20cm.

Another view similar to that used by John Hall & Sons and an unknown maker in their two "Oriental Scenery" Series. The titles used by these makers vary slightly and the exact title of this view by Cork, Edge & Malkin needs confirmation. See following entry.

"Tomb of Jeswuntnagurth" (D367)
The exact title of this view by an unknown maker in the "Oriental Scenery" Series has now been confirmed. It was produced on a dished plate 8¾ins:22cm. Ill: FOB 47.

Jaswant Rao espoused the Marathi cause against the Mogul powers, and "moved across the Indian scene like a blazing and erratic comet". He was struck down by insanity in 1808, and died three years later.

"Tombs near Etaya" (New)
Maker unknown. Parrot Border Series. Dish 10½ins:27cm and deep dish 8½ins:21cm.

Etaya, known today as Etawah, is a town situated on the river Jumna, about 60 miles south-east of the city of Agra.

"Tournament" (New)
Samuel Moore & Co. A romantic-style pattern showing jousting knights on horseback, no doubt reflecting the great public interest in the famous Eglinton Tournament of 1839. The printed mark includes the makers' initials S.M. & Co.

Tower (D368)
This common Spode pattern is catalogued by Drakard & Holdway as P714 and shown by them on a wide range of shapes. It is extensively illustrated elsewhere, including Coysh 1 107; Whiter 70, 97 and 99; S.B. Williams 84-89.

Tower of London (New)
An impressive view of the Tower of London was used by Wedgwood with their Blue Rose border on large items. An example is illustrated in this volume on a Foot Bath (qv), and a soup tureen is on display in the museum at Nyon, in Switzerland.

The Tower of London has been a fortress, a palace, a prison, and a place of execution, and has also housed public records, the Royal Mint, and an arsenal for small arms. For over four centuries, until 1834, it also housed the Royal menagerie.

Toys (D368)
Reports concerning the make-up of toy tea sets indicate that they usually consisted of six cups and saucers, two plates, teapot, sucrier, creamer and slop bowl, although there would be variations. Extensive information about toy wares can be found in Maurice & Evelyn Milbourn's *Understanding Miniature British Pottery and Porcelain 1730-Present Day*.

Trade Card (D368)
Three more similar miniature advertising plates, possibly intended for use as give-away items, are known.
See: Callard & Callard; Thomas Gibson; Richard Stanway.

Treacle Pot (New)
A rare item in the form of a barrel-shaped pot with handle and a screw-on lid. The rim is narrower than the base, but there is no lip. Ill: FOB 40.

Trench Mortar (New)
An attributed title for a Spode chinoiserie pattern which is catalogued by Drakard & Holdway as P618. It has also been called Malayan Village and Pearl River House, the latter title being preferred in Copeland pp.74-77.

Trophies (D370)
These three Spode patterns of Chinese trophies are catalogued by Drakard & Holdway as P628, P629, and P630. The variant called Trophies-Dagger has also been referred to as Fitzhugh, but this alternative title conflicts with other patterns. A fourth Trophies pattern with the Marble border was produced, but with added underglaze orange decoration. Examples of the original three Trophies patterns can also be seen in Copeland pp.130-135; Coysh 1 15; Coysh 2 95; Drakard & Holdway S121 and S193; Whiter 28-30; S.B. Williams 122.

"Trophy" (New)
Maker unknown. A pattern featuring a group of floral baskets and a prominent lyre. The title "TROPHY" appears printed on a ribbon cartouche.

Troutbeck, E.T. (New) fl.c.1846
Sandyford, Tunstall, Staffordshire. A previously unrecorded potter known to have made printed wares by virtue of marked patterns titled "Chinese Gem" and "Epirus". An impressed mark consists of the maker's name and the address "TUNSTALL" within concentric circles surrounding an anchor. Examples of the pattern "Chinese Gem" have also been reported with unidentified initials M.T. & T.

The only known record of this potter is an entry in a Staffordshire directory dated May 1846 where he is listed as being an earthenware manufacturer.

"Tudor" (D370)

This title is recorded as being produced by David Methven & Sons but there is some doubt about the entry. A pattern featuring a geometric arrangement of carved stonework designs has been noted with a hexagonal printed panel mark containing the title "TUDOR" and with the single initial M. beneath. On stylistic grounds an attribution to John Maddock, who is known to have used this initial mark, would appear more reasonable.

Tulip Vase (New)

An alternative name for a Quintal Flower Horn (qv), a vase in the shape of five horns moulded together.

The Turk (New)

This is a recently adopted title for the rare Spode pattern which features the Caramanian Series view of an Ancient Granary at Cacamo within a floral border, illustrated on a dessert plate in D22. Drakard & Holdway catalogue the pattern as P715 and show it on a small cream jug in S136. Another example on a coffee pot can be seen in the Cliffe Castle Museum at Keighley in Yorkshire. It is decorated with a circular print on either side, possibly from the same copper plates as the dessert plate illustrated in the *Dictionary*. The floral border appears around both the shoulder and the pedestal foot.

Turkish Castle (New)

This is a recently adopted title for a rare pattern which is attributed to Spode and catalogued by Drakard & Holdway as P716, and also illustrated by them on an egg stand in S157. As with The Turk (qv), it is related to the Caramanian series, but the central scene featuring a castle flying a long pennant is printed within a floral border. This central scene is also shown in D369, printed three times around the rim of a marked trial plate, believed to have been made by Neale & Co. The examples shown by Drakard & Holdway are not marked but they give reasons for their attribution to Spode, based on both the pattern itself and the shapes of known wares.

Turnbull, G.R. (D371)

The mark used at the Stepney Pottery is incomplete and should have the word "POTTERY" curving below to make a full circle. It has been recorded on a romantic scene within a geometric and Greek key border.

Turner & Tomkinson (New) fl.1860-1872

Victoria Works, Tunstall, Staffordshire. Jewitt states that Turner & Tomkinson produced "ordinary printed and enamelled earthenware... for the home and Colonial markets". Printed marks with initials T. & T. have been recorded, and one blue-printed pattern was titled "Cattle"

Twig Basket (New)

See: Basket.

Twisted Tree (D372)

This pattern was called "India" by the Brameld factory, and is sometimes marked with a cartouche in the form of a Chinese figure with an urn on a bench inscribed "INDIA / STONE CHINA". Ill: Cox 47 (and Mark 60).

The same pattern was produced by James Reed of Mexborough under the title "Tapestry". He obtained the copper plates at the Rockingham Works sale in 1843.

Two Figures (D372)

The Spode version of this chinoiserie pattern is catalogued by Drakard & Holdway as P602 and shown by them on a dish in S81. It is also illustrated in Copeland pp.68-69; Coysh 1 3; Whiter 3.

Two Temples (D372)

An alternative name for the Spode chinoiserie patterns which are catalogued by Drakard & Holdway as Broseley (qv) and Temple (qv).

"Tyburn Turnpike" (D372)

A plate from the Beaded Frame Mark Series by an unknown maker, with the border clobbered in several coloured enamels and an iron-red rim, is illustrated in Colour Plate XXVI.

"Tyrol Hunters" (D372)

This romantic-style scene by Davenport has been noted on an ornate sauce tureen. The cartouche mark includes the title "Tyrol Hunters" with the maker's name "DAVENPORT" beneath. The Tyrol became part of Austria after the Congress of Vienna in 1814.

"Ulysses Following the Car of Nausicaa" (New)
Joseph Clementson. "Classical Antiquities" Series. Dish.

Along with other patterns from the series, this design is marked with a registration diamond for 13th March, 1849.

In the *Odyssey*, following his departure from Calypso, Ulysses was shipwrecked by Poseidon off the coast of Scheria. He swam ashore and fell asleep on a bed of leaves in a wood beside a gentle stream. Nausicaa, guided by a dream sent by Minerva, took a wagon full of garments to be washed in the stream, and with her attendant virgins played and sung as they waited for the washing to dry in the sun. Their revelry awoke Ulysses, and Nausicaa provided him with food and clothing, and then led him part of the way back to the city, where he was later accepted into the court of her father, King Alcinus, and his queen, Arete.

See: "Ulysses Weeps at the Song of Demodocus".

"Ulysses at the Table of Circe" (D374)
The plate from the "Classical Antiquities" Series by Joseph Clementson is illustrated here.

Circe was a noted sorceress who lived on the island of Aeaea. When Ulysses came there in his wanderings, she enchanted two-and-twenty of his companions and turned them into swine. Ulysses himself, having obtained from Mercury a herb with the power to resist sorcery, went boldly to Circe who once again entertained him and plied him with food and drink at her table, and then attempted to trap him in the same way as his companions. Protected by the herb, he forced her to disenchant his comrades, and afterwards she plied them all with hospitality before helping them on their way and giving them guidance in safe passage past the Sirens.

"Ulysses Weeps at the Song of Demodocus" (New)
Joseph Clementson. "Classical Antiquities" Series. Plate. Ill: Williams & Weber p.61.

Along with other patterns from the series, this design is marked with a registration diamond for 13th March, 1849.

Following Ulysses' shipwreck off the coast of Scheria and his discovery by Nausicaa, he arrived at the palace of her father, King Alcinus, where he begged assistance from Queen Arete. Accepted at the court, he was entertained by the lays of the minstrel Demodocus who had been bestowed by the Gods with the power of song, but denied the blessing of sight. He sang of the secret loves of Mars and Venus, and also about the fall of Troy, and Ulysses was moved to tears. Alcinus was later to provide a ship for him to return to his home at Ithica and his wife Penelope.

See: "Penelope Carrying the Bow to the Suitors"; "Ulysses Following the Car of Nausicaa".

"Union" (D374)
The pattern recorded by Venables & Baines was registered on 17th February 1852, and was also printed in mulberry. Ill: Williams & Weber p.633.

"Ulysses at the Table of Circe". *Joseph Clementson. "Classical Antiquities" Series. Printed titles and maker's mark with registration diamond for 13th March, 1849. Plate 8¼ ins:21cm.*

Union Border Series (New)

An adopted name which is used to cover a series of rural scenes produced by John & Richard Riley. Most pieces are unmarked but the impressed name "RILEY" is sometimes found, particularly on dessert plates. The border is similar in style to Wedgwood's Blue Rose border, but consists of prominent rose sprays on a background of thistles and shamrocks. Four different centres are illustrated here, and all scenes recorded to date feature a group of animals in the foreground:

(i) Two cows and a donkey. Plate 6½ ins:17cm. Ill: FOB 54.

(ii) Cattle and sheep, with man, woman and child. Plate 8¾ ins:22cm.

(iii) Cattle and herdsman. Soup plate 10¼ ins:26cm. Ill: Williams & Weber p.413.

(iv) Cattle by stream. Soup plate 10¼ ins:26cm.

(v) Horse, goat, sheep, cows and donkey, with seated herdsman in centre. Dish 18¾ ins:48cm.

(vi) Goat, sheep and cow, further sheep and cows, and a donkey. Dish 16½ ins:42cm.

Union Wreath (D374)

These three Spode floral patterns are catalogued by Drakard & Holdway as P823, P824, and P825, and shown by them on several different shapes. Examples are also illustrated in Coysh 1 117-118; Whiter 56-58; S.B. Williams 159.

"Unto God Only Be Honour and Glory" (D375)

Two further plates from the Riley dinner service have been discovered and are now back in the ownership of the Drapers' Company.

It has, however, subsequently been pointed out by Roger Pomfret in "John & Richard Riley — China & Earthenware Manufacturers", *Journal of Ceramic History,* Vol.13 (1988), that the Drapers' Company of Coventry purchased an extensive blue-printed armorial service from the Riley factory. He illustrates three items with the same arms and motto, and also the original invoice for a total sum of £84 12s. 6d., dated 8th September 1823. It is possible that the previously quoted purchase of a dinner service recorded in the accounts of the London Drapers' Company relates to some other wares.

Another dinner service with these arms and motto has also been recorded, this time with the border from Spode's Greek pattern. However, on grounds of both design and quality, the example noted did not appear to be of Spode manufacture. It is believed that Copeland made wares with the Greek border for the Company later in the century, but their products would usually be marked.

"The Upper Lake of Killarney" (New)

Careys. "Irish Views" Series. Plate 9ins:23cm.

The three lakes of Killarney are a famous tourist attraction about one and a half miles to the west of the town of the same name. They lie in a basin surrounded by lofty mountains and wildly picturesque ravines, and are studded with thickly wooded islands. The Upper Lake, covering 430 acres, is fed by the river Flesk and is joined to the Middle or Muckross Lake by a two and a half mile channel called the Long Range.

Union Border Series, scene (ii). John & Richard Riley. Impressed "RILEY". Plate 8¾ ins:22cm.

Union Border Series, scene (iv). John & Richard Riley. Unmarked. Soup plate 10¼ ins:26cm.

Union Border Series, *scene (vi). John & Richard Riley. Unmarked. Dish 16½ ins:42cm.*

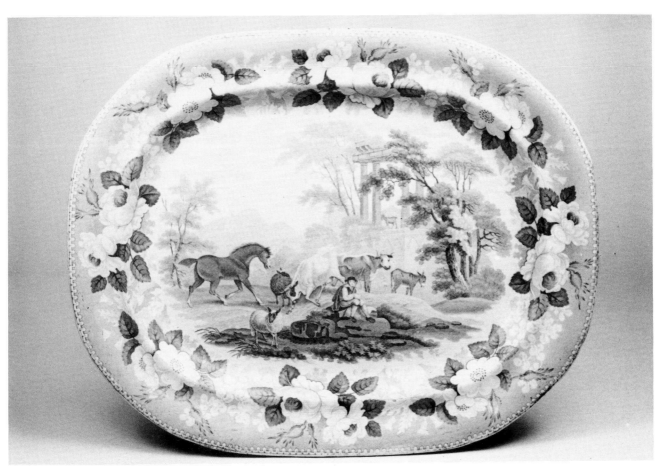

Union Border Series, *scene (v). John & Richard Riley. Unmarked. Dish 18¾ ins:48cm.*

"Valle Crucis Abbey, Wales" (D376)
This view by an unknown maker in the Pineapple Border Series was also used on tureen stands 13ins:33cm and 16¼ins:41cm. An example with an interesting reserve in the border containing the name "A. Emmerson" (qv) is illustrated in Colour Plate XIII. A smaller but otherwise similar stand which is mismarked "Slingsby Castle, Yorkshire" is shown in FOB 10.

Vandyke (New)
A recently adopted title for a Spode floral pattern which Drakard & Holdway catalogue as P828. It features a floral spray within an irregular border shaped rather like goatee beards, hence the title.

"Vas Floreat" (New)
John Hulme & Sons. A pattern with a vase and a basket of flowers together with a bowl of fruit, all within a border of roses and jugs of flowers. The printed mark shows a large bird holding a pennant inscribed with the title and with the makers' name beneath.

The Latin title translates to a vessel or receptacle rich in flowers.

"Venetian Scenery" (D376-377)
This romantic scene by Robinson & Wood was also printed in green.

"Venus" (D376)
Venus was the Roman goddess of spring, and became identified with the Greek Aphrodite. Caesar erected a temple in her honour, and in AD 135 an even more impressive temple was built by Hadrian. The name was later given to the most conspicuous planet.

"Verandah" (New)
Maker unknown. A floral and geometric design incorporating arches of trelliswork. The title "VERANDAH" is printed in a diamond-shaped frame of flowerheads.

The word verandah was originally used in India for an open portico attached to a house.

"Vernon's Head Tavern, North Audley Street" (New)
Maker unknown. A dinner plate printed with the standard Willow pattern has been noted with an underglaze blue-printed inscription:
Vernon's Head Tavern
North Audley Street
incorporated into the top of the picture. This would have been specially ordered for use in the tavern.

North Audley Street connects Grosvenor Square to Oxford Street in central London, and the Vernon's Head Tavern was at number 32, by a pillar box at the junction with Green Street. It had a succession of different landlords throughout the 19th century including:
1826 James Duncan Saxe
1835 William Linford
1840 G.W. Clarke
1842 John H. Marshall
1846 Richard Hurst
1859 Mrs. M. Tait
1861 W. Walker
1867 M. Haddock
1868 C. Hayley
1872 C. Godfrey
According to London directories the name was simplified to Vernon Head from 1874, and the tavern seems to have closed down in 1883.

The tavern may have been named after either Richard Vernon (1726-1800), a founder of the Jockey Club and so-called "father of the turf", or James Vernon (1646-1727), a politician who was the local M.P. for Westminster between 1698 and 1702. Other possibilities include the two English admirals with the same name. Edward Vernon (1684-1757) served in the Mediterranean, Baltic, and West Indies, and gained fame for taking Porto Bello in 1739. He served as M.P. for both Penryn and Ipswich, but his naval career ended ignominiously when he was cashiered in 1746. Sir Edward Vernon (1723-1794) had a less flamboyant career but was knighted in 1773, became commander-in-chief in the East Indies, and eventually a full admiral in 1794.

"Verona" (D377)
The patterns by Lockhart & Arthur and David Methven & Sons are, in fact, different. Both are illustrated in the *Scottish Pottery Historical Review*, No.5, 1980, pp.50-51.

Verona was frequently visited by young men on their Grand Tour, and Hester Lynch Piozzi, formally Mrs. Thrale and a close friend of Dr. Johnson, described Verona as the gayest town she had ever lived in.

"Victoria" (D378)
Another potter used this title:
(ii) Dimmock & Smith. A pattern showing Queen Victoria on horseback against a background of Windsor Castle, the cartouche mark incorporating the makers' initials D. & S.

"Victoria Review" (New)
Maker unknown. A pattern showing Queen Victoria reviewing a military parade, recorded on a washbowl, ewer, and soap dish. The title "VICTORIA REVIEW" appears printed at the base of the design. Ill: FOB 48; J. May, *Victoria Remembered*, 18.

May suggests that the wares were made either to commemorate a review scheduled to take place in Hyde Park at the end of July 1837, or a similar review at Windsor a month later. Victoria refused to take part in the first because she was not allowed to attend on horseback. However, the building in the background of the pattern appears to be the Colosseum in Regent's Park, originally built by Decimus Burton for Thomas Horner between 1823 and 1827, altered by W. Bradwell in 1845, and demolished in 1875. Furthermore, the bowl appears to be of later date, possibly about 1850. In view of these inconsistencies, the review concerned cannot yet be positively identified.

"Viege". *Wood & Challinor. Printed scroll cartouche with title and makers' initials. Dessert plate 9ins:23cm.*

"Viege". *Original pen, ink and wash drawing inscribed "Viege or Visp. By Mrs. Young". 4¾ins:12cm by 6¾ins:17cm.*

"Viege" (New)

Wood & Challinor. A view printed within a floral border, which forms part of a series of continental scenes, another of which is titled "Lake of Como" (qv), and a third may be "Bacharach" (qv). A dessert plate is illustrated here together with the original pen, ink and wash drawing on which the scene is based. This is inscribed "Viege or Visp. By Mrs. Young". It has not yet proved possible to trace this artist, and the potters would probably have copied an engraving rather than the original painting. As with the other views, a printed scroll cartouche contains the title "VIEGE" and the makers' monogram W. & C. appears in a reserve beneath. The border also appears on an unmarked Pap Boat (qv).

Viege is an old name for the Swiss town of Visp which lies in the Rhône valley about 65 miles east of Lausanne. In the 18th and early 19th centuries, wealthy young men on the Grand Tour had to decide where to cross the Alps, and those who chose the Simplon Pass would make for Viege, probably via Geneva. The journey over the pass was hazardous, but by 1817 road building had started. It took about eight hours to reach the highest point before the descent to Domodossola, so an early start was necessary if the crossing was to be completed by nightfall.

Vieillard, Jules, & Cie. (New) fl.c.1845-1895
Bordeaux, France.
 See: David Johnston & Co.

View in the Fort, Madura (D380)
Rare examples of this Herculaneum pattern are known with the text and music for Psalm 115, "Non Nobis Domine", printed on the reverse in puce.

"View in Geneva" (New)
Davenport. A typical romantic pattern with buildings in the foreground and distant scenery, noted on toilet wares marked with the title in a scroll cartouche.

View of the Imperial Park at Gehol (D381)
Research by Pat Latham has revealed that there was an error in the original source book from which this view was copied. The Davenport pattern actually shows "A View in the Garden of the Imperial Palace at Peking", not Gehol, and is taken from Sir George Leonard Staunton's *An Authentic Account of an Embassy from the King of England to the Emperor of China* (1797). This consisted of two volumes and a folio of 44 plates, but two of the plates were transposed in the folio. The artist William Alexander remained in Peking while Lord Macartney went to Gehol.

"View of London" (D381)
This view is now known to have been copied from a large engraving, but no further details are yet available.

"Views in Mesopotamia" (New)

James Keeling. The title of this series appeared in the *Dictionary* in error as "Views of Mesopotamia". The printed cartouche mark with the title "VIEWS in MESOPOTAMIA" on what appears to be a four poster bed with palms in the background is illustrated in Williams & Weber p.538.

The views were taken from *Travels in Mesopotamia* by J.L. Buckingham. Research by Hugh Stretton has located the following entry in the *Staffordshire and Pottery Mercury* dated 22nd November 1828:

> Mr. James Keeling, earthenware manufacturer of this town, has produced a most beautiful dinner service, the designs on which consist of a series of the views accompanying Mr. Buckingham's *Travels in Mesopotamia*.
>
> We understand other manufacturers are completing services of ware, with illustrations from Turkish and Oriental scenery.

These "Views in Mesopotamia" are usually printed in black or blue on dinner wares with gadrooned edges, but arcaded dessert wares were also produced in a blue body with the designs printed in black and added gilding. Currently identified views, with Buckingham's chapter numbers where known, are:

(i) Oriental Conversazione and Garden Entertainment (Chapter VI). Exterior of octagonal soup tureen. This is also the source of the printed cartouche mark mentioned above.

(ii) Tomb of Zobeida, Wife of Haroun-el-Rashid, the Caliph of Bagdad (Chapter IX). Plate 10½ins:27cm. Ill: FOB 39; P. Williams p.169.

(iii) Return from a Desert Excursion in Search of the Walls of Babylon (Chapter X). Circular stand 13¾ins:35cm and octagonal tureen stand, interior and lid. Ill: FOB 39.

(iv) Turkish Coffee-House near the Bridge of Boats on the Tigris at Bagdad (Chapter XII). Tazza or footed comport 11¾ins:30cm. Ill: FOB 39.

(v) A Fountain near Aleppo. Handled oval dishes 13ins:33cm. Ill: FOB 39.

(vi) View of Birs Nimroud. Plate 9¼ins:23cm and arcaded dessert plate. Ill: Williams & Weber p.538 (on a blue plate with the design printed in black).

"Views of Mesopotamia" (D384)

See previous entry.

"Views...Wales" (New)

Maker unknown. An ornately moulded jug printed with two different country scenes and a wide floral border both inside and out bears a cartouche mark in the form of a harp inscribed "VIEWS / ... / WALES". The middle word is indistinct and could be either "IN" or "OF".

"Vignette" (D384)

The pattern used by Thomas Dimmock is a romantic scene within a floral border with a light background. The printed mark is in the form of a crowned cartouche inscribed "VIGNETTE / STONE WARE", and has the maker's initial D at the base. Some examples also bear an impressed Dimmock monogram.

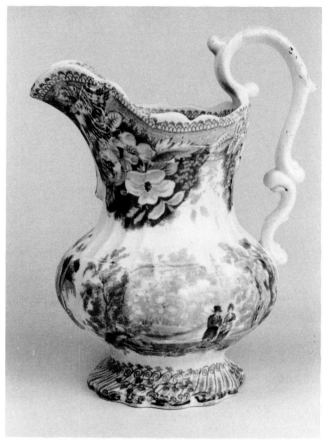

"Views ... Wales". *Maker unknown. Printed title mark in the form of a harp. Jug 6¼ins:16cm.*

"Views ... Wales". *Maker unknown. Printed title mark on jug above.*

"Vignette" Series (D384)

John Denton Bagster. Additional scenes, allocated titles either here or in FOB 41, 42, 52 and 55, are:

(iv) The Meeting. A man with horse talks to a woman with basket. Soup tureen interior.

(v) Woodcutters' Lunch. Two men seated on a felled tree with tools scattered around. Soup tureen and small long tray from a pickle set. Ill: FOB 53.

(vi) Resting Family. A seated group of a man and woman with baby with uptilted cart in the background. Soup tureen.

(vii) Rural Beggars. A woman putting something into a hat held by a man who stands with another woman outside a doorway. Soup tureen lid.

(viii) Haymaking. Boy with pitchfork leans on hayrick and talks to a girl with a large jar. Plate 9½ins:24cm.

(ix) Sheep at Hay Rack. Five sheep by a hay rack, three eating, one reclining and the other grazing. Dish 12½ins:32cm and toilet box.

(x) The Topers. Two seated men with barrel, one drinking from a tankard. They are accompanied by a child and dog. Square bowl 8¼ins:21cm. It has been reported that this scene is copied from a painting by George Morland called "The Peasants' Repast". A creamer with this scene printed with a different border, which may not be a Bagster product, can be seen in FOB 53.

(xi) Scottish Shepherd. Shepherd wearing tartan and a Tam o'Shanter, leaning on a crook and tending two sheep.

(xii) The Cows. Two cows by a rock and tree in the foreground, all in front of a village with a church.

(xiii) Watering Place. Mounted rider, his horse taking a drink from a stream.

"Villa Scenery" (New)

Maker unknown with initials D. & B. This probably relates to Deakin & Bailey of Lane End but may alternatively have been used by Dalton & Burn of the Stepney Bank Pottery, Newcastle-upon-Tyne. A typical floral romantic scene within a flowery scroll border printed on wares with a moulded edge. The cartouche mark shows a bird holding a scroll inscribed with "Villa Scenery" in script and the makers' initials D. & B. Ill: Williams & Weber p.266.

Village Church (D386)

A large bowl in the Village Church pattern has been recorded with the mark "CLEWS / WARRANTED / STAFFORD-SHIRE" beneath a crown with the letters G and R on either side, impressed twice. This remains the only known piece with a maker's mark but it must be recognised that it only proves that the Clews factory did use this pattern. It was clearly used with slight variations by other potters and it is still not possible to attribute wares printed with this design with any certainty.

A very similar scene was used by David Dunderdale & Co. at the Castleford Pottery. It can be seen on a marked sauceboat illustrated by D. Edwards Roussel in *The Castleford Pottery 1790-1821*, plate 53.

"A Village on the Ganges" (New)

Maker unknown. "Oriental Scenery" Series. Dish. Ill: FOB 47.

From the original source print this view is known to show a village above Boglipore in northern India. It lies on the river Ganges to the east of both Patna and Varanasi (Benares).

"Village & Pagoda on the Ganges" (New)

Thomas & Benjamin Godwin. Indian Scenery Series. Dish 12½ins:32cm.

See previous entry.

"Vignette" Series. *John Denton Bagster. Woodcutters' Lunch; scene (v). Unmarked. Tray from pickle set, length 7ins:18cm.*

Village Scene (D387)

This Spode design is now known to be part of a larger pattern known as Musicians (qv).

The Villager (D387)

Another potter used this view:

(v) Jones. A tureen has been noted with the impressed mark "JONES", possibly relating to Elijah Jones of the Villa Pottery at Cobridge.

"Villaris" (New)

Davenport. A romantic rural scene, featuring a boat on a river with a large house on the far bank, printed on teawares. The title appears in script within a scroll cartouche with the maker's name beneath.

The significance of the title is not yet known, although it could possibly be related to Pasquale Villari (b.1827), an Italian historian who took an active part in the Neapolitan Revolution of 1848.

"Vine" (D389)

The pattern by John Rogers & Son was also printed in brown.

Violin (New)

A name which has become accepted for the early chinoiserie-style design illustrated on a marked Joshua Heath soup plate, D174. An unmarked drainer can be seen in FOB 34 and in NCS 62, p.34, where it is considered to be "almost certainly by Bradley & Co., Coalport". Further unmarked teawares are illustrated in FOB 49 and 50. There are variations in the pattern and its border, and it would appear to have been made by two or more different factories.

"Virtus Vera Nobilitas" (New)

Virtue is true nobility. A motto associated with the coat-of-arms of Trinity College, Oxford.

A circular blue printed dish decorated with the college coat-of-arms together with "TRINITY COLLEGE KITCHEN" on a ribbon above and the motto on a similar ribbon below has been recorded. The dish bears an impressed Copeland mark together with date marks for November 1899.

Visp (New)

The modern name for the Swiss town of Viege (qv).

"Vista de la Habana" (D390)

One plate with this view printed in pale mauve has been reported with the initials W.R. for William Ridgway added at the base of the cartouche mark.

Colour Plate XXVI. "Tyburn Turnpike". *Maker unknown. Beaded Frame Mark Series. Printed title mark. Plate 8¼ ins:21cm.*

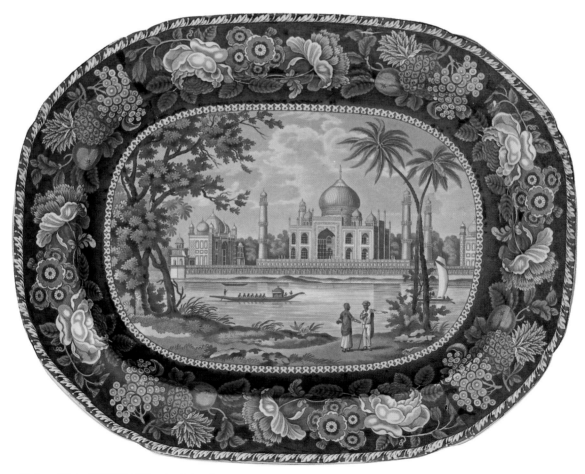

Colour Plate XXVII. "Tomb of the Emperor Shah Jehan". *John Hall & Sons. "Oriental Scenery" Series. Printed titles mark with makers' name. Dish 18¼ ins:46cm.*

"Wakefield Lodge, Northamptonshire" (D391)
A comport of very distinctive shape printed with this view from the Crown Acorn and Oak Leaf Border Series is illustrated in Colour Plate XXIII; another of identical shape printed with the River Fishing pattern and marked "MEIR" is shown in Colour Plate XXII.

The original hunting lodge by Kent, if it was ever completed, was considerably altered by Matthew Brettingham for the Duke of Grafton in 1759. The tetrastyle porch in the view is clearly part of Brettingham's alterations.

Wallis, William (New) **b.1796**
An etcher and line engraver of landscapes and architectural views. His work appeared in several books, including Grey's *The Excursions Through Essex* (1818), which was source for some of the views in Andrew Stevenson's Rose Border Series.

Walsh, William (New) **fl.c.1815-1822**
Newcastle Street, Burslem, Staffordshire. William Walsh was working in Burslem in 1815 and is recorded as an earthenware manufacturer in directories for 1818 and 1822 but there is no further entry in 1828. The blue-printed mark "WALSH" was reported (D392) on a dish in the India Series printed with the View in the Fort, Madura, normally made by the Herculaneum Pottery in Liverpool. In FOB 47 Pat Latham reports two dishes with the same printed mark decorated with the print Mausoleum of Sultan Purveiz, near Allahabad.

"Wanstead House, Essex" (D392)
Two untitled views of this house have now been identified, one previously known as Palladian Mansion in the "British Scenery" Series (D60), and the other illustrated on a loving cup by an unknown maker (D230). These views are both copied from an engraving in Grey's *The Excursions Through Essex* (1818), which was also the source for the titled view in Andrew Stevenson's Rose Border Series. The engraving is illustrated in this volume along with another dish from the "British Scenery" Series (qv).

The house no longer exists.

"Warleigh House, Somersetshire" (D393)
Another view with this title is:
 (ii) William Adams. Flowers and Leaves Border Series. Plate 10¼ ins:26cm.

Warren (D393)
The printed "WARREN" mark, illustrated on an "Irish Scenery" soup plate, almost certainly relates to the retailer Samuel Warren of 28 Dame Street, Dublin. Other marks, including the address, have been reported on "Arctic Scenery" wares and appear in surviving records dating between 1835 and 1861 of the Ridgway, Morley, Wear & Co. and succeeding partnerships. See: NCS 53, pp.6-8.

"Warleigh House, Somersetshire". William Adams. Flowers and Leaves Border Series. Printed title mark and impressed maker's eagle mark. Plate 10¼ ins:26cm.

"Warwick Vase" (D394)

In their booklet *The Warwick Vase*, Richard Marks and Brian J.R. Blench state that J. & M.P. Bell & Co. registered various versions of their Warwick Vase pattern between 1850 and 1890, and they also illustrate another version issued "after 1881".

Water Cistern (New)

A water tank, normally designed to hang on a wall, used for the supply of water to basins or water closets. Only one blue-printed example, decorated with the view of "Orielton, Pembrokeshire" from the Grapevine Border Series by Enoch Wood & Sons, has so far been noted.

Water Closet (New)

See: Stephen Hawkins & Co.; Lavatory Pan; Henry Marriott.

Watering Can (New)

A large blue-printed watering can is illustrated here. It is decorated with the "Florentine" pattern and is thought to have been produced by George Gordon of Prestonpans. This is the only transfer-printed watering can so far recorded.

Watering Can. *Maker unknown. Unmarked. Height 12ins:30cm.*

Waterloo (New)

An alternative title for the Spode pattern known in the past as Italian Church and catalogued by Drakard & Holway as P709. It has now been identified as a view of the church at the village of Waterloo, in Belgium. A similar view was used in the Berlin service presented to the Duke of Wellington in about 1817. The church stood opposite his headquarters at Waterloo. One of the Berlin plates is illustrated by Pat Latham in a short article titled "Two Sources of Underglaze Blue Prints on Early 19th Century Pottery" in the *Transactions of the English Ceramic Circle*, Vol. 12, Part 1 (1984). The Spode pattern is illustrated here on a saucer and in Coysh 1 108; Drakard & Holway S144; Whiter 63; S.B. Williams 95.

Watson, William (D395)

Another interesting jug by Watson & Co., decorated with a view thought to show Edinburgh, is illustrated in FOB 34. The printed mark consists of the name "WATSON & Cº" in a rectangular frame.

The Wedgwood Factory (D396)

An important paper by Una des Fontaines describing the early patterns produced at the Wedgwood factory appeared under the title "Wedgwood Blue-Printed Wares 1805-1843" in the *Transactions of the English Ceramic Circle*, Vol. 11, Part 3 (1983). It lists most of the factory's authentic pattern names and gives a good guide to their dates of introduction. Two patterns are illustrated in this volume under their factory names of Pagoda and Pavillion (sic).

"Wellcombe, Warwickshire" (D397)

The view by Enoch Wood & Sons in their Grapevine Border Series was also used on a dish 14½ins:37cm.

"Wellington Hotel, Waterloo" (D397-398)

A sucrier, teabowl and saucer with this Shorthose pattern are illustrated in FOB 33. A detailed article by Ron Govier discussing the design and its derivation appeared in FOB 45.

The inscription in French found on the similar pattern by an unknown maker proved difficult to read. Other examples with clearer prints reveal that it should be "Le Prince de la Couronne de Hollande, Waterloo" (translating to the Crown Prince of Holland, Waterloo).

Waterloo. *Spode. Printed "SPODE". Saucer 5½ins:14cm.*

"Wenlock Abbey, Shropshire". *Maker unknown. Pineapple Border Series. Soup ladle, length 11ins:28cm.*

"Wenlock Abbey, Shropshire" (New)

Maker unknown. Pineapple Border Series. Soup ladle.

Wenlock lies 14 miles south east of Shrewsbury, and Wenlock Abbey, or Wenlock Priory as it is known today, was founded as a nunnery in 680. The present building is Early English. The Prior's Lodge, a private house, dates from 1500, and is a fine example of domestic architecture.

"Whampoa" (D398)

Whampoa, known today as Huang-pu, lies on an island in the eastern estuary of the Pearl River, or Si-kiang, just below Canton in the south of China. The Chinese destroyed large quantities of opium brought into Canton by the British in 1839 and this led to the Opium War (1839-1842). Canton was opened up to the British as a treaty port in 1842, and to the French and Americans in 1844, when Whampoa also became a treaty port, giving the foreigners independent legal, judicial, and other extraterritorial rights and privileges.

Wheatley, Francis W. (New) 1747-1801

An artist whose painting "The Cottage Door" (qv) was copied for a pattern by Phillips of Longport. He worked in Dublin from 1779 to 1784, and when he returned to London devoted himself to painting pictures of "the deserving poor". The series "Cries of London", engraved in 1795, is typical of his work.

Whittingham, Ford & Co. (New) fl.1868-1873

Union Bank, Burslem, Staffordshire. A partnership which used initials W.F. & Co. on printed marks including pattern titles such as "Singanese".

"Wild Rose" (D399-400)

Other potters who used this design were:
William Adams & Sons, Stoke-on-Trent, Staffordshire
John Brindley & Co., Shelton, Staffordshire
Joseph Burn & Co., Newcastle-upon-Tyne, Northumberland
Robert Cochran & Co., Glasgow, Scotland
Thomas Goodfellow, Tunstall, Staffordshire
Lockhart & Arthur, Glasgow, Scotland
Middlesbrough Pottery, Yorkshire
Thomas Nicholson & Co., Castleford, Yorkshire
George Phillips, Longport, Staffordshire
John Reed, Mexborough, Yorkshire
Sewell & Co., Newcastle-upon-Tyne, Northumberland
Joseph Twigg, Swinton, Yorkshire
James Wallace & Co., Newcastle-upon-Tyne, Northumberland
John Wood, Newcastle-upon-Tyne, Northumberland

Willey, Thomasine (New) fl.1818

Thomasine Willey's name appears on two plates by an unknown maker, one in the City Museum, Stoke-on-Trent, and the other in the Victoria & Albert Museum, London. They are printed with the standard Willow pattern but the top section of the design, including the doves, has been replaced by an inscription "THOMASINE WILLEY / 1818" printed underglaze in blue. It has not yet proved possible to trace Thomasine Willey but these were presumably presentation plates made to mark her birth or some similar occasion.

Willow Pattern (D402)

The Spode version of this famous chinoiserie pattern is catalogued by Drakard & Holdway as P609 and shown by them on a range of different shapes. It is widely illustrated elsewhere, including Copeland pp.33-44; Whiter 10-12; S.B. Williams 101.

Willow Pattern Makers (D402-403)

Other potters who used this design were:

John Allason, Sunderland, Durham
Bathwell & Goodfellow, Burslem, Staffordshire
William Brownfield & Son, Cobridge, Staffordshire
Joseph Clementson, Hanley, Staffordshire
William & Samuel Edge, Lane Delph, Staffordshire
Ford, Challinor & Co., Tunstall, Staffordshire
Godwin, Rowley & Co., Burslem, Staffordshire
Thomas Goodfellow, Tunstall, Staffordshire
Griffiths, Beardmore & Birks, Lane End, Staffordshire
William Lowe, Longton, Staffordshire
Middlesbrough Pottery, Yorkshire
George Phillips, Longport, Staffordshire
Pountney & Co., Bristol, Somerset
Wood & Brownfield, Cobridge, Staffordshire

A copper plate used for printing the standard Willow Pattern design is illustrated here which includes a cartouche mark with the unidentified initials S. & Co.

"Windsor Castle" (D404)

An additional titled view is:

(v) Copeland & Garrett. Seasons Series. Soup tureen stand. This pattern bears the month "September" on the prominent vase of flowers in the foreground.

Other untitled views have been identified in the series marked "British Palaces" (qv) and "English Scenery" (qv).

The view titled "Windsor Castle" from the "Metropolitan Scenery" Series by Goodwins & Harris is illustrated opposite on a dish, together with the original source print for the game of cricket depicted in the foreground. This was a copper plate engraving by Cook which appeared as the frontispiece in the *Sporting Magazine* for June 1793. It shows a match played on 20th June 1793 on the first Lord's Ground at Marylebone between teams representing the Earls of Winchelsea and Darnley. The prize was a purse of 1,000 guineas, and the game was won by Lord Winchelsea's side.

"Windsor Festoon" (D406)

This floral pattern by John & William Ridgway is illustrated here on an ornately moulded dessert dish.

The Winemakers (D405-406)

This pattern has now been noted on a large unmarked soup tureen.

"Winter" (New)

See: "Seasons".

Willow Pattern Makers. *Copper plate of standard Willow Pattern including cartouche mark with unidentified makers' initials S. & Co.*

"Windsor Festoon". *John & William Ridgway. Printed shield-shaped title cartouche with "OPAQUE CHINA" and makers' initials. Moulded dessert dish 10ins:25cm.*

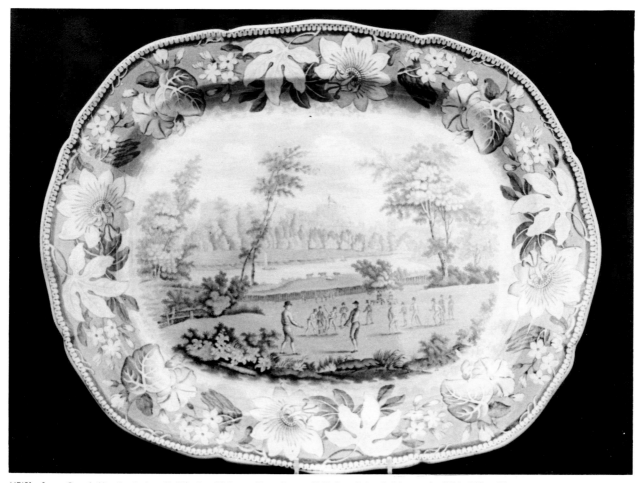

"Windsor Castle". *Goodwins & Harris. "Metropolitan Scenery" Series. Printed titles mark. Dish 19ins:48cm.*

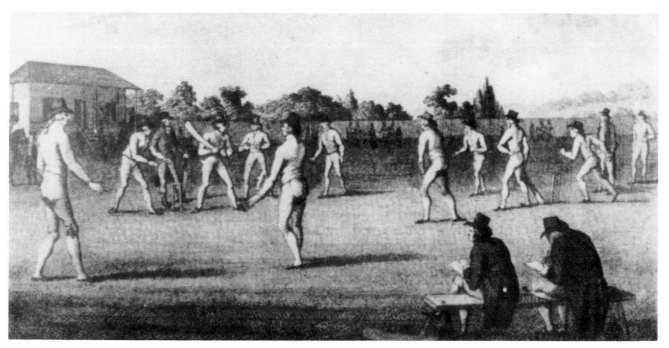

"Windsor Castle". *Source print for the cricket match in the foreground of the dish above, taken from the "Sporting Magazine" for 1793 and inscribed "GRAND CRICKET MATCH, played in Lord's Ground Mary-le-bone, on June 20 & following day between the EARL'S of WINCHELSEA & DARNLEY for 1000 Guineas".*

Wiseton Hall, Nottinghamshire. *Possibly Pettys & Co. Unmarked. Plate 9¾ins:25cm.*

"Withers" (New)

The printed leafy cartouche mark containing the name "WITHERS" which is illustrated here, is taken from a small dish in the Durham Ox Series (qv). This is not a pattern name, and although its significance is not yet known, it probably relates to a retailer or the original owner rather than a potter.

"Withers". *Unidentified mark from a Durham Ox Series dish.*

Wiseton Hall, Nottinghamshire (New)

A view by Pettys & Co. of Leeds, previously referred to as the Gazebo pattern, has now been identified as Wiseton Hall in Nottinghamshire. An unmarked plate is illustrated here but a marked example can be seen in Coysh 2 66.

Wiseton Hall, near Clayworth, midway between Bawtry and Gainsborough in the north-east corner of Nottinghamshire, was a three-storey house built for Jonathan Acklam in 1771. In 1814 it passed to the Spencer family, and wings were then added. It was demolished in 1960.

Wiss, Robert (New)　　　　　　　　**fl.c.1830-1872**

A lavatory pan has been noted with a pattern which includes the inscription:

R. WISS
Patentee
38 Charing Cross
LONDON

Robert Wiss is first listed in a London directory for 1830 at 167 Fleet Street, but in 1831 he had moved to 38 Charing Cross. He remained at the same address until 1858 when he moved successively to 87 St. Martin's Lane (1858), 63 Mortimer Street (1863), and finally 29 Great Portland Street (1866-1872). He is listed throughout as either a Patent Water Closet Manufacturer or a Patentee & Manufacturer of the Portable Water Closet. Despite the inscription and the directory listings, no patent is listed under the name of Robert Wiss prior to 1852.

"Wistow Hall, Leicestershire" (D406)

The plate from the Foliage Border Series by an unknown maker is illustrated here. The dish from the Large Scroll Border Series by John & Richard Riley illustrated D406 is mismarked and actually shows the view of "Bretton Hall, Yorkshire".

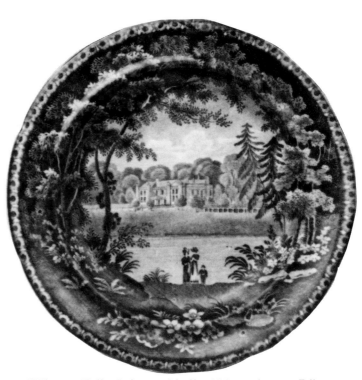

"Wistow Hall, Leicestershire". *Maker unknown. Foliage Border Series. Printed title mark. Plate 8¾ins:22cm.*

"Woburn Abbey" (New)
Maker unknown. Passion Flower Border Series. Sauce tureen.

"Woodland" (New)
W. Baker & Co. A rural scene featuring a horse and cart. Two people are waiting in the cart which has stopped for the horse to drink from a stream.

Woodman (D408-409)
This Spode genre scene is catalogued by Drakard & Holdway as P703. It is also illustrated in Whiter 61 and 98; S.B. Williams 136-137.

Woolf, Lewis (New) fl.1856-1883
Ferrybridge, Yorkshire. Lewis Woolf bought the Ferrybridge Pottery in 1856 and built the nearby Australian Pottery in the late 1850s. He operated in his own name until about 1870 when he was joined in partnership by his two sons and traded as Lewis Woolf & Sons. Printed wares are known marked with initials L.W. or L.W. & S., including patterns such as "Albion" and "Chinese Marine".

Woolf, Sydney, (& Co.) (New) fl.c.1860-1887
Australian Pottery, Ferrybridge, and Rock Pottery, Mexborough. Sydney Woolf was a son of Lewis Woolf (qv) and ran the Australian Pottery, becoming sole owner in 1877, where his business continued until 1887. He also took over the Rock Pottery in 1873, where he traded as Sydney Woolf & Co. until c.1883. He served in the House of Commons as Liberal M.P. for Pontefract.

Wares from the Australian Pottery, as it name implies, were intended mainly for export to Australia, but a version of the "Eton College" pattern was produced, marked with initials S.W. and impressed "FERRYBRIDGE".

Wooliscroft, George (New) fl.c.1851-1864
Tunstall, Staffordshire. Little appears to be recorded about this potter except that he worked different potteries at Tunstall from 1851 to 1853 and again from 1860 to 1864. Godden gives his addresses as Well Street and High Street for the earlier period, and then Sandyford Potteries later (see Godden M 4308). One blue-printed pattern titled "Eon" was registered in February 1853, and two other designs were registered in June 1853 and November 1862. Other printed patterns were titled "Excelsior" (also used by Samuel Moore & Co.) and "Rosette". The full name "G. WOOLISCROFT" appears in printed marks.

"Worcester" (D410)
Another view with this title is:
 (iii) Charles Harvey & Sons. Cities and Towns Series. Ewer.

Worstead House, Norfolk (New)
A view used by an unknown maker on a sauce tureen stand in the Crown Acorn and Oak Leaf Border Series has been identified as Worstead House. Ill: FOB 39.

Worstead is a small town some eight miles north-east of Aylsham in Norfolk. The house, usually called Worstead Hall, was built for the baronet Sir Berney Brograve by James Wyatt between 1791 and 1797. It has since been demolished.

"Writtle Lodge, Essex". Source print taken from Grey's "The Excursions Through Essex".

Worthington & Harrop (New) fl.1856-1873
Dresden Works, Hanley, Staffordshire. Partnerships with this name were operated by John Worthington and William Harrop until 1864, and thereafter by Thomas Worthington and William Harrop. The firms produced printed wares for the home and American markets, including the common "Asiatic Pheasants" pattern, marked with initials W. & H.

"Writtle Lodge, Essex" (D410)
This pattern is illustrated below along with the source print engraved by W. Wallis for Grey's *The Excursions Through Essex* (1819). The lodge is referred to as the Seat of Admiral Fortescue but it probably changed hands in the 1820s.

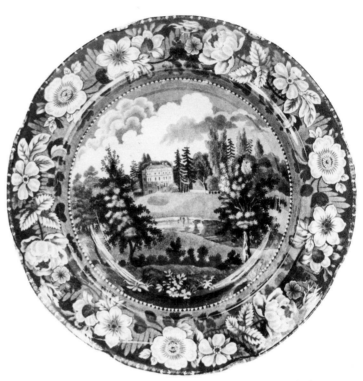

"Writtle Lodge, Essex". Andrew Stevenson. Rose Border Series. Printed title mark and impressed maker's circular crown mark. Soup plate 10¼ ins: 26cm.

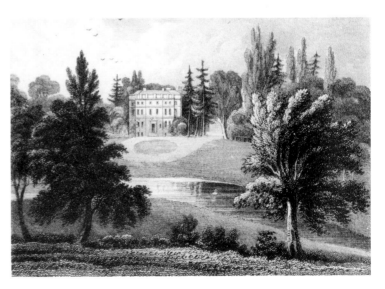

"Yeddo" (D411)

Yeddo, or Yedo, was the name formerly given to the Japanese capital city, which was renamed Tokyo, meaning eastern capital, in 1868.

"York" (D411)

The dish from the Cherub Medallion Border Series by Herculaneum is illustrated below. Its size is now known to be 15ins:38cm.

"Yorkshire Relish" (New)

Maker unknown. Miniature advertising plates are commonly found with the standard Willow pattern but with the inscription "YORKSHIRE" and "RELISH" let into the top and bottom of the border. An uncommon variant has "YORKSHIRE RELISH" at the top and "THICK OR THIN" at the bottom. A further variant has been noted with the inscriptions reading "GOODALL'S" and "YORKSHIRE RELISH".

According to the Oxford Dictionary a relish is "a highly flavoured pickle which gives zest to food with which it is served and also stimulates the appetite. It is usually composed of different tart fruits and its flavour is sweet-sour". Yorkshire Relish was produced by Goodall, Backhouse & Co. of Leeds, and their advertising material described it as "the most delicious sauce in the world".

"Yorkshire Relish". *Maker unknown. Unmarked. Miniature advertising plate 4¼ins:11cm.*

"York". *Herculaneum. Cherub Medallion Border Series. Printed title mark and impressed "HERCULANEUM". Dish 15ins:38cm.*

Zebra. *Spode. Impressed "SPODE". Dish 11¼ ins:29cm.*

Zebra (D413)

This pattern was normally produced in blue by John Rogers & Son, but they also printed it in a greyish-brown. Other variants of the pattern were made by Toft & May (see Little 67) and at Leeds; examples in both blue and brown have been noted clearly impressed "LEEDS POTTERY".

A very rare dish is illustrated here with a clearly impressed Spode mark. Since it has not previously been recorded and it is not a standard Spode design, one of the above firms may have been supplied with some unglazed wares from Spode to help them fulfil an urgent order.

A set of 24 copper plates for a Zebra pattern were amongst those offered for sale in 1831 from the works run by Charles Bourne (qv). No marked blue-printed earthenwares made by Bourne have yet been recorded.

"Zoological" (New)

Robinson, Wood & Brownfield. A series of patterns printed in light blue noted on dinner wares, each item decorated with scenes showing different animals in zoological gardens. The printed oval cartouche mark has a crown at the top and includes the inscription "STONE / WARE / R. W. & B. / ZOOLOGICAL". Scenes include:

Antelope. Lid for soup tureen.
Camel. Ornate soup tureen.
Lion cages. Dish.
Tiger cages. Dinner plate.
Unidentified birds, possibly a heron and a spoonbill. Dessert plate.
Zebra pen. Miniature sauceboat.

"**Zoological**". *Robinson, Wood & Brownfield. Printed cartouche with series title and makers' initials. Plate 10¾ ins:27cm.*

"**Zoological**". *Robinson, Wood & Brownfield. Unmarked. Miniature sauceboat, length 3¾ ins:10cm.*

"Zoological Sketches" Series (D413)

Job Meigh & Son. Additional designs are:

Armadillo. Tea plate.
Elks (?). Vegetable dish.
Foxes raiding a farmyard. Lid of vegetable dish.
Gazelle.
Ring-tailed lemur.
Skunk. Tea plate and shaped pickle dish.
Tiger. Sauce tureen stand.

The design listed in the *Dictionary* as a badger is in fact a skunk, illustrated here on a shaped pickle dish.

See: "Improved Stone China".

"Zoological Sketches" Series. Skunk. Job Meigh & Son. Printed series title mark with makers' initials. Shaped pickle dish, length 5½ ins:14cm.

"Zoological Sketches" Series. Elks (?) and Foxes. Job Meigh & Son. Printed series title mark with makers' initials, and impressed seal with "Improved / Stone China" (both marks on base only). Vegetable dish and cover, overall length 12¾ ins:32cm.

218

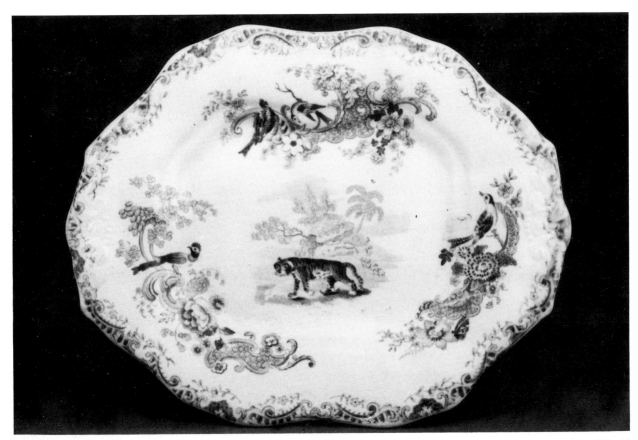

"Zoological Sketches" Series. *Tiger. Job Meigh & Son. Printed series title mark, and impressed seal with "Improved / Stone China". Sauce tureen stand 8¼ins:21cm.*

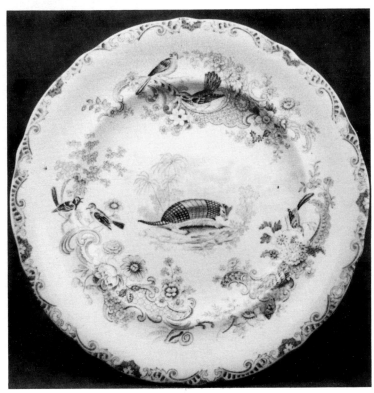

"Zoological Sketches" Series. *Armadillo. Job Meigh & Son. Printed series title mark with makers' initials, and impressed seal with "Improved / Stone China". Tea plate 7½ins:19cm.*

Appendix I: Unattributed Patterns

In both the original *Dictionary* and this volume, an attempt has been made to list all patterns which are marked with a title, as well as many patterns where their authentic factory names are known or which have been allocated a widely accepted title by collectors or dealers. There remain thousands of patterns which are unmarked and unattributed, and an arbitrary selection of such pieces encountered during preparation of this volume is illustrated in this Appendix. They are offered without comment in the hope that some may become identified by comparison with other surviving marked examples. Unless otherwise stated, with the minor exception of workman's marks which appear of little immediate import, all these pieces are unmarked.

Tentative titles have been adopted here for reference purposes, but they are not intended to be definitive. Other titles, unknown to the authors, may already be in use, or more appropriate titles may be suggested, in due course. We would be delighted to hear from anyone who can help identify the makers or sources of any of these patterns, or who can add any other information about the wares covered in the *Dictionary* and this volume.

Banana Tree Chinoiserie. *Dish 20½ ins:52cm.*

Bird's Nest. *Plate 8¾ ins:22cm.*

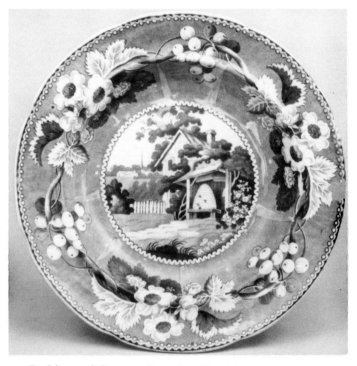

Beehive and Cottage. *Soup plate 10ins:26cm.*

Botanical with Butterfly. *Arcaded plate 7ins:18cm.*

Castle Keep. *Teapot, length 9¾ins:25cm.*

Celtic Greeting. *Saucer 5½ins:14cm.*

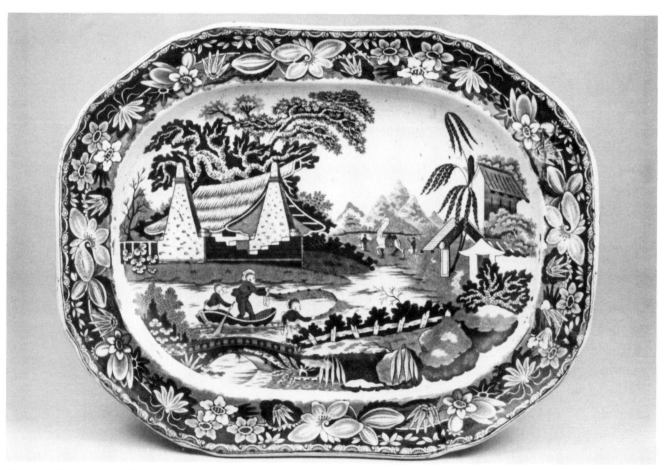

Chinese Fisher Boys. *Dish 15ins:38cm.*

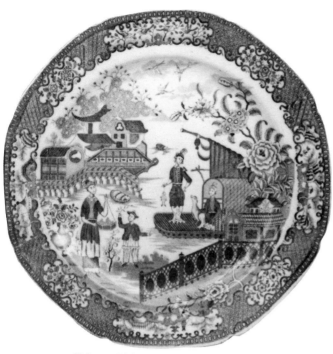

Chinese Fisherman. *Plate 9½ ins:24cm.*

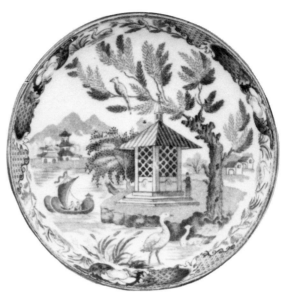

Chinese Gazebo. *Saucer 5¼ ins:14cm.*

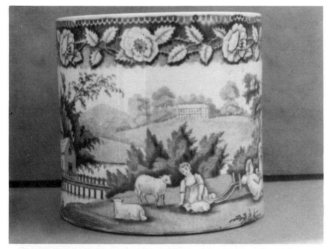

Classical Figures. *Jug 4¾ ins:12cm.*

Cottager and Children. *Two views of a mug, height 4¾ ins:12cm.*

Death of the Stag. *Plate 8ins:21cm.*

Dogs on the Scent. *Washbowl 12½ins:32cm.*

Eastern Garden Scene. *Two views of a mug, height 4 ¼ ins:11cm.*

Eastern Tent. *Two views of a mug, height 4 ¼ ins:11cm.*

Elephant with Eastern Border. *Cup and saucer, diameter of saucer 5½ ins:14cm.*

Family Group. *Saucer 4¾ ins:12cm.*

The Flasher. *Pickle dish 6½ ins:16cm.*

Footbridge. *Saucer 5ins:13cm.*

Giant Sheep. *Bowl 10½ins:27cm.*

Girl with Firewood. *Jug 2½ins:6cm.*

227

Goatherd. *Dish 12 ¾ ins:32cm.*

Gun Dogs. *Teapot, length 11 ¼ ins:29cm.*

Hare and Leverets. *Saucer 5½ins:14cm.*

Harpist and Castle. *Ewer 9ins:23cm.*

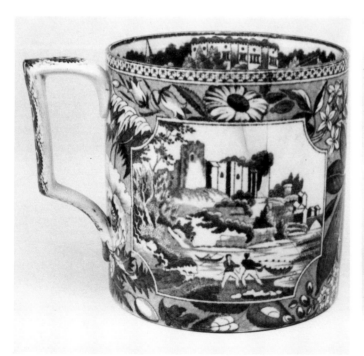

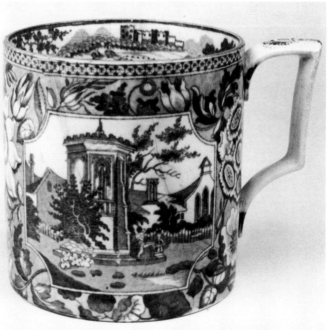

Heritage Scenes. *Two views of a mug, height 4¼ins:11cm.*

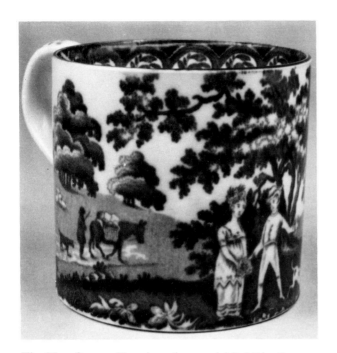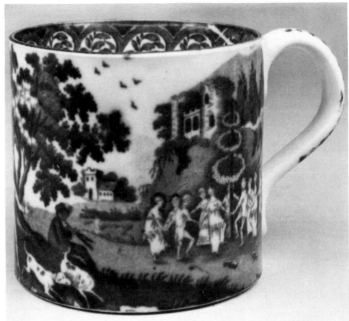

The May Queen. *Two views of a mug, height 3½ins:9cm.*

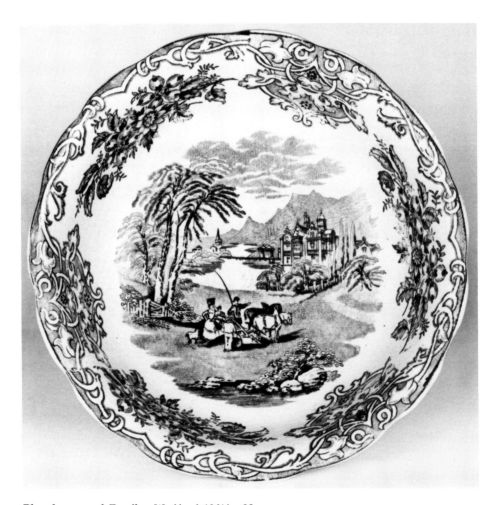

Ploughman and Family. *Washbowl 12¾ins:33cm.*

Quadruped Centre. *Cup and saucer, diameter of saucer 5 ¼ ins:14cm.*

Resting Farm Boy. *Saucer 4 ¼ ins:11cm.*

Resting Soldier. *Saucer 5 ½ ins:14cm.*

231

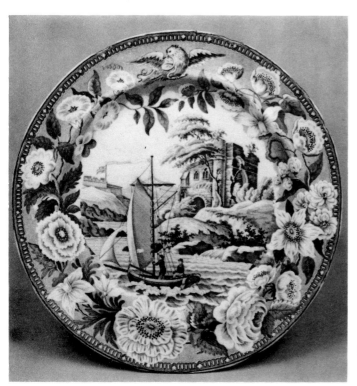

Sailing Boat. *Plate 9¾ins:25cm.*

Sea Shells. *Cup and saucer, diameter of saucer 5¼ins:14cm.*

Sheet Flowers and Tendrils. *Arcaded plate 7¼ins:18cm.*

Sheet Fronds and Sunflowers. *Plate 5¼ins:14cm.*

Spinning Wheel. *Deep saucer 5½ins:14cm.*

Stable Door. *Dished cereal plate 7½ins:19cm, and domed lid 6¼ins:16cm.*

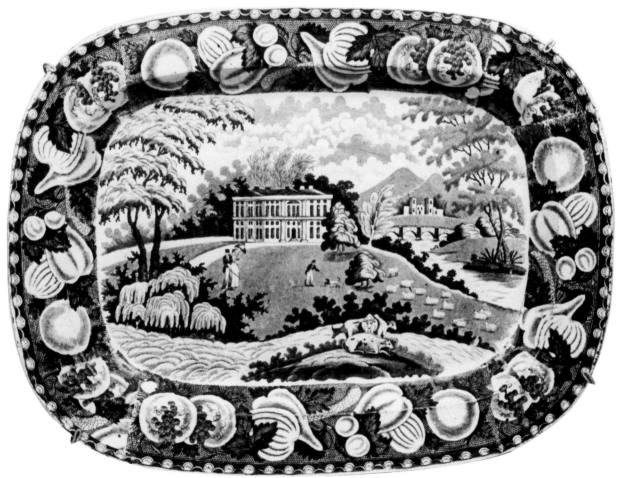

Stately Home. *Dish 18¾ins:48cm.*

Strawberry and Apple. *Impressed fractional date mark for September 1824. Plate 8½ins:22cm.*

Swan Centre. *Soup plate 9½ins:24cm.*

The Sundial. *Plate 10ins:25cm.*

Swineherd. *Saucer 5 ¼ ins:14cm.*

Swan and Peacocks. *Plate 8 ½ ins:21cm.*

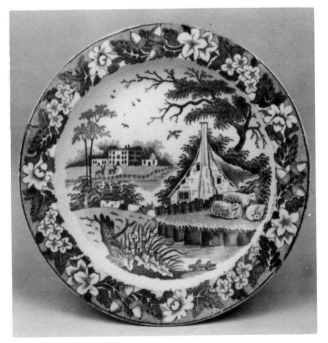

Tall Chimney. *Plate 6 ¼ ins:16cm.*

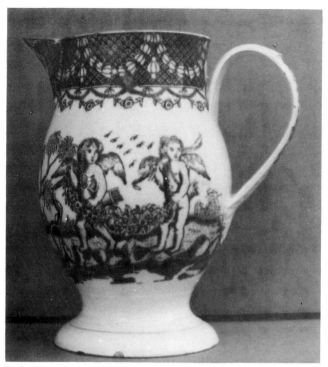

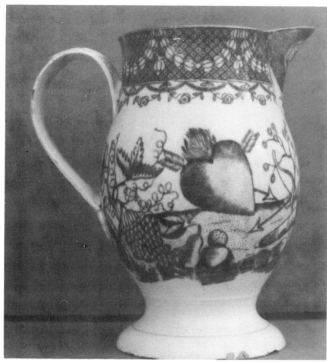

Valentine. *Two views of a jug, 6½ ins:17cm.*

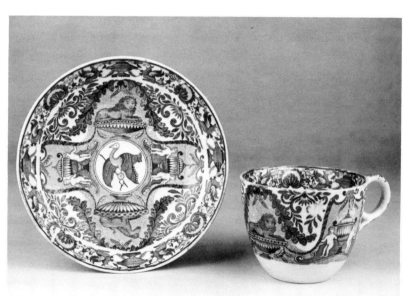

Vulture Centre. *Cup and saucer, diameter of saucer 5½ ins:14cm.*

Winding Road. *Miniature teapot, height 4ins:10cm.*

Appendix II: Initial Marks

Further initial marks recorded on blue printed wares include:

B	Thomas Barlow	L.W.	Lewis Woolf
B. & H.	Bodley & Harrold	L.W. & S.	Lewis Woolf & Sons
	Beech & Hancock	M. & P.	Machin & Potts
D.B. & Co.	Davenport, Banks & Co.	P.B.	Poulson Brothers
	Davenport, Beck & Co.	P.Bros.	Poulson Brothers
F. & T.	Flacket & Toft	P. & G.	Pountney & Goldney
G.B. & B.	Griffiths, Beardmore & Birks	S.W.	Sydney Woolf
G. & D.	Guest & Dewsberry	T.B. & Co.	Thomas Booth & Co.
H.	C. & W.K. Harvey	T.G. & F.B.	T.G. & F. Booth
H.A. & Co.	Harvey Adams & Co.	T.N. & Co.	Thomas Nicholson & Co.
H.B.	Hawley Brothers	T. & T.	Turner & Tomkinson
H.H. & M.	Holdcroft, Hill & Mellor	W	Edward Walley
H. & K.	Hollinshead & Kirkham	W.A.A.	William Alsager Adderley
H.N. & A.	Hulse, Nixon & Adderley	W.A. & Co.	William Adams & Co.
J. & T.E.	James & Thomas Edwards	W.F. & Co.	Whittingham, Ford & Co.
J. & T.F.	Jacob & Thomas Furnival	W. & H.	Worthington & Harrop
J. & T.L.	John & Thomas Lockett	W.T.H.	W.T. Holland

The following unidentified initial marks have also been recorded:

A. & Co.	See: "Thomson's Seasons".	H.	See: "Holy Bible" Series; "Indian Scenery".
B.	See: "Chinese Juvenile Sports".		
B. & B.	See: "Poppy".	H.W.	See: "Irish Scenery" Series.
B. & G.	See: "Asiatic Pheasants"; "Chinese Marine".	I.W.	See: "The Minstrel".
		M.T. & T.	See: "Chinese Gem"; E.T. Troutbeck.
B. & S.	See: "Chinese Marine"; "Corrella".	R. & D.	See: "Botanical Beauties".
D. & B.	See: "Villa Scenery".	R.K. & Co.	See: "Asiatic Pheasants".
D.W.	See: "Scott's Illustrations" Series.	S. & Co.	See: Willow Pattern Makers.
		T.H. & Co.	See: Ornate Pagodas.
E. & Co.	See: "The Pet Goat".	T.H.W.	See: "Arabian Sketches".
E.N. & N.	See: "Chinese Villa".	W.	See: "Amaranthine Flowers".
F.R. & Co.	See: "Eton College".	W.G.	See: "Albion".

Appendix III: Source Books

Contemporary source books known to have been used by makers of blue-printed earthenwares were listed in Appendix II of the *Dictionary*. Further books used by the potters have now been identified, including:

Caunter, Rev. H., *The Oriental Annual or Scenes from India*, London, 1834.

Cooke, G., and Cooke, W.B., *Views on the Thames*, London, 1811 and 1822.

Elliott, M., *The Progress of the Quartern Loaf*, London, 1820.

Forrest, C.R., *A Picturesque Tour along the Rivers Ganges and Jumna in India*, London, 1824.

Franklin, J., *Narrative of a Journey to the Shores of the Polar Sea, in the years 1819 to 1822*, London, 1823.

Grey, J., *The Excursions Through Essex*, London, 1818.

Grey, J., *The Excursions Through Suffolk* (two volumes), London, 1818-1819.

Hamilton, W., *Collection of Engravings from Ancient Vases, mostly of pure Greek workmanship in sepulchres in the Kingdom of the Two Sicilies, but chiefly in the neighbourhood of Naples*, Naples, 1791-1795.

Hodges, W., *Travels in India*, London, 1786.

Howitt, S., *Fables of Aesop and Phaedras*, London, 1809-1811.

Kirk, T., *Outlines from the Figures and Compositions upon the Greek, Roman and Etruscan Vases of the Late Sir William Hamilton, with engraved borders. Drawn and engraved by the late Mr. Kirk*, London, 1804.

Parry, E.W., *Journal of a Voyage for the Discovery of a North-West Passage from the Atlantic to the Pacific, Performed in the Years 1819-20*, London, 1821.

Parry, E.W., *Journal of a Second Voyage for the Discovery of a North-West Passage from the Atlantic to the Pacific, Performed in the Years 1821-23*, London, 1824.

(The two books by Parry are titled correctly here, and not as on p.417 of the *Dictionary*.)

Pyne, W.H., *Microcosm; or a Picturesque Delineation of the Arts, Agricultures, Manufactures &c. of Great Britain*, London, 1802-1807.

St. Non, J.C.R. de, *Voyage Pittoresque ou Description des Royaumes de Naples et de Sicile*, Paris, 1781-1786.

Staunton, G.L., *An Authentic Account of an Embassy from the King of England to the Emperor of China*, London, 1797.

Storer, J., and Greig, I., *The Antiquarian and Topographical Cabinet*, London, 1807-1811.

Swan, J., *Select Views on the River Clyde, Engraved by Joseph Swan from Drawings by J. Fleming*, Glasgow, 1830.

Bibliography

The following publications have either appeared since the original *Dictionary* or provide additional relevant information:

Anstruther, I., *The Knight and the Umbrella*, London 1963.

Baker, J.C. (ed.), *Sunderland Pottery*, fifth revised and extended edition Sunderland 1984.

Bell, R.C., *Maling and other Tyneside Pottery*, Princes Risborough 1986

Copeland, R., *Blue and White Transfer-Printed Pottery*, Princes Risborough 1982.

Cox, A., and Cox, A., *Rockingham Pottery & Porcelain 1745-1842*, London 1983.

Drakard, D., and Holdway, P., *Spode Printed Ware*, London 1983.

Edwards Roussel, D., *The Castleford Pottery 1790-1821*, Wakefield 1982.

Elvin, C.N., *Handbook of Mottoes*, London 1860; reprinted and revised 1963, 1971.

Fontaines, U. des, "Wedgwood Blue-Printed Wares 1805-1843", *Transactions of the English Ceramic Circle*, Vol. 11, Part 3, 1983.

Godden, G.A., *The Illustrated Guide to Ridgway Porcelains*, London 1972; reprinted and revised as *Ridgway Porcelains*, Woodbridge 1985.

Heaps, L., *The Log of the Centurion*, New York 1974.

Larsen, E.B., *American Historical Views on Staffordshire China*, New York 1939; reprinted and revised 1950, 1975.

Latham, J.P.M., "Two Sources of Underglaze Blue Prints on Early 19th Century Pottery", *Transactions of the English Ceramic Circle*, Vol. 12, Part 1, 1984.

May, J., *Victoria Remembered*, London 1983.

Milbourn, M. and E., *Understanding Miniature British Pottery and Porcelain 1730-Present Day*, Woodbridge 1983.

Pomfret, R., "John and Richard Riley — China and Earthenware Manufacturers", *Journal of Ceramic History*, Vol. 13, 1988.

Sussman, L., *Spode / Copeland Transfer-Printed Patterns Found at 20 Hudson's Bay Company Sites*, Ottawa 1979.

Walker, J., *The Universal Gazetteer*, London 1810.

Williams, M., *The Pottery That Began Middlesbrough*, Redcar 1985.

Williams, P., and Weber, M.R., *Staffordshire II, Romantic Transfer Patterns*, Jeffersontown, Kentucky 1986.